THE ART OF
Zandra Rhodes

My special thanks are due to Robyn Beeche
for her extensive photographic work
and especially for the Butterflies and Textiles.

This book is dedicated to my fabulous
mother, Beatrice Ellen Rhodes, and my
grandmother, Beatrice Rosina Twigg,
and to all those who proudly wear my
clothes

THE ART OF
Zandra Rhodes

Written by Zandra Rhodes and Anne Knight

Researched by Marit Lieberson

ZANDRA RHODES PUBLICATIONS LIMITED

MICHAEL O'MARA BOOKS LIMITED

This edition published jointly in 1994 by Michael O'Mara Books Limited,
9 Lion Yard, Tremadoc Road, London SW4 7NQ and
Zandra Rhodes Publications Limited, 85 Richford Street, London W6 7HJ

First published in Great Britain in 1984
Copyright © 1984 by Zandra Rhodes

A CIP catalogue record for this book is available from the British Library

ISBN 1–85479–997–5

10 9 8 7 6 5 4 3 2 1

Jacket photograph by Robyn Beeche. Visagiste and Hair Artist Yvonne Gold.

Printed and bound in Hong Kong by Paramount Printing Group Limited

Contents

Illustration Credits

The authors and publishers are grateful to those listed below for permission to reproduce copyright material on the following pages: 54, Museum of the American Indian, New York; 76, 77 bottom, *Anan*, 1971; 235 right, reproduced from *Avenue* magazine; 212 left, by courtesy of Michael Chow; 119 bottom right, *Cosmopolitan* magazine; 61 right, by courtesy of CVP Designs; 20 top left, 30 top left, reproduced with kind permission of Parfums Christian Dior; 200 top right, reproduced with kind permission of Fabergé and Nadler, Larimer & Cromer; 203 left, Griffith Observatory, Los Angeles, California; 216 right, the Solomon R. Guggenheim Museum, New York (© ADAGP Paris, 1984); 51 bottom left (copyright © the Hearst Corporation), 106 bottom left (copyright © 1974 the Hearst Corporation), 106 right (copyright © 1975 the Hearst Corporation), 175 right, 182 bottom right (both copyright © 1977 the Hearst Corporation), courtesy of *Harper's Bazaar*; 65 bottom left, 157 bottom right, 175 bottom left, reproduced from *Harper's and Queen* (© the National Magazine Company Ltd); 14 top left, 202, David Hockney; 200 left, reproduced with kind permission of International Distillers and Vintners (UK) Ltd and Young & Rubicam Ltd; 105 right, *Interview*; 144 bottom right, Paul Jasmin; 177 right, Allen Jones; 17 top, second from left, reproduced with kind permission from the archives of Lever Brothers Ltd; 78 second from left, Musée National d'Art Moderne, Paris, photo Bulloz, (© SPADEM Paris, 1984); 14 top, second from right, the National Maritime Museum, London; 191 right, Barbara Nessim; 44 top right, the *New York Times*; 18 bottom right, *Nova* magazine; 204 top right, published with kind permission of the artist and the Victoria and Albert Museum (Crown Copyright); 69 top left, reproduced by gracious permission of Her Majesty The Queen; 18 bottom, second from right, reproduced from *Queen* magazine (© the National Magazine Company Ltd); 123, reproduced with kind permission of Martin Sharp; 203 second from left, © Smithsonian Institution 1976; 14 top right, the *Sunday Times* Magazine; 17 top left, the Tate Gallery, London (© SPADEM Paris, 1984); 64 left, 105 left, John Topham Picture Library; 156 bottom left, courtesy of *Town and Country* magazine; 78 left, Transworld Features; 26 top right, 39 top left, 67 top and bottom (Crown Copyright), 68 top left and second from left, 80 left (Crown Copyright), 127 top left, 177 left (Crown Copyright), 229 bottom right (Crown Copyright), by courtesy of the Victoria and Albert Museum; 21 right (copyright © 1969 by the Condé Nast Publications Inc.), 31 right (copyright © 1970 by the Condé Nast Publications Inc.), courtesy American *Vogue*; 24, 35 left and right, 50 right, 51 top left and right and bottom right, 52, 65 top left, 66, 74, 75 left and bottom right, 88 left and right, 89 top left and right, 106 top left, 119 top right, 120, 139 left and right, 156 top left and bottom right, 157 top right, 209 right, 224 right, reproduced from *Vogue* (© the Condé Nast Publications Ltd); 50 left, reproduced from Italian *Vogue* (© the Condé Nast Publications Ltd); 80 second from left, reproduced by permission of the Trustees, the Wallace Collection, London; 16, 30 top right, 89 bottom left, 91, Elizabeth Whiting & Associates; 37, page from *Costume Patterns and Designs* by Max Tilke, reproduced with kind permission of A. Zwemmer Ltd.

Individual photographers are credited beside their pictures.

Acknowledgments

I would like to thank all my friends for their support, but I will mention here especially David Sassoon and Adel Rootstein who patiently listen to my problems on the telephone, and Dicky Choppin, who taught me at the Royal College of Art, and showed me the correct beginning of the road.

I am particularly grateful to those photographers whose work I have used to recall the past, capturing all the atmosphere of my dresses as they were happening in various Editorials or their own personal files, especially: Tim Street-Porter who hunted through all his work; Barry Lategan who assisted wonderfully when transparencies needed to be found; Norman Eales in Los Angeles who helped me transatlantically to find his work; and Clive Arrowsmith who provided the fabulous black and whites of his beautiful *Vogue* photographs and many others. Thanks are also due to Beatrix Miller, who allowed her staff painstakingly to hunt out all the *Vogue* transparencies I needed; and to Norman Parkinson, who has beautified my dresses on his glittering clients.

In my own studio, Gill Curry, first made me start on this book. Both she and Louise Kois have patiently and skilfully helped me trace slides and photographs, doing all the research and general co-ordination. Jill Griffiths worked on my drawings and paperwork to make them suitable for photographs and she has shared many of my textile adventures with me. Jane Raven organised the revamping of the dresses for all the butterfly pages, as well as running all my beading and finishing departments. Since I do none of my work in a vacuum, I thank my staff for their patience while I have had to spend hours sorting through all this archival material, and for making sure the show still goes on: especially Ben Scholten, who is in this story; Hazel Bidder, who makes my dress design a practicality; and of course, Karen Kaliszewski, who has to fight to protect me.

I am indebted to Marit Lieberson, who has known me since she was an editress on *Queen* before I started dress designing. Her detective work in helping me probe my memories, and her persistence, enabled me to sort out the muddled piles of work at my finger-tips and discover the true journeys that each design related to and, as a result, helped me create the format.

I also owe thanks to Nate Kacew, who shut me in a New York hotel room and told me to finish all the writing so that this book was finally completed; and, last but not least, to Anne Knight and Ronnie Stirling, for being silent pillars of strength.

1984 Z.R.

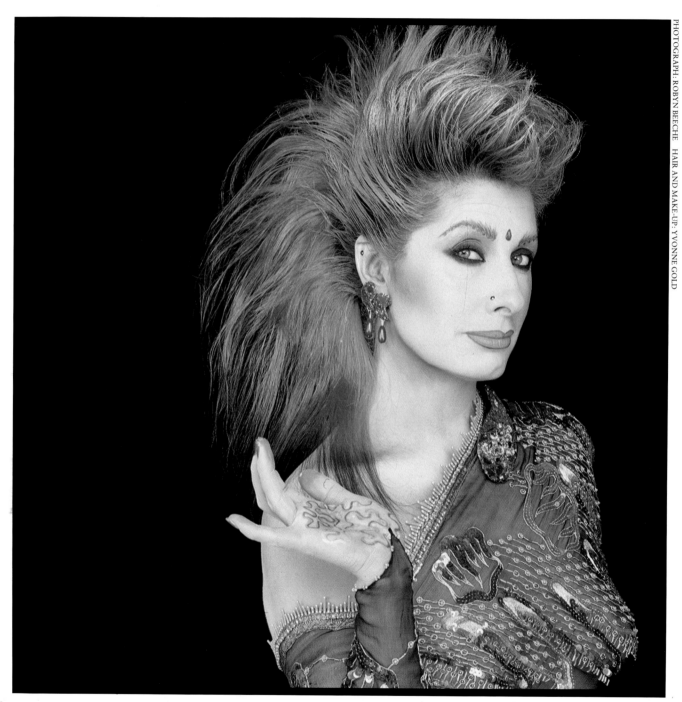

PHOTOGRAPH: ROBYN BEECHE HAIR AND MAKE-UP: YVONNE GOLD

Photograph of Zandra for 'Indian' poster, 1982

Introduction

I had for a long time wanted to do a book about my work because I wanted to chart the story behind my designs. They are not produced lightly and flippantly, but evolve through an interpretation of my surroundings, seen in my own special way. I feel that one of the major contributions to the world of fashion I have been able to make is my originality of textile print design and the way I have allowed the textiles to influence the garment shapes. This is what I want to demonstrate.

In my original concept I was inspired by a fabulous book of water-colour drawings by Max Tilke, called *Costume Patterns and Designs*. In this all the garments are laid out clearly, just as butterflies are displayed in showcases, and this has influenced the presentation of my own dresses. I had initially thought of calling this book *Zandra's Butterflies*, conceiving it as a book without words where the garments would speak for themselves. For several years, together with Robyn Beeche, a close friend and photographer, I had been perfecting a method of cataloguing dresses flat so that they transcended period and showed how the prints had been used.

Then those around me said, no, we want you to show your formative vision, the source, the sketches, the textiles, and finally, the butterflies. My publisher wanted a verbal explanation, a story, as it were.

I was thrilled with the idea of doing this book. I was in love with the idea and thought it would be easy. After all, I had carefully recorded everything I had ever done from the day I started. I possessed the drawings, the press cuttings, and the dresses. The original of every garment I had ever made was in my personal archives, nearly two thousand of them stored away. I know of no other fashion designer who owns every one of their originals, and it is a strict rule of the Zandra Rhodes House that nothing from my sample collection may be sold.

In the event it wasn't easy—what is? I should have known. However, it made me think about my work in a way I might never otherwise have done. So I looked back over sixteen years of textile prints and fashion design. This began to show me how I interpreted what I saw in front of me with my own intensely personal vision. Because of my background as a textile and not a fashion designer, I believe I see things more as an artist, interpreting what I see from a deeply personal point of view. For me this creative process does not lose any of its pain with repeated application. Sometimes it is an agony. I cannot say simply and precisely how I arrive at anything I do, because it is always an interrelationship of knowledge and experience. It is certainly not purely academic, although I have always turned to traditional sources like museums to research subjects chosen; but equally I draw on my own past, and everything that is going on about me now.

I love to work with people all around me, asking their opinion—'Do you like the colour?'—'What about this shape?'—'Do you think it would be better turned round?' All those sorts of questions. I am not often very influenced by what is said but I find that communication of the idea, live, and not just within myself, helps to sort out the problems. My friends' interest generates my enthusiasm and helps me to keep going on an idea especially when it doesn't work the first time, which is often the case. Friends are paramount to my existence. I am introspective. I thrive on admiration and need that close contact to get me out of myself. I like to talk about the things in my head and often unknowingly friends I like become the catalyst, giving a new twist to an idea by taking me to an exhibition or suggesting a place to visit for a vacation. Finally, my really intimate friends support, succour and inspire me, laugh with me, listen to my woes, understand my dilemmas, hear me out, encourage my

endeavours and, perhaps because most of them are also artists, they relate to my devastating insecurity, turning it from destruction into creation.

Through tracing my own methods I have found that my different themes relate to journeys of some kind in a very quixotic way, where the final images are almost unexplainable (even to me) until all the links are put together. So I resolved to chart these journeys and take a close look at the interpretations and results which emerged from them, and to try to pin down this creative process visually for others to share. About sixteen journeys proved to be involved. Each one has been an adventure for me, starting seventeen years ago with the local and tangible impressions of the supermarket, T.V. shows and the Blackpool Illuminations. Later, the broadening circles of experience that came to me as the pattern of my life became more international, meant that the influences on my designs were expanded in just the same way, and this helps to explain what has now become recognised as my particular style.

I was born in Chatham, Kent, England, in 1940 and grew up there. At that time the area was semi-rural. Our house was only a short bicycle ride from woods full of bluebells and celandines. At the bottom of the garden, looking over the North Downs, was a chalkpit. The view from there was one of the first things I drew in my sketchbook at school.

I came from a working-class family, and you could say that in every sense of the word. My father was a lorry driver. My mother had been a fitter at Worth in Paris. I had a younger sister, Beverley. I was completely obsessed by my school work and homework. As a family, we almost never sat around doing nothing. Even when we went on holidays we always took things like jigsaw puzzles and worked on them together. I have often thought it was an advantage that television did not exist in those days so there was no distraction. I feel lucky that my parents made work so imperative. I never resented being compelled to work, and I have never changed. I still work seven days a week, fourteen hours a day, and there is no vacation for me unless it is actively associated with my work.

All the things I remember doing in my childhood have stayed with me and still appear in my prints. The fret-saw shapes of the jigsaw puzzles must have been the first wiggles to become imprinted in my mind's eye. Even now these wiggles nearly always appear somewhere, even if only as fillers in the background of my new designs (a signature all of their own). I love the way words look, graphically, so writing has always been a

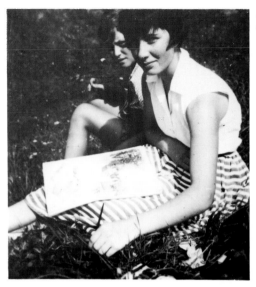

Zandra sketching at an early age

Zandra's sketch of the North Downs

pleasure for me. I wrote boringly and neatly in my school books. I never minded writing lines at school and, although I was naturally left-handed, I taught myself to write with my right hand so that I could do italic script. We had to do writing exercises, practising pages of words to improve our skills. Calligraphy became a passion and so I have often incorporated my thoughts and sometimes little poems into my prints. The words made designs of their own and, linked with the jigsaw shapes, became very important to my prints.

Another thing, which has stayed with me, was that I had to explain and justify my name throughout my childhood. It was Zandra with a Z—not Sandra with an S. I used to practise writing it over and over again—explaining it and writing it, no wonder it became an integral part of me, so that I write the name Zandra into my patterns, my publicity handouts, my labels, my shop bags, and almost everything I do—just like the wiggles.

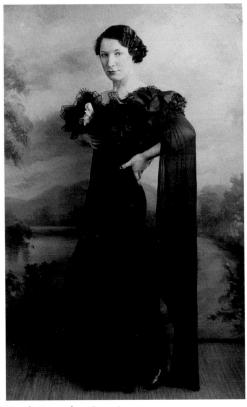

Zandra's mother, Beatrice

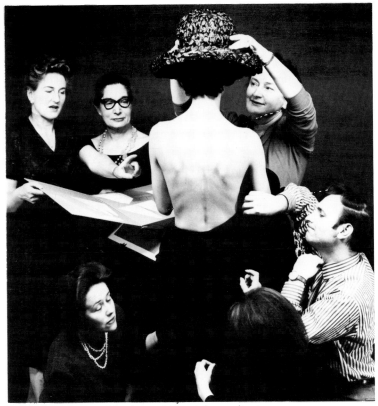

Zandra's mother teaching (second from left, standing)

The strongest influence in my childhood was undoubtedly my mother. She was an exotic woman, dramatically dressed, stylish and chic, always immaculately and heavily made-up, very opinionated, dominating our house, dazzling my childhood, embarrassing me in my awkward years; but ultimately being my strength and my direction. From 1959 to 1968, when she died, she was a senior lecturer in the Fashion Department at Medway College of Art. She is still spoken about today by those people who worked with her and students she trained. I often receive letters from people who want me to know how much they admired and respected her. She had an amazing effect on others. She was so interested in them that they accepted her advice. She taught belief in oneself and almost invariably, I believe, to the advantage of all those who came into contact with her. I can feel her presence around me when I am working in my studio, although I must admit I come from a very psychic family. I went

to Medway not at all wanting to do fashion. In fact, I didn't want anyone to know that it was my mother who taught there, since I was determined to make my own way in my own right, and I took elaborate pains to avoid her.

I admired the flamboyant character of the printed textile tutor, Barbara Brown. It was because of her I decided to specialise in textiles, and through her, I applied for and won a scholarship to the Royal College of Art, at that time the world's art mecca. I loved designing textiles. I enjoyed the discipline of the prints, that they had to be cut and used economically, that I had to consider measurements and repeats, that it was both technical and artistic at the same time, and directed towards an end product outside the pattern itself. I was proud to be a textile designer and I did not feel I was inferior to a painter or sculptor; it was my *métier*. I loved it and enjoyed the mental challenge of taking an art form into another stage; that is still an impulsive

motivating force in my work. My ideas are never static. I don't just design a print or a dress, produce it, and then drop it. The theme keeps worrying me to be developed and the original idea becomes linked to something new and is regenerated. I suppose that is why the so-called 'Rhodes Style' is so strong and emphatic.

When I left the Royal College in the early 1960s, it was fashionable to design furnishing fabrics; and, in fact, my degree print was bought by Heal's as a furnishing fabric. But it was during my second year at the Royal College that I became interested in the different discipline of dress fabrics. I was the first in the College's Textile School, for a long time, to turn away from furnishing textiles to doing dress fabrics. Maybe I took to dress fabrics because of my mother? Furnishing fabrics tend to be large-scale, and in the early 1960s frustrated, would-be artists designed furnishing fabrics, painting such things as abstract landscapes. I did not want people to go around like a walking painting for the benefit of the artist, and I did not think they should have to hold up their arms for the benefit of the print they were wearing. I was excited by the idea of things divorced from themselves, prints designed flat but never used in that manner, lines written instead of drawn, words spelled out instead of just illustrated. In learning to design for dress fabrics, I was involved in a special adventure, that of patterns which would not hang flat but would be cut and put together again in many different ways. Therefore, I treated myself similarly, like a canvas, pinning paper on to myself and walking around, moving, creasing, and studying the effects.

I loved printing and was a very flamboyantly messy student, always with dye on my nails. I enjoyed working closely with the colours and, from those early days right up until today, I still work with dyes and printing and make up all my own colourways, which are now catalogued so they can be mixed at the mere quote of a number.

I found out from my first experiments into the world of textile design that I was like no one else and fitted into nobody else's shoes. This meant that all along I was the best promoter and advertisement for my clothes because I represented the whole, not just a facet. Soon after that I came to the conclusion that if I was not going to wear and represent my clothes, who else was? Then as my business gradually grew, I had to show a new look every six months and change my own appearance every six months; I realised my small business had become an empire and I

had created a dragon. However, in spite of its size, I still make sure I am involved with the essential looks being created and I plan show scenes on the most accurate of charts.

As an extension of this type of designing I used myself as a canvas with no compromises, experimenting with my image, using cosmetics and my hair to create an impact. As a final note about myself, I have always been very extreme in my appearance, from sticking feathers with eyelash glue on the ends of my dyed green hair in the 1960s, and embroidering and patching jeans quite outrageously, right up to my photograph for the Indian-inspired poster of 1982 when I used blue make-up influenced by a blue Indian god.

From the beginning of my involvement in textile and fashion design, I have rejected the conventional and opposed formal attitudes. I have recklessly injected colour and beauty into my designs and have fought for originality and freedom of choice. This has been incomprehensible to many, but I have persisted in my beliefs and in the end I know I will win—this is still only the beginning.

Journey into Lights

Pop Art and the Beatles were on the crest of the wave when I was at the Royal College of Art. The current influences around me were Roy Lichtenstein, with his comic-book style, Andy Warhol's 'Soup Can', leading me to the glories of the supermarket, and Jasper John's use of words and letters. Emilio Pucci, the elegant Florentine aristocrat, was a current couturier designing and printing his own fabrics in complete panels for his garments. I was already experimenting with panels of my own, and I would try on the painted paper designs in front of the mirror, cutting out holes for my head, and turning them around on my body. This was the tail end of Swinging London. Mary Quant had invented the mini. Marion Foale and Sally Tuffin were installed in Carnaby Street; they were the unstated influence on the then young Yves St Laurent, with their use of Liberty prints.

I graduated from the Royal College in 1964. My last major project and the theme behind my diploma show was medals. This was originally sparked off by a painting by David Hockney, 'Generals'. From the way the picture was painted it was the medals that first caught my eye and must have subconsciously also been linking in my mind with the current Pop Art/Union Jack craze. David Hockney had graduated two years before me from the Painting School of the Royal College. I adored his work. I then studied at the War Museum and the Wellington Museum, drawing medals, and produced designs with medals translated into a Pop Art style. Heals bought one of the medal print designs and *Queen* used one for a cover in a dress by Foale and Tuffin. The Royal College of Art arranged a meeting for me with Pucci, who was showing his collection at Woollands.* Alas, he didn't offer me a job in Florence but told me to concentrate on designing in black and white. Who knows what would have happened to my career if he had taken me back to Florence to design for him!

*A shop in Knightsbridge, London, now, sadly, gone.

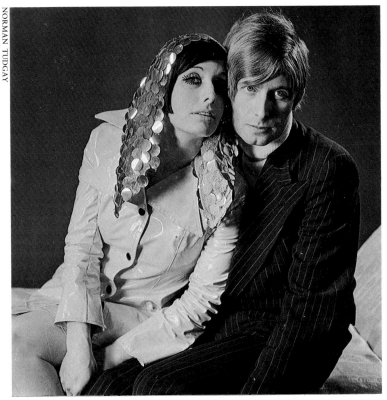

NORMAN TUDGAY

Portrait of Zandra with Alex MacIntyre, before she started making her own clothes. The sequined helmet she is wearing is by James Wedge, and the suit in yellow plastic is by Ozzie Clark.

Right, Lemuel Francis Abbott's painting of Viscount Horatio Nelson (1758–1805) wearing medals

Far right, Zandra in front of her 'Medals' fabric at the Royal College of Art diploma show, 1964

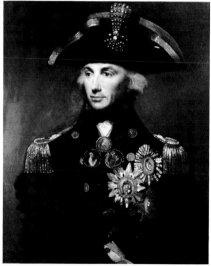

IAN YEOMANS

Below, 'A Grand Procession of Dignitaries painted in Semi-Egyptian style' by David Hockney. Oil on canvas, 84 × 144 inches (214 × 367 cm.), © David Hockney 1961.

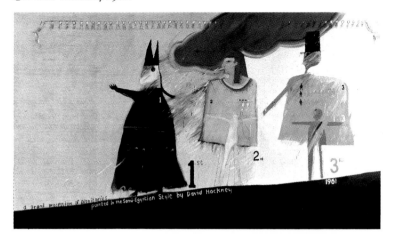

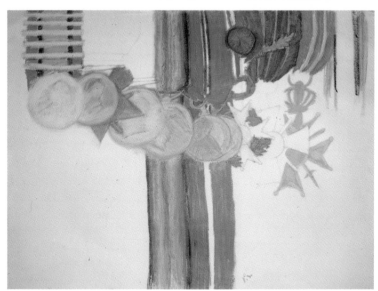

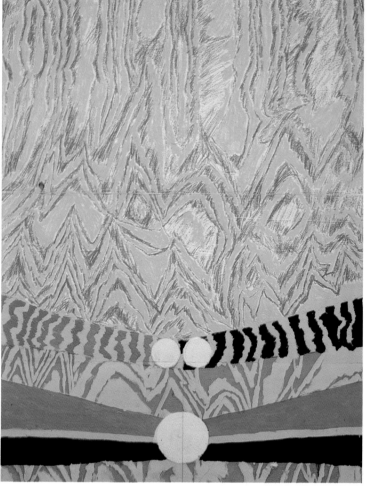

Above, Zandra's crayon study of medals

Right, 'Moiré Medal Panel' design for cotton velvet. Design repeat 55″ (139·7 cm.), width of fabric 36″ (91·4 cm.).

Right, section of eight-colour 'Medals' print on cotton sateen (produced by Heal's as a furnishing fabric). Design repeat 30″ (76·2 cm.), width of fabric 48″ (121·9 cm.).

Below, panel print design for full length garment

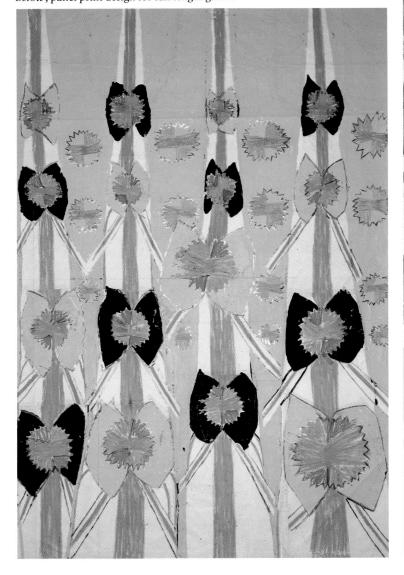

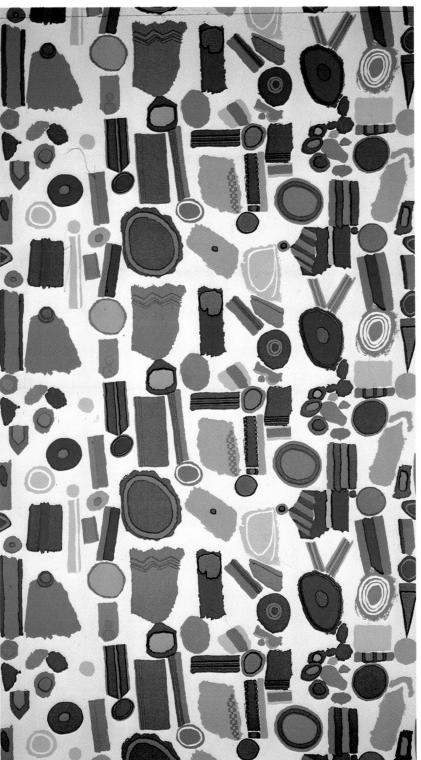

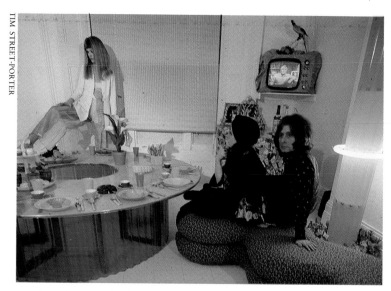

Zandra at home with Alex. On the left, Janet Street-Porter modelling transparent trousers and a bikini top by Sylvia Ayton and Zandra Rhodes.

After graduating with no job, I set up house in St Stephen's Gardens, London, with Alex MacIntyre, who had been in the same class with me at the Royal College. We were existing hand to mouth, rushing down to the Portobello Road late on Saturday to buy cheap fruit and vegetables from the stalls just closing up. Food was not that important. We were determined to live in our world—a world of today—and that meant making it all ourselves, creating our own Pop environment, a perfect world of plastic, true to itself, honestly artificial. We covered everything in plastic by the yard, including the walls and even the television set; we had plastic grass carpets, collected plastic flowers and trees, used synthetic marble and 'Fablon' tiles. We made the furniture by drawing shapes on the floor and building laminate and foam seating and tables on these spots. We built standard lamps from pillars of plastic, circling them with neon bulbs. 'A wonderful world from Woolworths'. I had seen an abstract landscape with a house and a river and a woman looking out of the window, painted by Duggie Fields. I fell in love with it and, although I had no money I just had to have the painting. I hung it across the window to make a false view and I put curtains on either side. I then cut out hardboard shapes to echo the forms in the painting and used them to conceal the lighting below it. Then

I placed plastic flowers around it, which brought the picture right into the room. Duggie came to visit me one evening and fell in love with what I had done with his painting. From the first moment there was a terrific affinity between us—it did not stop him, though, getting his lawyer to chase me for the money. I know him so well now and he told me he was ashamed to do it, but he needed the money so much he had no alternative. I did pay him eventually, in instalments, so we never got as far as the Courts. We love each other dearly.

Alex and I were building up the print works at our Studio in Porchester Road, where we took on other people's printing to help pay for our own. I was also teaching part-time, at Ravensbourne College of Art with Leslie Poole and Sylvia Ayton, and at High Wycombe and Birmingham. I hated it but the money supported our frugal standard of living and enabled me to design in between. Since we were always short of money our lifestyle was very simple, centred around work, television, the supermarket and any trips within our means. It was from this limited environment that I took the images which influenced me. Jonathan Miller presented a vivid television documentary on Las Vegas, showing the neon signs and electric sculptures in the sky. I clearly remember the picture of the Neon Man, advertising the programme, appearing on the cover of the *Radio Times*. We used to buy Omo soap powder, which had drawings of the Rainbow Men on the packets to publicise their competition. (These men called from door to door giving out prizes for the correct answers to a series of questions.) From these two impressions emerged my 'Mr Man' print. (Years later when I went to Las Vegas I was photographed under the same Neon Man outside the Golden Nugget.)

Alex and I went to visit his parents, and from where they lived it was a short distance to Blackpool to see the famous Blackpool Illuminations—enormous fantasies in electric light, millions of coloured bulbs shaped into spectacular magical fountains and fairytales. The Blackpool Tower seemed like the Eiffel Tower illuminated against the northern sky. I started to draw what we had seen but I found I was concentrating on the source—I drew lightbulbs again and again. Lightbulbs blinking and sparkling, with live filaments and neon elements.

Another on-hand inspiration was comics—crudely printed in black and red half-tone dots. As I said at the beginning of this chapter, I loved Lichtenstein's blow-up interpretations of American popular comics and, with the selections of comics available

from my local newsagents, I produced my own designs with explosions and enlarged half-tone dots. All my dots were done by hand with crayons, and I distorted the explosions and word bubbles to make images that were especially my own and suitable for textiles.

Right, five-colour 'Mr Man' print on crêpe. Design repeat $27\frac{1}{2}''$ (69·9 cm.), width of fabric 36″ (91·4 cm.). (N.B. Man and floral shapes are created in imaginary neon.)

Below left, 'Campbell's Black Bean Soup, 1968' by Andy Warhol

Below right, the Omo advertisement that inspired Zandra's 'Mr Man' print

Bottom, 'Rainbow Man' paper design

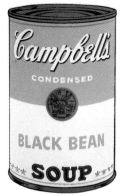

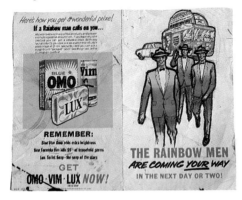

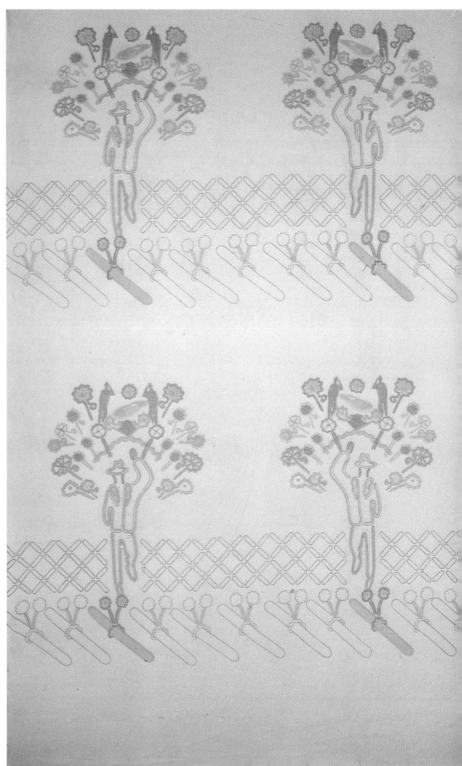

Check design using 'dots' and 'explosions'

Left, Zandra's first magazine cover. Trouser suit by Foale and Tuffin, with Zandra's 'Pop Art' style print in three colours on fine wool challis.

Right, paper dress in 'Lightbulb' print

Above, a torn-out section of a comic pasted into Zandra's sketchbook

Below, panel design on paper, with 'dots' and 'explosions'

Right, Zandra trying on paper designs in front of a mirror

Far right, Zandra wearing her 'Diamonds' design from brick and comic inspiration

Below right, three-colour 'Lightbulb' print on satin. (N.B. Patterns in the background came from empty firework wrappers.)

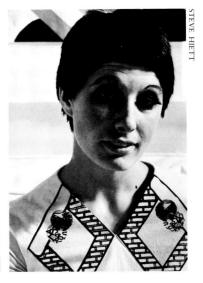

Below left, paper design using cut-out pieces from the print opposite

Bottom left, paper design of 'lightbulbs'. There were far too many colours to be practical for production.

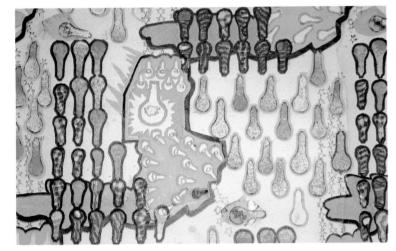

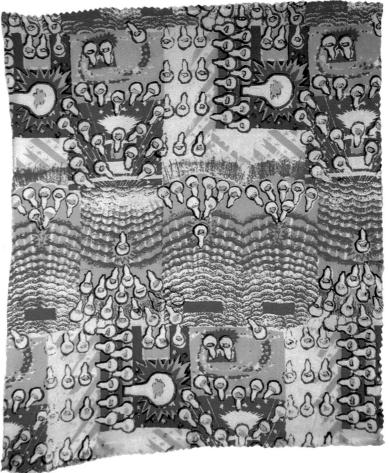

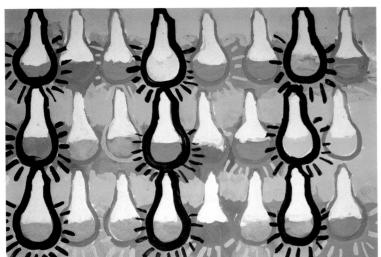

19

I started out to try to sell my textile designs to the big Companies, but they were totally uninterested and said my work was too extreme. Not successful in that direction, I bypassed the classic textile route of selling paper designs and set myself up to produce the printed fabric, selling direct to fashion designers Marion Foale and Sally Tuffin, who had their own successful fashion business and Carnaby Street Shop. They commissioned 'Dominoes', 'Explosions' and the first of my 'Lightbulb' prints. After three seasons I was experiencing frustrations with the fashion world not understanding what I was doing. The current vogue in textiles was Op-Art, put together in very simple garment shapes. I was unhappy that my patterns were just being cut out at random and the possibilities of what the print and garment could do together were being ignored. My work was becoming more and more figurative—reflecting the Pop world about me, less and less abstract, and at this time fabrics were not figurative, so Marion, Sally and I parted company.

I went into partnership with Sylvia Ayton, the idea being that I would design the prints and she the clothes. I suppose in the back of my mind I felt I would be able to get the prints I believed in used, and used in the manner I visualised. One dress I loved at that time, though, was the first we did together, a bikini of sequins printed on a moire shift. In the beginning we sold the clothes wholesale, but did not do well enough. Sylvia thought I looked too extreme and frightened the buyers (see the picture of me in my sequined helmet) and she too was growing uncertain of my prints. They were becoming more and more obviously figurative, 'Teddy Bears', 'Lipsticks' and 'Hands & Flowers'. 'Lipsticks' and 'Hand & Flowers' were influenced by a magazine advertisement of that period photographed by Guy Bourdin. I had this advertisement cut out and stuck up in my studio. I love the strength of good imaginative advertising.

When I start designing I begin with no restrictions and just experiment—without the confines of size or amount of colours. When the theme is clear in my head, I then start to do things properly. The design for 'Hands & Flowers' is a really good case in question—where the final design was in two colours, but the example shown here has many more. With the lipstick designs, it was even more complicated. Because I could not decide how the designs should look, I made small screens with individual motifs and printed these in different arrangements on the cloth. Some I hand coloured in with special textile crayons (see butterfly no. 5).

At this stage I had no intention of giving up, even though everything was such an uphill climb (buyers were not accepting the clothes with their prints and I was increasingly aware that

Sylvia no longer liked my prints with her work). I felt if we could bypass the conservative wholesale buyers and reach the public with a shop, everything would be all right. So I found additional partners and we opened 'The Fulham Road Clothes Shop'. Vanessa Redgrave had a small share in the shop, and I designed a print called 'We love you Vanessa.' It was my first print to use handwriting, but I shall leave the handwriting for now since I develop this theme further in the Japan & Lovely Lilies chapter.

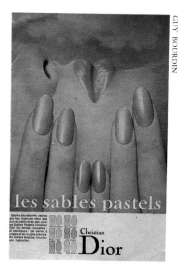
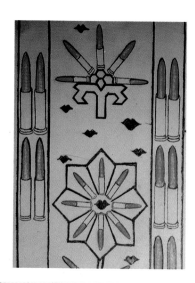

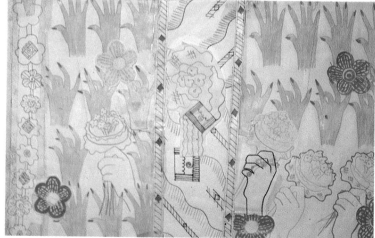

Top left, the Christian Dior advertisement that influenced Zandra

Top right, paper design with Zandra Rhodes imagery in the style of a Victorian engraving on calico

Above, original 'Hands and Flowers' design later simplified for printing in three colours

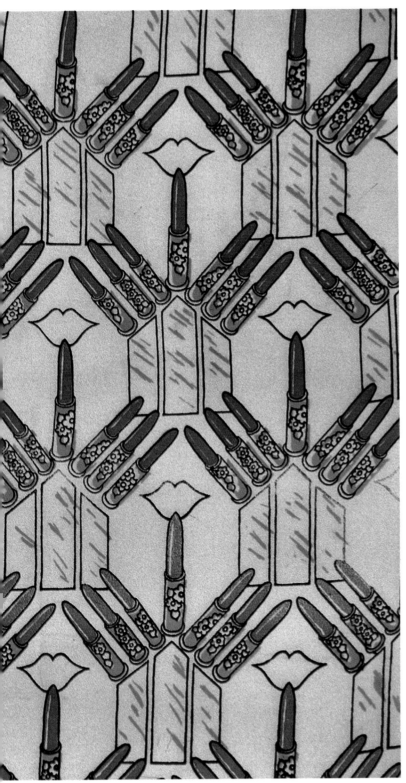

This was also when I began to develop my theory that what we find ugly today will be beautiful tomorrow. I see I wrote in my sketchbook one day, 'I'm tired of good taste. I want to do everything wrong and get a result that is of value and valid as well.' I was consciously working with crude, disquieting colours in order to produce something new.

My appearance was mildly shocking. I shaved back my hairline and wore two pairs of false eyelashes on each eye, one on the top and one on the bottom. Sometimes I wore a turban and lots and lots of jewellery. Eccentric then; not now though. All this satisfied me but was the cause of conflict between Sylvia and myself. The combination of people and ideas was not working and I began to realise that I and my prints had too strong a personality to fit into someone else's designs. It was too early for the Fulham Road to be fashionable and in the end the business collapsed. Obviously, it was time for me to take my prints, my designs and my future into my own hands. Also, as so often happens in my life, in quite an insignificant way, a very decisive link was forged. Moya Bowler, the shoe designer, introduced me to Richard Holley, an extravert Texan who saw my long, printed, chiffon scarves and snapped them up to sell in America. Richard Avedon used one to cover the face of a model wearing the fur coats he was photographing for American *Vogue* (see picture below). The idea of going to America had been quietly lurking in my mind for some time. That photograph sparked it off. I was on my way, but I had some distance to travel first.

Left, three-colour 'All-over Lipsticks' print on crêpe. Design repeat 36″ (91·4 cm.), width of fabric 36″ (91·4 cm.).

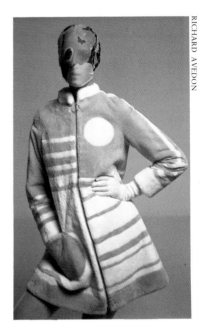

RICHARD AVEDON

Right, model wearing Zandra's oblong silk chiffon scarf

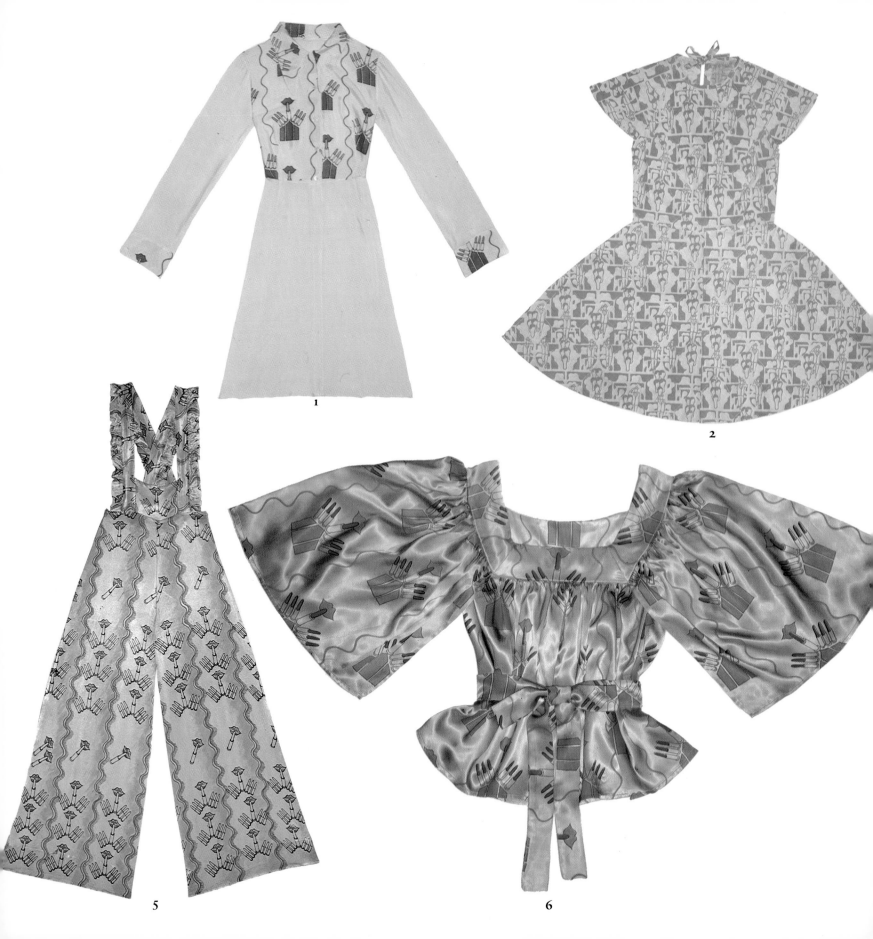

1

2

5

6

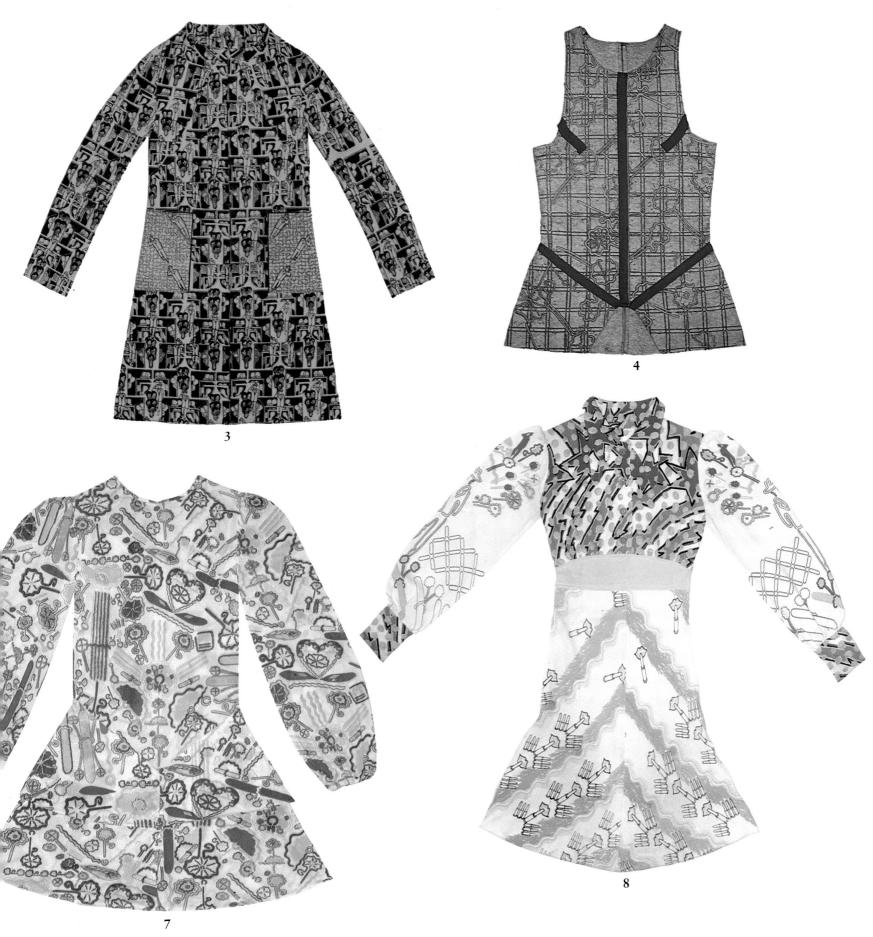

3

4

7

8

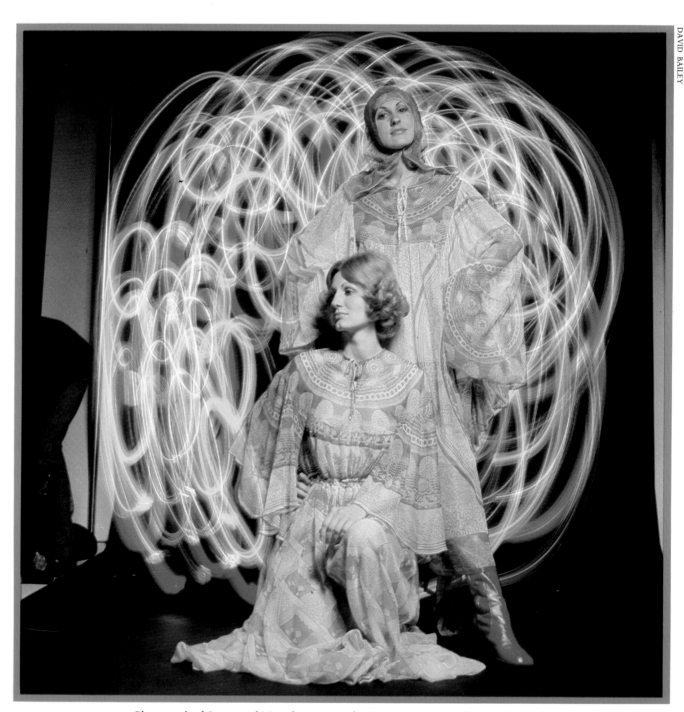

Photograph of Oxana and Myroslava Prystay for *Vogue*, 1969 (Butterfly nos 11 and 13)

Wales and Knitting

The first collection of prints, which I made to use for myself, were based on knitting and it happened quite gradually. But of course, when I think about it, I suppose it was obvious that the inspiration would be drawn from the everyday things that were around me. I probably recalled my childhood, my mother knitting at home and during the holidays. In the house we had endless patterns and embroidery books with various stitches, how to do them and how to use them. I used to pore over these. That was the seed.

By 1968 Alex MacIntyre had joined up with Richard Holley to find 1930s Fair Isle jumpers to export to the U.S.A. They were travelling around England and Scotland, specially visiting the country markets to find these gems, which, newly cleaned, fetched a high price in the New York antique shop of Michael Malcé. This was a time of great friendships for Alex and myself, particularly with Janet and Tim Street-Porter. Janet was then fashion editor of *Petticoat* and Tim a photographer. We were all just starting our careers, terribly enthusiastic about our work, interested in everything that was going on and deeply involved in each other's ideas. Tim's parents had a house near Tregaron in Wales where we went for weekends and holidays. The cottage, grey-stoned, stood in the centre of rugged sheep-farming country, wonderfully remote, where the mountain ponies ran wild, streaking across the heather-covered hills, and the air was heavy with the smell of peat fires. We used to climb and walk for hours in these harsh surroundings, wrapped against the wind in layers of wool, knitted scarves, gloves and hats. We would wake early in the morning, bake bread with live yeast, listen to 'The Archers—an everyday story of country folk' on the radio, and cook big pots of soup on the stove for supper. In the evenings we would sit talking, all of us beside a huge fire, with Janet and me knitting away or patching and embroidering our dungarees.

When I was in London, I went through the textile study room at the Victoria & Albert Museum, just to see the knitted bedspread and the wonderful bed-hangings in woollen embroidery with lots of chain stitch; that was my academic background creeping in! So it seemed quite natural for me to draw from this subject for my prints. I was particularly fascinated by the stitches themselves and how to interpret them flat; but also the patterns formed by knitting, with their combination of stitches and colours, became an integral part of my thinking. I wanted to do the designs as if they had actually been knitted, bearing in mind the restrictions of the medium (that everything must be in chain stitch and therefore somewhat simplified). I drew a circular shawl with stitches decreasing toward the centre with chain-stitch flowers in a circle at the centre, and a long fringed scarf like

Zandra in Wales

those the four of us wore with printed knitted fringing at the ends and, the key to it all, a knitted picture, based on the patterned sweaters and the landscapes I had seen.

The prints evolved were, first, 'The Knitted Landscape Scarf', then 'Knitted Circle' and finally 'Diamonds and Roses'. (The print 'Diamonds and Roses' is not actually graphically knitted, but has come into this chapter at this time because it was used in combination with the 'Knitted Circle' to make the garments shown.)

I now had to learn how to take these prints into the world of fashion. I had never been trained as a fashion designer, but I did not think it could be such a mystery. I had only to find out how to start. I knew the essence of the product was the dreaded pattern-cutting and that, once learned, I had to manipulate it to my personal view of clothes, using my prints to their best advantage as I had previously visualised them in my sketchbook. The first things I had to overcome were the natural prejudices levelled at me: 'Once a textile designer, always a textile designer.' 'A career cannot be changed mid-stream.' I asked help of two friends who were with me at the Royal College, Leslie Poole and Norman Baines. Norman had originally been a librarian so I knew he would be sympathetic because I, like him, was starting in the middle without full training and knowledge. They taught me how to make a pattern, about the grain of fabric, how to do a lay. They showed me I could make a map of my body. For the first time, I was experimenting with my own printed fabric, draping pieces over myself, walking around and moving the patterns and the colours. It was exhilarating. They never said, either of them, 'You can't do that or that won't work or that's not the way to do an armhole or a sleeve.' Norman was with me when I interviewed machinists and finally engaged one. My machinist was very open-minded and pleased to go along with me in my new way of thinking and I was finally able to make clothes the way I wanted them to be, without any restrictions, nobody to say, 'It's not commercial, the buyers won't like it, it won't sell.' I was in my element. I let the prints guide me. So my first-ever collection was born. It mainly featured the 'Knitted Circle' print. I had designed in a circle. Now I cut in circles, sewed in circles and at last the creative circle was complete. I made swirling, dramatic shapes with no concessions to the saleable, the acceptable or the ordinary. The true Rhodes style came into being.

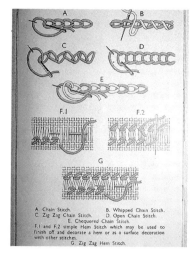

Far right, knitted detail from the Victoria and Albert Museum
Top right, a page from one of Zandra's mother's sewing books
Below right, a paper rough. Note the close link between knitted and sewn stitches.

Right, three-colour 'Knitted Landscape' scarf, on silk chiffon. Screen repeat 45″ (114·3 cm.), total design repeat (with motif reversed) 90″ (228·6 cm.).

Far right, four-colour 'Diamonds and Roses' print on silk chiffon. Design repeat 36″ (91·4 cm.), width of fabric 45″ (114·3 cm.).

Over page, three-colour 'Knitted Circle' print on silk chiffon. Design repeat 42″ (106·6 cm.), width of fabric 45″ (114·3 cm.).

Below, the original paper design for 'Knitted Landscape' scarf

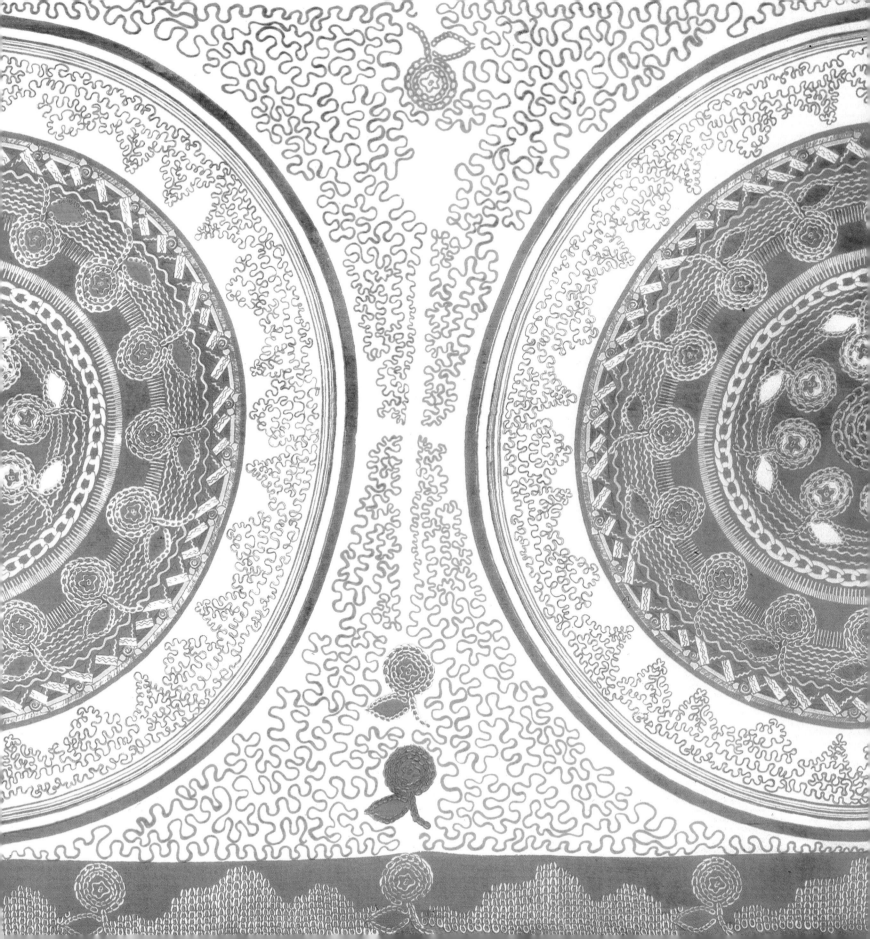

The most interesting thing to note here, which occurred once this book was laid out with its butterflies, was the total change in my style between the butterflies of Chapter 1, on pages 22 and 23, and those of Chapter 2, on pages 32 and 33. At the time I had not seen this as such a total change to fantasy, but obviously that is what it was. My prints had taken me by the hand and shown me how the dresses should be. I was no longer relying on someone else to do that for me. So new shapes were being formed naturally.

I used to fit the clothes on Janet who was very enthusiastic and supportive and Tim photographed them. Thanks largely to both of them, I have records of all my early designs. Just at that time, I met two most amazing girls, Oxana and Myroslava Prystay, and their all-embracing enthusiasm encouraged my determination to go to New York where, they convinced me, lay the path to fame and fortune. More of them in the next chapter . . .

I booked a charter flight to New York and Richard Holley, the American, insisted on looking after me, introducing me to lots of friends. The atmosphere in New York was sparkling and at that time they were very welcoming to English designers, or so it seemed to me. I was lucky to have two letters of introduction. One by Beatrix Miller, editor of English *Vogue* to Diana Vreeland, the editor-in-chief of American *Vogue* and the other to the head of *Women's Wear Daily*, the world's fashion bible. The city opened like a magic storybook. Diana Vreeland arranged a chauffeur-driven limousine to whisk me around town and I had my clothes photographed in colour for *Vogue*, with Natalie Wood wearing them. Geraldine Stutz bought the dresses for Henri Bendels and *Women's Wear Daily* ran a story about me. Angelo Donghia,* whom I met through friends, commissioned a collection of furnishing fabrics and wallpapers. America's most fashionable ladies, Evangeline Bruce, Chessie Raynor and Mica Ertegun, bought my clothes and later they, too, became good friends.

None of this period passed without an effect on my appearance. I was wearing my printed 'Knitted Landscape' scarf wrapped tightly around my head, with artificial curls drawn on my forehead. I had been much impressed with Guy Bourdin's photograph for a Christian Dior cosmetics advertisement (see opposite). This had sections of different colours painted across the model's face so I experimented with coloured crayons to

Left, the Christian Dior make-up advertisement

Right, printing 'Knitted Circle' at the Porchester Road studio

Zandra in New York wearing one of her chiffon kaftan dresses with the 'Knitted Landscape' scarf on her head

decorate my own face and that was how I looked when I arrived in New York, to achieve the fame and fortune I had been promised.

* Angelo Donghia is a top American interior designer.

Right, preliminary fashion sketches

Far right, Natalie Wood modelling circular coat (Butterfly no. 12)

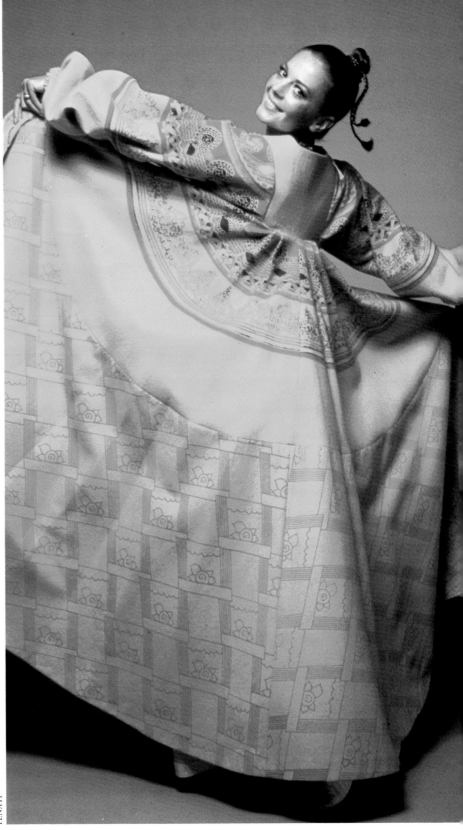

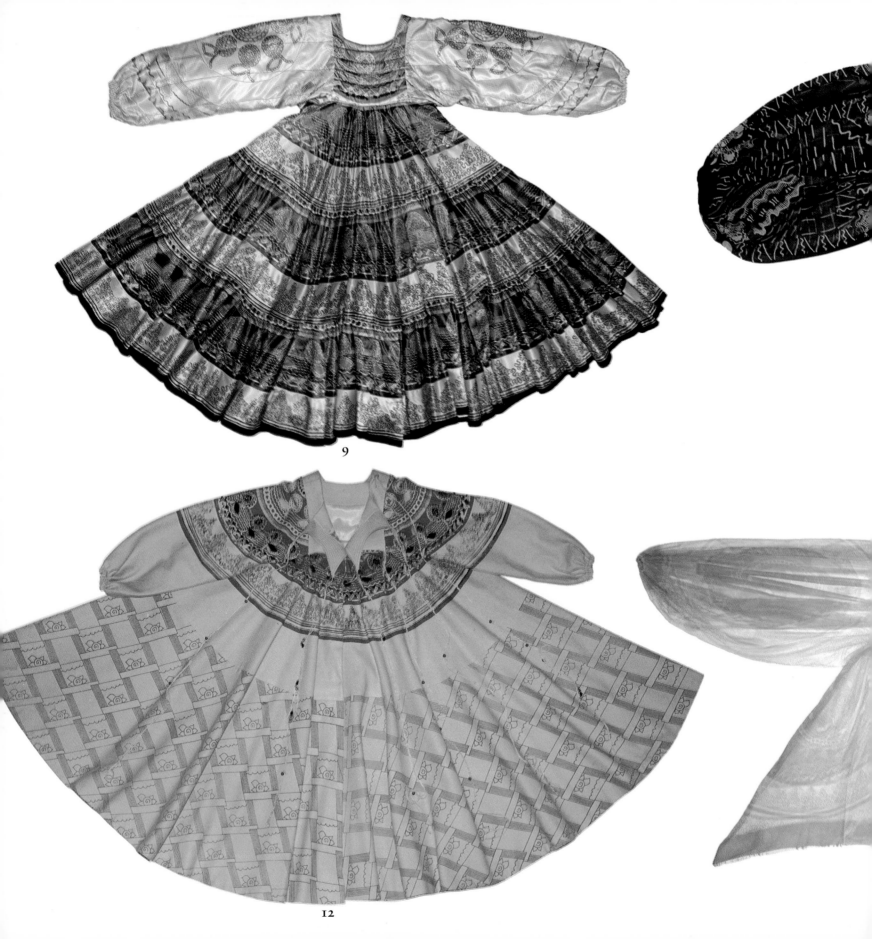

9

12

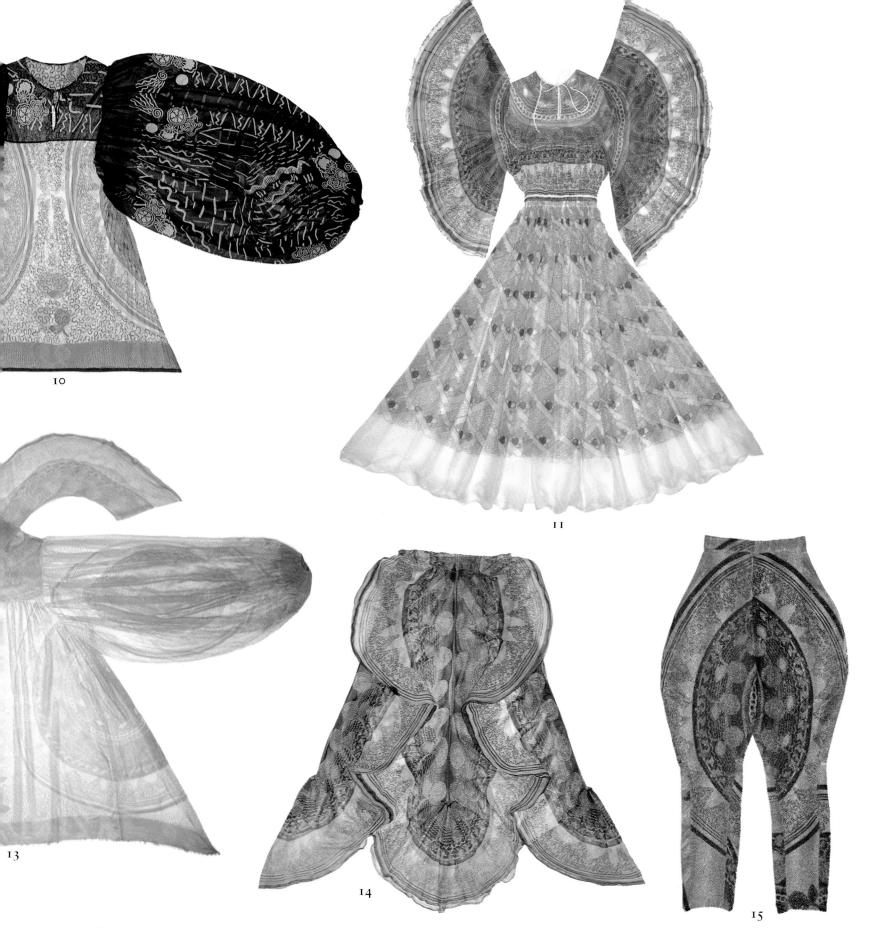

10

11

13

14

15

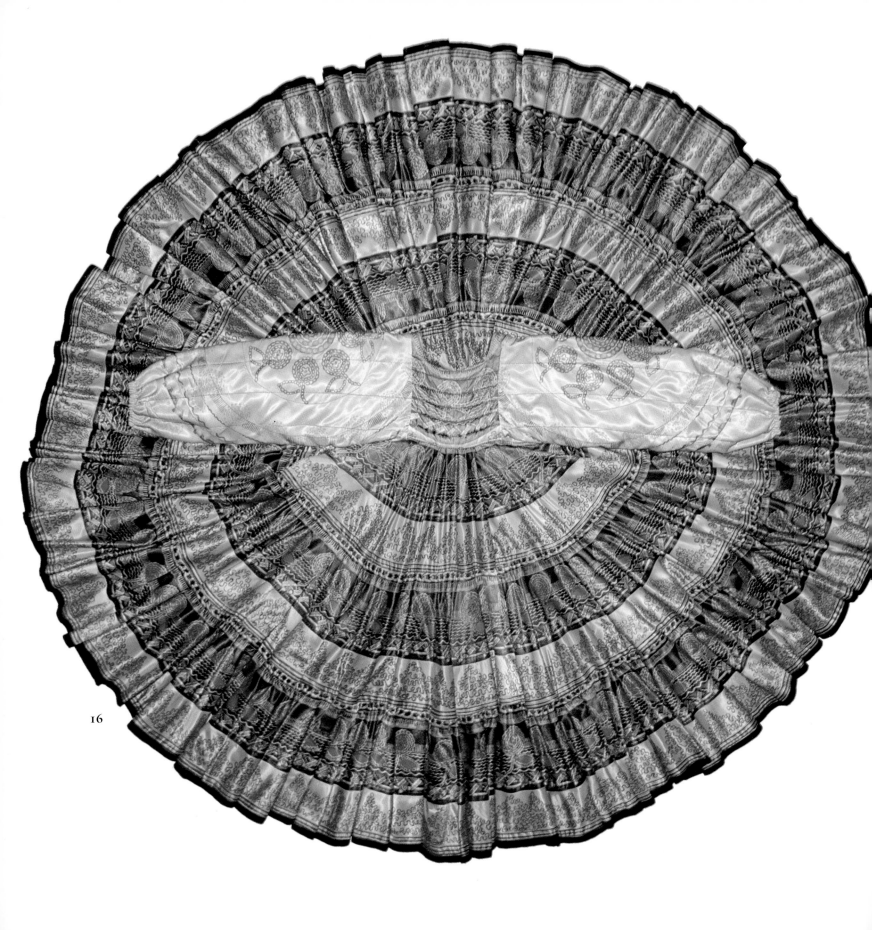

16

When I returned to London, Beatrix Miller, editor of English *Vogue*, with her young editress, Marit Allan, gave me another introduction, this time to Anne Knight, Merchandise Director of Fortnum and Mason. She bought my first collection and featured me as the new star in London's fashion firmament. So now I had a foot in my two dearly loved cities, the commercial rocks of Geraldine Stutz and Anne Knight, the editorial support of *Vogue*, London and New York, and the loving enthusiasm of my friends. I was starting the long climb to the stars and it was a long way from Fair Isle sweaters in Wales.

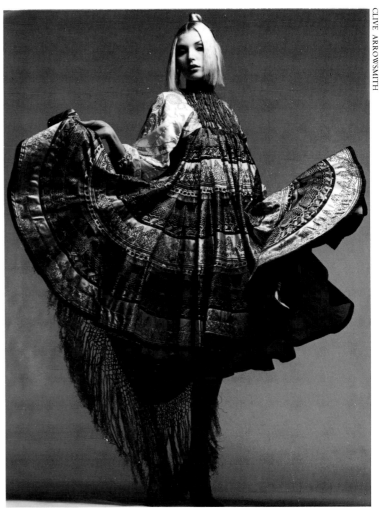

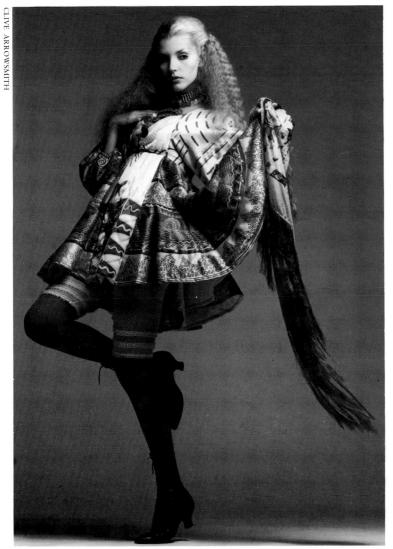

Above, quilted satin dress (Butterfly nos 9 and 16)

Right, short quilted satin dress

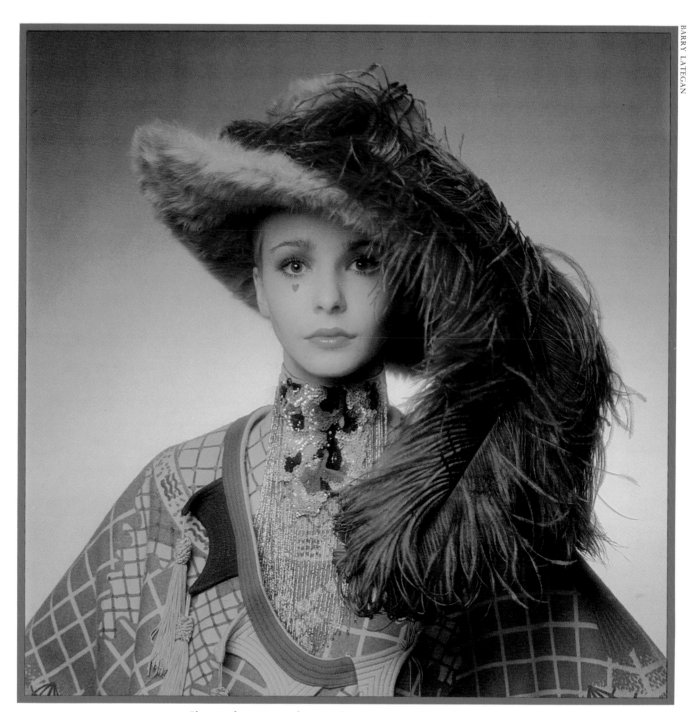

Close-up from *Vogue* photographic session, 1970 (Butterfly no. 26)

The Ukraine and 'Chevron Shawl'

In Europe and America it was the twilight of the 1960s and the hippies, but still a time when folklore was appealing. The Beatles were in India absorbing that culture their way. The Rolling Stones were in Marrakesh soaking up Morocco. The cognoscenti were just taking up the gypsy look but Paris couture had not yet launched the Rich Peasant Collections.

I had come across the actual chronicle of costume, the definitive book by Max Tilke on *Costume Patterns and Designs*, while I was teaching at Ravensbourne College of Art. This book was infinitely appealing to me, with its simple and detailed pages showing the cut and form of traditional clothing throughout the world. Details of armholes, wrapped trousers, embroidered waistcoats and flat, worked-out-kaftan and peasant garment shapes were all explained with the simplicity of a gardening book. It was far more exciting and informative than the edicts of Paris couture, which I found too stringent and rule-bound. At this moment I did not want to be held by the strictures of couture; Tilke showed me what I wanted to know, how basic clothes had been put together traditionally. I think this book doubly appealed to me because I could understand the peasant solutions and patterns explained. (Remember, I was more or less self-taught; I had semi-ignored my mother at home as she draped material on her dress stand, and I had studied textile design, never intending to enter the world of sewing; that came when I could not sell my prints.) Also, thinking back, I found this very early photograph of myself (page 38) in Austrian costume at the age of 10 and I can remember how much I loved this and the cross-stitch and hand-work on it.

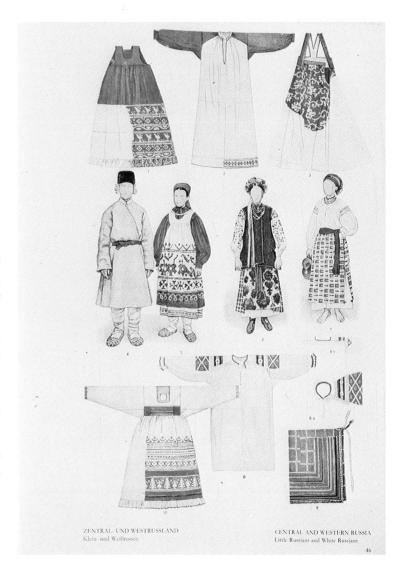

ZENTRAL- UND WESTRUSSLAND
Klein- und Weißrussen

CENTRAL AND WESTERN RUSSIA
Little Russians and White Russians

46

Right, a page from Max Tilke's book

So then came along Oxana and Myroslava Prystay, twin American/Ukrainian models, who whisked me along on an adventure of imagination. I had got to know them because they had breezed into The Fulham Road Clothes Shop, buying my scarves to wrap around their heads. It is them in the *Vogue* pictures orchestrated by Marit on page 24.

I have never been to the Ukraine, but these two were so vibrant and compulsive in their enthusiasm, their approach to everything, so single-minded and dynamic, that I almost felt I had made the journey. They were rich in tradition, wearing their own national costume with great verve, and all the other bits and pieces of clothing they took to make up their colourful appearance became a deceptively authentic look. They combined colours and prints in an exotic way, they were shocking and original, without boundaries in conception, but somehow always superlatively chic, immediately acceptable. They impressed me because they were so cosmopolitan. For the first time I was really meeting people who were used to travelling the world.

At about the same time, I met Maurice Hogenboom, handsome Dutch photographer, who talked to me about far-away places. I admired his appearance too. He wore long flying cloaks, Tibetan shirts and, like Oxana and Myroslava, combined exotic clothing from every country to suit himself. It was how I wanted to look, exciting, without the strictures of couture, a walking, dancing encyclopedia of folklore. Don't forget, I was still shut up within myself at my studio in Porchester Road. I felt ordinary, so completely tied to work, seemingly without any cultural relief. I was getting up at five in the morning, going to my studio to set out the day's work for my machinist, and then rushing to catch the train to get me to Birmingham to teach. I was also doing a lot of the essential work in the studio myself in those days. Apart from creating the prints and printing, designing the clothes and pattern-making, I was cutting out the dresses and hand-rolling the edges of the fabric. I was terribly introverted, thrown back into my own world, so I fed on the colour and glamour of others, absorbing everything they told me, observing the most minute details of their dress, then making my own interpretations.

I can't remember anything specific about how I arrived at 'Chevron Shawl' except that it originated in tasselled Victorian shawls, and I know there were a lot of those around at the time, worn over everything and even as skirts on their own. Just as, in Chapter 1, I had drawn lightbulbs with the light exploding from them, here I drew the fringe with its wiggly tassels on the fringe ends. My own version of wiggly simplified flowers in the centre of the shawl triangle I know is my own interpretation of long- and short-stitch embroidery, which apart from featuring so heavily on ethnic shawls, was also around me for all of my childhood. In my grandmother's bedroom was a bedspread embroidered by my mother, of huge hollyhock flowers in long- and short-stitch.

'Chevron Shawl' combined a feeling of the fashionable peasant with details from Victoriana. It worked well on so many fabrics. On calico, which made the pointed, dramatic coat shown on page 47, on chiffon for the garments (butterfly nos 17a and b, 19), and on quilted silk (page 47). I used many devices to suggest the fringe and tassels, cutting the print into pointed zig-zag shapes and adding feather tassels and finally tying feathers on to the chiffon to anchor the pointed hems of the dresses.

Further developments from the 'Chevron Shawl' and its rough interpretations of embroidery stitches and patterns were 'Wiggle and Check', 'Snail Flower' and 'Tasselled Circle'.

Later, when I was asked to design a fur collection, I referred back to 'Chevron Shawl' for inspiration. Many of the original details I later developed derived directly from this period: dolman sleeves, peasant yokes and fluted collars. I had the fur dyed in bright colours too.

Left, Zandra, aged ten, in Austrian costume

Right, Zandra in Hyde Park, 1970

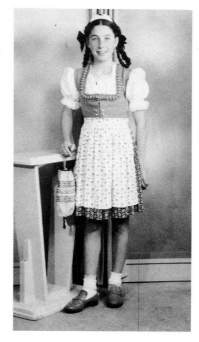

STAN WOODWARD

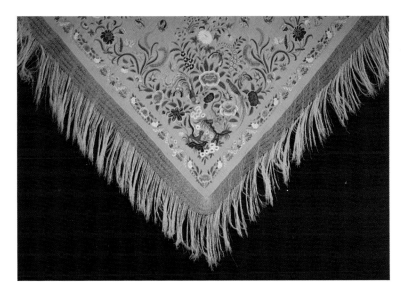

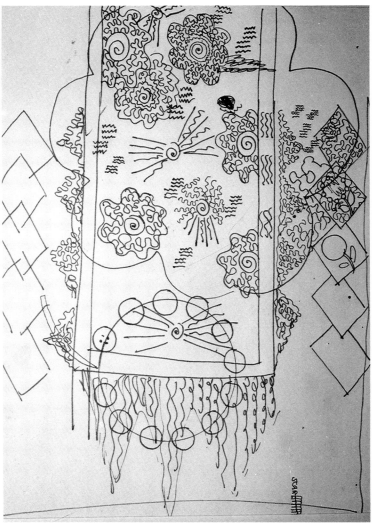

Top, fringed shawl from the Victoria and Albert Museum

Above, 'Zig-zag' tassel design on paper

Right, paper design for a scarf

Naturally, my appearance reflected my work. I loved wearing the 'Chevron Shawl' print, especially the quilted calico coat with the points (on page 44), with wide baggy trousers and high Biba boots. My make-up too had lots of colour, with bright reds around the eyes. At that time, Vidal Sassoon was making coloured Isadora wigs. I wore one in New York, but it gave me headaches, so on my return, I asked Leonard, my hairdresser, to dye my hair green with my silk dyes and I have had it brightly coloured ever since. At this time, I had feathers glued to the ends of my hair with eyelash glue.

Over page, three-colour 'Chevron Shawl' print on calico. Design repeat 25″ (63·5 cm.), width of fabric 50″ (127 cm.).

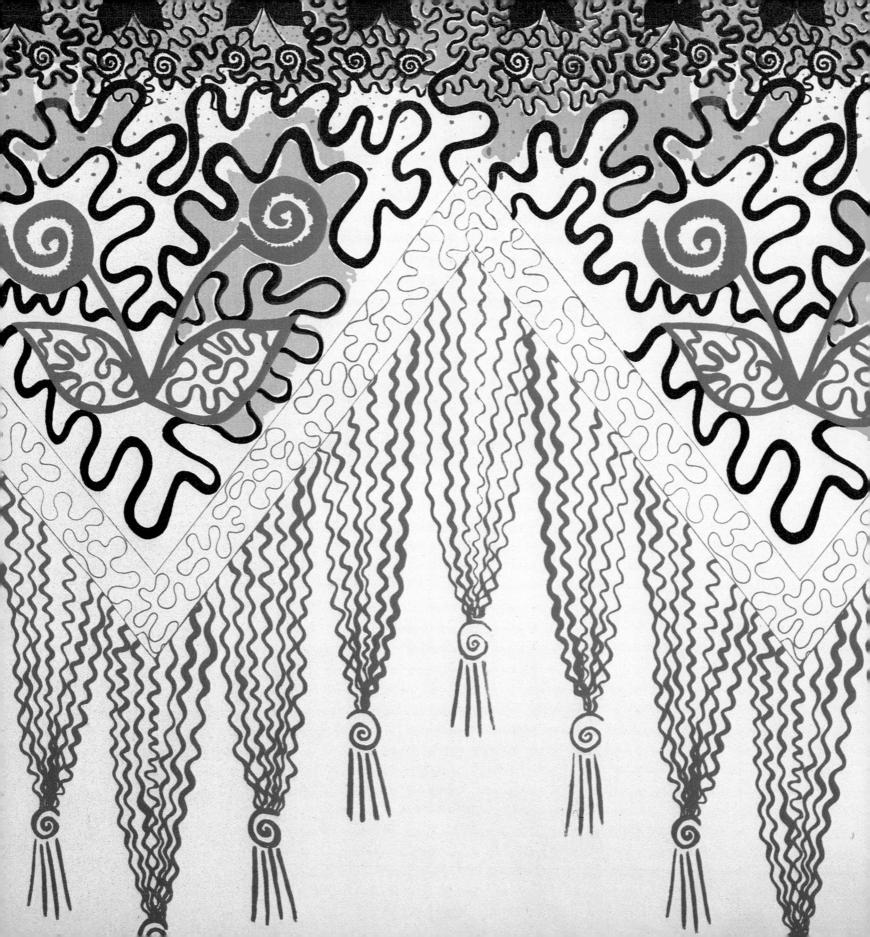

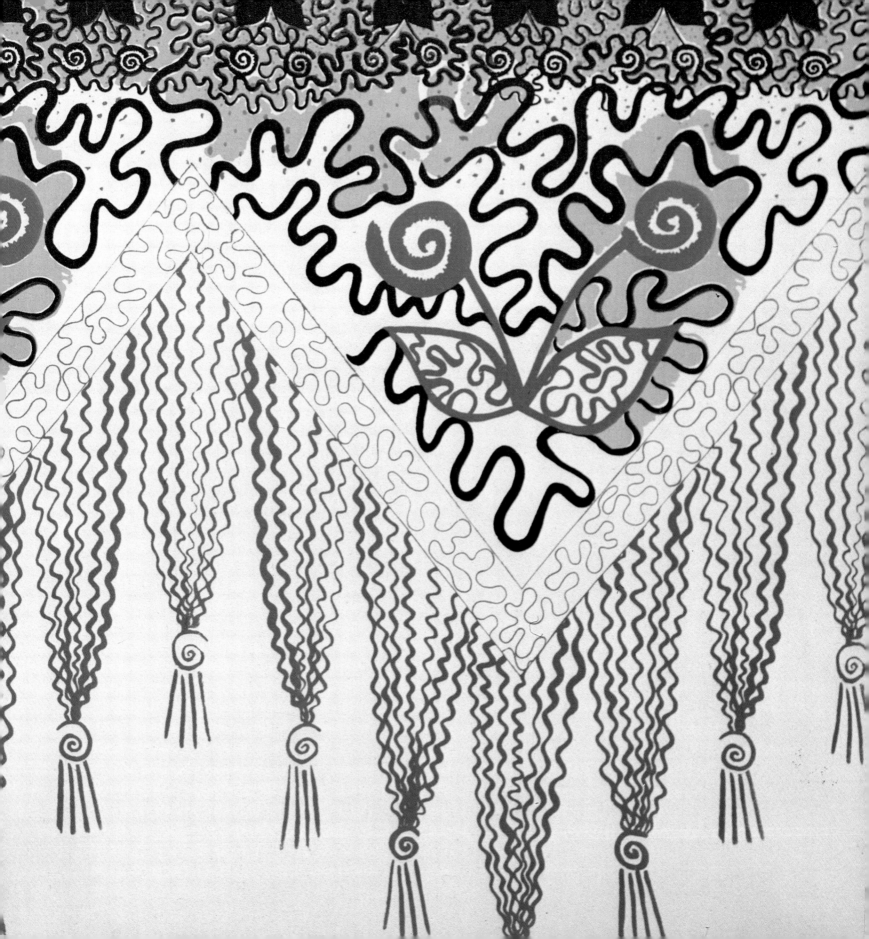

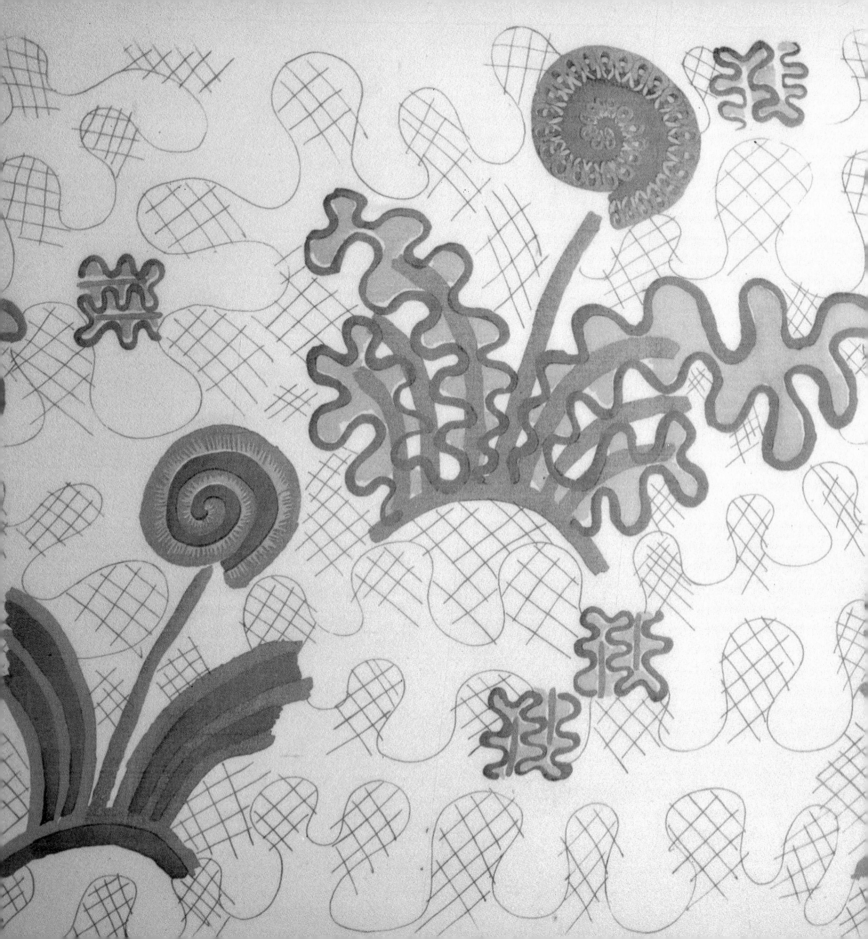

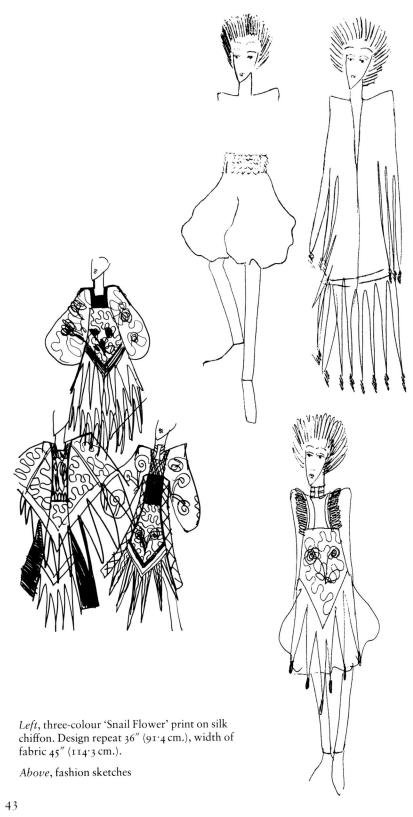

Left, three-colour 'Snail Flower' print on silk chiffon. Design repeat 36″ (91·4 cm.), width of fabric 45″ (114·3 cm.).

Above, fashion sketches

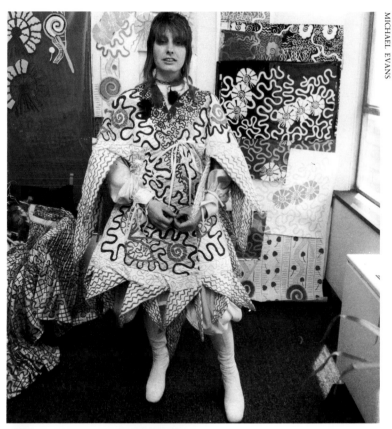

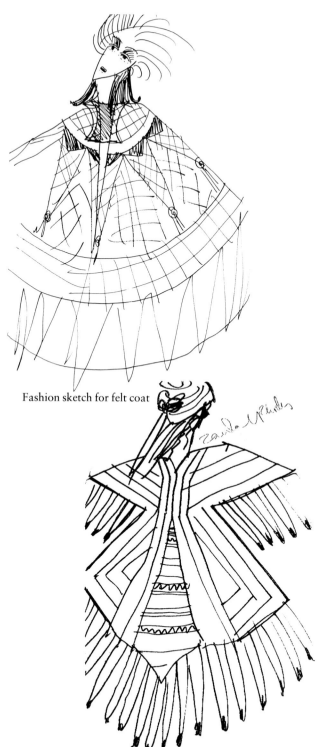

Fashion sketch for felt coat

Fashion sketch for fur coat showing development from print to fur tails

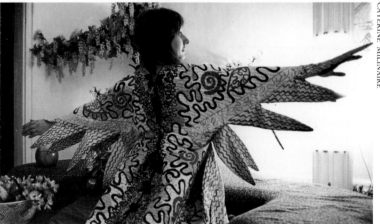

Top, Zandra wearing her quilted calico coat and silk trousers in front of wallpaper designs for Angelo Donghia

Above, Zandra at home in her quilted calico coat as above (Butterfly no. 19)

Right, three-colour 'Tasselled Circle' print on cotton sateen. Design repeat 46″ (116·8 cm.), width of fabric 48″ (121·9 cm.). (N.B. This circle was designed purely as a circle without interlocking motifs like 'Knitted Circle' or 'Mexican Circle'.)

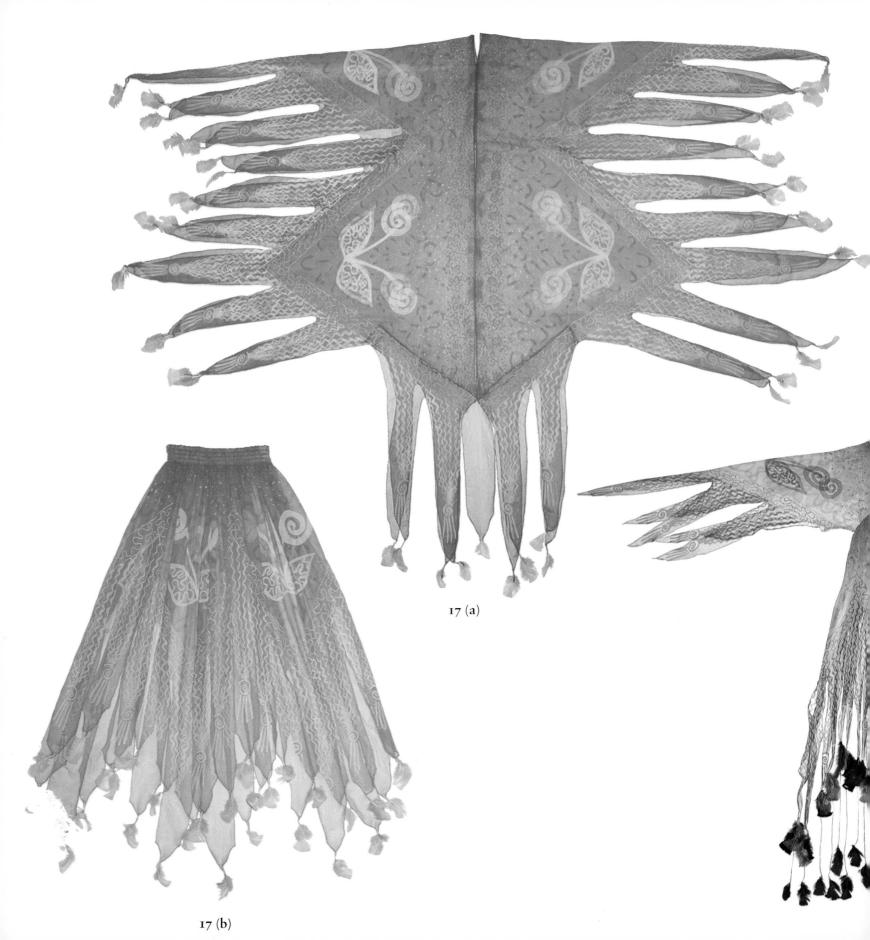

17 (a)

17 (b)

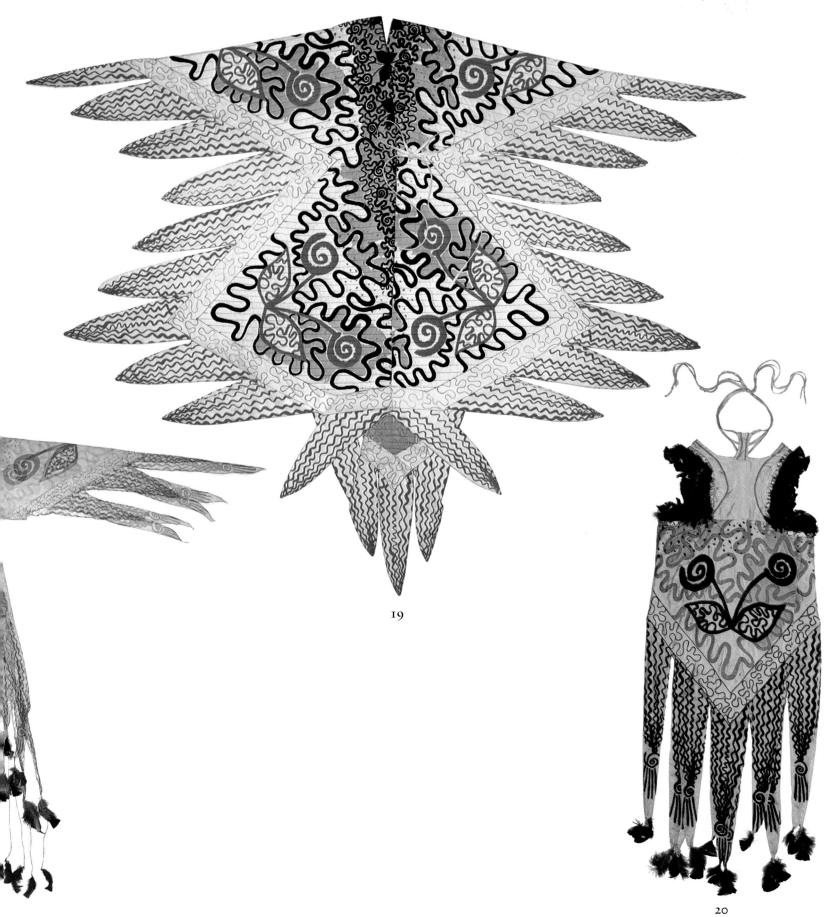

19

20

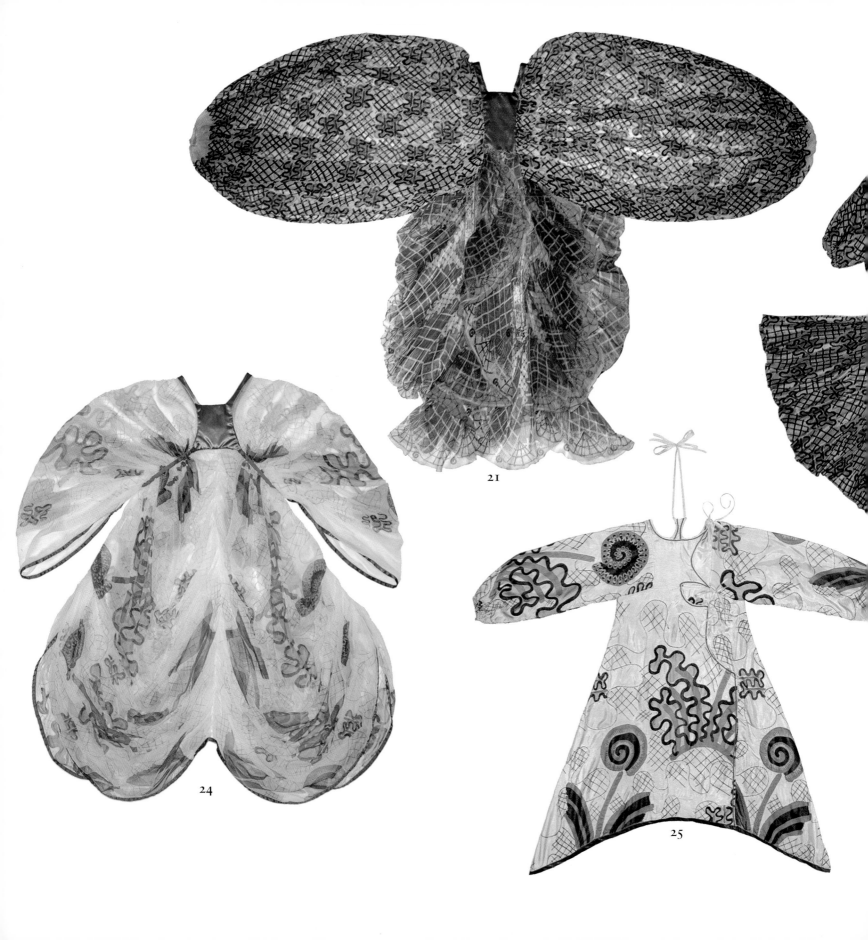

21

24

25

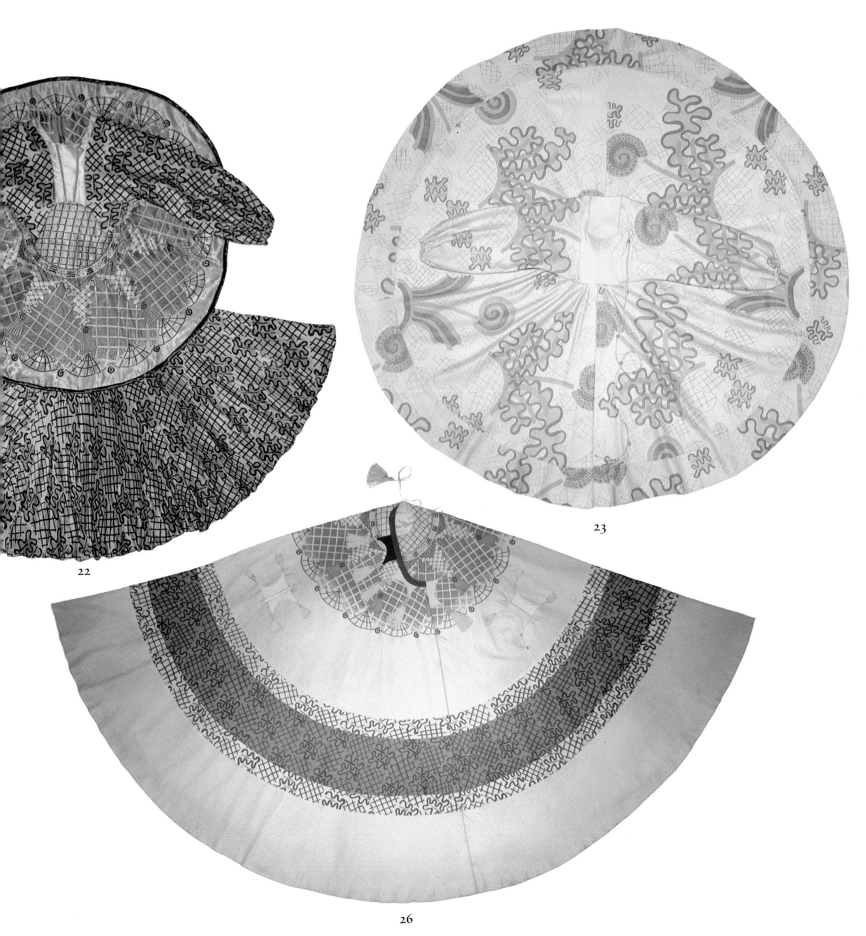

22

23

26

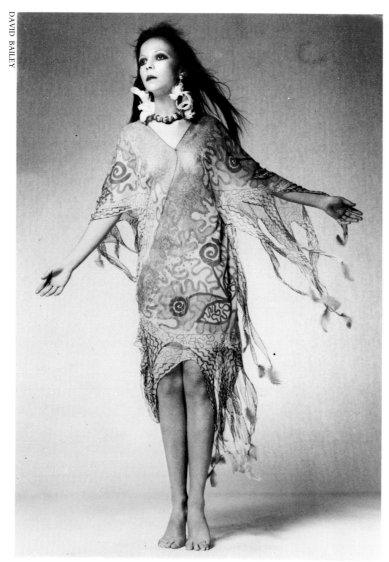

Penelope Tree modelling chiffon jacket (Butterfly no. 17a)

Penelope Tree modelling jacquard satin dress (Butterfly no. 22)

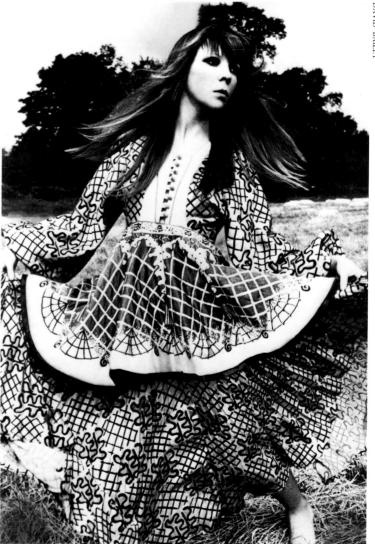

50

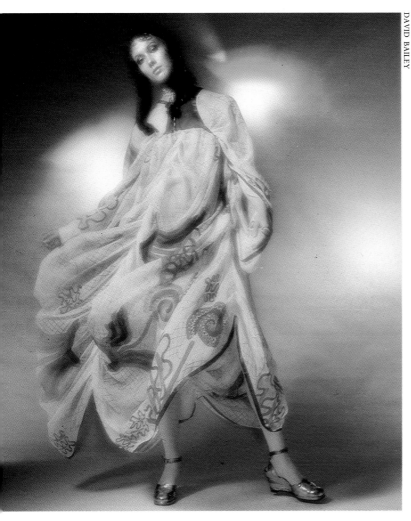

DAVID BAILEY

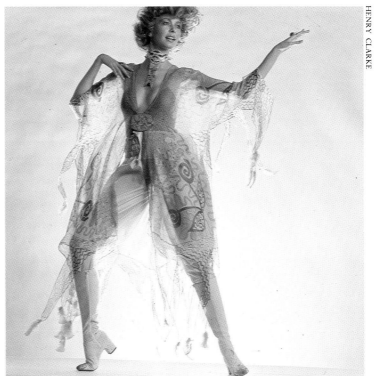

HENRY CLARKE

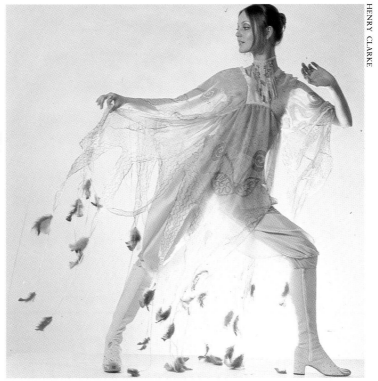

HENRY CLARKE

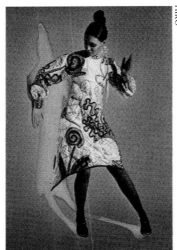

HIRO

Above, Butterfly no. 24

Top right, chiffon jacket (Butterfly no. 17a) over silk trousers

Far right, 'kaftan style' dress (Butterfly no. 18) over silk trousers

Right, Butterfly no. 25

Photograph for *Vogue*, 1970 (version of Butterfly no. 9)

New York and 'Indian Feathers'

In September 1970 I made my third trip to New York. It was a very colourful scene at that time. For someone like me the atmosphere was positively electric and in the end it was a visit which had a significant influence on my work.

This time I arrived armed with an address book fat with names of friends and friends of friends. The first 'friend of a friend' was Stephen Naab and I stayed in his apartment on West 83rd Street, a stone's throw from Central Park. He is an interior designer and had been a classmate at 'Pratt'* with Richard Holley, who later was to design the interior of my London shop.

Stephen, himself an amazing character, introduced me to a circle of artistic people I probably would never otherwise have met ... Ron and Karen Bowen (he a painter, she a graphic designer), Michael and Donna Malcé, antique dealers, and Jo Lombardo, an exotic extravert graphic artist. They showed me another New York, entirely different from the modern city I had always imagined. They were all what I suppose you would call 'artistic', living a Bohemian sort of existence and very real and genuine. In their homes they surrounded themselves with their own art and bric-à-brac, folk art from a different culture from mine—American Gothic, American primitives and incredibly detailed patchwork quilts, Early American painted furniture and early Hobo Art (a technique used by tramps to carve old cigar boxes into useful objects such as photograph frames and jewellery boxes). They had collections of Art Deco, 1940s Kitsch and Mickey Mouse memorabilia.

*Pratt Institute is one of the top three New York art colleges, the other two being Parson's School of Design and Cooper Union. The English equivalents are the Royal College of Art, St Martin's and the Slade.

This was *not* the classic, visitor's New York of skyscrapers, elegant stores and the up-town Manhattan lifestyle. Pointed wooden water-towers on high stilts are on the top of all high-rise buildings in New York, and for some reason they make me feel that I am up a mountain, not in a very high apartment. They have a homely quality like sheds in the back-yard—maybe it is because their shape resembles corn stooks on mountain slopes with the clear sky behind them. The proud spirit of Americana made itself felt in all the homes I visited. Hobo art, which I had never seen before, to me had the purity of spirit that related it more closely to Africa than to what one would have thought existed in America. Michael and Donna Malcé's antique shop in the Village specialised in it. It was this rebirth and consciousness of roots which my American friends were experiencing and inviting me into—and part of it was also the growing consciousness of Red Indian culture—which made me eventually look at and study Red Indian art and life.

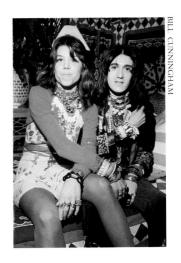

Jo Lombardo (then called Jo Jewel) and Donna Malcé

BILL CUNNINGHAM

All my friends looked absolutely amazing, embroidering and patching their torn jeans much as I had been doing, covering themselves with brooches, beads and bangles in a really extravert way. Jo Lombardo actually called himself Jo Jewel in those days because he wore so much jewellery. To change your name like that was, in itself, something unheard of in England at that time. I had never seen anything like it and I don't believe many people in London had either, except those who had seen me. I had feathers on the ends of my dyed green hair—imagine! I was literally painting my face, not just using make-up in a conventional way, and I was wrapping scarves around my head experimentally. I was, to say the least, regarded as a strange lady. Later, when I became more accepted, I was described as a true British eccentric, but in 1970 it wasn't like that. I wasn't taken seriously and suddenly there I was in New York with people I could immediately relate to. They loved the way I looked, adored me as a person and thought my work was sensational and of lasting value. Coming from London where not so many people believed in me, I flourished in their encouragement and thrived on their enthusiasm.

1970 was an intriguing year to be in New York anyway. There was an explosion of ideas. In the aftermath of 'Hair' there was a new freedom in thinking and an acceptance of individuality. Many people were dressing in a very unusual innovative way, decorating themselves, like my friends, with all sorts of baubles and feathers. It was a quite primitive style actually. We spent hours and hours together in Central Park, which was the hub of the action. I was fascinated by the way the people there looked and, equally, we fascinated them. Our appearance was so exotic, they would come up and look at us with admiration, so it was really a two-way thing. I enjoyed their reaction to me as much as I was stimulated by them. I now realise that subconsciously I must have related the whole experience to the American Indian.

One day Stephen took me on the I.R.T. subway to the Museum of the American Indian on the corner of 155th Street and Broadway, on the far side of nowhere. I'll never forget the impact of those amazing Indian costumes. I was so excited by what I saw that for the first time I was able to overcome my terrible self-consciousness about sketching in public, and I started drawing like mad.

The Museum shows the variation in the lifestyle of the Indians in different areas, from Alaska through Mexico to South America. You can see the evidence of the climatic differences in the clothes they wore and even more in the colours they used, which were sober from the snows of the north, almost like

camouflage, and gradually became more and more vivid as the tribes moved south to the sun. Faced with the costumes, I was overwhelmed by the sophistication of the cut and the brilliance of the decorative details used by people I had only thought of as primitive, galloping across my television screen pursued by cowboys. Here were intricate patterns worked in dyed porcupine quills, cut horizontally and used as beads; superb jackets made from half-inch triangles of sealskin of different shades, sewn into the finest patchwork; leather frock-coats with inset embroidery in quills and feathers. Feathers were everywhere; feathers tied on purely as adornment; feathers dyed and sewn with cross-stitch on to jackets; feathers used as edgings which dictated the outline as well as the decoration of the clothes.

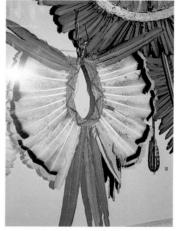
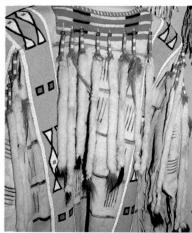
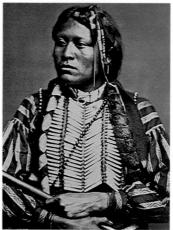
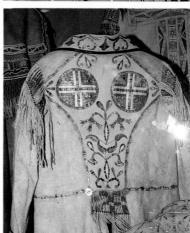

Top left, feather headdress

Top right, jacket with fur tails and blue glass beading

Above left, Pacer's son, Kiowa-Apache. Photograph by Will Soule, Indian photographer at Fort Sill, Oklahoma, 1869–74.

Above right, leather jacket with dyed porcupine quill embroidery

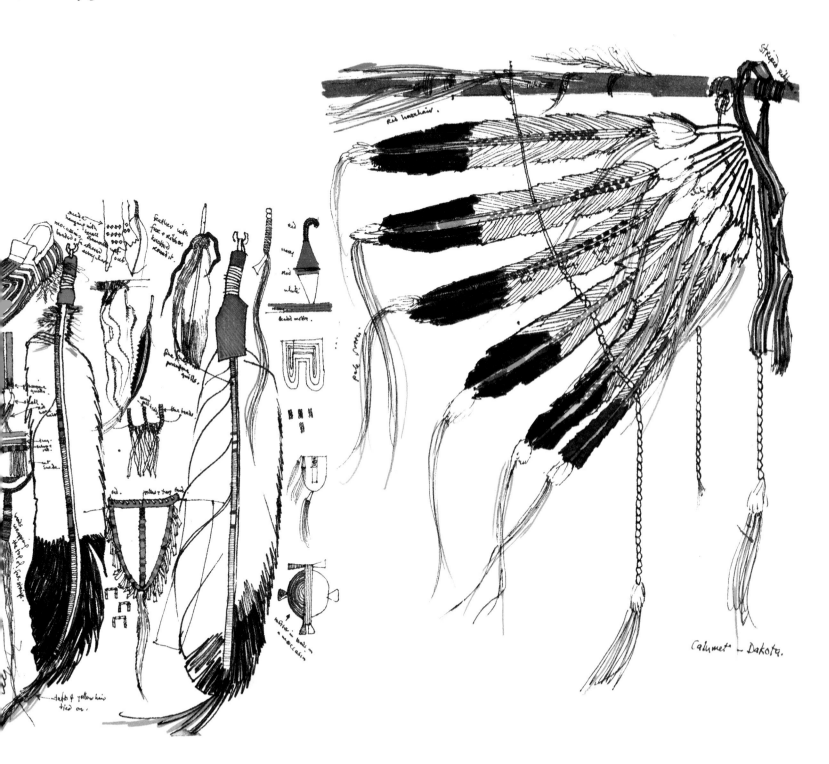

When I got back to London, everything started to 'gel' in my mind. The development from one idea to another was working again. My New York friends, the 'people' carnival in Central Park and finally the detailed sketches I made in the museum, all were the inspiration for the 'Indian Feather' themes. I wanted to give the impression in the print that the feathers were sewn or embroidered on to the fabric with cross-stitch, which was a progression from my previous collection, 'Chevron Shawl', where I had actually attached feathers to my dresses. Thus, from real feathers, I went to printed feathers and from there to cutting the print to make feathered edges including the feather sunspray, which on hindsight, I am sure, is linked to a chieftain's head-dress. At this stage, I did all the cutting out round every feather myself and then hand-rolled the edges. I found this neater and quicker than machining. It is a technique perfected and still used by me. I printed in the natural colours originally used by the Indians; terracotta, indigo, black, and turquoise feathers. It is still my favourite combination in this print although, since I do use it again and again, I recolour it every time.

Most of my textile designs are directional. They are not easy all-over prints and therefore my garments need a lot of thought. The patterns lead me along and influence the way I use them so I nearly always arrive at a dress design by experiment, just by cutting up the printed fabric and playing around with it. I see how the fabric hangs, pinning it on to my body or a dress stand until I find it looks right as a skirt or a bodice, maybe. I always consider what is left and try to make it into another part of the dress. I can't tolerate waste and use every inch. I didn't know just how adaptable these feather designs would prove, as entire prints or as borders and motifs. In fact, 'Indian Feather Sunspray' has been perfect for my way of working; so too, has 'Indian Feather Border'.

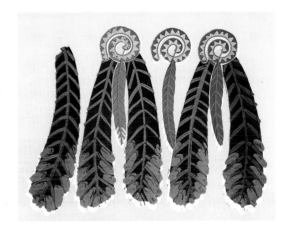

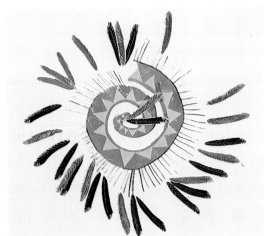

Right, experimental paper designs

Opposite page, four-colour 'Indian Feather Border' print on silk chiffon. Design repeat 36″ (91·4 cm.), width of fabric 45″ (114·3 cm.).

Over page, three-colour 'Indian Feather Sunspray' print on silk chiffon. Design repeat 29″ (73·6 cm.), width of fabric 45″ (114·3 cm.).

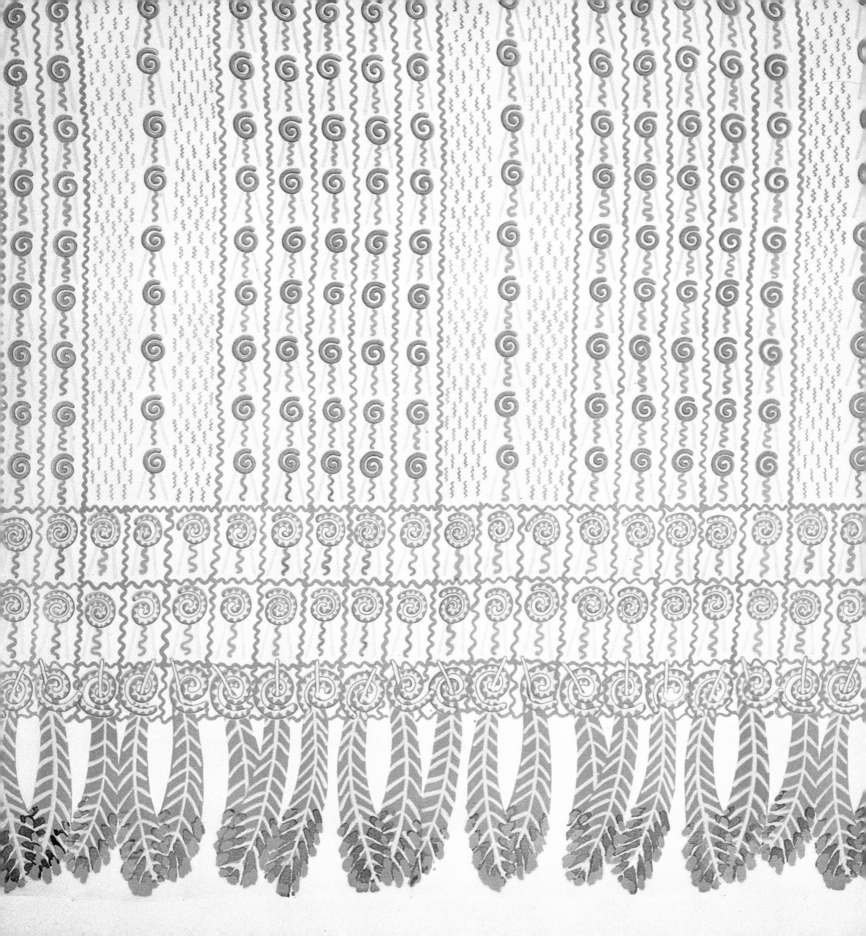

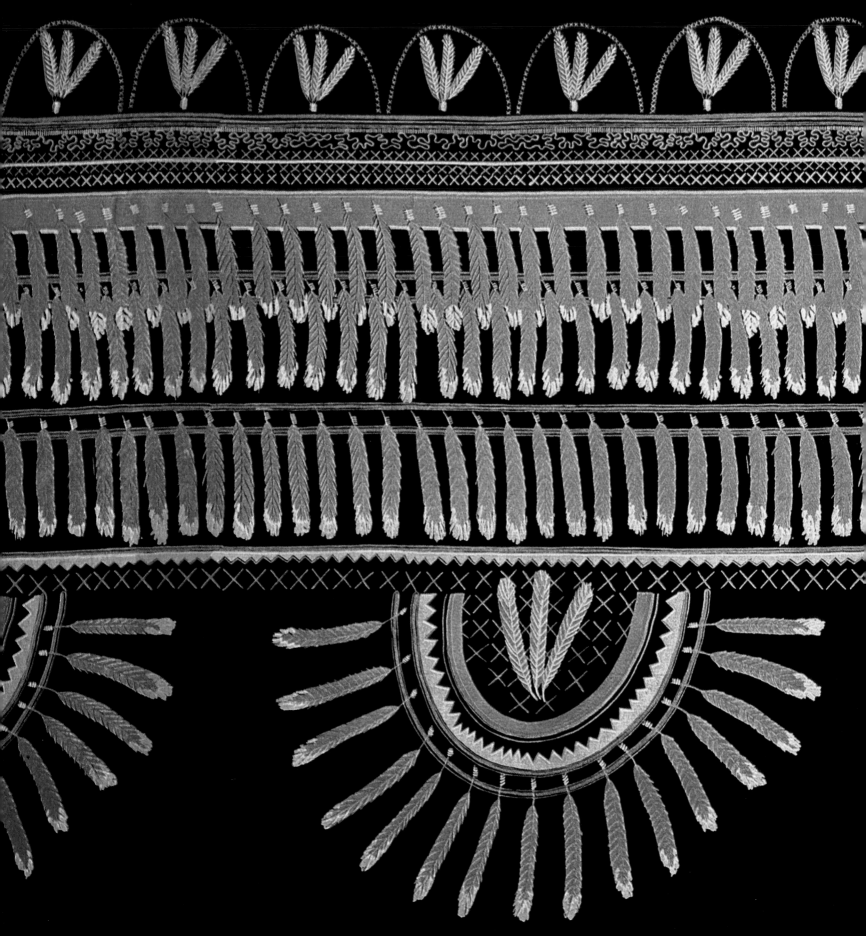

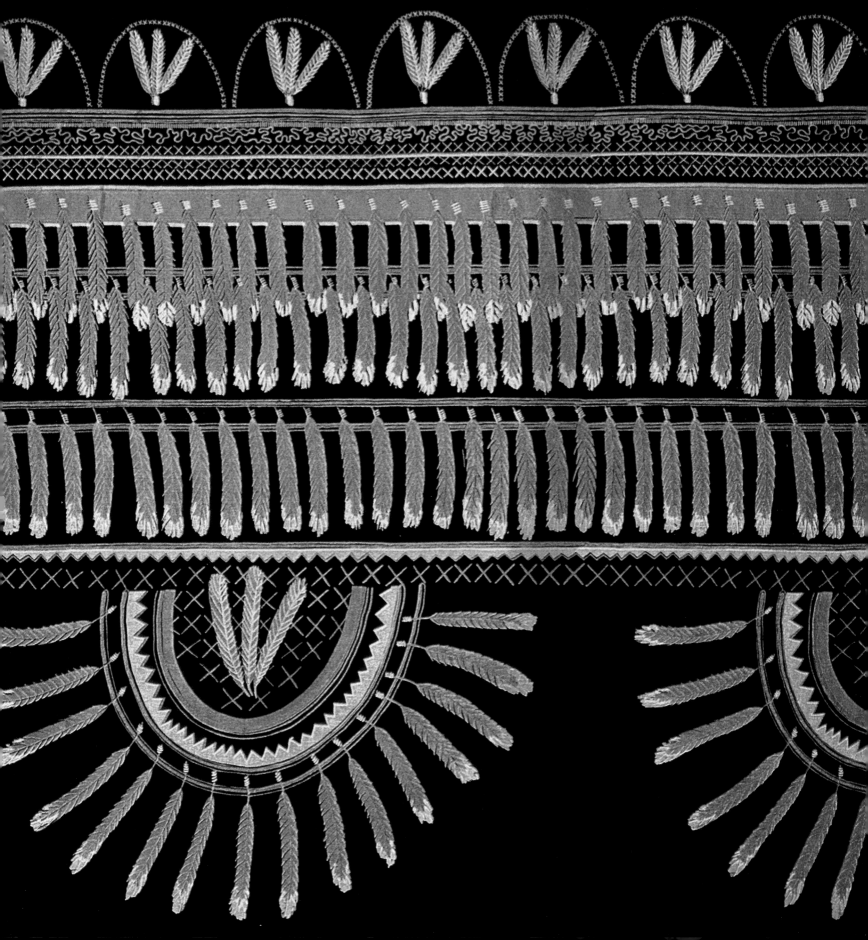

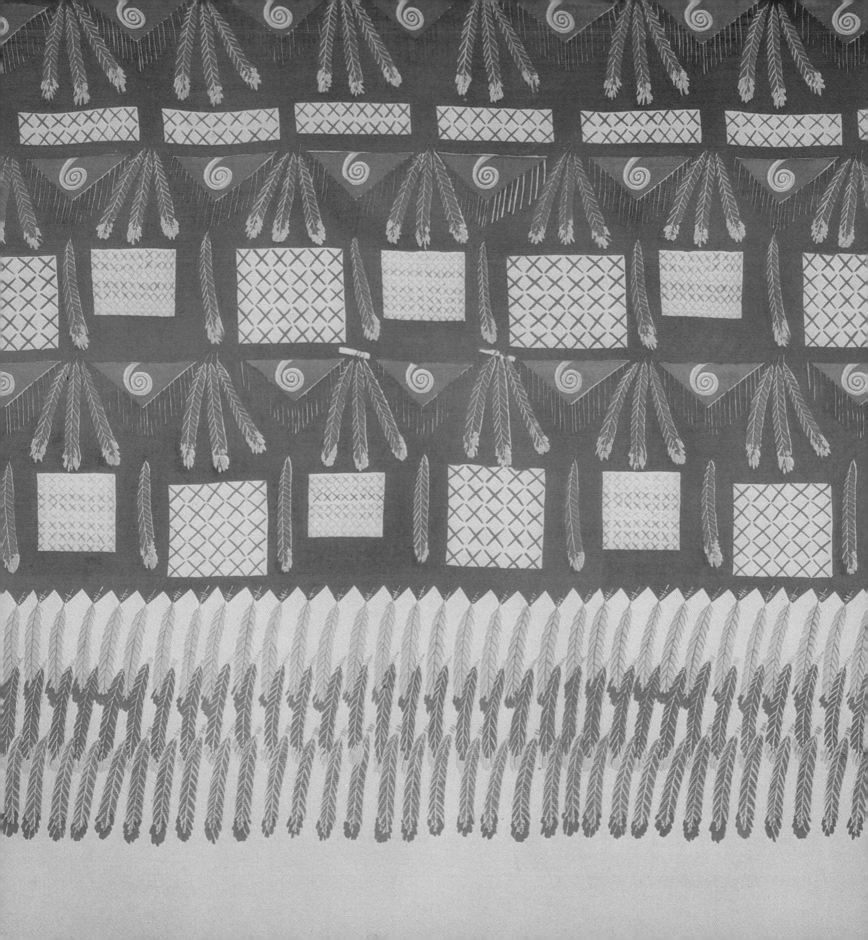

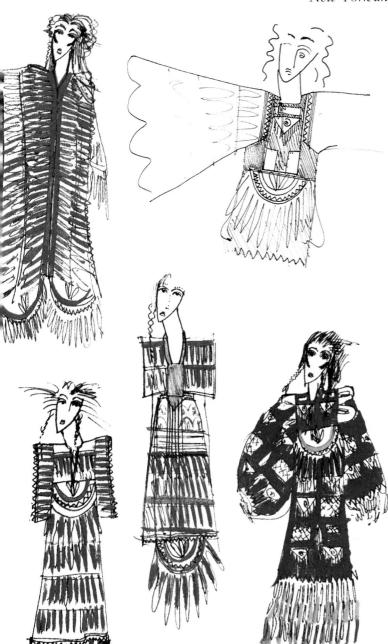

Whenever I have a space in my work programme, I develop some new use for my designs. People had been asking me for table linen, so I decided to use the 'Indian Feather Border' print for tablecloths, napkins and lapmats (huge napkins which are perfect for a buffet).

Although I was trained as a textile designer, I had not applied any of my own prints to furnishing fabrics. I had purposely cut myself off from them in 1969 with my first dress collection, so that I would not be labelled as a textile designer. Then I met Christopher Vane Percy, an internationally famous interior designer with his own elegant shop in Weighhouse Street, Mayfair. He encouraged me to refine them to be more saleable. Together, we created Zandra Rhodes Living, producing cushions and furnishing fabrics for sumptuous interiors (see below).

Richard Holley used the 'Indian Feather' prints when I commissioned him to design the interior of my London shop. It was Richard, working closely with me, who led me to experiment with the dusty rose and ginger interior colours that have become such a part of me. He was such a perfectionist and would make me really re-think those colour schemes until they were just right. For Richard I also worked on exotic 'trompe l'œil' ceilings with the feathers growing up from columns. These designs were never used in the shop but were later in some CVP* interiors.

*The name of Christopher Vane Percy's shop.

PETER WARNER

Left, four-colour 'Feather and Triangle' print on silk chiffon. Design repeat 28″ (71·1 cm.), width of fabric 45″ (114·3 cm.).

Above, fashion sketches

Right, interior of the CVP shop, using 'Indian Feather Border' fabric

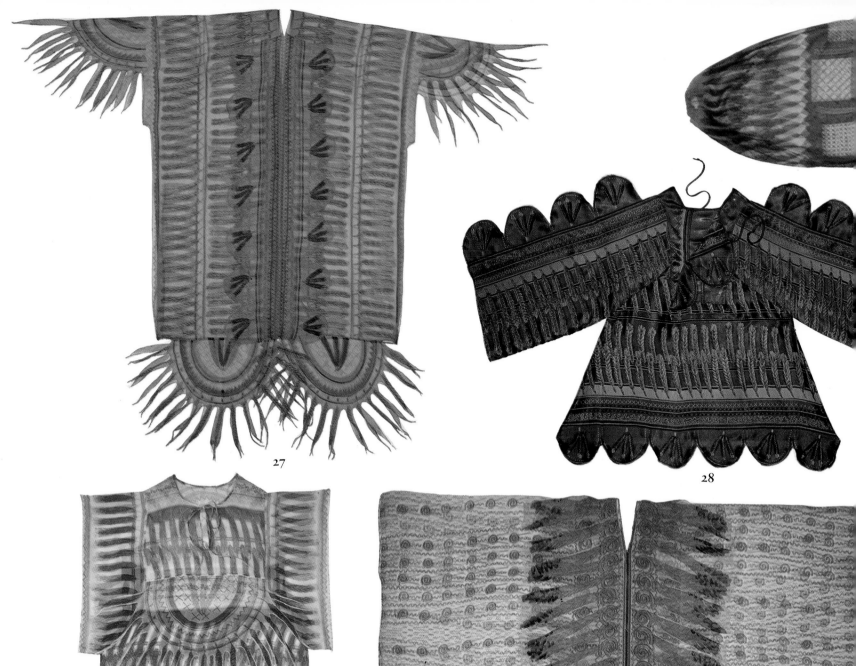

27

28

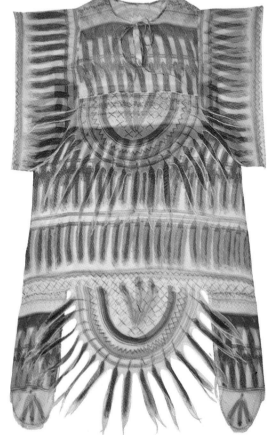

31

32

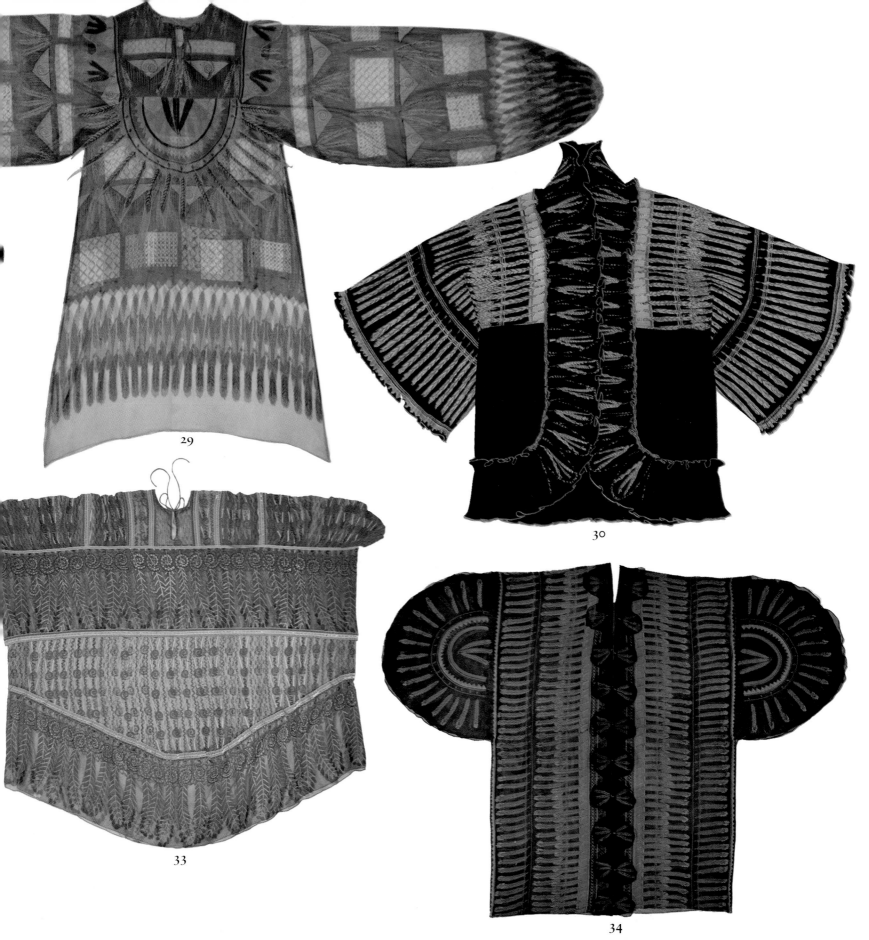

29

30

33

34

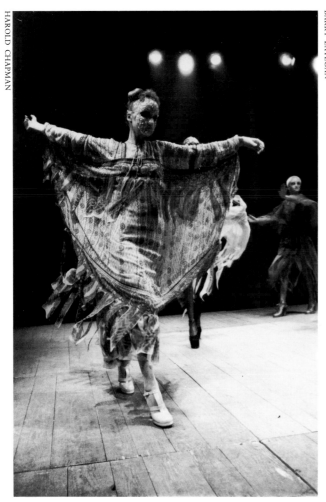

Beaded mask on model from Roundhouse Show, 1972
(Butterfly no. 33)

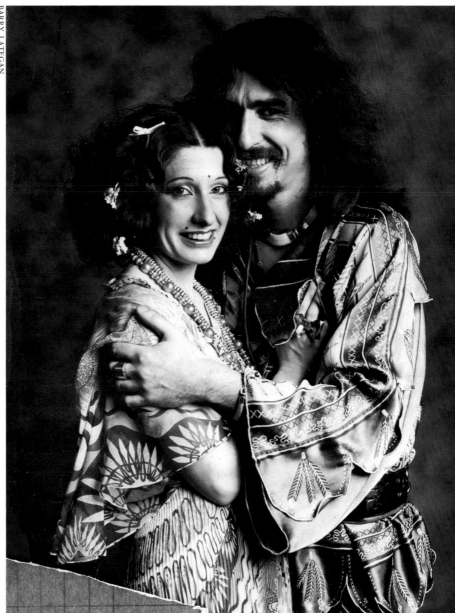

Zandra with Grant Mudford. Grant is wearing Zandra's first man's
shirt, using 'Indian Feather Sunspray' print (Butterfly no. 28).

64

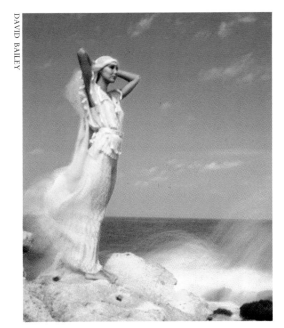

DAVID BAILEY

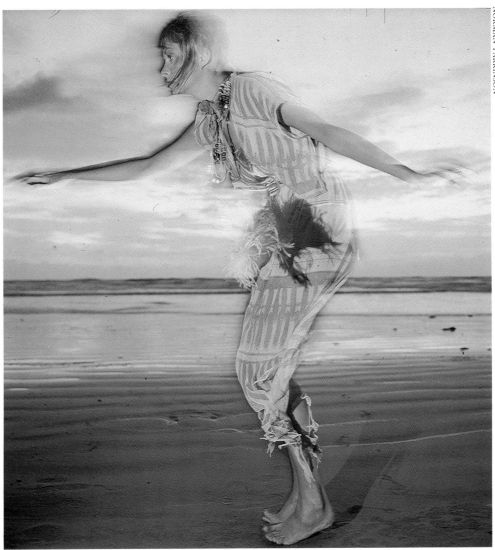

NORMAN PARKINSON

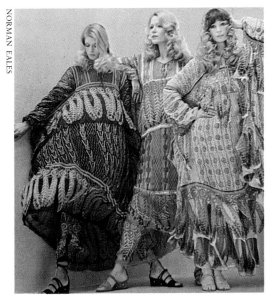

NORMAN EALES

Florida, 1971

Top, Marie Helvin

Above, Butterfly no. 33 in three different colourways

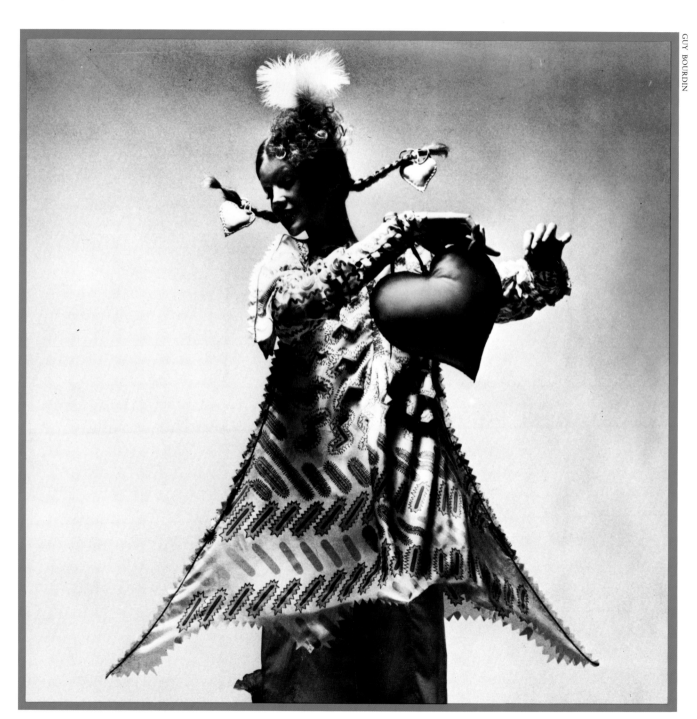

Photograph for *Vogue*, 1971 (Butterfly no. 37)

The Victoria and Albert Museum and Elizabethan Silks

The Elizabethan era had always fascinated me. As a student I walked through the costume court of the Victoria & Albert Museum to look especially at the zig-zag cut silks of the Elizabethan doublets, they had such a powerful style.

Now, about this time in 1970, after the visits I had made to New York, I think that the consciousness of roots that I had become aware of in America started to affect me strongly. Going round The Museum of the American Indian, the intricate patterns of porcupine quills and natural fur somehow made me think of my own Elizabethan roots. They were a sophisticated folk-art form! In fact many of the most fabulous drawings recording the Red Indian natives that I have seen were done during the early period of discovery and were Elizabethan in their style.

The treasure house of Hilliard miniatures was also there in the Victoria & Albert for me to look at, with the amazing Queen Elizabeth I and her ornate costumes rich in detail and splendid ornamentation.

What I found so amazing about folk art was the natural development and use of everything around. With the Indians it was decoration with such a strange thing as porcupine quills! In Europe it was raw cuts in fabric as decoration. What a strange punk idea! Civilization had, in 1970, considered itself so advanced as to have left these natural techniques behind. Suddenly the wonderful pink bodice, made from slashed silk, had a new meaning for me, I kept going back to it and that was the spur for my Elizabethan slashed silk collection. I decided to do a modern interpretation.

First, I took the cut detail from this bodice (see picture) and used it in the same way the Elizabethans had, cutting the fabric in zig-zag patterns myself, by hand, with a sharp knife. I then designed a print which fitted round the cuts and called it 'Sparkle'. The zig-zags and hatched shapes were all again

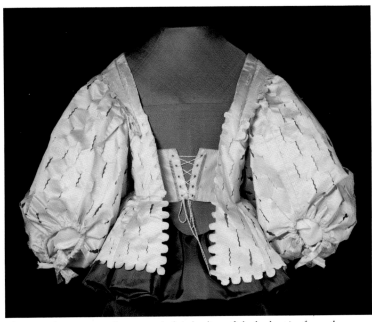

Above, early seventeenth-century lady's bodice of slashed satin, from the Victoria and Albert Museum. Although not true Elizabethan, this bodice is a splendid example of the slashed silk technique.

Below, pinking punches, c. 1850; tools as used for cutting silk in Elizabethan times, from the Victoria and Albert Museum

67

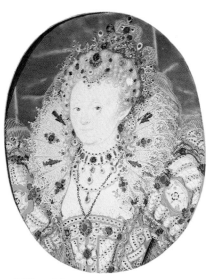

Left, stump work from the Victoria and Albert Museum
Right, sixteenth-century portrait of Elizabeth I by Nicholas Hilliard, from the Victoria and Albert Museum
Far right and bottom, preliminary thoughts combining fabric patterns with Red Indian garment shapes

sketches of Red Indian garment shapes

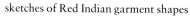

influenced by stitchwork, the idea being that I had done blanket stitch or herringbone all round the holes. The print also had oval cigar shapes so that the silk could then be cut in the middle of them, the positioning being dictated by the cigar shapes.

I laid out the separate motifs for my sparkle print (the zig-zags, the ovals and the blanket-stitched ovals) with a strange combined formality that had something of Tudor symmetry about it. Hampton Court, England's Tudor Palace, the home of Henry VIII, had been an influence here. I loved its zig-zagged chimney brickwork and the intricately laid-out gun room, where the weapons formed giant criss-cross patterns. Its grounds were so perfectly planned in the Elizabethan style, the yew trees trimmed in the topiary manner, and the knot garden had lovely clipped hedges of aromatic shrubs with brilliant kaleidoscopes of colour all appealing to my sense of design and to my love of plants and flowers. I enjoyed the harmony of this ordered, peaceful atmosphere, and it was a great influence on my total pattern layout.

The second stage was to print the fabric and then cut the silk within the pattern dictated by the print. The slashes were pure Elizabethan but both the print colours and the dress shapes were a logical development from my American Indian Collection, where the shapes were influenced by the skin shapes themselves.

Trophies of Arms, 1699, Hampton Court Palace, London

Initial sketch working out 'Sparkle' design

Below, paper designs with all-over 'Sparkle' motifs

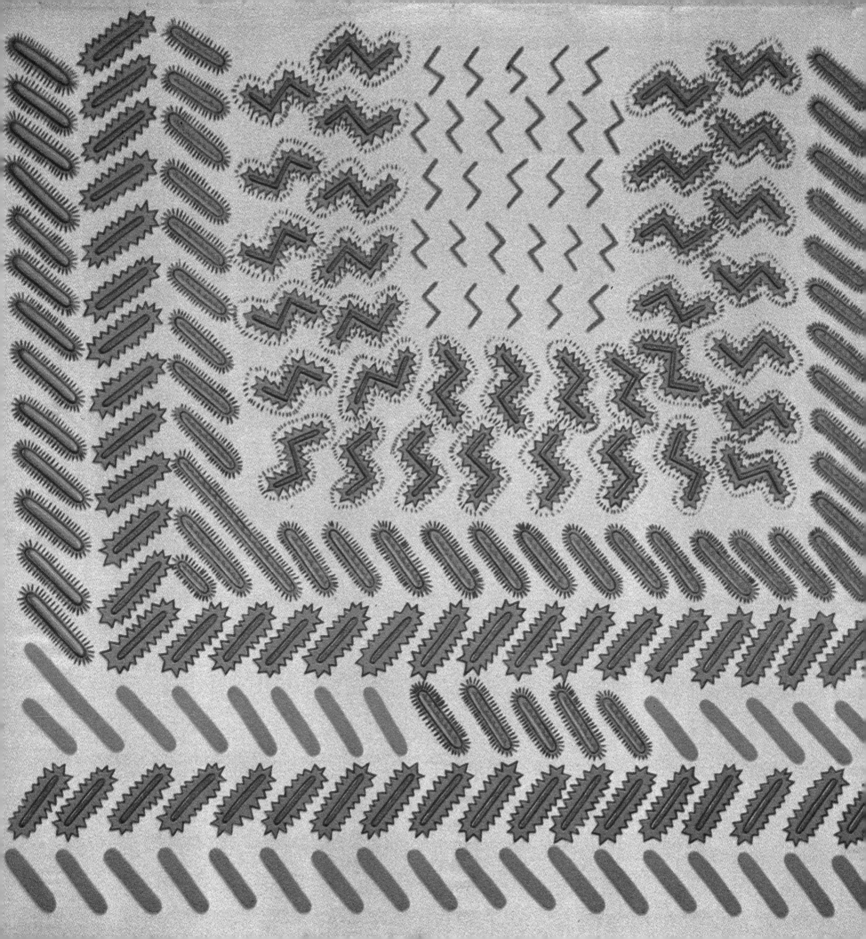

They worked well together. For added embellishment, I smocked some of the dresses and from the printed fabric made little silk tassels with pinked raw edges which were held with fine knots of the same material, inspired by Elizabethan stump work. Some of the garments were layered, one shape worn over another, and others were lengthened with the addition of a border of different print – the Indian Feather Border from my previous theme (see butterfly nos 31 and 33 on pages 62 and 63). The Collection was not very well received because people couldn't understand the raw edges (even though it had been all right to do in Elizabethan times) but the 'Sparkle' print was a success. After the cut silk I printed 'Sparkle' on chiffon and created petalled tops and skirts with streamers of chiffon, all their edges hand-rolled. There has not been the space here to fit in a butterfly of this but see the photograph of the garment on page 75. Even today I use this print to great advantage as a one-colour print on my classic front-drape dress with large pearls around its neck.

The Collection formed part of my very first fashion show which I decided to do in America. Chelita Secunda, friend and mentor of Ossie Clark* came with me to New York and we stayed in the Village in a loft belonging to Adel Roostein. It was above the studio showroom where she exhibits all her famous display mannequins. Going through there on my way to the top floor was like being in a modern fantasy of Madame Tussauds. Adel's models were all sculptured on well known beauties of the day and so true to life. Chelita helped me with the presentation which we gave in Angelo Donghia's town house. I played Janis Joplin and showed my clothes to an audience of America's most influential ladies of fashion, especially the High Priestess of American fashion, Diana Vreeland, and the King, Halston. The reception was thrilling; applause and congratulations for me for what I considered was a powerful victory for the 'New Elizabethan' me!

I was wearing coloured stockings rolled down over coloured tights under my cut-silk mini-shorts and I had little tufts of coloured hair that I would attach into my own. With platform-heeled boots and feathers and fur flying, I was set to make an impression, cut a dash, *circa* Elizabeth II.

*The cult British pop dress designer of the late 1960s and early 1970s, who was especially known for dressing the wives of the Beatles.

Left, preliminary sketches for the cut silk dress

Far left, three-colour 'Sparkle' panel print on fine silk. Printed in 41″ (104·1 cm.) panels with 13″ (33 cm.) gaps, width of fabric 36″ (91·4 cm.). (This design was also printed without 13″ (33 cm.) gaps to make a continuous pattern.)

71

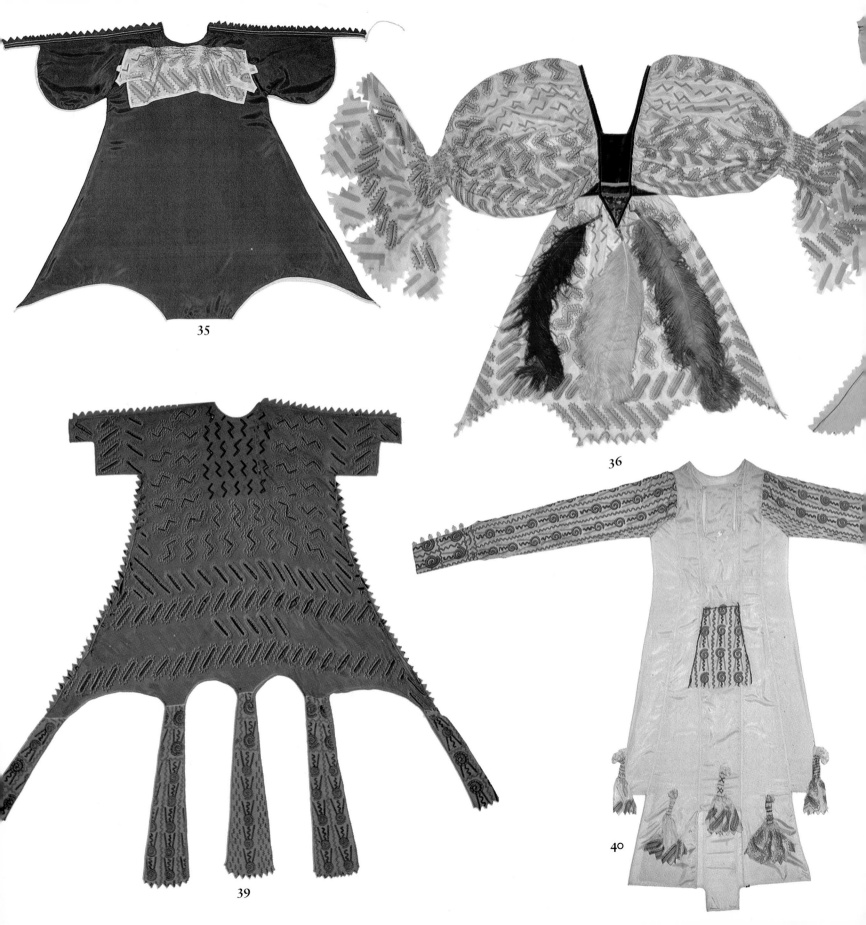

35

36

39

40

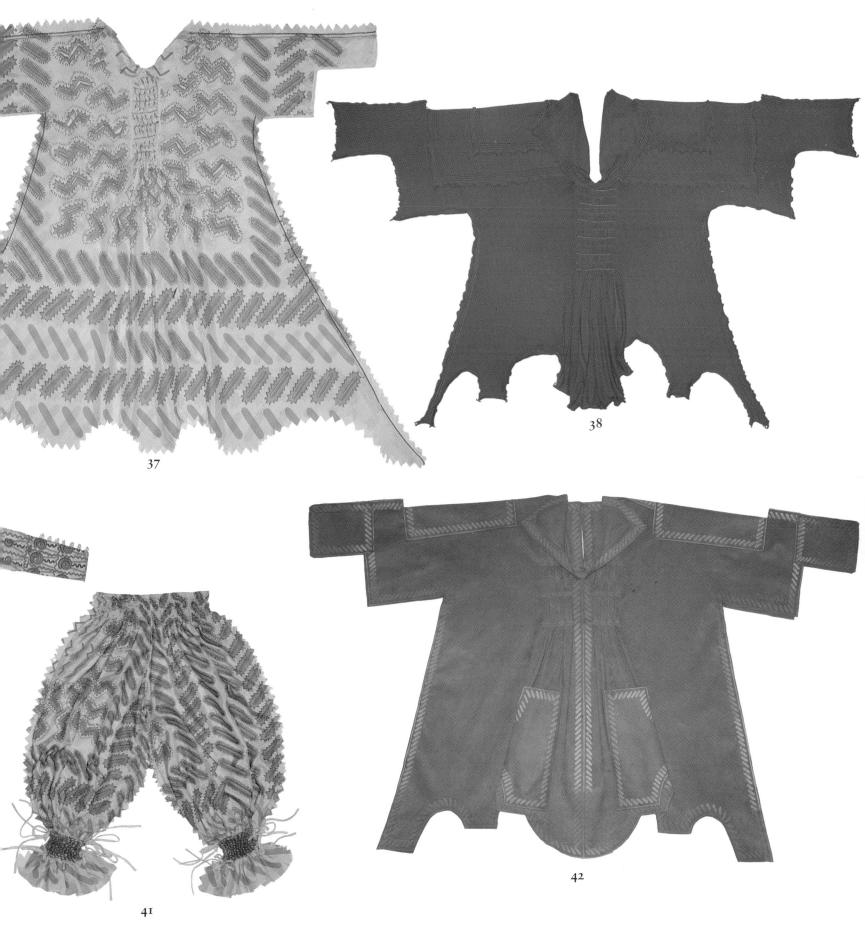

37

38

41

42

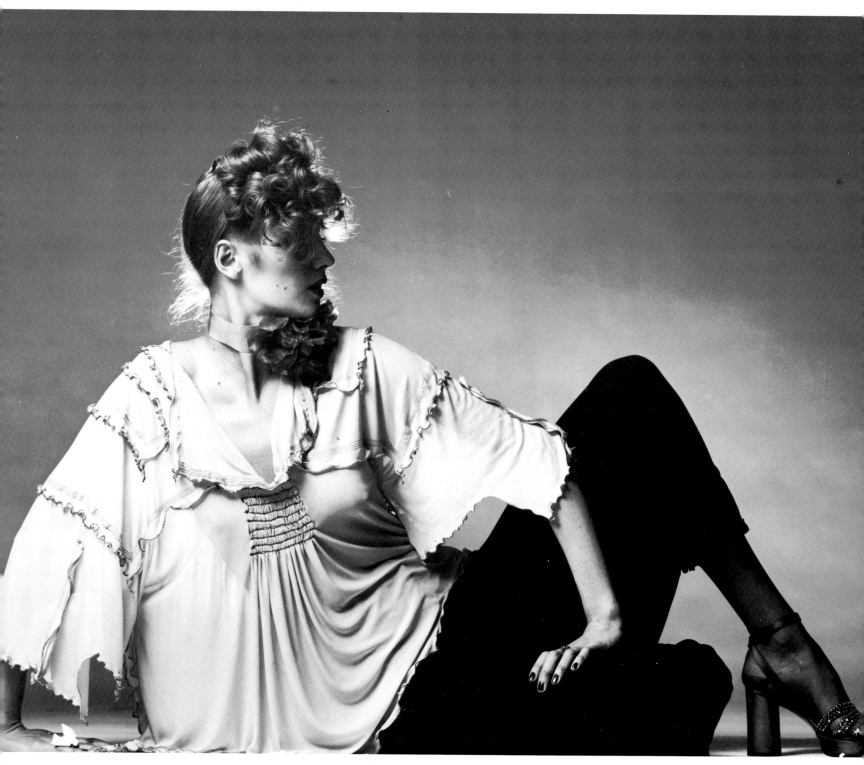

CLIVE ARROWSMITH

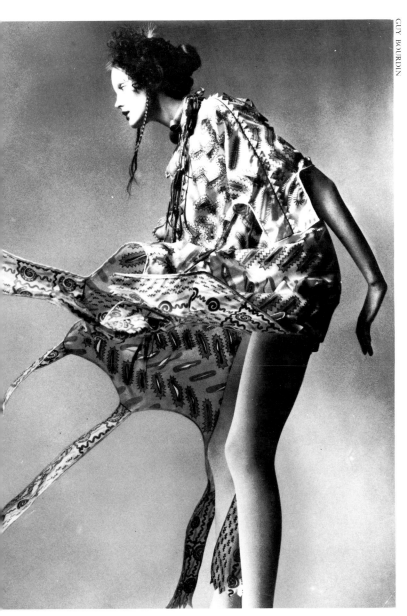

GUY BOURDIN

BARRY LATEGAN

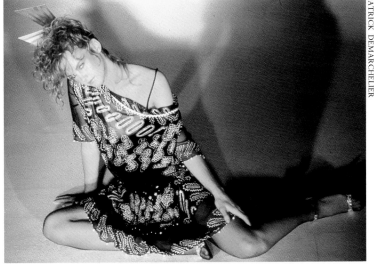

PATRICK DEMARCHELIER

Above, Butterfly no. 39

Left, Butterfly no. 38

Top right, Zandra on the programme cover for her New York Show

Right, example of 'Sparkle' design on silk chiffon, used in a later collection

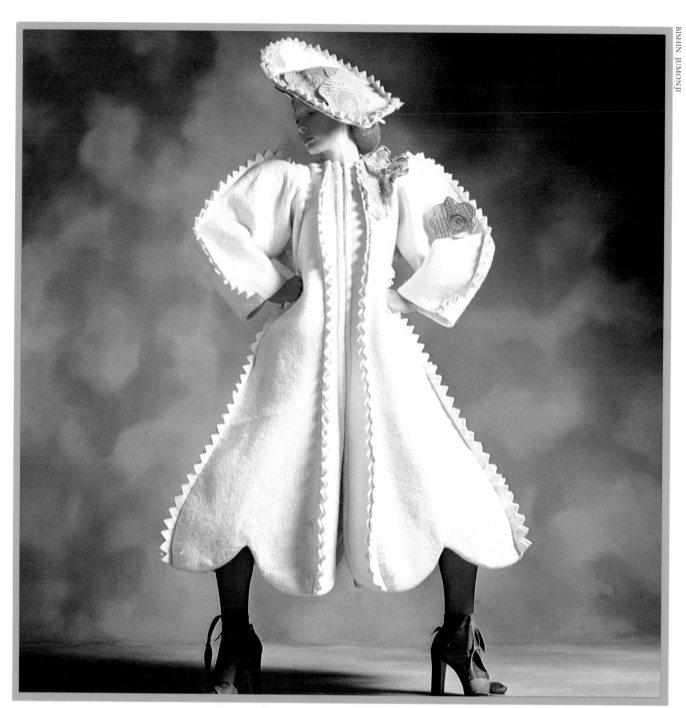

Photograph for *Anan*, Japan, 1971 (Butterfly no. 57)

Paris, Frills and Button Flowers

It was not a very long journey, no further afield than J. & J. Stern Ltd., Button Manufacturers, 5 Great Chapel Street, London W1. I went there to buy some buttons. Six thousand they had to choose from and those I took were simple flower and geometric shapes. I kept looking at this abundant collection, not only for the buttons themselves, but because I loved the way they were attached to the cards, with little pinked shapes of coloured fabric around each sample (see opposite). It seemed to me the presentation was more important than the buttons; anyway I remembered the image and tucked it away in my memory bank.

In 1971, a French-based design consultancy called MAFIA summoned me to Paris to do some textile designs and I was travelling there and back fairly regularly. I was pleased and flattered to be invited to Paris, the impenetrable stronghold of world fashion and textile design. I made several good friends there, notably Emanuelle and Quasar Khanh and their large family, and Karl Lagerfeld, grand master of Parisian chic.

As with New York, going and working in Paris and making friends there gave me a new slant on the city. I was able to experience the behind-the-scenes sophistication in which my friends lived. There was Karl, with his huge Art Deco furniture collection (incredible at that time) and, as two Virgos together, we would look at his collection of historical garments and discuss detailing of the past. The Khanhs and their ultra-modern, French-style living, in a way that had not touched London, were totally refreshing to me.

While I was on the first of these design trips I had time to go to the flea-markets with the Khanhs in their glass car, and on another visit I picked up hundreds of very old magazines on making lace and doing crochet (but these I didn't use until the next chapter, page 98. At this stage they were to rot away on my

A button card

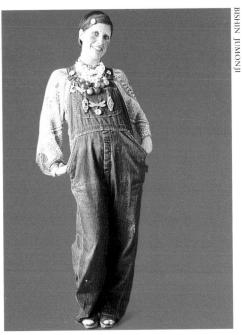

BISHIN JUMONJI

Zandra in dungarees with button jewellery by Mick Milligan

walls, turning brown).

Yves St Laurent was the leading light of the Haute Couture. His last collection had been short and graphic with vivid flower print colours and there was a green fox coat with a great silhouette. I cut out the photograph of it from *Elle* and pinned it on my wall next to the button cards, for later.

I wanted to design a flower print but not a traditional one, and the fancy buttons on my studio wall encouraged me to try. I thought I would draw the flowers like buttons stitched on to the fabric, the buttons being the flower centres with modern, bold Matisse shapes for the petals (see opposite). So my first print was 'Button Flower'.

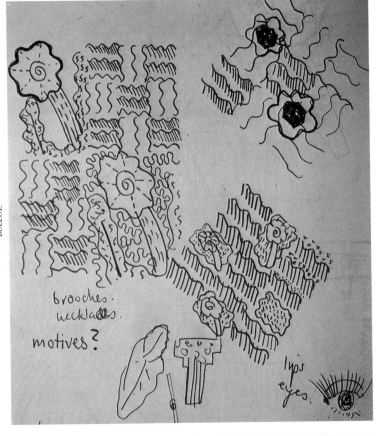

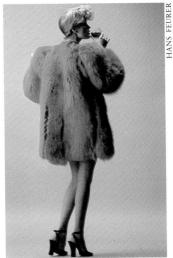

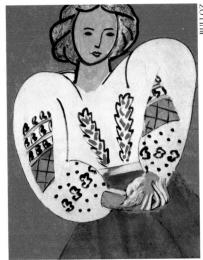

Above left, Yves St Laurent coat

Above right, 'La Blouse Roumaine' by Henri Matisse, 1940, Musée National d'Art Moderne, Paris

Top right, preliminary sketchbook designs

Below right, Zandra trying on paper designs in front of a mirror

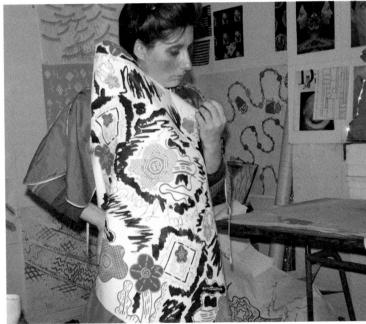

Opposite page, three-colour 'Button Flower' print on silk chiffon. Design repeat 23″ (58·4 cm.), width of fabric 45″ (114·3 cm.).

78

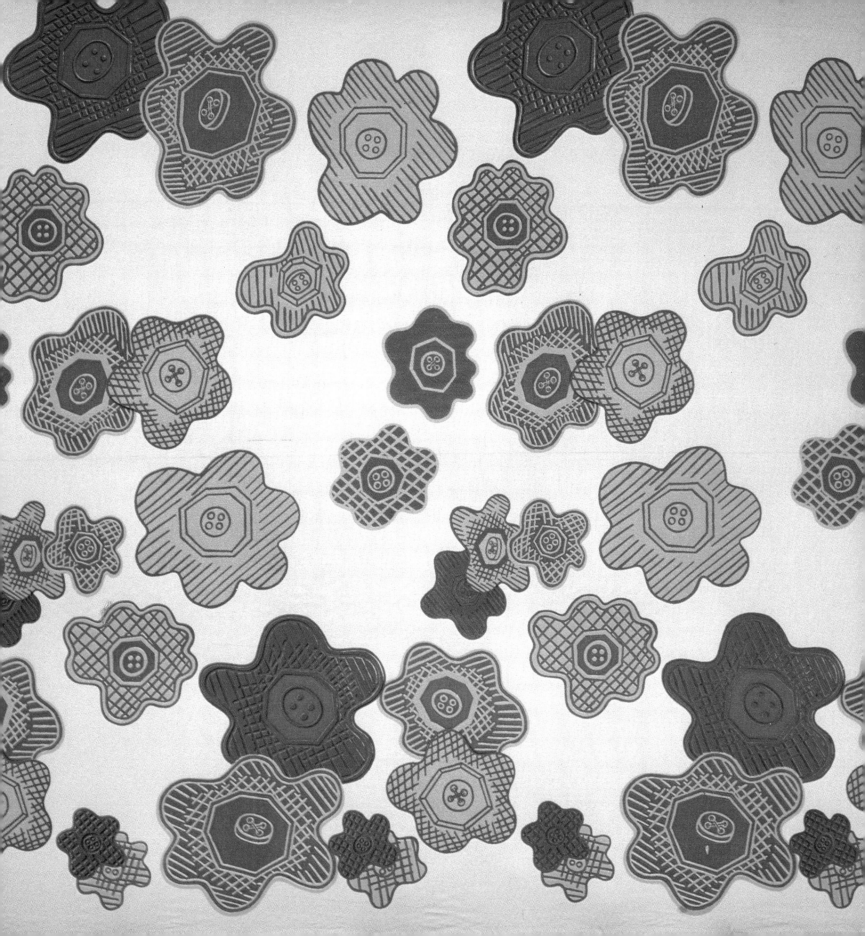

I wanted to expand this idea and develop more prints on the theme of buttons and bows and I studied examples in the Costume Court of the Victoria and Albert Museum and noted particularly how they had been used as an intrinsic part of design and decoration of the clothes they were on. Then I found myself drawn over and over again to the Fragonard and Boucher paintings in the Wallace Collection. Here I was fascinated not by the shapes, but by the wealth of detail; frills, buttons and bows, lace and flowers and the abundance of decoration in the dresses but, particularly, I loved the frills. Then first 'Button Flower' became wiggly and frilly, so developing into 'Frilly Flower', and then 'Frilly' came into being.

When it came to designing the clothes for the new Collection, several factors, including the green fur coat, all jumbled together, forming a link in my mind that led me to my final garment themes. I was now being stimulated by influences other than my print designs, the shaping, draping and detail expertise I was in contact with were taking me away from the flat, ethnic shapes and towards Paris and its couture.

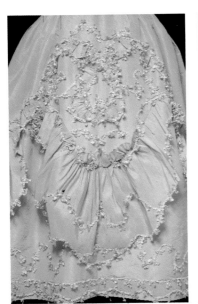

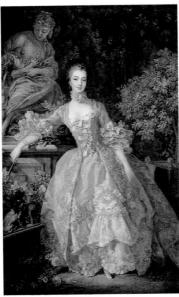

Above left, detail of skirt frills on dress of yellow silk, c. 1770, Victoria and Albert Museum

Above right, 'The Marquise de Pompadour' by François Boucher, 1759

Right, ideas on paper which show the development of the frill motif

Opposite page, three-colour 'Frilly' print on satin. Design repeat 26″ (66 cm.), width of fabric 36″ (91·4 cm.).

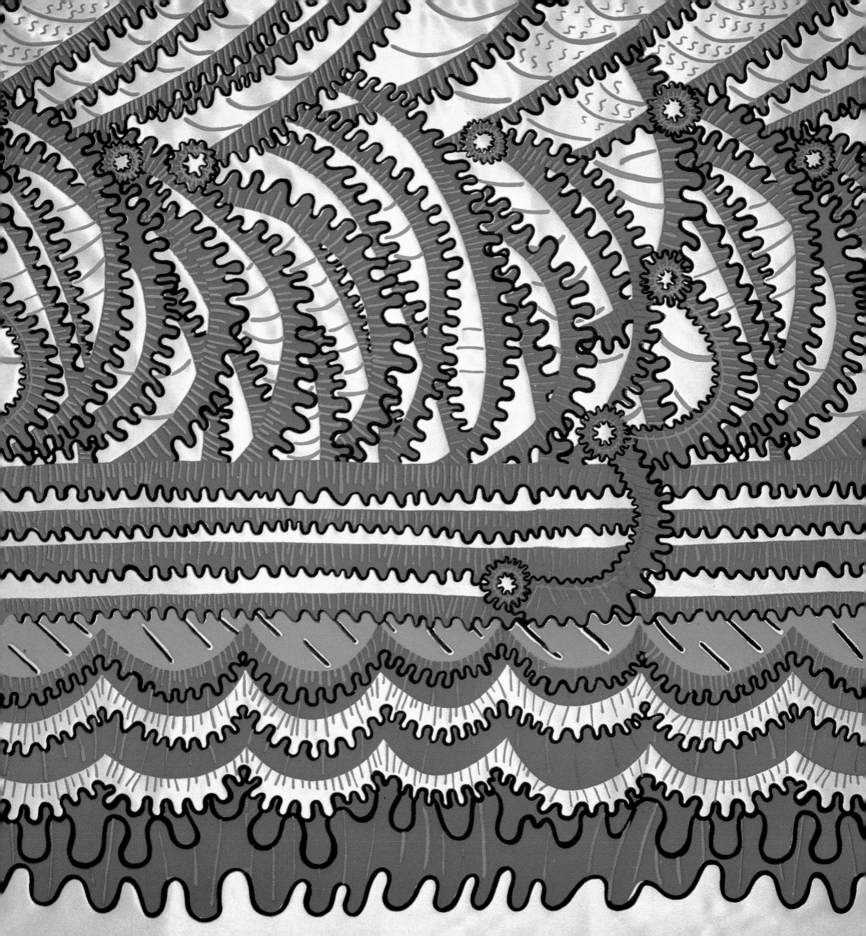

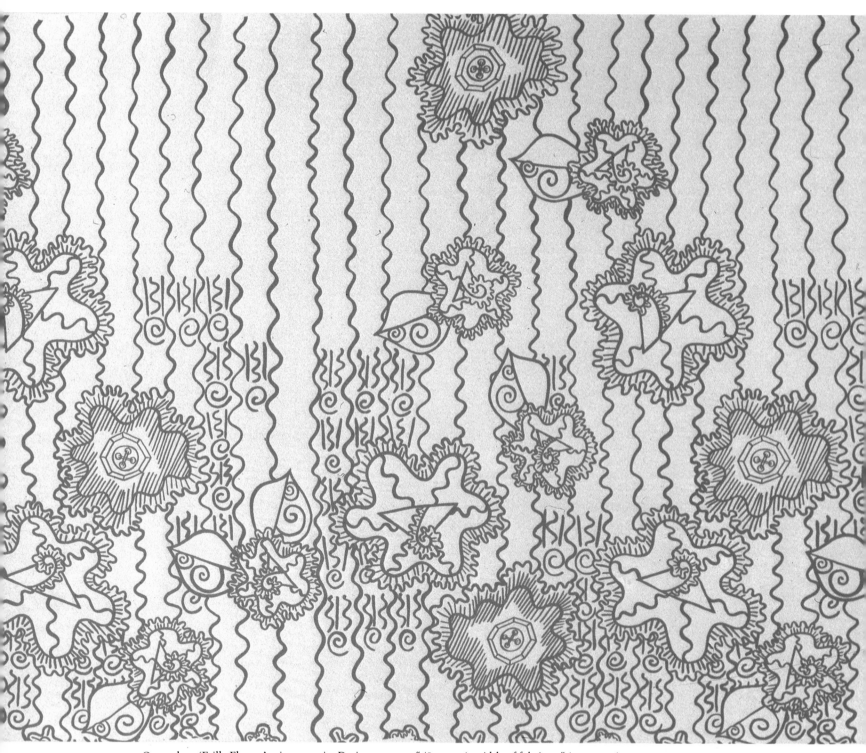

One-colour 'Frilly Flower' print on satin. Design repeat 32″ (81·3 cm.), width of fabric 45″ (114·3 cm.).

Magnetised by the intrinsic tiny details I had been studying—the buttons, bows and frills which I had interpreted two-dimensionally in my prints—I then became involved in the three-dimensional quality of frills. I searched for a way to create them by putting lettuced outside edges on my dresses. I made these by stretching the edges of my silken jersey as it was being oversewn. This was revolutionary at the time. I used this edging on a draped jersey dress but still kept the small, ethnic, quilted bodice. I made initial developments in jersey, with lettuced edges and seams on the outside, tentatively in the Elizabethan Collection with the Red Indian shapes (see page 68).

Having taken the original decision to put the seams on the outside, it was a short step to making coats with seams on the outside and notching them in zig-zags, Elizabethan-style. The Zandra Rhodes dinosaur coat was created, the panels of fabric being subtly shaped as if they were curved fox pelts sewn boldly together with zig-zag seams on the outside. A total new creation evolved. I made several dinosaur coats in felt and trimmed them with Matisse felt flowers cut and quilted from the prints, placing them on to the shoulder Matisse style (see photograph) and then stitched on to form a decorative motif. Skirts to go with the shorter jackets in this collection were a strange combination of pleats put together in the manner of frilled layers, the pleating sprayed in many directions.

Anne Knight at this time had left Fortnum & Mason, so I had nowhere in England to sell my clothes. Consequently, for a short time I sold them in a small boutique in the Fulham Road called Piero de Monzi. There was a small gallery (The D.M. Gallery) attached and here I did my first London fashion show, small and intimate, with my fashion drawings framed and on exhibition at the same time.

Right, fashion sketches

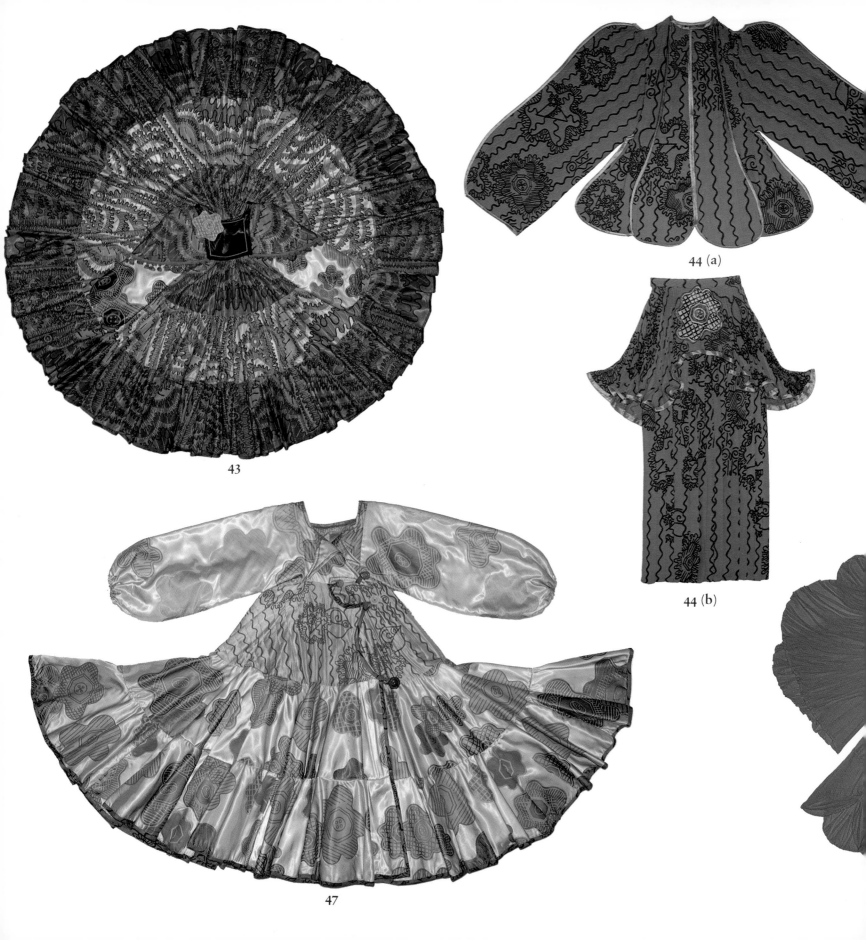

43

44 (a)

44 (b)

47

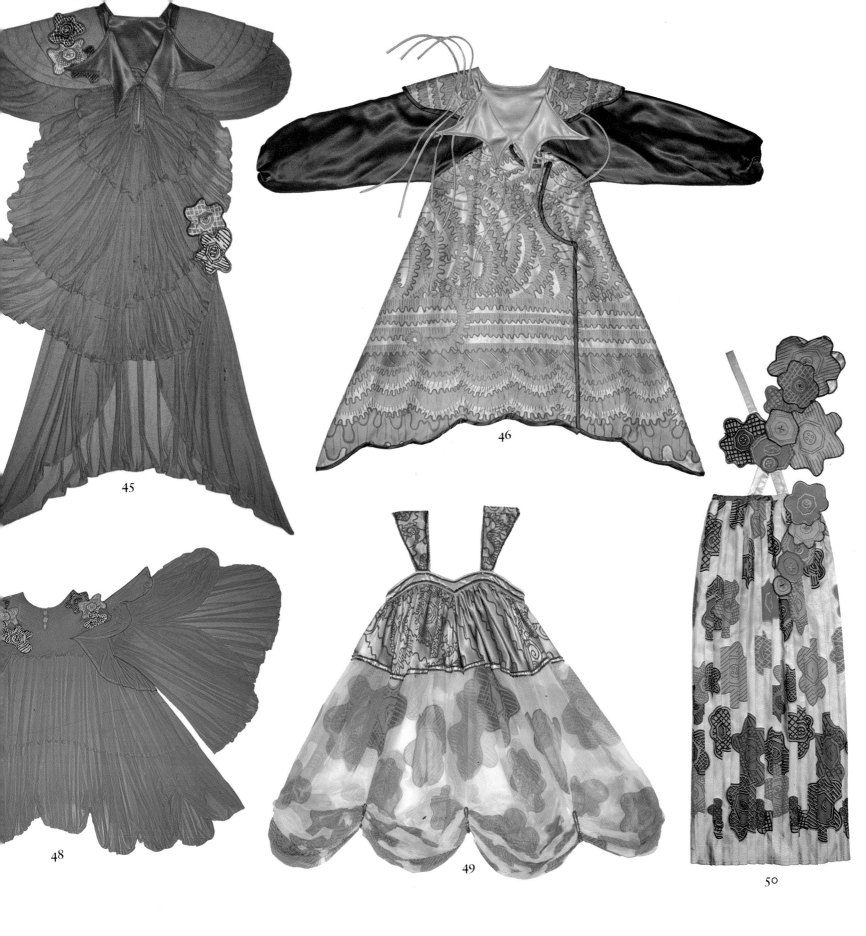

45

46

48

49

50

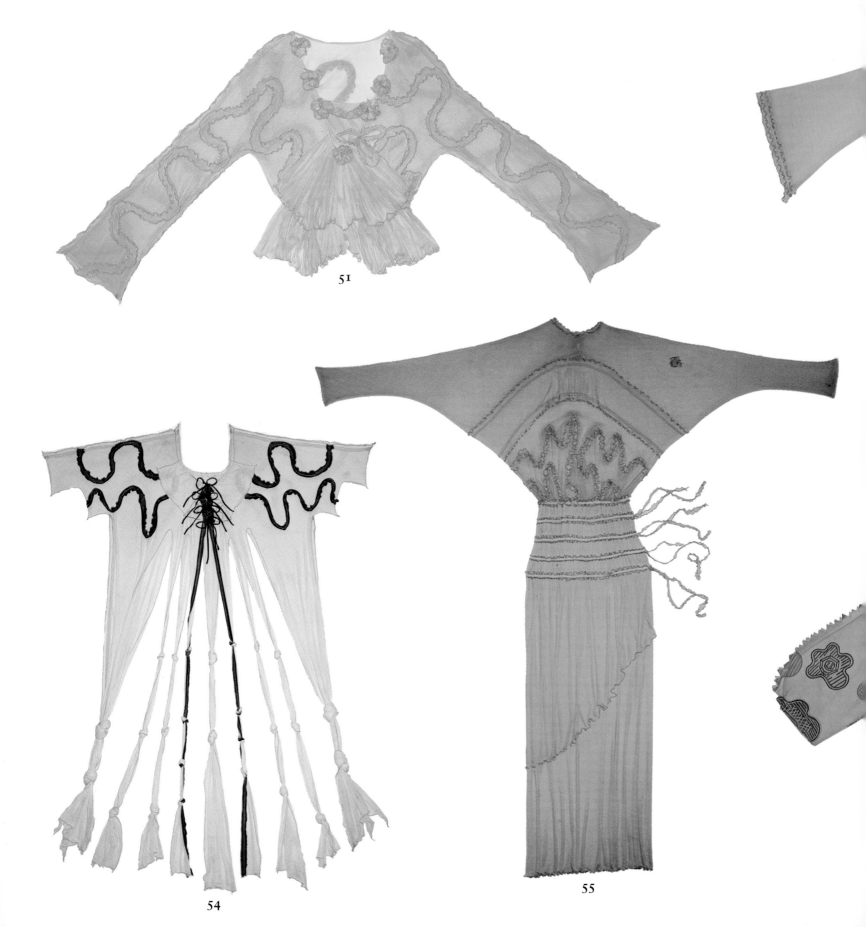

51

54

55

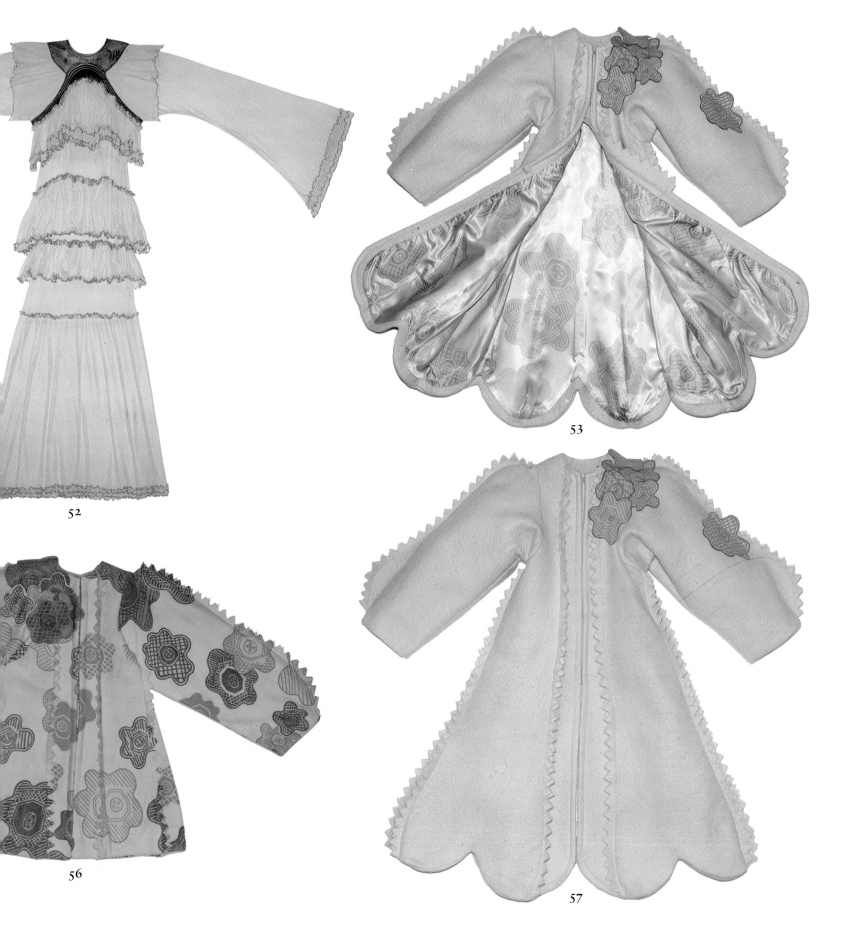

52

53

56

57

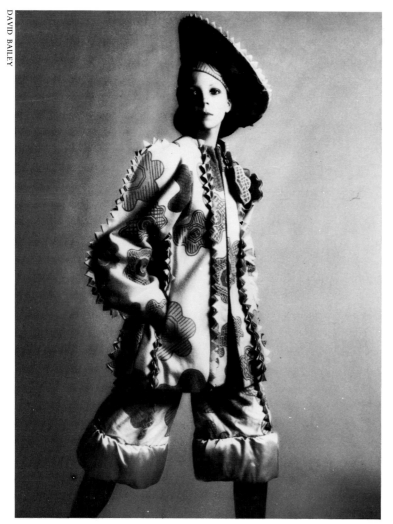

DAVID BAILEY

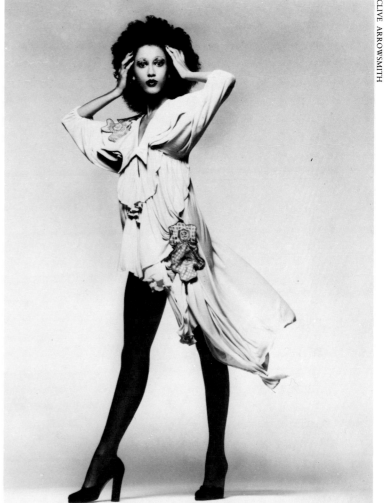

CLIVE ARROWSMITH

My look at this time had become more severe. I had plucked my eyebrows almost completely away and right where my eyebrows began I put Vaseline dots and stuck on iridescent glitter. My hair was straight and Leonard put in multi-coloured streaks. It was caught to one side with silver-studded rhinestone 'buttons' specially designed by Mick Milligan to go with the 'Button Flower' Collection. He also made pins in this theme which caught down the centres of the appliquéd flowers. My fashion drawings on page 83 show this jewellery on the girls' hair, catching down the snoods on the back of the heads.

It was looking like this in my pink and grey dinosaur coat and rolled-up-to-the-knee quilted satin trousers that I made preparation for my first trip to conquer Australia and Japan, and as usual I had no idea how momentous this trip was going to be.

Above left, Penelope Tree modelling Butterfly no. 56

Above, Pat Cleveland modelling Butterfly no. 45

Top right, 'Bubble' dress (Butterfly no. 49)

Below right, Zandra at home. Specially commissioned Zandra Rhodes 'Button Flower' design ceramics by Carol McNicoll in foreground.

Far right, quilted kaftan (Butterfly no. 47)

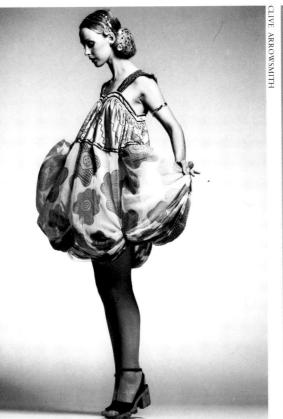

CLIVE ARROWSMITH

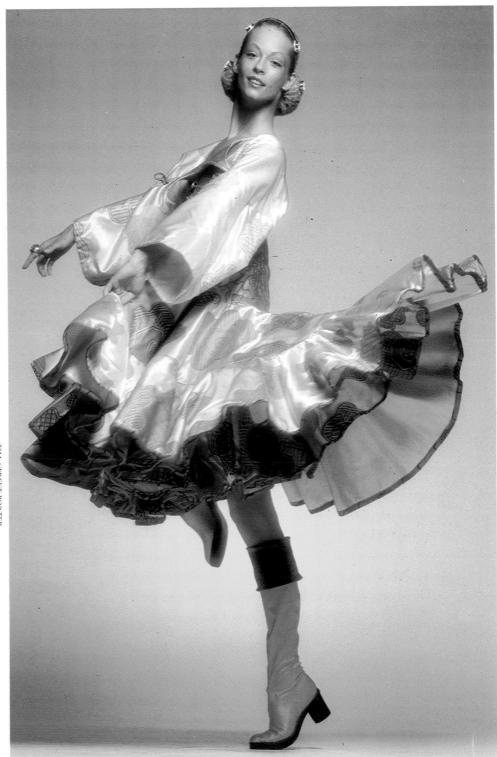

CLIVE ARROWSMITH

TIM STREET-PORTER

PHOTOGRAPH: BARRY LATEGAN MAKE-UP: BARBARA DALY

Photograph for 'Lily' poster, 1972 (Butterfly no. 59)

beautiful lilies beautiful lilies beautiful lilies beautiful lilies beautiful lilies beautiful lilies beautiful lilies beautiful lilies beautiful lilies beautiful lilies
a field of lilies a field of lilies a field of lilies a field of lilies a field of lilies a field of lilies a field of lilies a field of lilies a field of lilies a field of lilies
lilies and more lilies lilies and more lilies lilies and more lilies lilies and more lilies lilies and more lilies lilies and more lilies lilies and more lilies lilies and more lilies lilies and more lilies lilies and more lilies

Japan and Lovely Lilies

Japan came as a shock to me.

In January 1971, I had set off for a promotional tour of Australia at the invitation of Sekers, a huge textile company. I had been persuaded to stop over in Tokyo on my way back to England by Kansai Yamamoto, the dynamic Japanese dress designer, whom I had met in London earlier. He was full of fire and enthusiasm about my potential in Japan and had arranged for me to show my collection with Seibu, the Japanese Harrods. There were television appearances, press interviews, parties and a feeling of carnival. I was in the midst of this, surrounded by my post-Australian entourage of friends, gorgeous models and two hundred of my exotic chiffon dresses. Michael Chow, England's Chinese restaurateur personality was there, a knowledgeable guide and catalyst, and it was he who encouraged me to produce the poster which appears on page 90 and which became the first of a long series. Incidentally, it was then that I introduced him to his future wife, Tina, who was one of the models in my show. Alex came to Tokyo to join me then left almost immediately. Despite all that my friends had told me about Tokyo, I found myself utterly out of place and I was lonely. I was perplexed by so many things. The language was incomprehensible and I was frustrated at not being able to read all the signs and directions—I couldn't do anything on my own or find my way around Tokyo. The Japanese approach to business baffled me. When Kansai took me to his workroom and, with great pride, showed me perfect copies of my dresses from his current collection, I was bewildered and didn't know how to react. I didn't understand that it was a great compliment to my work.

Against that there was so much I admired. For example, the way merchandise was displayed in the stores and markets in such an incredibly precise manner was marvellous. The lacquer trays and lunch boxes, all fitting together and set in geometric design,

were a lesson in arrangement. The food in the shops and restaurants was presented so beautifully, often cut out like flowers and fans. Everything was a design. The paradox was always there. I was confused and hid in my hotel room, childlike and helpless, trapped by the urban intensity of the city.

In my loneliness, I took refuge in the friendship of a remarkable Japanese, Mr Kurisaki or 'Kurichan' (to his intimate friends) who was both nightclub owner and professional flower arranger. He spoke no English and I hadn't a word of Japanese so we could not understand each other, but when I met him in his nightclub, there was an instant bond of unspoken communication. On this and subsequent trips, we visited temples and exchanged gifts. He has been my key to the enigma of Japan and he opened my eyes to Japanese culture.

Zandra entertaining Kansai Yamamoto in her London home

On this visit, Kurichan became my muse in an extraordinary way. He was a man who surrounded himself with flowers and used them as a form of expression, which was something I could understand. It was he who sent beautiful lilies to my hotel room and these were the lilies I began to draw. It was this strange environment that made me turn in on myself and draw the things closest to me, familiar and loved flowers. The work that resulted was my most successful print of all. There in Tokyo, I started to sketch lilies, then fields of lilies, lily collars, lily petals around my ladies' faces and finally I added the words 'A Field of Lilies' and 'Lovely Lily Flower'. Now that I think back, lilies have always been popping up in my drawings. I found several very early ones in my boxes of memorabilia. Also, I remembered my mother's wedding photographs, with lilies all around her, even in her hair.

With this print, I wanted to use calligraphy. It was calligraphy that impressed me most about Japan. I had become mesmerised by the insistence of it, by the flashing notices, the posters and placards, the handwritten signs on the impeccable arrangements of fresh fish, vegetables and flowers in the markets. I particularly loved the corner shrines with their myriads of tiny messages. They seemed to be feathered with fluttering white words winging their way up to spirits. So it became natural for me to want to incorporate words with my image of Tokyo. I asked another friend, Mr Otsuka, to write the word 'Lilies' in Japanese for me to use, but it didn't work the way I wanted in the finished print.

Perhaps here it might be time to mention my special technique of working with designs, called intercutting,* where I continually cut and recut the paper, fitting it together. In this way I replace mistakes until the motifs are exactly where I want them. This does, however, mean the original design is sometimes very scruffy with peeling Sellotape. This is especially obvious with the original paper design of 'Reverse Lily' (below).

This lily chapter was one of the hardest to put together because during this early period of my career each print led me along a new and different path. Each path was a fresh adventure with its own set of problems. I find dress designing very difficult and there are many mistakes along the way to an original design.

**Intercutting* is a technique of cutting two pieces of paper (one directly on top of the other) at the same time so that the incorrect piece can be cut out, then lifted out, leaving a clean, exact-fitting replacement from the sheet that has been lying underneath. The design is then turned over and stuck edge to edge with Sellotape.

Asakasa market, Tokyo 'Kurichan'—Mr Kurisaki

Above, Zandra's parents' wedding photograph

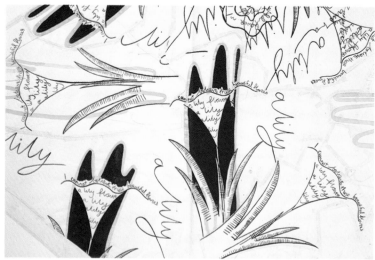

Above, paper design for 'A Beautiful Lily Flower'

A selection of lily sketches

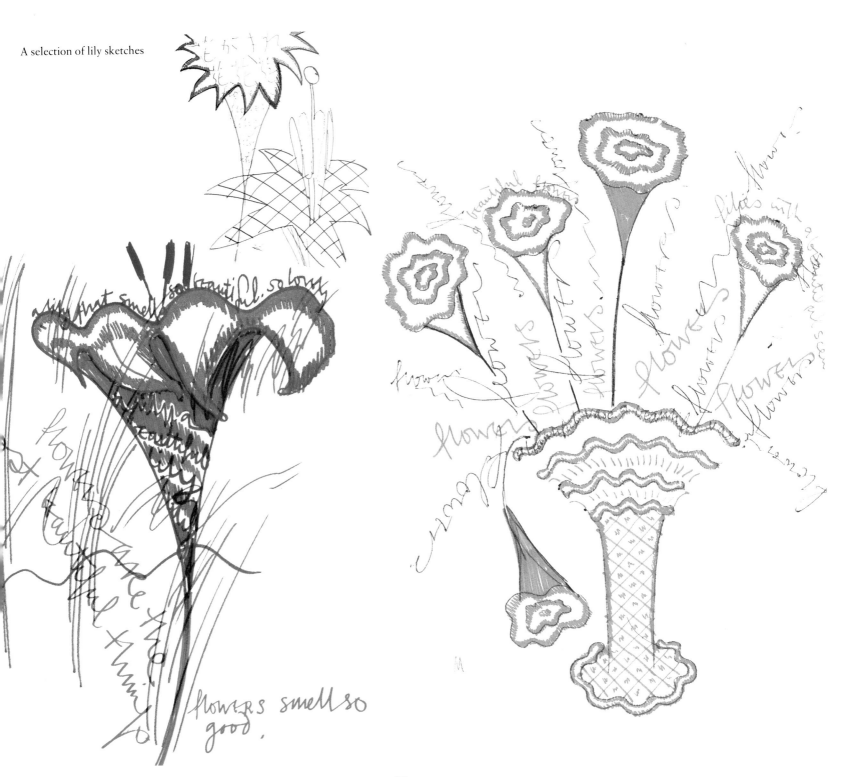

flowers smell so
good.

Some of the designs that don't work are essential to what is born later. 'Field of Lilies' and 'A Beautiful Lily Square' came first, and neither of them worked on my first garments, but I still felt it was a wonderful time for me. From 'A Beautiful Lily Square' I made square armholes and cuffs, and from 'Field of Lilies' I made an asymmetrical, draped, taffeta dress. Then the 'Field of Lilies' dresses started to work. I gave them contrast-lined lily collars, bodices and long glove details (see butterfly nos 59, 60, 61 and 64). The linings for the bodice and gloves were difficult to work out so I charted out on paper where I wanted the linings and glove tops to start, and that is how I arrived at the proportions of 'Reverse Lily'. So in doing all the research for this chapter I was forced to recollect the time difference, and reason for being, between 'Field of Lilies' and 'Reverse Lily'.

The Lily Prints are vital in two respects. First, I love them and feel they represent the best of my work. It is the original paper design 'Field of Lilies' that the Victoria and Albert Museum chose for their textile archives. Second, with the 'Reverse Lily Print', I developed a way of printing by turning the screen to reverse the print. It was a new technique which I have since used time and again, with great effect. So this design, by accident, provided a format for many other prints such as 'Lace Mountain' (pages 132 and 133), 'Cactus Volcano' (pages 148 and 149), and 'Scribble Turnaround' (pages 196 and 197), and others. All these designs are printed in the same way, although it is not a conventional formula.

The screen itself forms only half the pattern, but when reversed and printed again, it completes the whole motif. It would be impractical to use a single screen for a print of this size. The complication (or art) of this type of design is to create a mirrored image but not necessarily end up with an obvious join line through the centre. (Note that in all the designs quoted, I have disguised this join line.) A further interesting detail in the case of the Reverse Lily design is that the curve in this motif controls the shaping of the garment bodice and is the line to which the chiffon linings are attached (see butterfly no. 66). Different parts of the print remaining are used as collars, sleeves and hems. I work out all my own paper designs and repeats and check every detail myself. I think this is why my work retains its individuality and is so instantly recognisable.

Over page, three-colour 'Reverse Lily' print on silk chiffon. Screen repeat 35″ (88·9 cm.), total design repeat 70″ (117·8 cm.), width of fabric 45″ (114·3 cm.).

Right, three-colour 'Field of Lilies' print on silk chiffon. Design repeat 35″ (88·9 cm.), width of fabric 45″ (114·3 cm.).

Preliminary rough for 'Reverse Lily' made by cutting up screen prints of 'Knitted Circle' to form the arc of the lined bodice

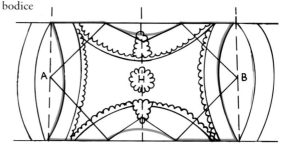

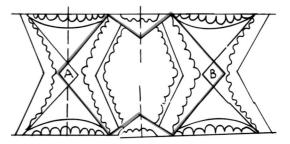

Diagrams showing a comparison between two totally different designs, 'Reverse Lily' and 'Lace Mountain', to illustrate how the same format can be used to achieve different results. 'Reverse Lily' (*over page*) is so called because the design when printed is reversed to complete the total repeat (A–B). The screen used for this design is only half of the whole motif (A–H).

Blue indicates one screen repeat.
Red shows how the bodices are cut within the pattern repeat.

Butterflies using this format in the 'Reverse Lily' print are nos 65, 66, 67 and 70 and in the 'Lace Mountain' print are nos 86, 88 and 90.

a lily

a field of lilies

beautiful lilies

grass

a field of lilies lots and lots of beautiful lilies, a field of lilies and yet more lilies lots and lots of lilies

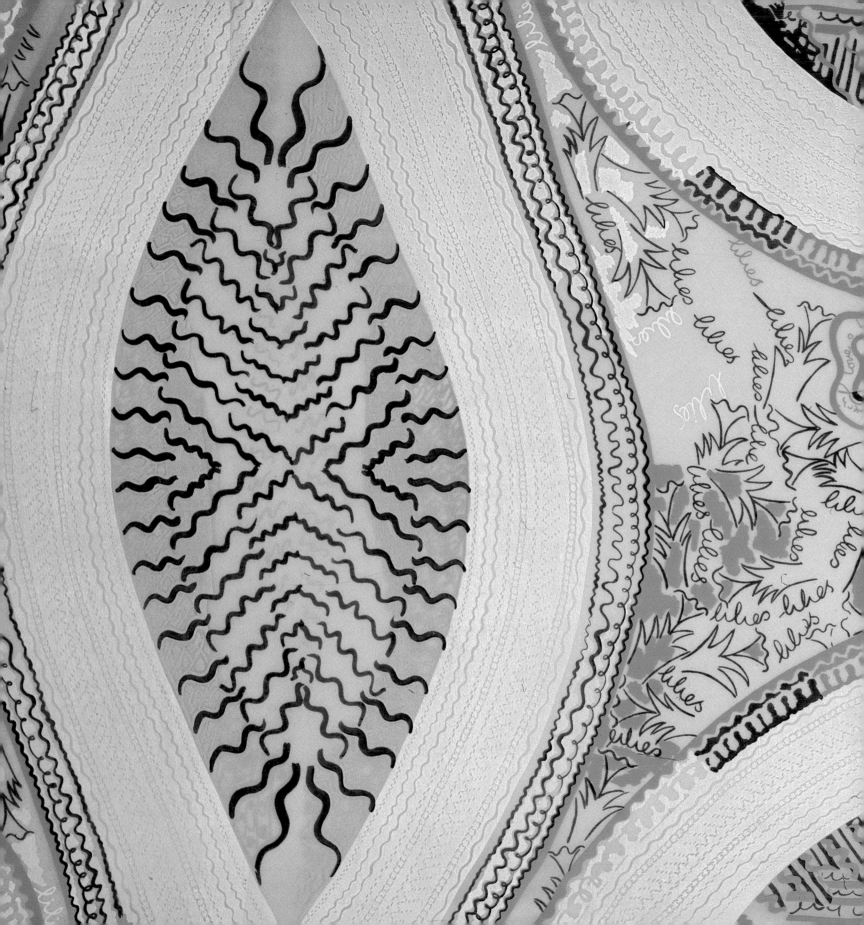

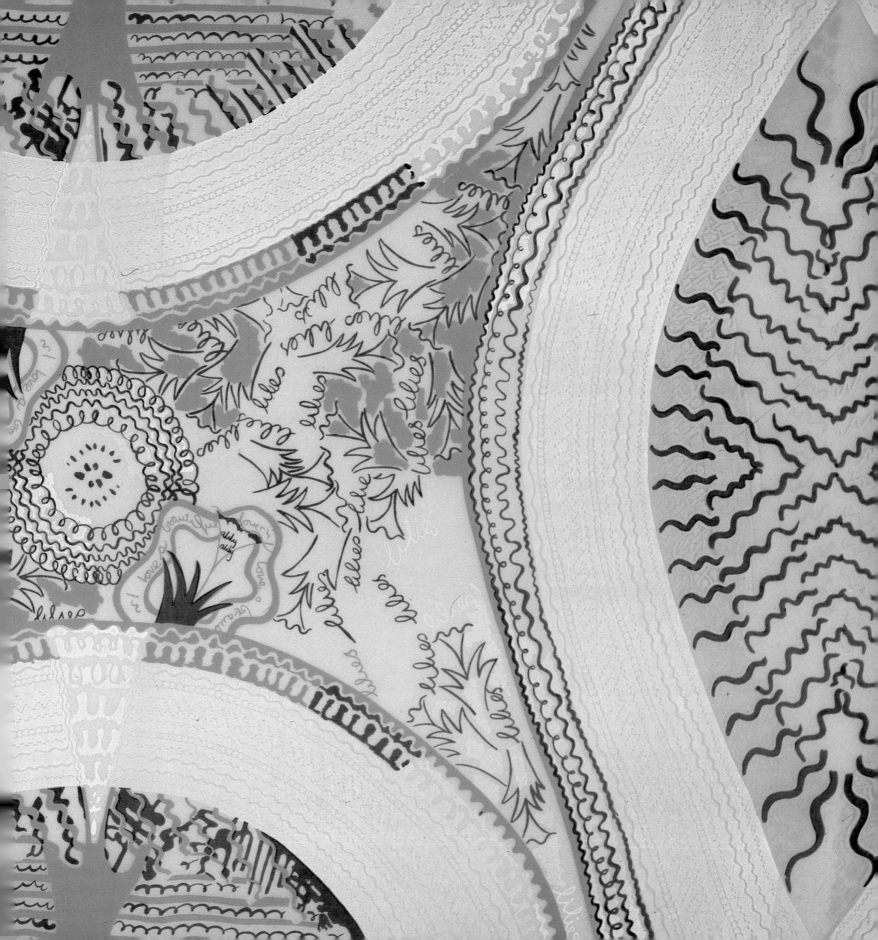

I had collected all those wonderful Paris broderie magazines in 1971 (see page 77) and had them on my studio wall as inspiration. I often have to wait until I can see how to develop an idea and also I am most particular that what I do must be a valid and original solution. Copying does not satisfy me. Some popular ready-to-wear companies in London had started to use embroidered fabric, so I tracked down the manufacturing company in Macclesfield and travelled north to see them. I looked through the endless reference books of A. W. Hewetson, Ltd and then I discovered that these machines could also make Guipure* lace—I could use all my motifs and words and link them together with these little bridges just like those on my studio walls! The time was right, so I designed a thick tactile, heavy, cream lace with lilies and the word 'lilies' captured in Schiffli† technique. Those brown magazine pages from the Paris fleamarket had had their effect.

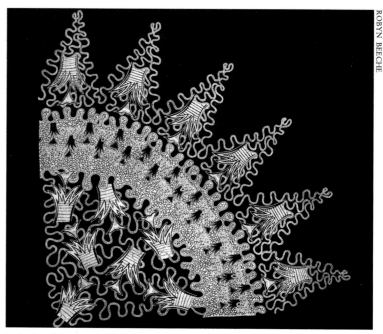

<div style="writing-mode: vertical-rl">ROBYN BEECHE</div>

Guipure was seventeenth-century tape lace, where straight tapes had to be bent, folded, or gathered to surround the floral designs. Later it became a lace where the motifs were held in position by a thick leg-work as opposed to fine net.

†*Schiffli* embroidery is named after a Swiss machine. The word actually means 'little boat', because the shuttle which goes into the machine looks exactly like a little boat with the top off. It was first invented in the late 1800s and consists of varying numbers of machine needles. It embroiders the fabric selvedge to selvedge, creating lace-type motifs by a sewing technique.

Schiffli guipure is a machine version of guipure lace and is made by embroidering thread (cotton or rayon) on to a really heavy-weight acetate. Care and attention is given to seeing that all stitches are properly fastened. The embroidered length of cloth is then dipped into an acetone bath and the acetate is eaten away, leaving a filigree lace.

Left, detail from *Paris Broderie* magazine

Top, preliminary sketches for lace

Above, design for a circular lace tablecloth

Opposite, far right, section of Schiffli 'Lily' lace as used in the wedding dress on p. 107

Opposite, right, section of Schiffli 'Signature and Lily' lace. The motifs are separated by cutting through the surrounding little bars, so making individual 'Signatures' and 'Lilies'.

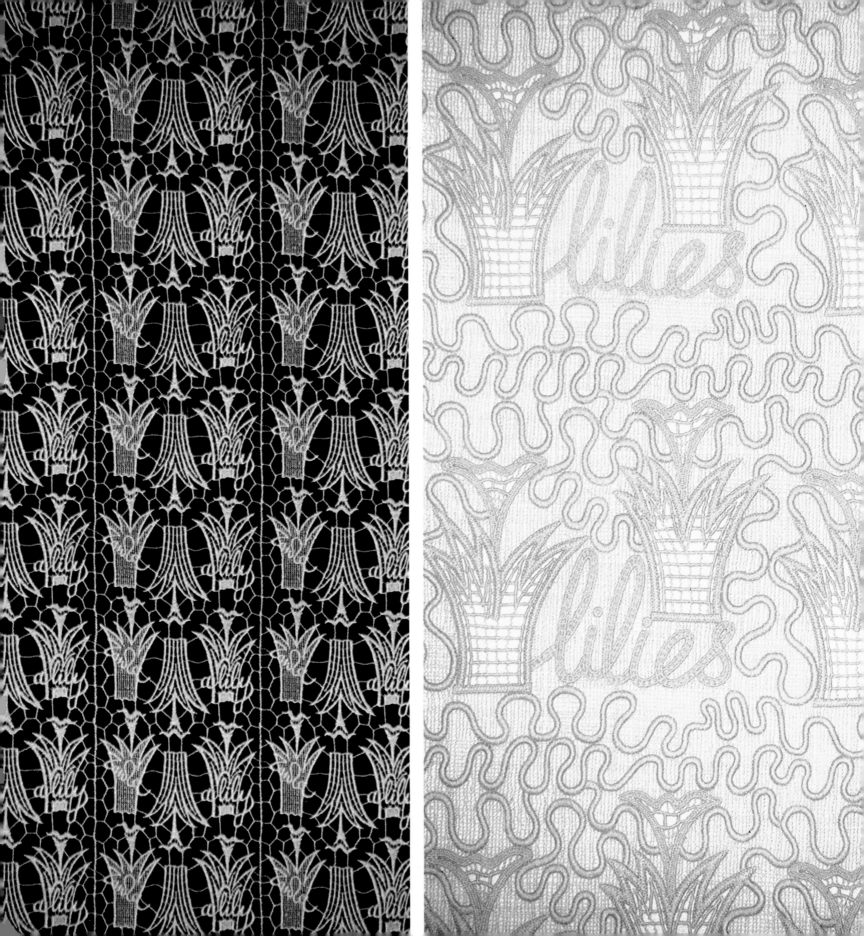

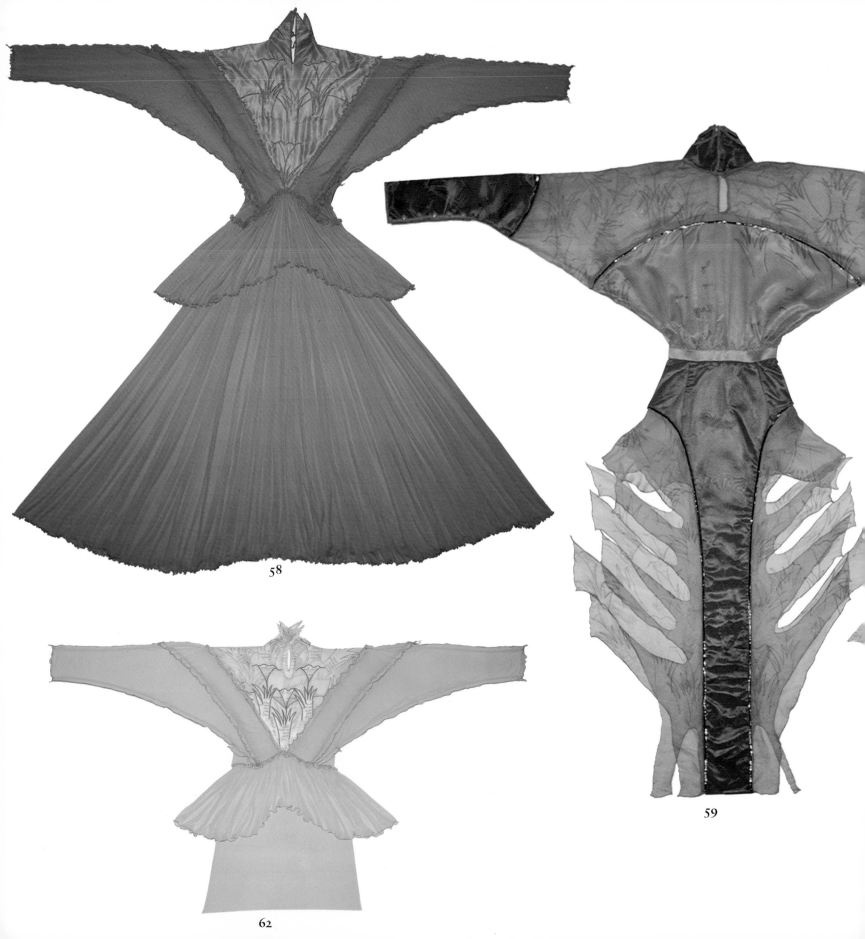

58

62

59

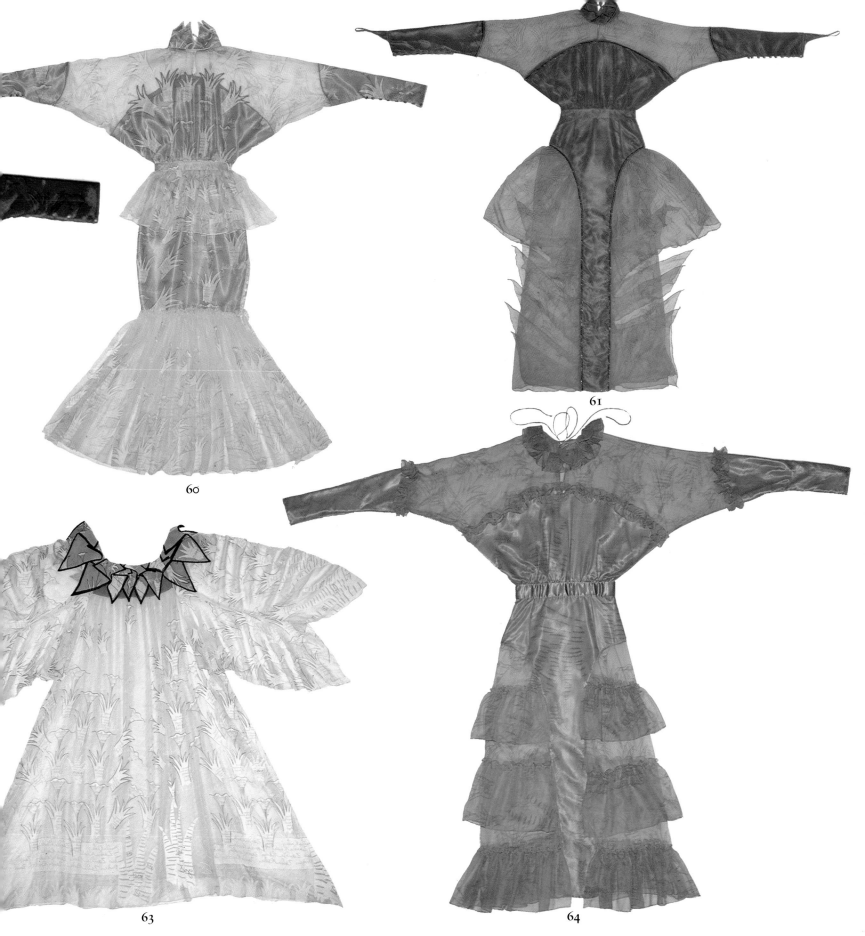

60

61

63

64

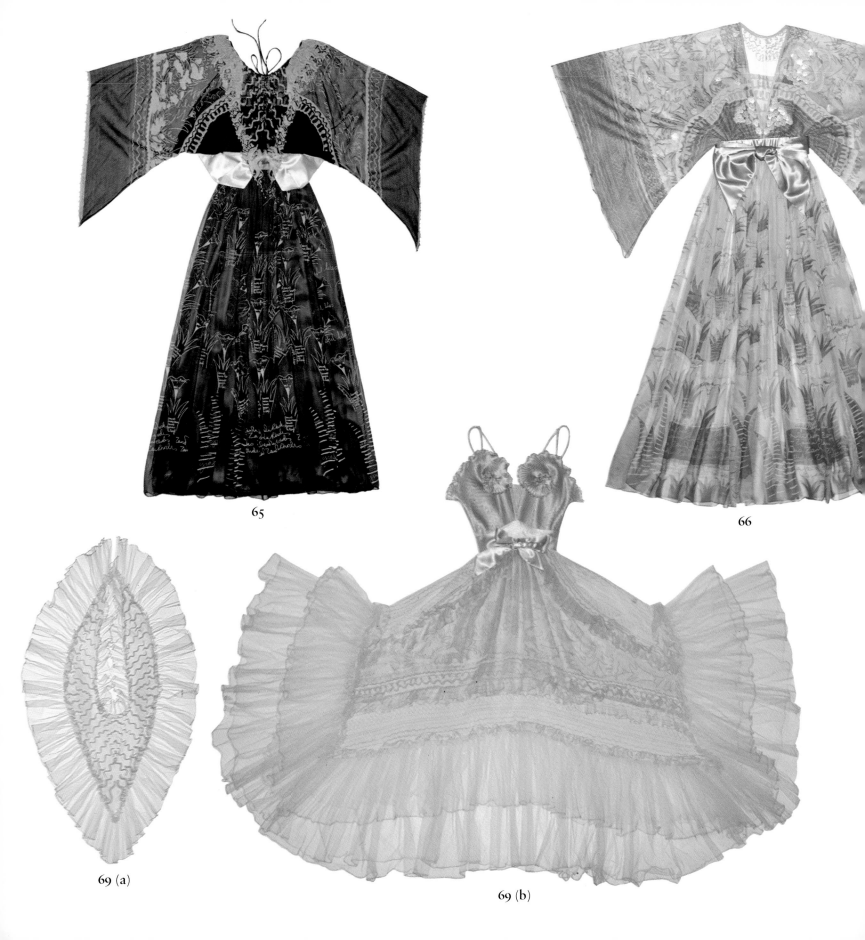

65

66

69 (a)

69 (b)

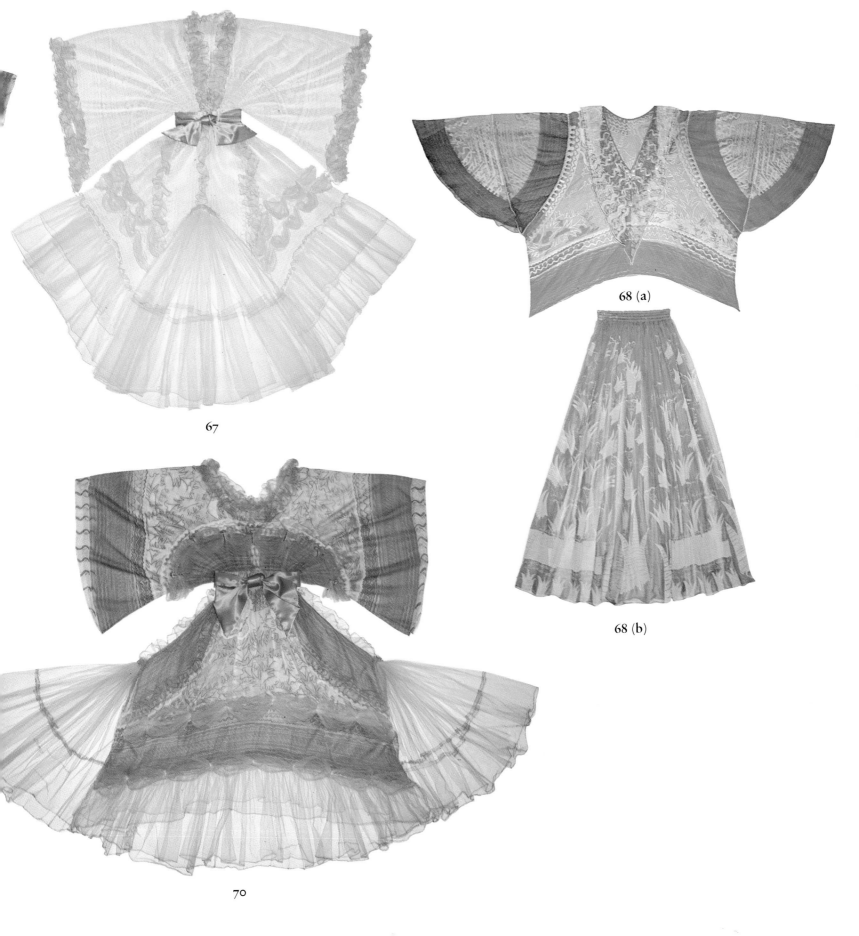

67

68 (a)

68 (b)

70

Also I should briefly mention here something else that I noticed when laying out these butterflies. It is here on the bodices of the 'Reverse Lily' dresses that I first started adding beads, which have now become such a trademark and feature (see Mexican chapter, and butterfly no. 114). I think in the far back of my mind I can dimly recollect either Bianca Jagger or Lauren Bacall asking for them, and this inspired me to start. Since then I have now researched and perfected the means to dye them any shade I need to match a print or accent a colourway.

Preliminary fashion drawings

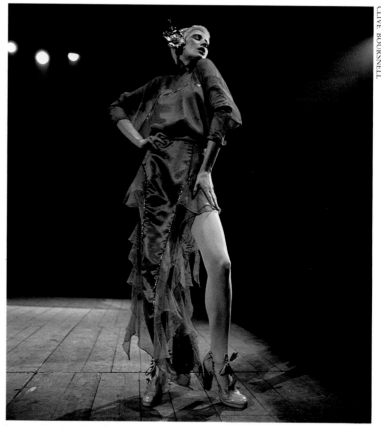

Renate Zatch in Zandra's Roundhouse Show, 1972 (Butterfly no. 59)

Below, Caterine Milinaire in the Roundhouse Show, 1972

Right, Pat Cleveland modelling Butterfly no. 70

HAROLD CHAPMAN

FRANCESCO SCAVULLO

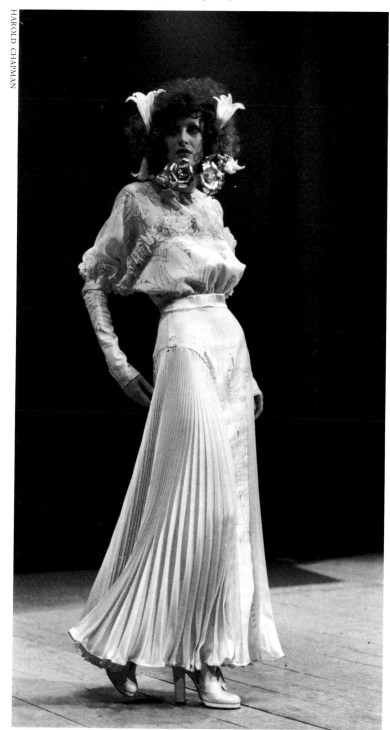

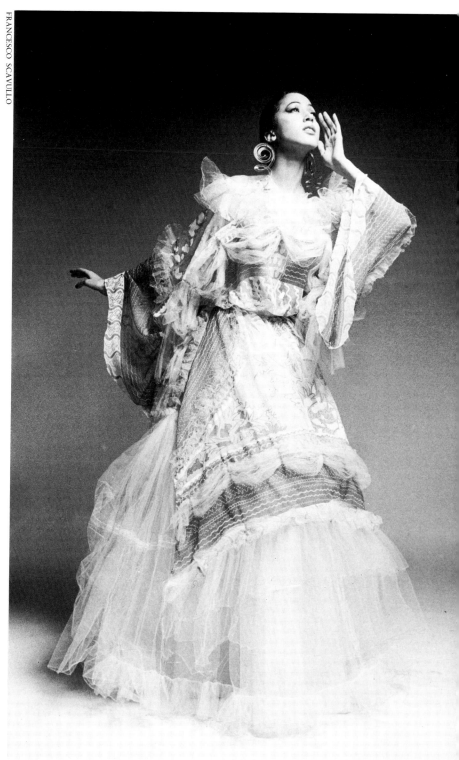

Top left, Twiggy on the cover of *Vogue*

Below left, photograph for *Harper's Bazaar* (Butterfly no. 67)

Below, Butterfly nos 68a and b

BARRY LATEGAN

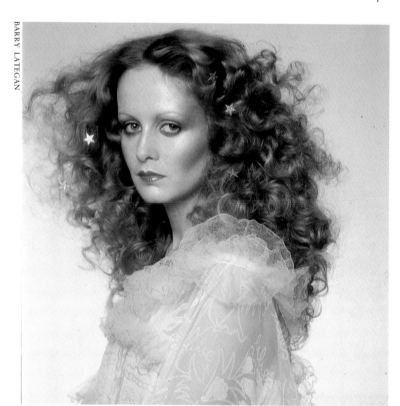

JEAN PIERRE ZACHARIASEN

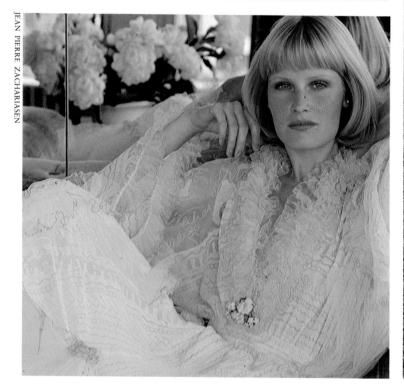

RICO PUHLMANN

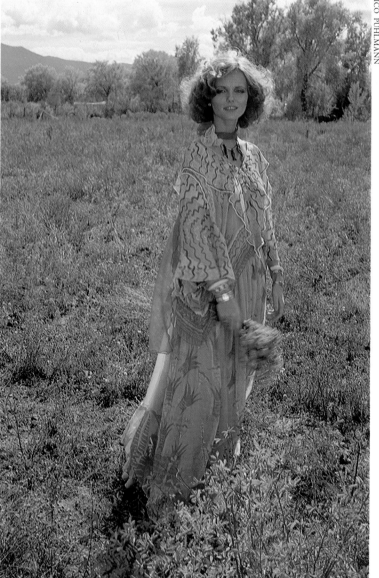

These lily prints and all their butterflies (on pages 100–1 and 102–3) had their great début at the Roundhouse Show—midnight 1972. Without knowing it at that time, I had collected together the most glittering international jet-set audience with stars from London, Paris and New York. Donna Jordan, the Warhol Superstar, was modelling and Bianca Jagger, at the very crescendo of her fame, added to the audience. As I mentioned before, Michael Chow had been my mentor and so the men in the audience had gifts of a lily bow-tie, and my first art-work poster was distributed all round London. (I forget if the ladies were given anything!) Afterwards David Bailey and Penelope Tree gave a party for me—but I can only remember being asleep through it with complete exhaustion (a habit which has disgraced me in so many people's books). The show was to Rio carnival music choreographed by Jacques Ross. It opened with the girls in special beaded masks and progressed to golden lily necklaces on tremblers by Mick Milligan rustling around their necks to even the slightest movement (page 104) (giving life to my fashion drawings of the ladies' faces surrounded by lilies). The finale of finales was Jacques waving a flag and escorting on Cathy Dahmen as the bride. Her skirt was like an inverted lily and her whole dress was made of thick Guipure lily lace.

The lily had now subtly crept into everything—it had become my trademark without my realising it—for example it crept into the Ayers Rock chapter in 'Lace Mountain' (pages 132 and 133). I have developed the lovely lily into many things in the home where Christopher Vane Percy and I have used it extensively, first as a print for curtains, where I reinterpreted the lily lace into print again. Then, using gilded brass, we developed this motif in metal to become door knobs and fingerplates, the bases of lamps and the edges of mirrors.

Here is an amusing anecdote to end my lily chapter. I was at a glamorous London ballet gala wearing the fabulous trembling lily necklace. I made a great entrance, but, during the Second Act, when the whole theatre was hushed and quiet, I fell asleep and embarrassed poor Christopher Vane Percy, who was escorting me, because the lilies rattled so loudly as my head fell over!

Right, wedding dress in Zandra's Roundhouse Show, 1972. Jacques Ross and Cathee Daymon as bride and groom.

PHOTOGRAPH: CLIVE ARROWSMITH HAIR: LEONARD MAKE-UP: BARBARA DALY

Photograph for 'Shell' poster, 1973 (version of Butterfly no. 72)

Woodstock and Shell Basket and Many Friends

By 1972 New York was a second home to me, as I was visiting it at least twice a year to show my collections, meet customers and arrange promotions, and generally stimulate interest in me and my designs. Many of the people I had met were, by now, close friends and I enjoyed them tremendously. Donna Malcé and Jo Lombardo had set up house together near Woodstock, in High Falls, up-State New York, and on Friday evenings I would hurry to New York's Port Authority and take one of the 'Adirondack Trailways' buses to their picturesque Colonial-style whiteboard house, complete with green painted shutters and veranda and eaves carved as if out of icing sugar.

Tradition stopped at the front door. The interior of the house was a riot of invention. Jo had laid one wallpaper on top of another, taking a rich magnolia paper as a base; he had used printed borders to fill frames around the doors and windows. He had cut out birds, feathers and flowers from other papers to make a composite design around the fireplace, light fittings or archways, sometimes adding rhinestones to the flower heads so that they glistened and glittered in the light. All the floors were hand-stencilled, painted with geometric or flower designs, even leopard spots. The furniture was covered with flamboyant flower prints and scattered with primitive American Indian cushions and quilts. Jo changed everything that came into his hands, decorated the most unlikely objects, turning them into art, transforming even a motley collection of broken china into opulent mantel-mirrors and jardinières.

I thrived in his and Donna's company and was enormously excited and inspired by them and their surroundings. It was in the kind of atmosphere they created that I could be open to inspirations and hunt for things that might inspire me or generally take me out of myself. Spending these whole week-ends within a riot of someone else's design world, and talking about

Above, the living room of Donna Malcé and Jo Lombardo

Right, the shell-covered basket

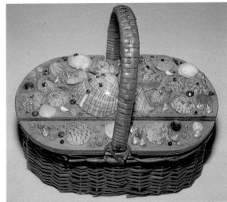

design all the time, was almost like going on a purging seminar. We would exchange ideas in a way which was rare and vital and which I am not able to do easily with many people.

The three of us had some great adventures. I had time in those days to drive in the country in the fresh green of early spring, the golden days of summer, in September when the trees wore a glaze of autumn colour and again in October when the roads would be lined with pumpkins for Hallowe'en. We had time to go antique hunting. That to me is an art in itself—finding odd objects and knowing when to buy and what to ignore. Jo and Donna were masters—I am no good at it except when I do it with them. One week-end, we went to a garage sale in the neighbourhood of their house, and I found a shell-covered wicker basket which I liked. We took it home and Jo decorated it for me by adding more shells and glittering jewels. Sketching that basket started me off on drawing shells.

Only then, reawakened to shells, I remembered seeing shell gardens in Jaywick Sands near Clacton with Tim Street-Porter, and also doorways in France which were shell-covered; both of these I had in slide reference and held in my memory bank. Also there were all the masses of exotic shell necklaces I had in my own wardrobe.

Sometimes when I am in that painful no-man's land of creating a collection out of seemingly thin air, I find it very difficult to work alone. I find I can only impose the discipline of work on myself by being with friends.

Back in London I spent a lot of evenings doodling at the home of Lorna and Stan Woodward. Stan and Alex worked together as television set designers, and Lorna had taught with my mother. Stan would patiently get out his film books as inspiration to me when I said I was stuck and Lorna would be getting on with her sewing. Their daughters, Sally and Lucy, were only seven or eight at the time and would help me with my drawings and sketches. I welcomed their child-like vision of shells in the drawings they did for me. I myself did lots and lots of shell sketches trying out different formats on paper. I found a strange bric-a-brac pattern on a 1930s bias scarf in my wardrobe which was just right for a background to the main shells—it had just the right seaweedy quality. I grouped the shells together in interesting clumps, so small motifs were in fact building a much greater over-all pattern. I designed a shell picture frame on paper, then cut that up and made 'Zig-Zag Shell'. Working on a format of a circle I drew a spiral of shells with the idea in the back of my mind that I would cut round the diminishing spiral and end up with some

magical snakelike shape; but when I eventually did this the results looked like shapeless rags.

I kept working away with the 'Shell Spiral' design and printed it on different fabrics. Eventually I came up with my first quilted satin jacket, using the complete design exactly and following the design curves to make the under-arm shape. The join between the two circles made a wonderful centre back (see butterfly no. 71a and b). I repeated the technique in my kaftan dress, using the same joining of the two circle spirals as the centre front of the garment. Each print dictates by its shape the way I cut and make it and there are usually complex problems to be solved.

After 'Shell Spiral' and 'Chevron Shell' (Zig-Zag Shell) came 'Shell Tablecloth', which, as the name says, was a print made for my table-linen. In 'Shell Tablecloth' the diagonal seaweed design became the border and for the centre I called again on my wiggles and created 'Wiggle & Shell'. This design I then also printed on chiffon and cut round the scalloped line of the shells to make 'Shell Stole'.

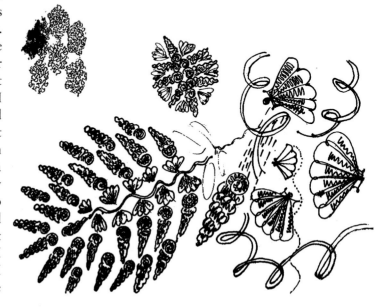

Left and top right, preliminary
'Shell' sketches

Far right, three-colour printed
'Shell' tablecloth on cotton. Size
43 × 81″ (110 × 206 cm.).

Over page, three-colour 'Shell
Spiral' print on satin. Design
repeat 43″ (109·2 cm.), width of
fabric 48″ (121·9 cm.).

Below, Lucy's shell sketch

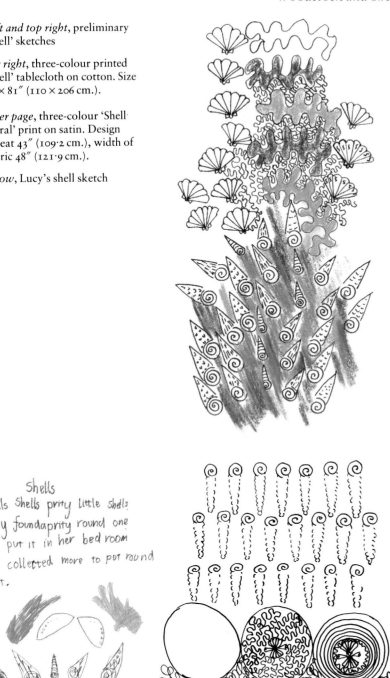

Shells
Shells Shells prity little shells
Mary foundaprity round one
she put it in her bed room
And collected more to pot round
it.

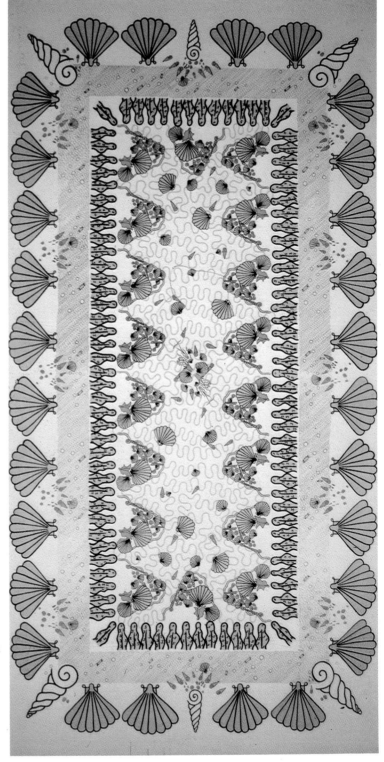

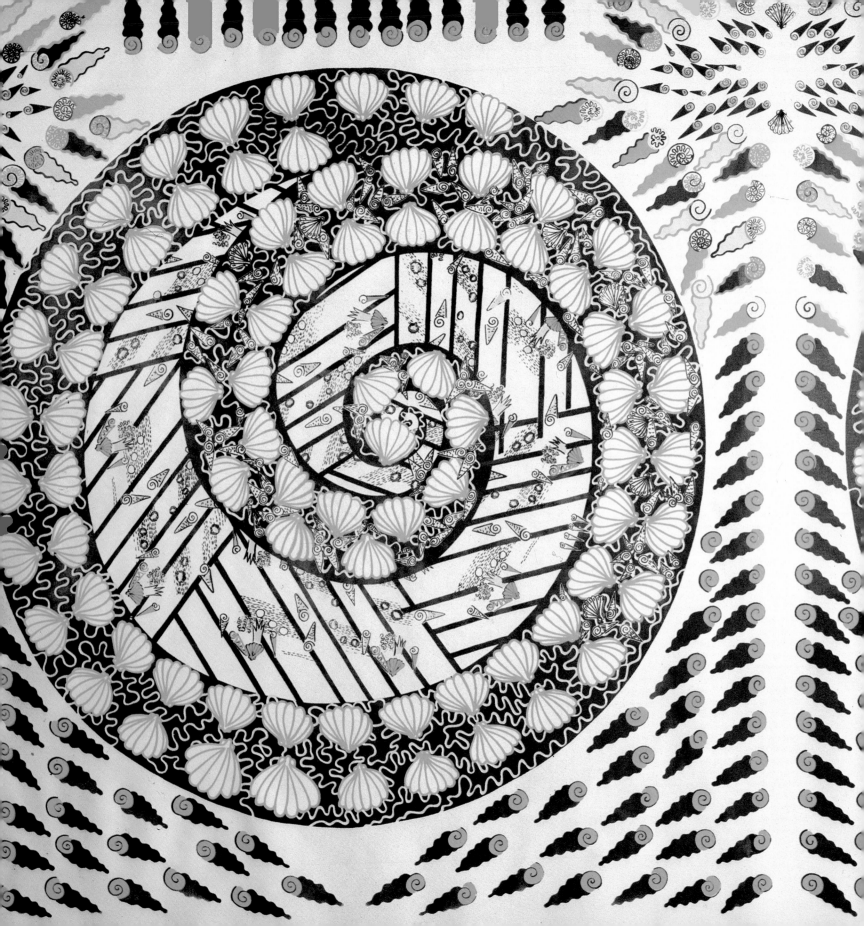

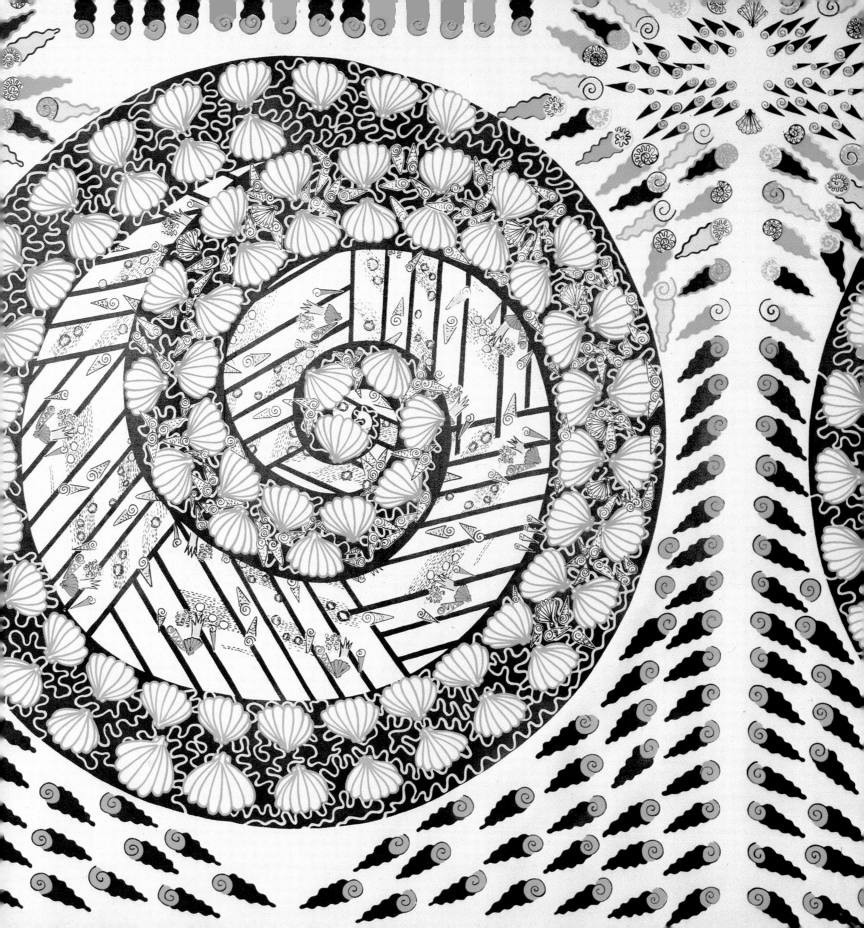

Two versions of 'Zig-zag Shell' print on silk chiffon:
(a) using one screen only.
(b) using the original four screens.
This illustrates clearly how a print can be changed by leaving out different
screens. Design repeat 36″ (91·4 cm.), width of fabric 45″ (114·3 cm.).

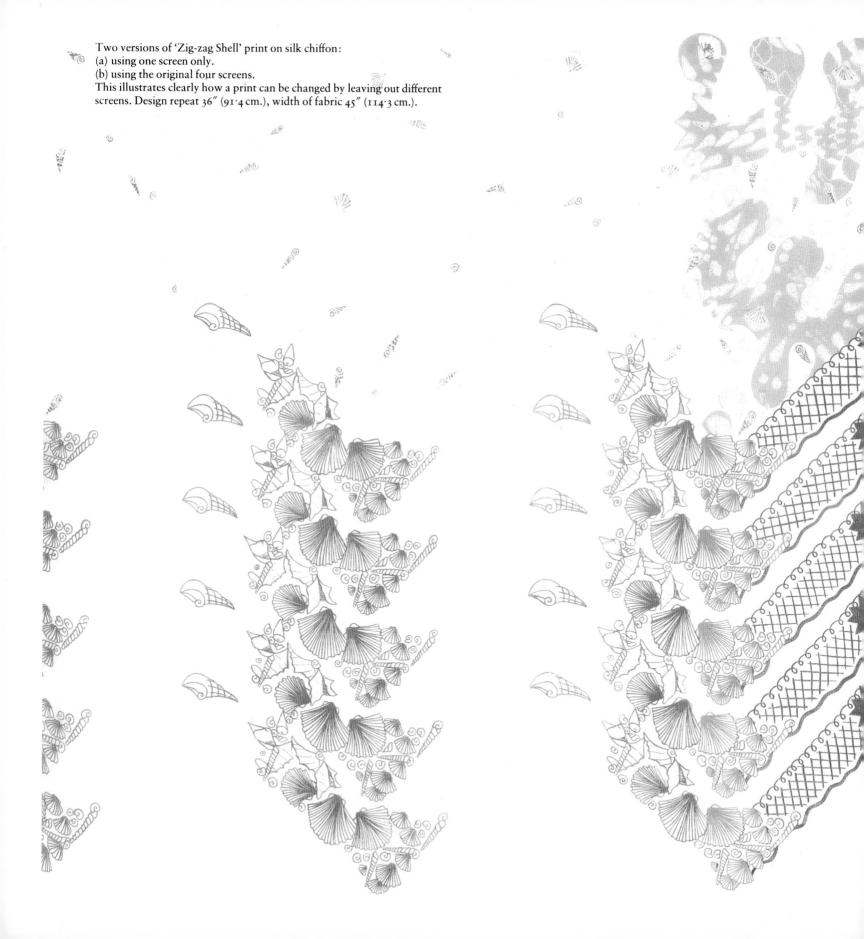

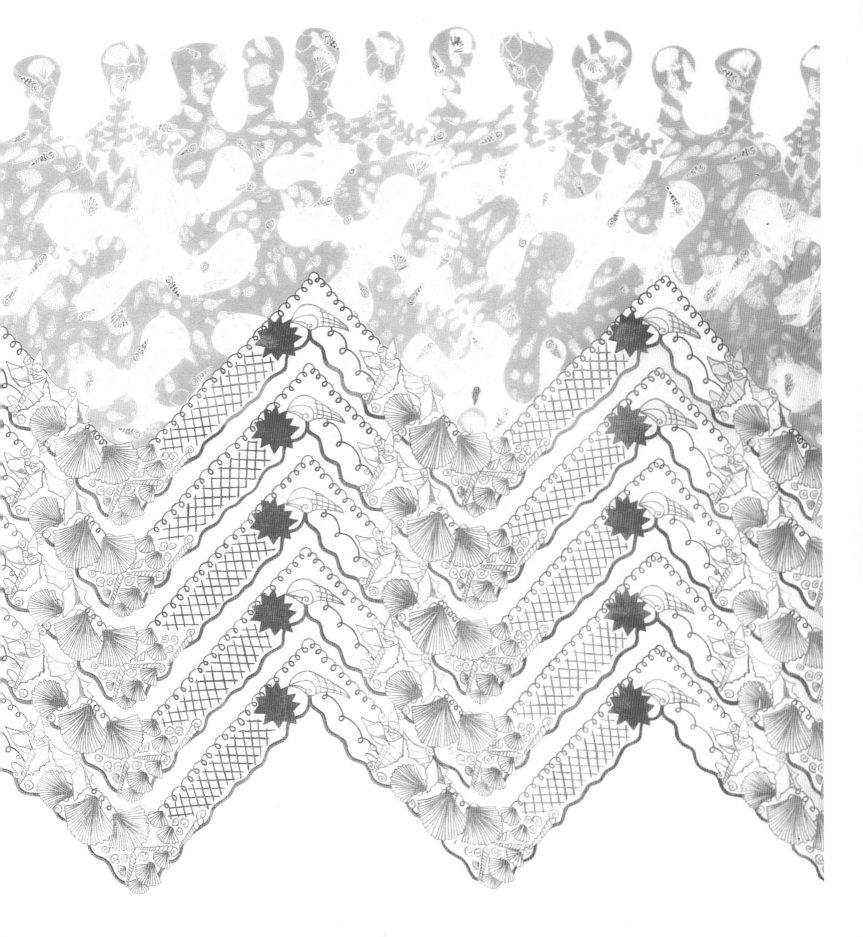

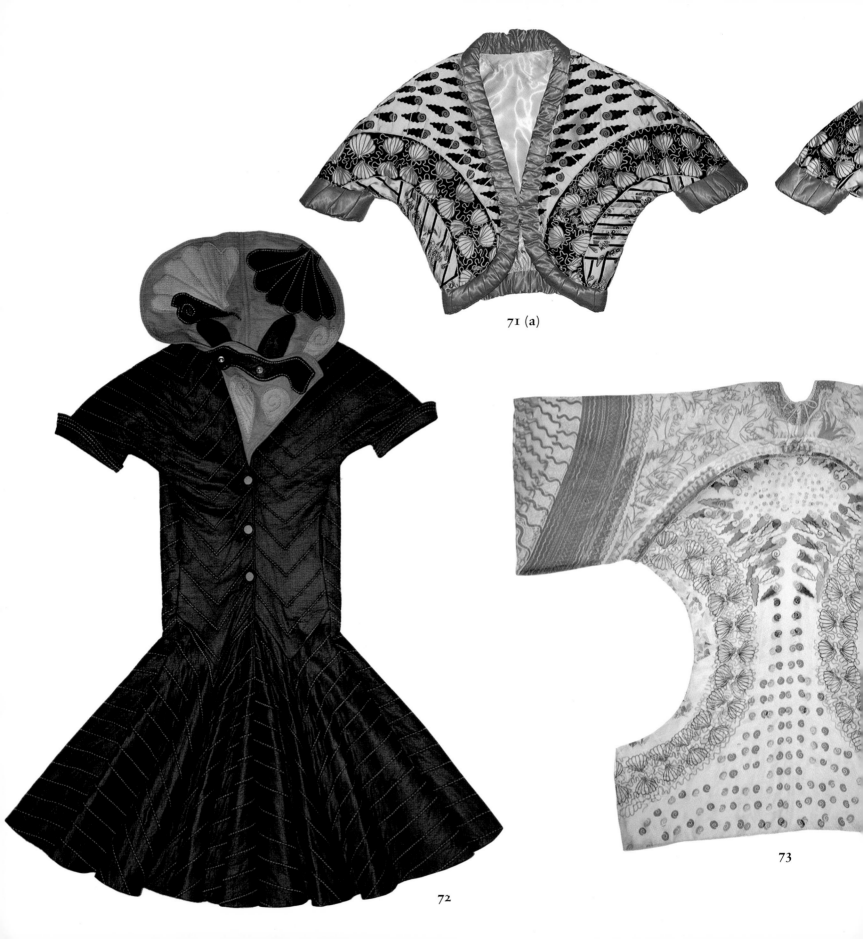

71 (a)

72

73

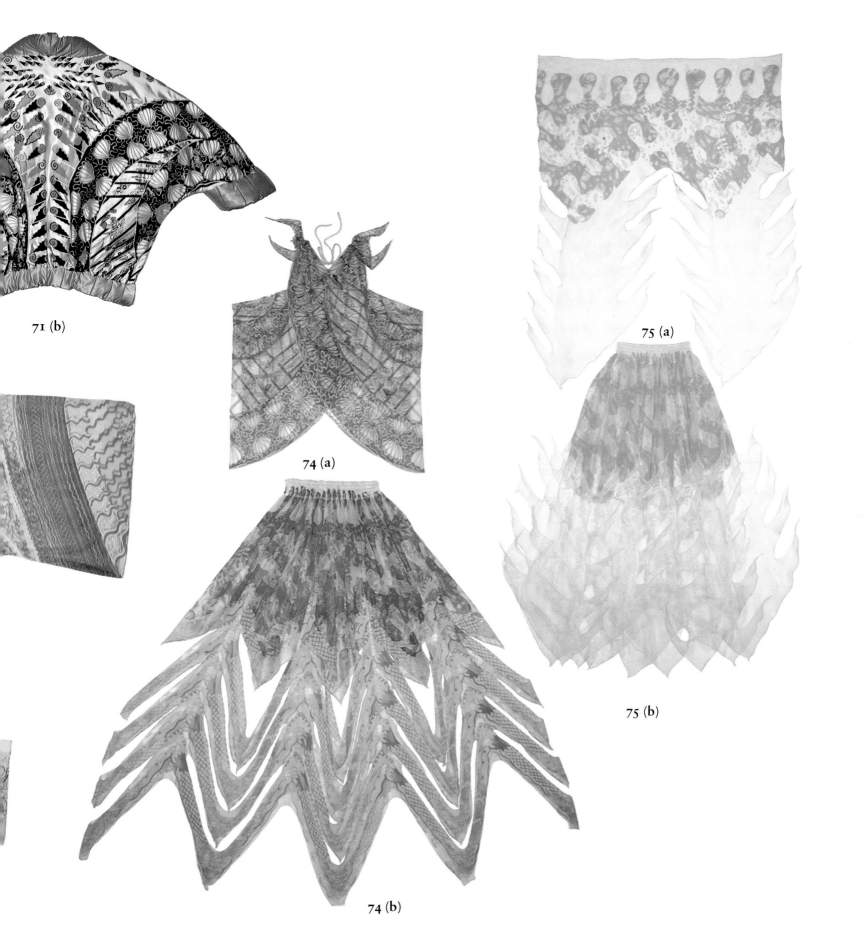

71 (b)

74 (a)

74 (b)

75 (a)

75 (b)

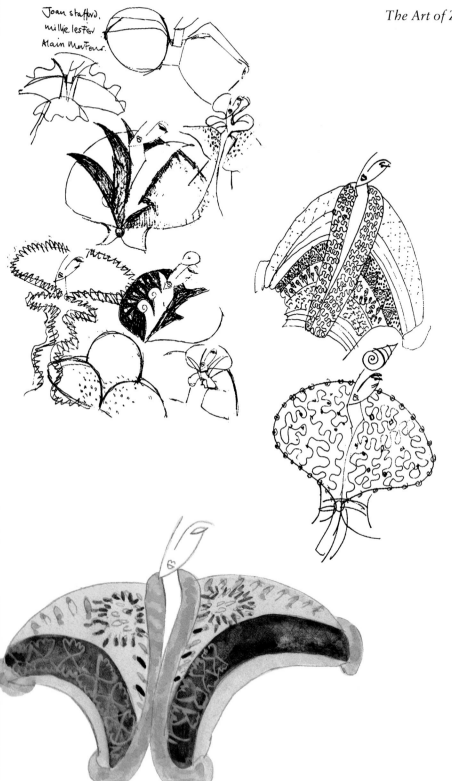

Apart from my shell prints in 1972–3, I started to work on a series of felt coats. The last coat I had worked on had been the zig-zag toothed dinosaur coat. Now I started to develop flared mermaid shapes with quilted felt and appliquéd shells and huge, structured, shell-shaped coat collars. These coats were much more sculptured than anything I had done before, perhaps as a result of my having been in Italy to present a collection with Karl Lagerfeld. We had talked a lot about French couture, and the formal control methods they used. This prompted me to make these collars with special boning to maintain the curves and keep them standing up in position.

With the wide collars and flared tails, I developed tiny pill-box hats. Some of the more exotic ones were embroidered by Tina Chow, who had become one of my most loved models. Tina (my mannequin from the Japanese Lily chapter) had left Tokyo to come to London and marry Michael Chow and I felt very involved as I had been the cause of their meeting in the first place. Tina beaded the shell hat especially for me (see page 119).

I launched this seashell show at the Savoy with a shocking pink set of stairs stretching right back Busby Berkeley style. The tableau formed with the pink and black coats was absolutely magnificent. The room was complete fairyland. Adel Rootstein mannequins with beaded face masks sat in the centres of all the tables in a décor especially worked out for me by Richard Holley, so that the room and the show combined to create a spectacular evening.

My coup of this year, however, was my first show in New York at the Circle in the Square, initiated again by two more friends, Maxine and Gary Smith, who, after seeing the Round House show, insisted I should do it in New York. They helped me make the necessary arrangements. So many amazing people came—but I didn't know that then and New York had never seen anything like it. One V.I.P. there was top American designer Bill Blass, who then insisted to Miss Martha, the grand-dame of the U.S. couture retailing industry, that she should order my dresses for her shops.

Above left, ideas for jackets and coats

Below left, sketch for quilted 'Shell Spiral' jacket (Butterfly nos 71a and b)

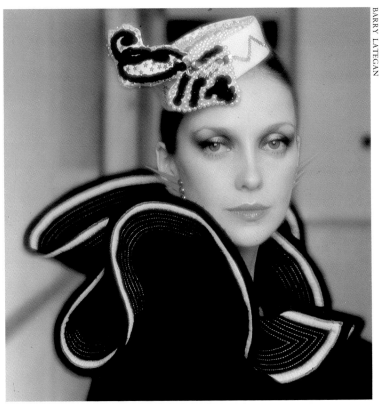

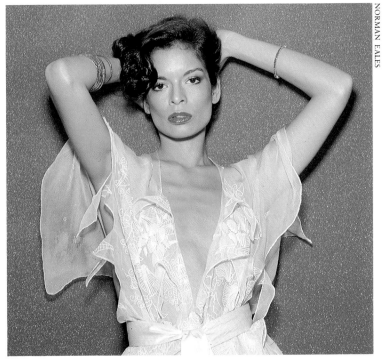

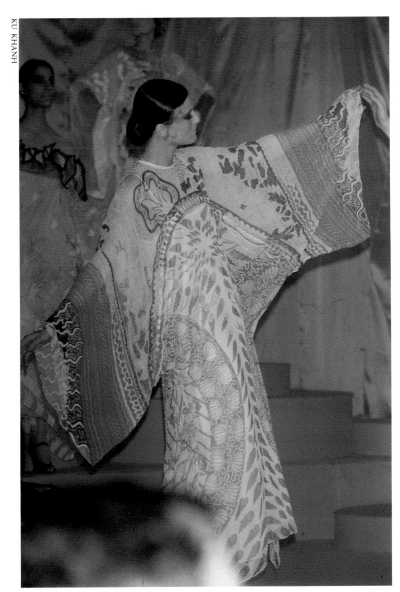

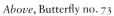

Above, Butterfly no. 73

Above right, *Vogue* cover showing fluted shell-shaped collar and beaded pillbox hat

Below right, Bianca Jagger modelling Butterfly nos 75a and b

The shell-prints did have a dream-like quality of their own and one of the most important developments in my work was when I designed the shell lace embroidery using the Schiffli technique on tulle. I used this for the romantic shell bride in the collection the same season. As a wonderful fairy-tale ending, Princess Anne wore this lace bridal dress for her official engagement photographs by Norman Parkinson.

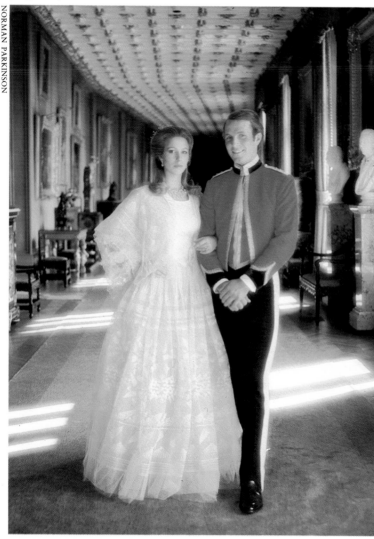

Above, Princess Anne's official engagement photograph

Right, two-colour embroidered Schiffli 'Shell' lace on Terylene net. As shown in the diagram, the repeat lines in the stitching, every two large shells, demonstrate clearly that this lace is done by machine. All needles start in position A and work their way down the fabric from selvedge to selvedge via B to C. Threads are not continuous throughout the fabric because they are cut away after completion.

120

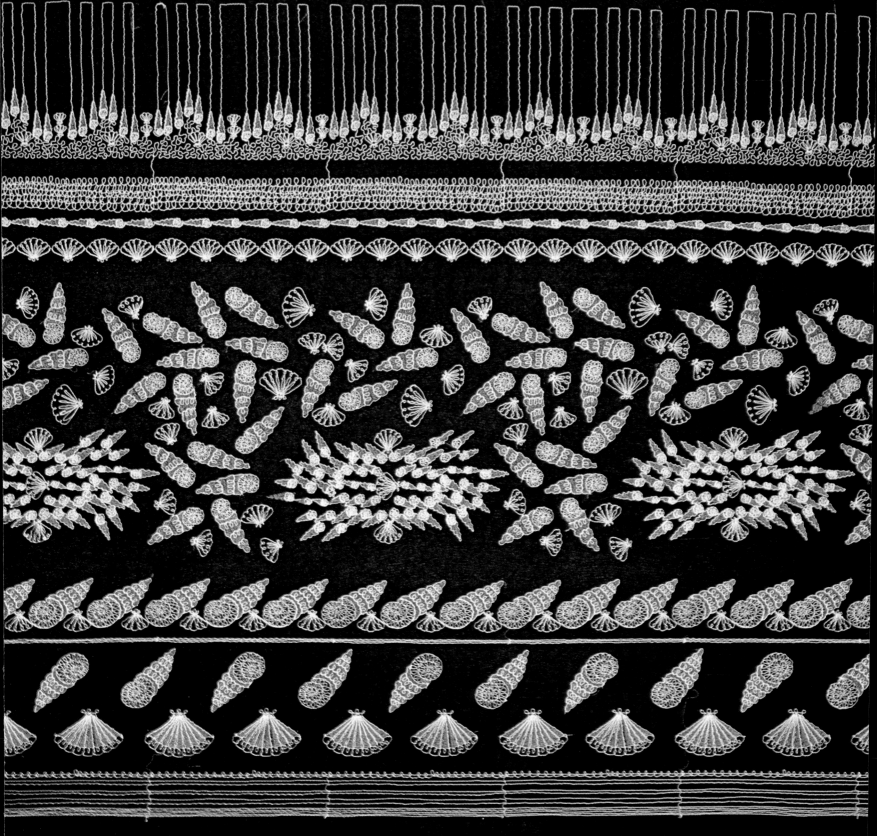

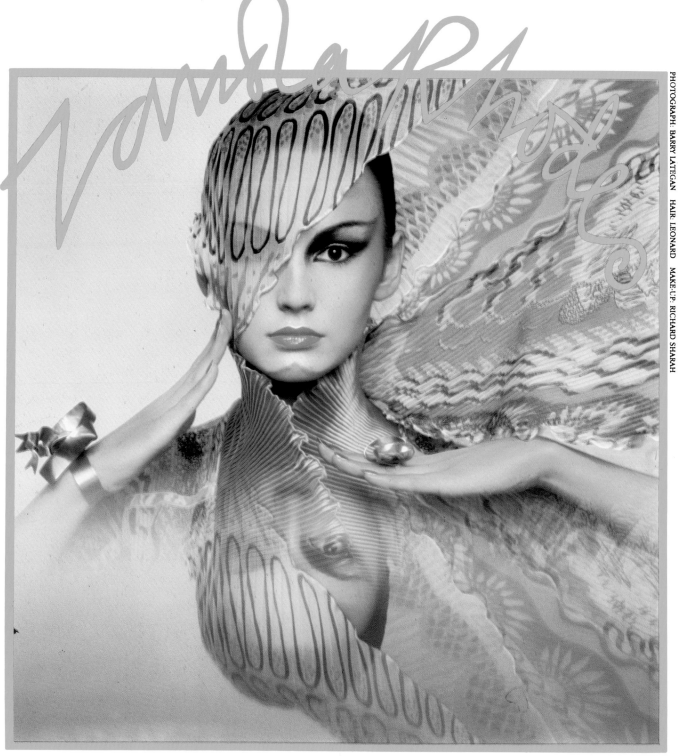

PHOTOGRAPH: BARRY LATEGAN HAIR: LEONARD MAKE-UP: RICHARD SHARAH

Photograph for 'Ayers Rock' poster, 1975

Australia and Ayers Rock

Before I went to Australia for the Sekers promotion in 1971, it had never been top of my list of countries I most wanted to visit. I hadn't had any real urge to go there; it just was not on my mind. Once there I fell in love with the atmosphere—it was young and energetic and there was so much activity, with everything moving at such speed. I found the Australians so open and friendly, whenever I made personal appearances in stores or on television and radio (and they were frequent) I was made to feel a star. It seemed people were hanging on my every word. They applauded my fashion shows. I had more invitations than I could possibly accept in any one evening. It was all so different from home, a wonderful charge to my ego. Also if you stay in a city like Sydney, which has a comparatively small population, you do get to meet everybody who is in town—not only the people working there, but all the visiting celebrities too. I remember Margot Fonteyn and Freddie Ashton were there on tour as were 'Pink Floyd' and we got together almost at once, when I would never have had the chance of an introduction to them in London.

It was my first meeting with Grant Mudford, the Australian urban landscape photographer, now working in America, who was to become for many years the closest person to me and a motivating force in my life. Martin Sharp, painter/cartoonist, had his exhibition at the Yellow House at this time and this was a great inspiration to me (see opposite). Previously he had come to London and achieved notoriety as the co-founder of *Oz* magazine. He stayed with me later in London, becoming a good friend. He did the staircase murals in my house and later designed the set for my Ayers Rock Show in 1974. His girlfriend, 'Little Nell', star of 'The Rocky Horror Show', starred for me in my shows and we worked out special dancing numbers together. The Australian film industry was only just starting up then and I found all those people very alive and creative and got a great spin-off from their way of thinking.

The whole trip was a marvellous experience in itself and very inspirational but, as so often happens in my life, its direct influence on my work came afterwards. It was the springboard to Ayers Rock.

Martin Sharp exhibition at the Yellow House, Sydney

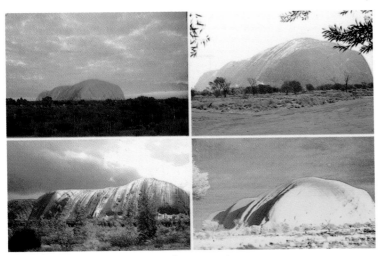

Postcard showing different views of Ayers Rock

At the back of my mind I was being deeply impressed by the dozens of postcards of the Rock, which were on all the racks in the bookstalls and kiosks. These postcards fascinated me and I kept asking people about THE ROCK, it was all colours of the rainbow—floating there—almost like a stone cloud above a grass landscape. I didn't get much response—the Australians I spoke to seemed to regard it with little interest and were surprised I wanted to see it. They thought there were other more exciting places to visit—Fiji, for example. It was very much like a visitor to England wanting to visit Stonehenge and my saying, 'Oh you don't want to see that—why don't you go to the South of France.' I wouldn't actually, but that was typical of their reaction. Nevertheless Ayers Rock was always there with me. Grant had taken terrific photographs of it too, works of art. He was very enthusiastic. I wanted to see it. I was determined that one day I would

Australia became my new love and in the summer of 1973 I was invited to design a collection for the young people who owned the Daily Planet (a ready-to-wear operation). So I went back to Sydney, back to the same wonderful warm reception—invitations to parties—please appear on television—do give interviews for magazines, newspapers, radio. This time I knew, no matter what, I was going to Ayers Rock.

I had persuaded my new boyfriend, Barry Zaid (a Canadian graphic artist working in New York) to fly out from New York to meet me. We took a plane from Sydney to Adelaide and from there to Alice Springs, where we hired a four-wheel-drive Toyota truck, and headed across the Outback for the very centre of Australia.

The Rock is about 200 miles from Alice Springs and for most of the way we were driving over unmade roads across Aborigine country. We passed flocks of fluorescent pink and grey galah birds, flamboyant in their gorgeous plumage, living free—and then in stark contrast, old-car dumps, grey, the cast-off material of twentieth-century society. It was a no-man's land. The desert was wonderful—the colour incredible—an endless vista of red earth fading into a misty blue horizon, punctuated all the way by these amazing stretches of spinifex grass, sprouting like big pin-cushions, sparse tufts which seemed to be etched into the sand with almost perfect symmetry. Red dust was everywhere—we were covered with it, our clothes, our hair, on our skin and eyelashes, even in my camera which I carried in a plastic bag. The soundlessness of the desert was something I'd never experienced—and always there was the mysterious light, part red, part blue. We stopped only to look, to draw, to photograph.

Then there it was—The Rock, Ayers Rock. Nothing I had seen, nothing I had been told, nothing I had imagined had been powerful enough. I was not prepared for the total impact of this monolith, held sacred and named by the Aborigines the great 'Ulura', reflecting light in an unearthly way, always changing. I wanted to experience its power, I wanted to be part of it. I wanted to draw it again and again in all its aspects, in all its colours.

Barry and I stayed in one of the three primitive prefab hotels where you could have a bed and breakfast and, along with coachloads of tourists, have a sort of school-dinner type evening meal. The day ended at 11 p.m. when the generator was switched off. Most people got up at four o'clock in the morning to see the sunrise. It was so freezing cold I wore my rainbow fur coat, but in the middle of the day between three and four it was in the 80s so we could lie on the Rock sunbathing. Barry was into meditation and yoga so it suited him. We made our own meals, vegetarian, there was only one store and not much choice. We used to gather fine twigs to build a fire and cooked the food over it in tinfoil. We really did live on the Rock, our day starting with waiting for the dawn to break. We walked, climbed, explored, photographed and talked about it. Most of all we were drawing, both of us, all the time, from dawn until dark. Barry was right at the top of his profession in New York at Push Pin Studios* which was a

*Push Pin Studios: Top design studio agency founded by Milton Glaser and Seymour Chwast. Famous for many graphics, Milton's Bob Dylan Poster with the waving hair epitomises the 60s.

Opposite page, Ayers Rock sketchbook drawings

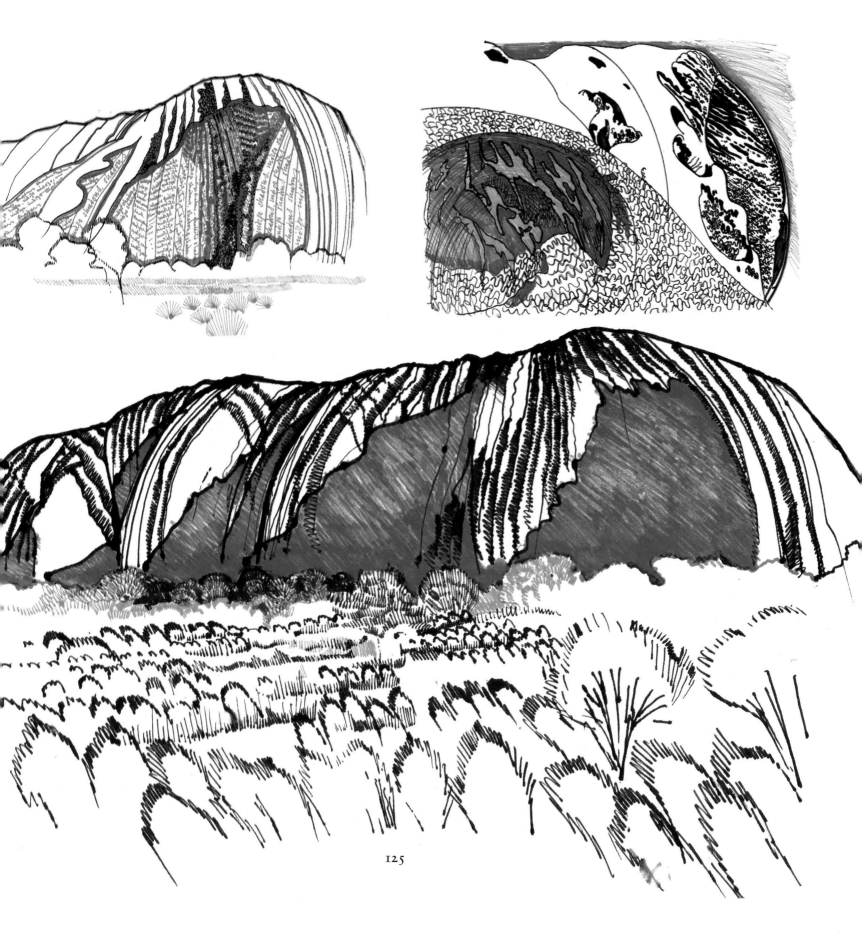

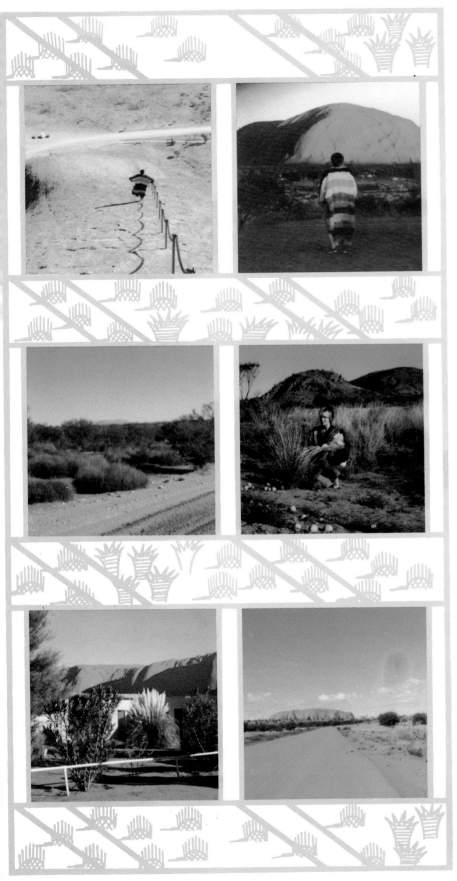

challenge to me, and there was definitely a feeling of competition between us, which spurred me on. I think some of the drawings of Ayers Rock and the Australian desert are among my best.

During this time Barry was teaching me about living in a way I hadn't considered before. He used to say, 'Your life is like water—if there is a space it will always be filled up again—so you have to make room in order to be renewed.' It's a lesson I still haven't totally absorbed, but then it helped me and it was a very happy time. I was letting in so many influences, new shapes, new thoughts—it was a period of radical re-thinking for me—a regeneration.

When I came home I made a special photo album with specially printed pages to record the whole adventure permanently, to show what the sunsets were really like as they happened and to depict whole vistas by sticking many Instamatic pictures together. (See opposite.) Then I started more drawings and the Australian experience began to be translated into textile designs. It's not always so straightforward, sometimes the influence is more oblique, but 'Ayers Rock', 'Sparse' and 'Spinifix* Landscape' are almost a direct translation of what I saw and sketched there in the desert, although I achieved them by different methods . . .

'Ayers Rock' is a pictorial print based on the eighteenth-century French Toile de Jouy technique of fine engravings to make a scenic pattern. I pinned my Australian sketches on the wall. Then I translated them into fine line drawings on translucent paper and afterwards made several dyeline reproductions. These I cut up, moving the pieces around in different combinations, big and small tufts of grass placed around the Rock, until I thought it looked authentic and at the same time exciting to my eye. One of the most famous dresses was, and still is, the one-shoulder dress with a stitched satin band, draped with folds of 'Ayers Rock' printed chiffon (see butterfly no. 76). I designed it in 1974 and it has become a classic. Another garment from this period which I adore is the four-cornered cloak in felt and I will always remember the tableau in my show directed by Jerry Pennick when he had all three colourways come on to the stage and dance like strange hobby horses with Pat Cleveland leading them—tears came to my eyes.

*The real grass is called spinifex but I, not knowing the correct spelling, called the designs Spinifix.

Left, a page from Zandra's photo album

Top, Toile de Jouy, from the Victoria and Albert Museum

Above, preliminary roughs for 'Ayers Rock' design

Right, 'Ayers Rock' design worked out by means of intercutting many dyelines. Because this design required much drawing and accuracy, the using of dyelines simplified the process and reduced labour.

Over page, two-colour 'Ayers Rock' print on felt (large repeat achieved by using four screens). Screen repeat 40½″ (102·9 cm.), total design repeat 81″ (205·7 cm.) achieved by using two extra screens—not possible to reverse this as motif would be upside down), width of felt 48″ (121·9 cm.).

'Sparse' and 'Spinifix Landscape' are both a simplification of the original pin-cushion shapes of the tufts of desert grass translated in a very tight geometric manner. At that time I was working on a jacquard knitwear collection and so was very aware of operating with a confined medium. A jacquard has to be knitted in straight or diagonal lines, so my patterns evolved in just that way—in straight lines.

In 'Spinifix Landscape' I created a sort of landscape out of the tufts then added sky and border lines from similar wiggle lines inherited from 'Wiggle and Check' (see chapter 3). I ended the heavy part of the design in the proportions of the golden section used in landscape paintings, then filled what was left with shapes that resembled dragons—this is why sometimes butterfly no. 85 is called the 'Dragon dress'. Also included in this group of jacquard-inspired linear designs was 'Spinifix Square'—exactly as its name implies: a square. This is not shown here as a flat pattern but is shown on butterfly no. 82 of this chapter.

'Spinifix Landscape' proved to be perfect for my pleated satin jacket (see butterfly no. 82) and also the sarong dress (see butterfly no. 79a and b) photographed on Jerry Hall by Norman Parkinson, such an incredibly seductive picture.

During this period I designed another Schiffli lace—this time a fine embroidery on Terylene net. (I used Terylene and not silk net, as silk net is too delicate and could not have withstood being stretched taut on the Schiffli machines, with needles going up and down upon it). This lace was designed as an edging that could also be used as an all-over fabric and I incorporated collar shapes amongst the pointed lines. It was doubly interesting since here clearly shows the interweaving of all the various designs I do. Some points were with lilies (Chapter 7) and others were the Rock, and all of them laced together by my eternal wiggle (with me since childhood). This particular lace I used for the bride of my Ayers Rock Show 1974 and in this Collection I introduced for the first time satin lingerie with lace edging. It was only three years later in 1977 that I was able to produce this at a marketable enough price with an American lingerie company called Eve Stillman.

'Lace Mountain'* was created from a collage, which is the way I usually work. I take a large sheet of paper and draw the overall outline, then stick on small pieces of paper on which I have made detailed designs. I use Sellotape so that I can move these bits about. Often, I pin the sheet on to the wall of my studio and look at it, sometimes for weeks, until I find a harmony and composition which satisfies me; when I make my final decision I

intercut† the pieces of paper together. It so happened when I did 'Lace Mountain' I used pieces of my drawings from the pointed Lily Lace (see page 98) and incorporated them in the design—hence 'Lace' mountain.

Early design for 'Spinifix Landscape'. The black and white section was added by intercutting of knitted jacquard ideas.

Below, Preliminary rough design for 'Lace Mountain'

Right, three-colour 'Spinifix Landscape' print on silk chiffon. Design repeat 42″ (106·6 cm.), width of fabric 45″ (114·3 cm.).

Over page, three-colour 'Lace Mountain' print on silk chiffon. Screen repeat 27″ (68·5 cm.), total design repeat 54″ (137·1 cm.), width of fabric 45″ (114·3 cm.). (See diagram on p. 94.)

*This design is also printed by reversing the screen (see page 95).
†See page 92.

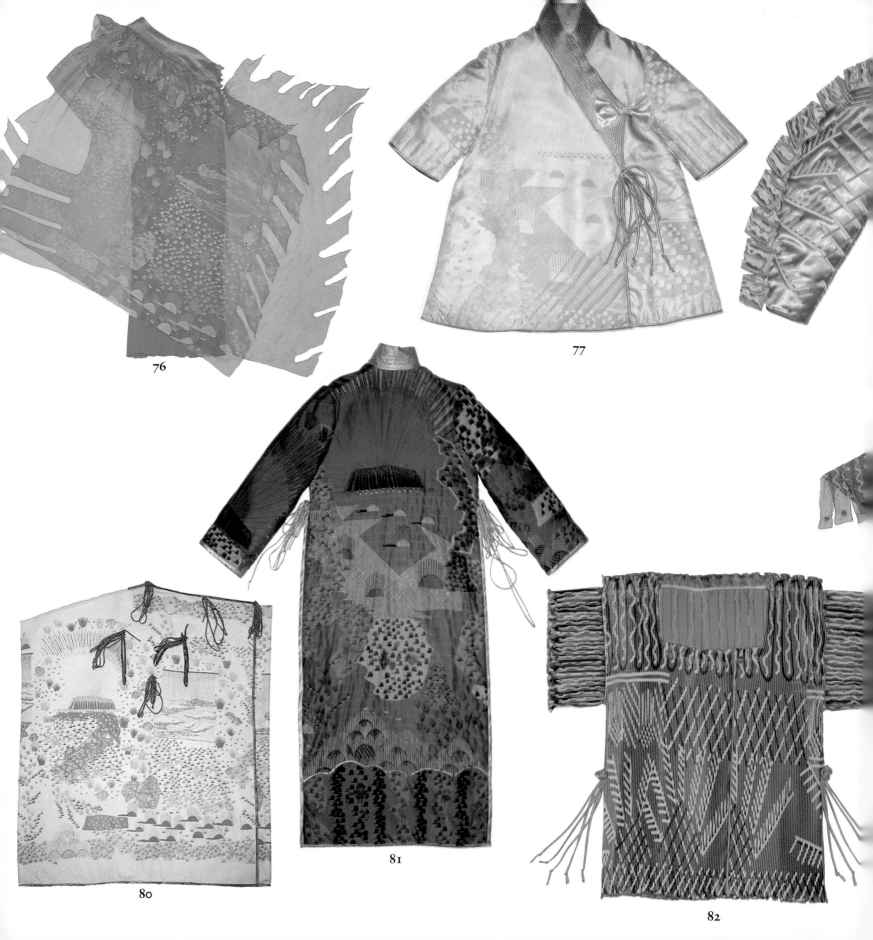

76

77

80

81

82

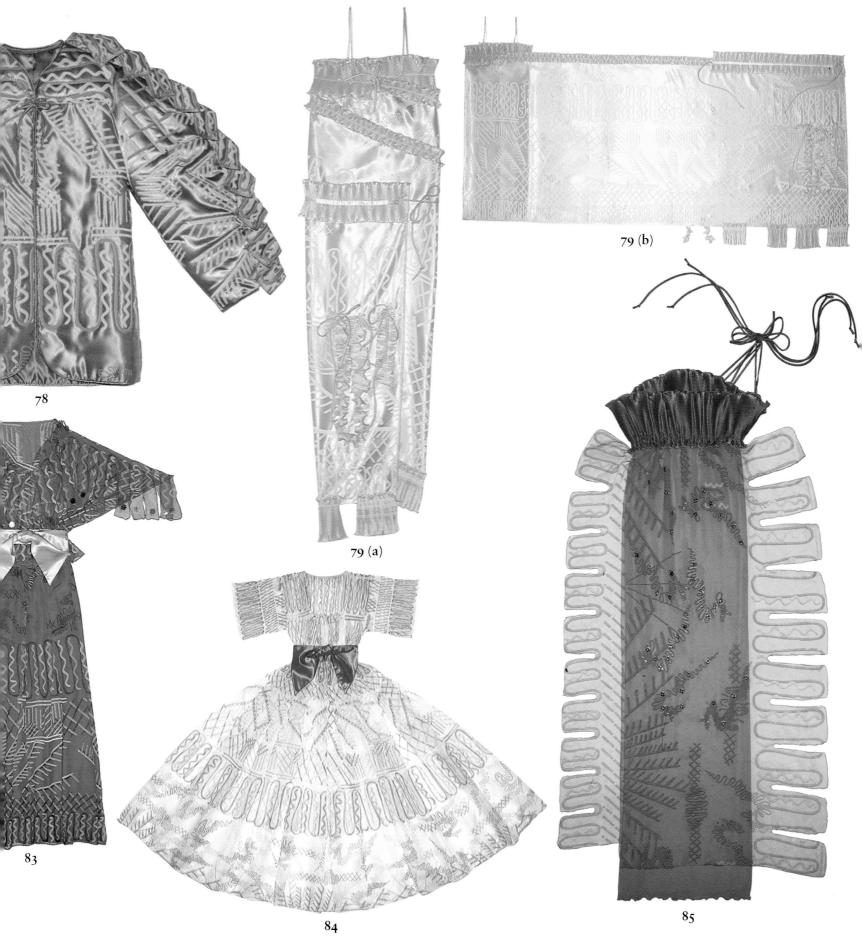

78

79 (a)

79 (b)

83

84

85

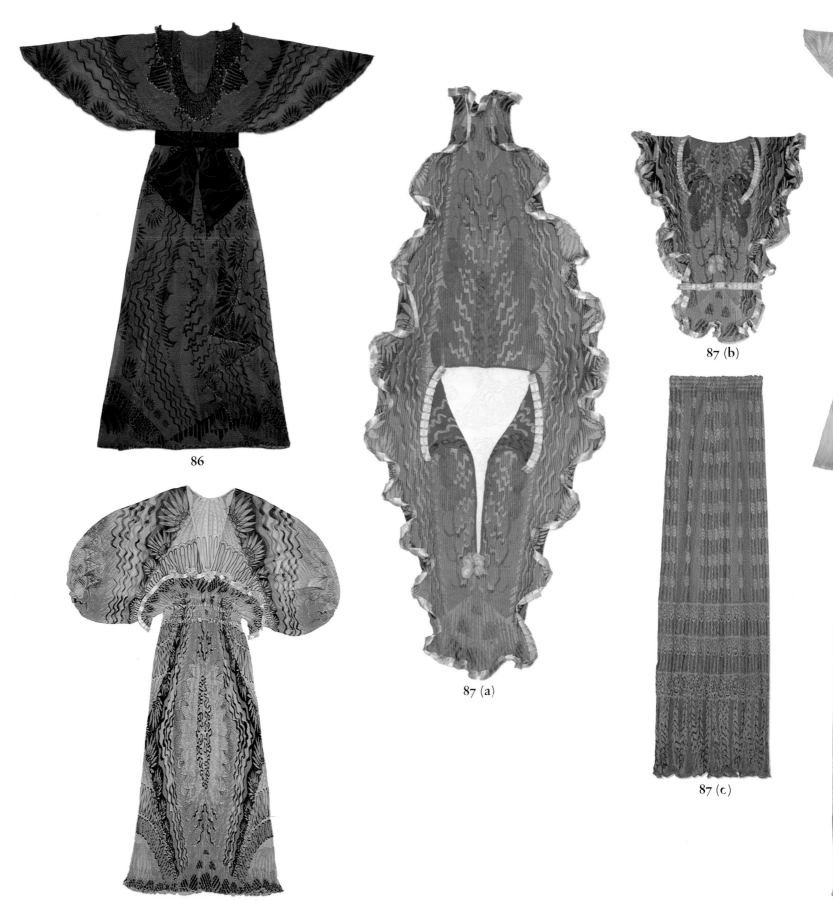

86

87 (a)

87 (b)

87 (c)

91

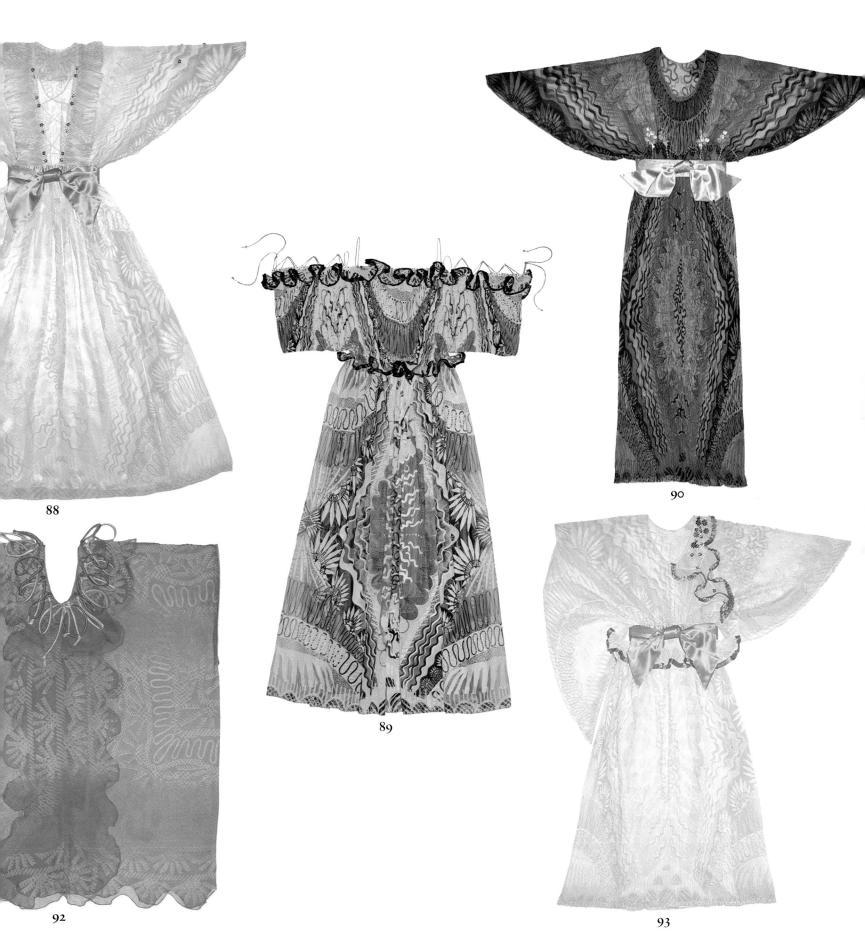

88

89

90

92

93

Just about this time Grant Mudford sent another Australian friend of his to see me in London, Richard Sharah, who was working as a make-up artist in the fashion world. His was pioneer work because he was the first make-up artist to break away from a conventional form of beauty. He wanted to interpret the contemporary mood in a memorable statement. He has an amazing and inexhaustible talent and we talked then, and still do, endlessly into the night, discussing new themes. Together we created the changing Zandra Rhodes face, always a logical extension of the total look I was working for. In 1975 we did our first poster together with Barry Lategan using the 'Lace Mountain' print. They helped me achieve what all my posters epitomise—an essential harmony between face and fashion (see photograph, page 122).

Above right, Princess Margaret wearing Zandra's pleated jacket (a version of Butterfly no. 82)

Below right, Little Nell modelling Butterfly no. 89

Below, black felt cloak (Butterfly no. 80)

NORMAN PARKINSON

BARRY LATÉGAN

Left, Jerry Hall modelling Butterfly no. 79

Above, Butterfly nos 76 and 94 (on the left)

Postscript

The Rock was first recorded in 1872 when Ernest Giles saw it from the northern side of Lake Amadeus. He reached it in 1873 only to find that a William Gosse had just examined it and named it Ayers Rock after the premier of Australia, Henry Ayers. The great grand-daughter of William Gosse (Sir Alexander Downer's daughter) was married in one of my chiffon dresses which incorporated the 'Lace Mountain' print. I have never met her, but it has always seemed like a story-book ending.

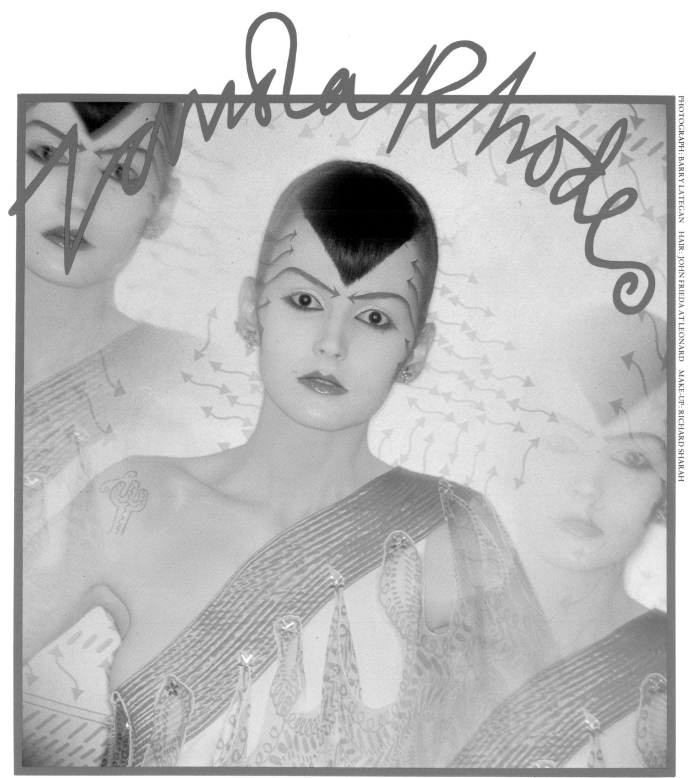

Zandra Rhodes

PHOTOGRAPH: BARRY LATEGAN HAIR: JOHN FRIEDA AT LEONARD MAKE-UP: RICHARD SHARAH

Photograph for 'Cactus' poster, 1976 (Butterfly no. 94)

Across the U.S.A. –
Cactus and Cowboys

Grant Mudford came to London in 1974 and lived with me until he went off to the United States on an Australian Arts Council grant. He lived in Greenwich Village New York and for the next few years we were both more or less commuting between there and London to be together whenever it slotted in with our work schedules.

In May 1975 I had to do a show in Los Angeles. I met Grant in New York and we set out in a Volkswagen Camper in search of America. There were so many things I was dying to see. When you are in New York it doesn't take you long to realise there is so much *of* America and anyway everyone seems to want to spoil your love affair with the Big Apple, telling you, 'New York isn't the United States'.

I had two weeks, absolute maximum, in which to reach Los Angeles so we decided to get through the first stretch as fast as possible. It was dark and raining when we left New York and we zipped across into New Jersey, then Pennsylvania, Ohio, Indiana and Missouri, at something like 500 miles a day. Then into Kansas, driving hour after hour on a freeway through endless wheatfields, stretching as far as the eye could see in an unchanging landscape, punctuated only by the huge grain-mills. The colour was an indescribable golden light, but so far there hadn't been anything terribly inspiring as far as my work was concerned—except, totally undiscerned, the first tiny link in the eventual chain—as we crossed the mid-West into the prairie states, we were constantly tuned into the radio station, listening all the time to Country and Western music.

I was very excited about the prospect of getting to Denver, Colorado (the beginning of the Rockies). Here were all the names remembered from my childhood, all associated with the early settlers and the wagon trains driving to the West. All the cowboy films my father had taken me to. Abalene was one.

It was in Colorado Springs that the second tenuous link in the creative process was forged—I bought myself a pair of genuine cowboy boots, embroidered leather, pointed toes and that strange mid-calf height, with turned-under cuban heels. Crossing the Rocky Mountains was a journey of extreme contrasts, the mountain ridges were snow-covered, it was very, very cold. But a day's drive later, on the plateau, it became very hot.

Finally we reached the Grand Canyon which I had imagined would be the biggest landmark of the journey. Unexpectedly it did not touch my emotions. I was anticipating the mystery of Ayers Rock. I think it was simply too overwhelming, too gigantic, too impressive for my sketchbook. I found it impossible to convey its impact in my drawings. There's the rub—getting out that dreaded sketchbook. It's the difference between taking

One of Zandra's Grand Canyon sketches

photographs and putting an impression on paper yourself. When you look at something your mind edits and you really only see what you want to see—just that which is of particular interest. The camera lens does not edit, which is why photos do not always say what you want them to say. The Grand Canyon is made for photography, which seems to absorb the whole landscape, unedited, whereas when I draw I have to focus on some special aspect which attracts my attention and I instinctively emphasise sometimes quite tiny details which interest me, but would never show in photographs. In essence I find now my photographs are quite an important part of my work, but only in conjunction with my drawings, and only after I have carried out the physical act of doing the drawings.

During the day, Grant always stopped driving for at least one two-hour period so that I could draw. I was trying desperately to capture something of the majesty of the surroundings, but it didn't work.

From the Grand Canyon we went back to find the Painted Desert and the Petrified Forest. All the other people stopped at the edge, but we climbed on down, and explored. These vast stretches of parched, crazed earth, once lakes but now dried up into coloured lines of sediment, are eerie and frightening—you could walk into them and get lost, you instinctively know you could die there. For the first time I think I understood the spirit of the pioneers, how it might feel to experience the fear of death. The bravery and courage, or even sheer foolhardiness of these men and women was brought home to me in the most realistic way.

GRANT MUDFORD

Left, Zandra sketching saqueros

Right, photograph from Zandra's album

Then on to Las Vegas through small towns indelibly stamped with the national style of the early communities, German, Scandinavian, Dutch, passing hundreds of giant hoardings glorifying the god of gamblers, the de luxe hotels, the whole gamut of superlative entertainment. There, in down-town Las Vegas, in all its electric reality, was the Neon Cowboy which had inspired my wonderful 1960s 'Mr Man' print, raising its hat and saying, 'Howdee partners'. I felt totally at home in the brash atmosphere. Grant naturally was in his element. Vegas so perfectly suited his art-form, urban photo-realism, and he took endless photographs of billboard statues, shopping bays, airstream caravans, and mobile-home sites on the Vegas outskirts at Kingman. We stayed there for two days, never placing a dime on a game of chance. When we reached Las Vegas I had immediately phoned Joan Quinn in Los Angeles and told her to expect us. She couldn't believe we were there. In fact I don't think any of our friends thought we would actually make it across America at all, let alone in ten days.

We left Vegas for L.A. driving through the Mojave Desert. This was the first time during the trip I felt really inspired. The familiar adrenalin started to flow through my veins. Unlike the parched, death-like atmosphere of the Painted Desert, in contrast to the billboards on the highway into The Strip, here was a living world—the beginning of cactus country. There they stood in the desert landscape—brutally alive—some, long-legged giants as

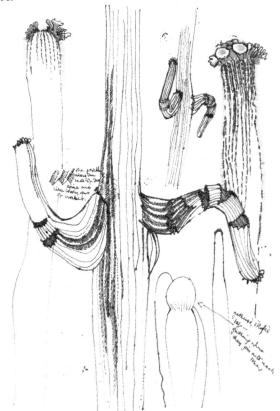

big as trees, swaying slightly, posing alone against the blue skies, others were like tiny people huddled together in groups. So this was the beginning of the journey of the cactus—I now knew what I wanted to draw. We stopped for me to do some sketching, but it wasn't long enough, for I had to get to Los Angeles for my personal appearance and fashion show at Michael Chow's new restaurant.

Once there we stayed with Joan and Jack Quinn. I had a few days before flying back to London and was burning to see more desert, draw more cacti. On their advice we went to Tijuana and Mexicali and from there across to Phoenix, where we drove straight into a great dust storm, tremendous gusts of wind blowing balls of tumbleweed about, dust spirals, doors creaking threateningly, just like a scene from the movie 'Hud'. Then we found the amazing Organ Pipe Cactus National Monument, a park filled with cacti, the 'Octillos' in wondrous red bloom, but the incredible giant 'Sequevos' dominating them all, wearing their flowers like white hats. Again I was struck by their human quality. Some were just like old men (in fact they are named 'Cactus Senilus'), hugely tall with soft hair reaching to the ground, their heads growing long wavy wigs. Others looked like bright young girls with crowns of flowers. I really loved them. This was it—I had found what I wanted—we parked the Volkswagen, camped with cacti all around us, and I was drawing non-stop for two days.

Detailed sketches of cacti
from Zandra's sketchbook

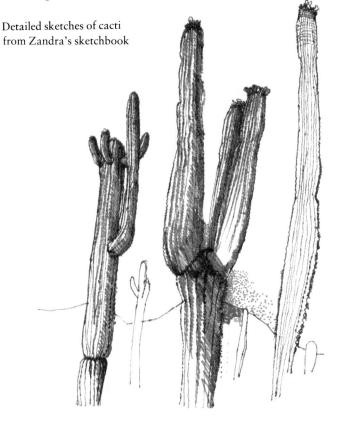

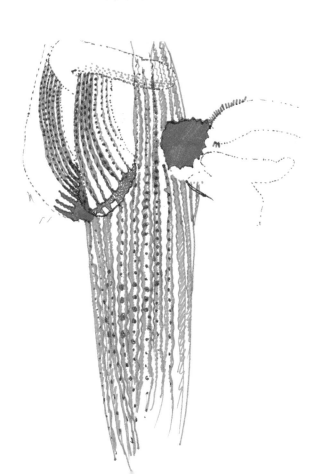

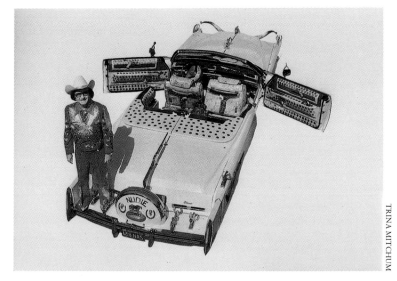

TRINA MITCHUM

Cactus sketch

Back to the Quinns' in L.A. for another short stay. Joan took me to Nudie's in the San Fernando Valley, the famous cowboy tailor, as his catalogue says, 'Folks, meet Nudie, master-tailor to countless western stars, wranglers, cowpokes, Sunday riders and dudes.' There, unquestionably, the third link and the final die were cast—but, just as always, I didn't immediately recognise the fact.

I went back to my London studio armed with my cactus drawings and photographs, a few cowboy photographs and sketches and the Nudie's catalogue. At first I only used those of the cacti, pinning them on the wall, side by side, the photographs supplementing the detailed sketches. So the prints were created:

Top, Nudie and his 'Westener' Cadillac

Above right, a portrait of Joan Quinn by Paul Jasmin

Above left, photograph from the cowboy pin-up wall in Nudie's

'Cactus Highway', 'Cactus Volcano', 'Cactus Everywhere', followed by 'Giant Cactus', 'Tiny Cactus', and 'Cactus Sparse'. But strange things were happening, little arrows had started to appear in the designs. Then the arrows took over, so 'Cactus Arrow Square' and 'Arrow Sunspray' were introduced and the Cowboy Collection was conceived.

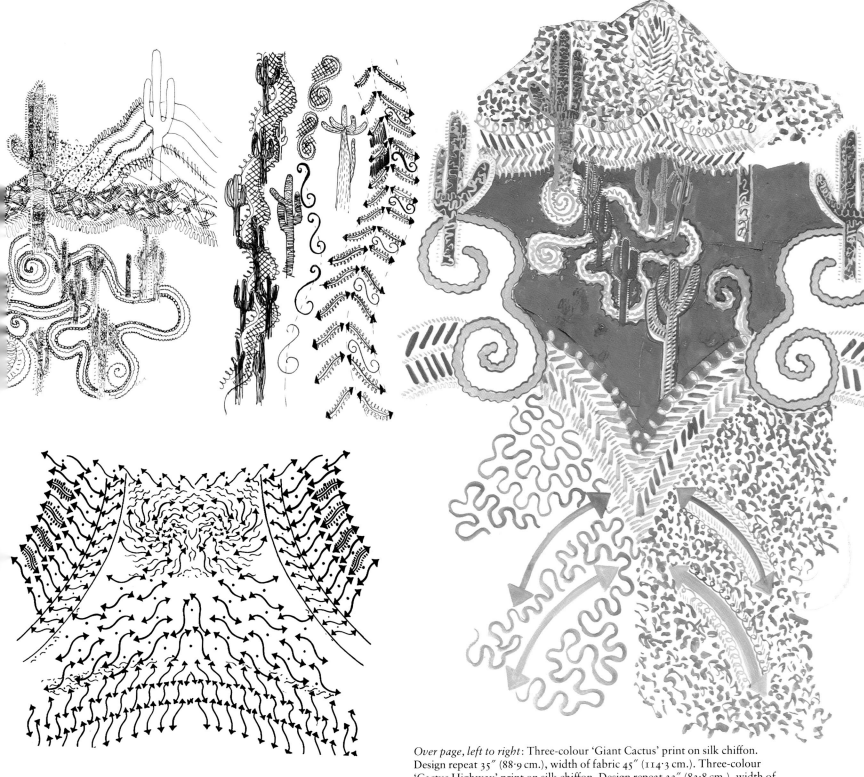

Preliminary designs for 'Cactus Everywhere' (*above left* and *far right*), 'Cactus Highway' (*right*) and arrows in a 'Reverse Lily' format (*below left*)

Over page, left to right: Three-colour 'Giant Cactus' print on silk chiffon. Design repeat 35″ (88·9 cm.), width of fabric 45″ (114·3 cm.). Three-colour 'Cactus Highway' print on silk chiffon. Design repeat 33″ (83·8 cm.), width of fabric 45″ (114·3 cm.).
Two-colour 'Cactus Everywhere' print on silk chiffon. Design repeat 35″ (88·9 cm.), width of fabric 45″ (114·3 cm.).

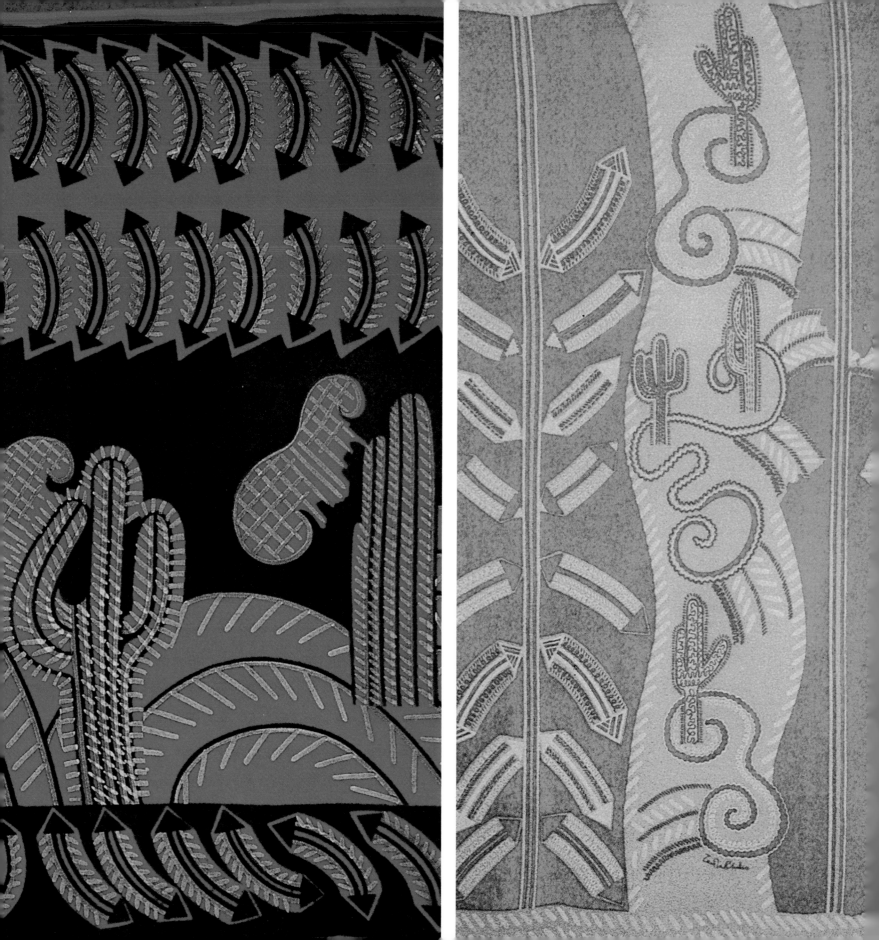

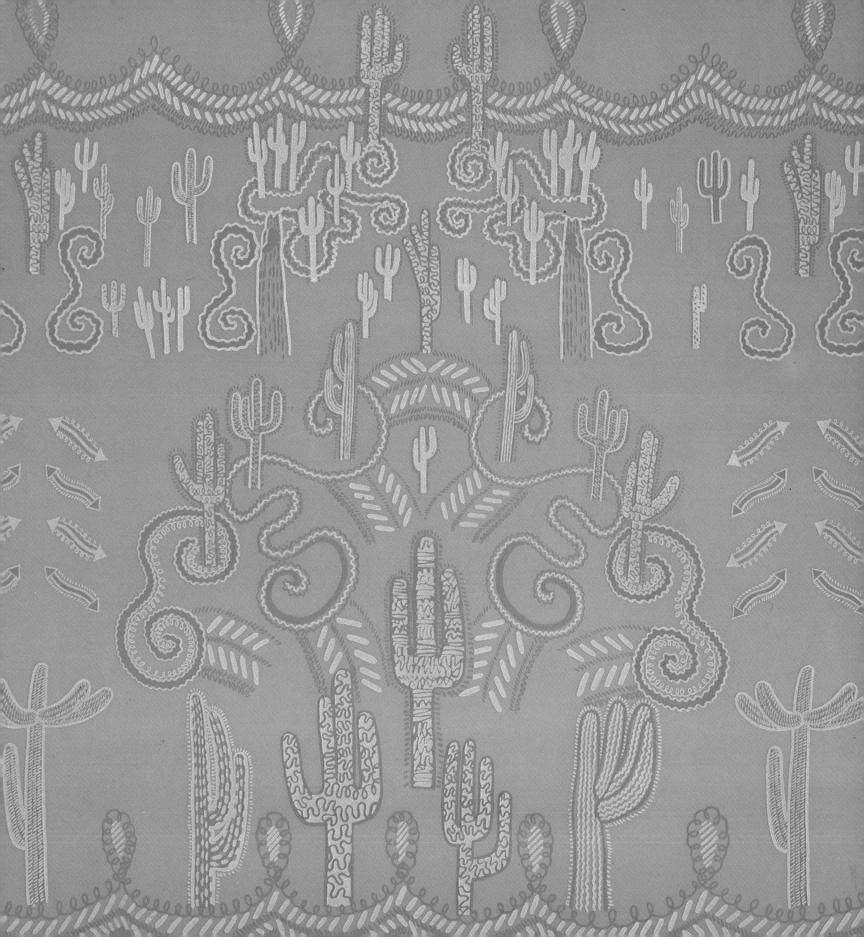

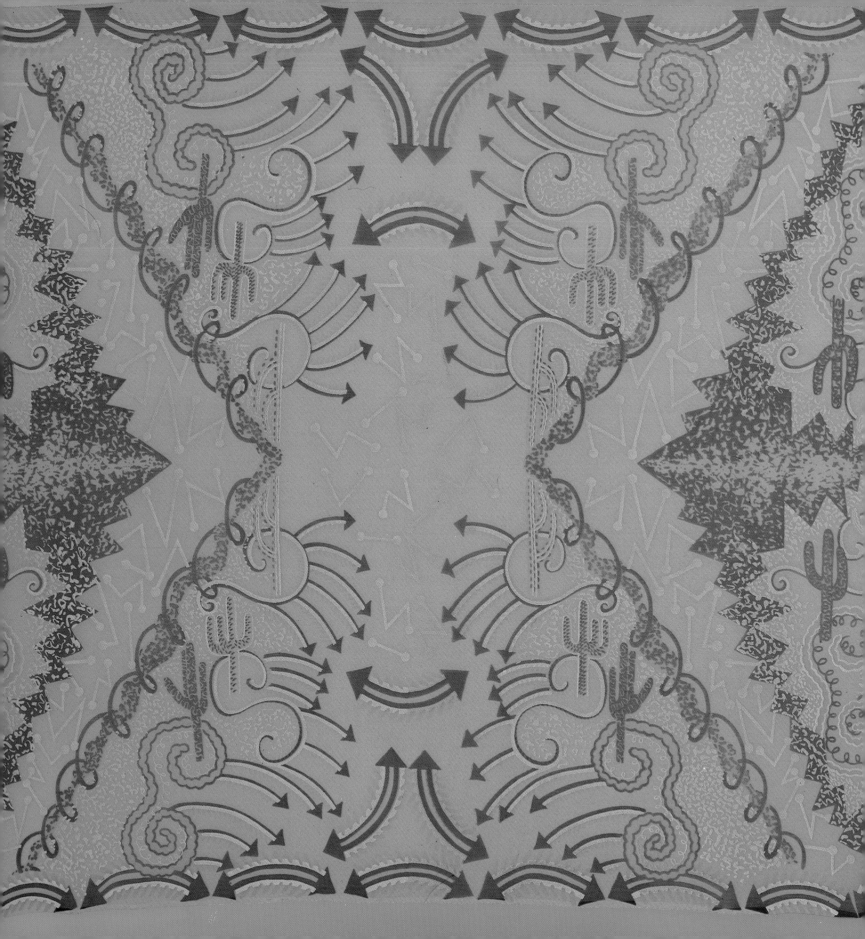

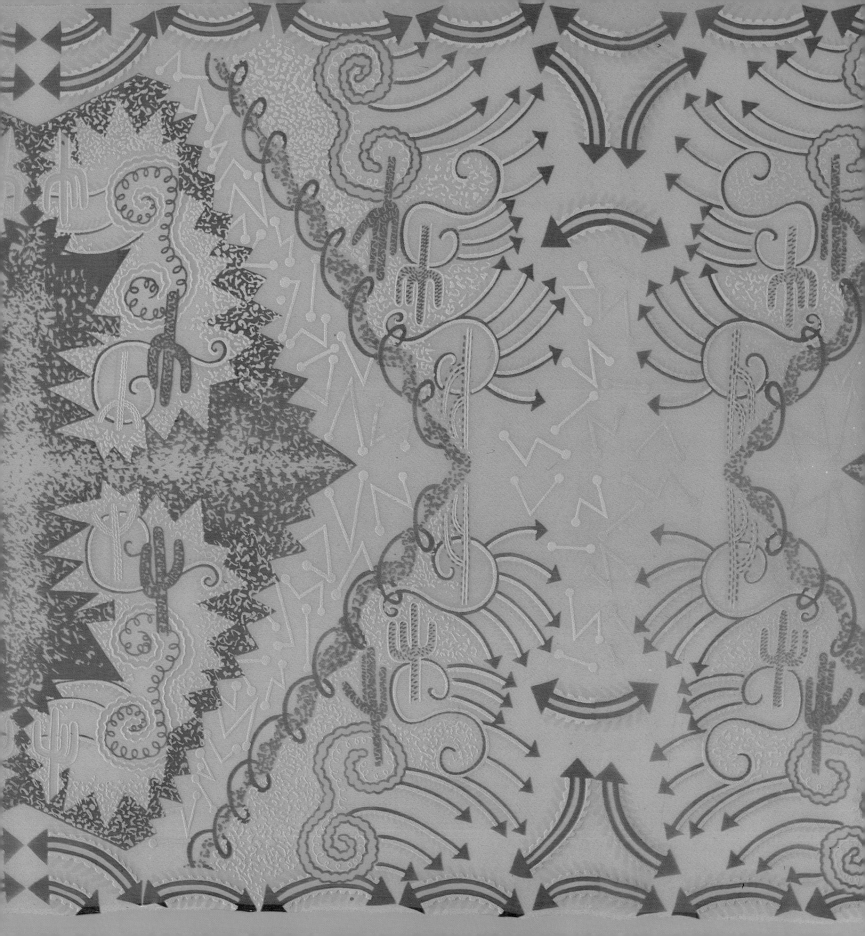

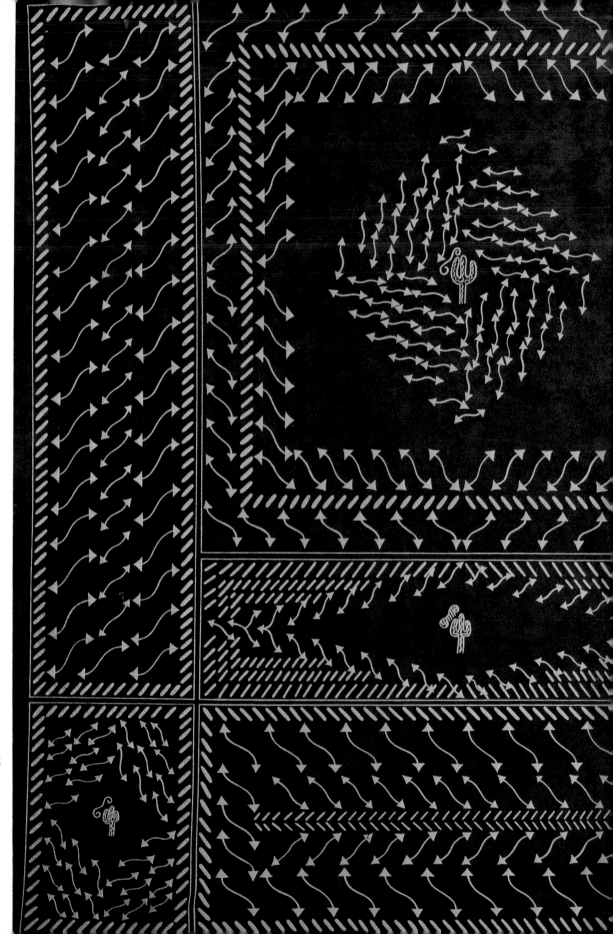

Preliminary designs for 'Cactus Arrow Square'

Previous pages, three-colour 'Cactus Volcano' print on silk chiffon. Screen repeat 29″ (73·6 cm.), total design repeat 58″ (147·3 cm.), width of fabric 45″ (114·3 cm.).

Right, 'Cactus Arrow Square' using one screen (four-colour effect achieved by rainbowing colours while printing) on Ultrasuede. Design repeat 44″ (111·8 cm.), width of fabric 45″ (114·3 cm.).

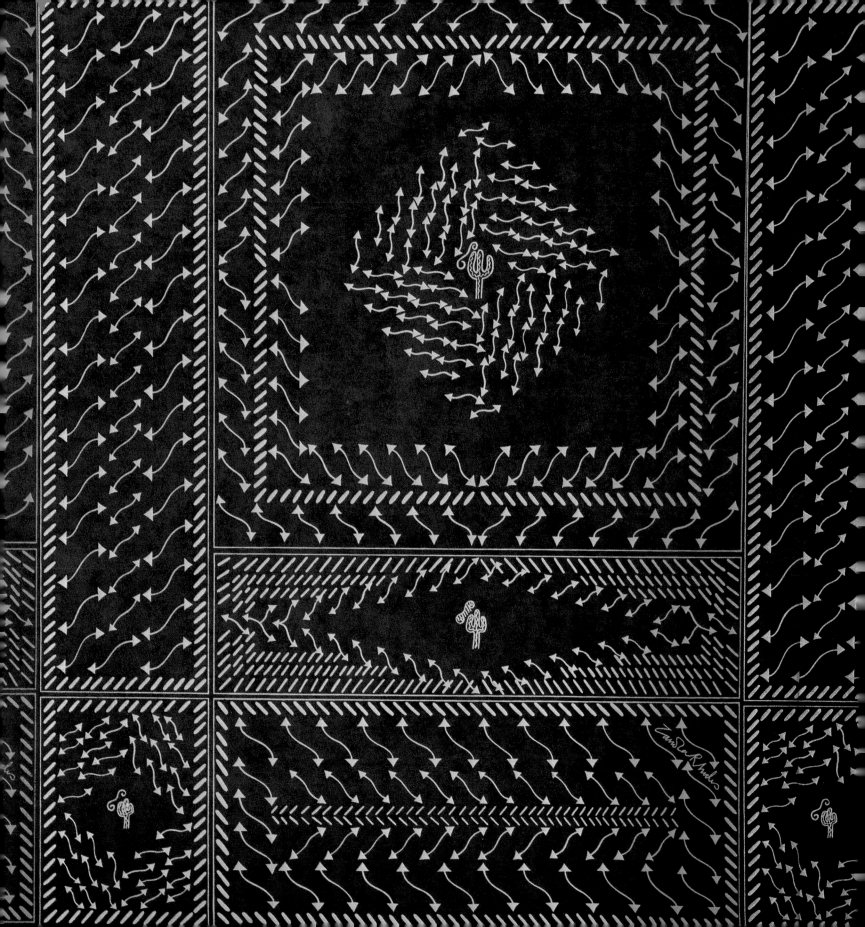

The cactus theme with its intruding arrows was printed on to chiffon and I cut around the prints in the usual Zandra way. Round the scallops of 'Cactus Everywhere' to make a kaftan (butterfly no. 95), around these same scallops, then rolling them and hanging them from glass stars around the bodice of the one-shoulder dress (butterfly no. 94), and round the diamond-shaped edges of 'Cactus Volcano' to make asymmetrical sleeves. For some of the colourways I used desert-type colours—one in particular was a greyish blue, printed with golden yellows.

But with these chiffon dresses only the prints were expressing the theme—it was to take the introduction of a day-wear range of clothes before a cowboy look was to come about. The only western image so far involved was the sheriff's stars holding the chiffon for the one-shoulder dress (butterfly no. 94).

At that time a fabric called 'Ultrasuede' in America and 'Alcantara' in Europe had become an enormous success. It was 100 per cent synthetic, unwoven and in a roll, like paper or felt, and almost indistinguishable in the hand from real suede—except it was nearly indestructible in normal wear, had none of the delicacy and faults of animal skins, and could be washed and easily printed, all of which appealed to my intensely practical approach to life and work.

Halston and Bill Blass had been using this fabric, which came in great colours, and I decided it was just the right fabric to tackle in a totally different way and from which to create a Cowboy day collection. A wonderful challenge: the fabric wasn't malleable so I had to learn a new way to handle it. Dainty hand-stitching and my fine sewing machines were not the answer. Fortunately, since they didn't fray, none of the cut edges had to be stitched, so there were no hems, only seams, which I laced or put outside, just as I had done on my silken jersey dresses. It was difficult to find the right technique—but the technique I found was in the printing.

I designed prairie shirts and tops with uneven hemlines just like real leather and I used the print technique in the same way as in 'Sparkle' (Chapter 5). Here I designed the print like a child's cut-out toy. The print was the exact pattern shape. Against this line were $\frac{1}{2}$-inch diagonal lines representing thonged oversewing. This I printed in rainbow colours, made possible by dragging four different colours across the screen while I was printing. The tops were a new version of the smocked jersey and silk tops (butterfly nos 37 and 38). To wear under them were gauchos, chaps and cowboy skirts. I made glittering see-through blouses and shirts for which I resurrected my original 'Mr Man' print (see page 18).

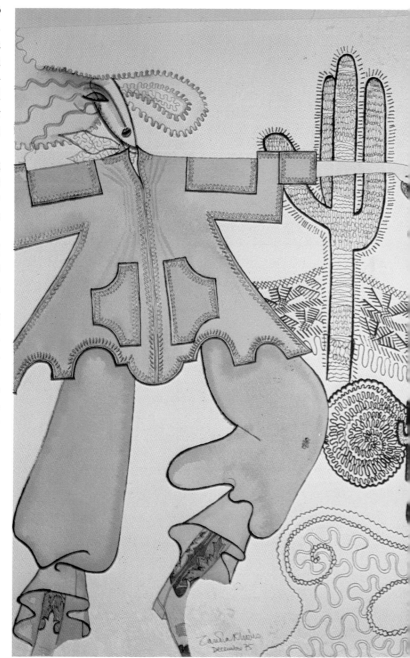

A watercolour sketch for Ultrasuede cowboy

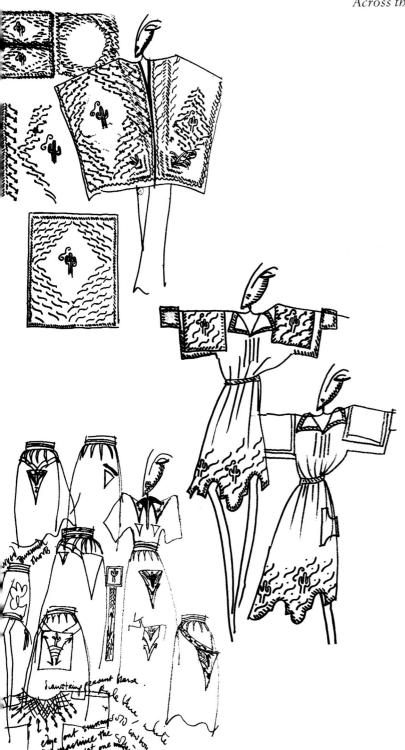

Cowboy fashion sketches

Zandra in her 'Cactus Everywhere' dress (Butterfly no. 99)

Although by now I totally acknowledged the influence of the Country and Western music, the cowboy background of the one-horse towns, the American Indians, the deserts, the Rockies, and Nudie, I wanted my collection to be neither a copy, nor a parody of the original, and certainly not totally ethnic. The more I thought, the more obsessed I became and the more convinced I was with the idea that the accessories should be authentic. So I looked towards America again.

In September I was booked to go to Houston to do a dress show for Sakowitz. By that time my Spring 1976 Collection was near to realisation, in my mind at least—no collection is ever really finished until the last five minutes before the presentation (and even then some of the clothes are invariably held together with tacking stitches). I knew I was going to do a fashion show in London at the Roundhouse in October and it had to look right. So I flew to Los Angeles from London, met Grant there, spent a day to have the famous 'Lovely Lily' tattooed on my thigh to show through my side-slit cowboy chaps, and then drove to Houston, stopping en route in El Paso because I wanted the best there was—the cowboy boots *par excellence* made by Tony Lama—thirty pairs from his staggering collection—ostrich, lizard, kangaroo, with embroidery and arrows, silver toecaps and cuban heels, and that strange mid-calf length that at the time the public eye was not used to.

153

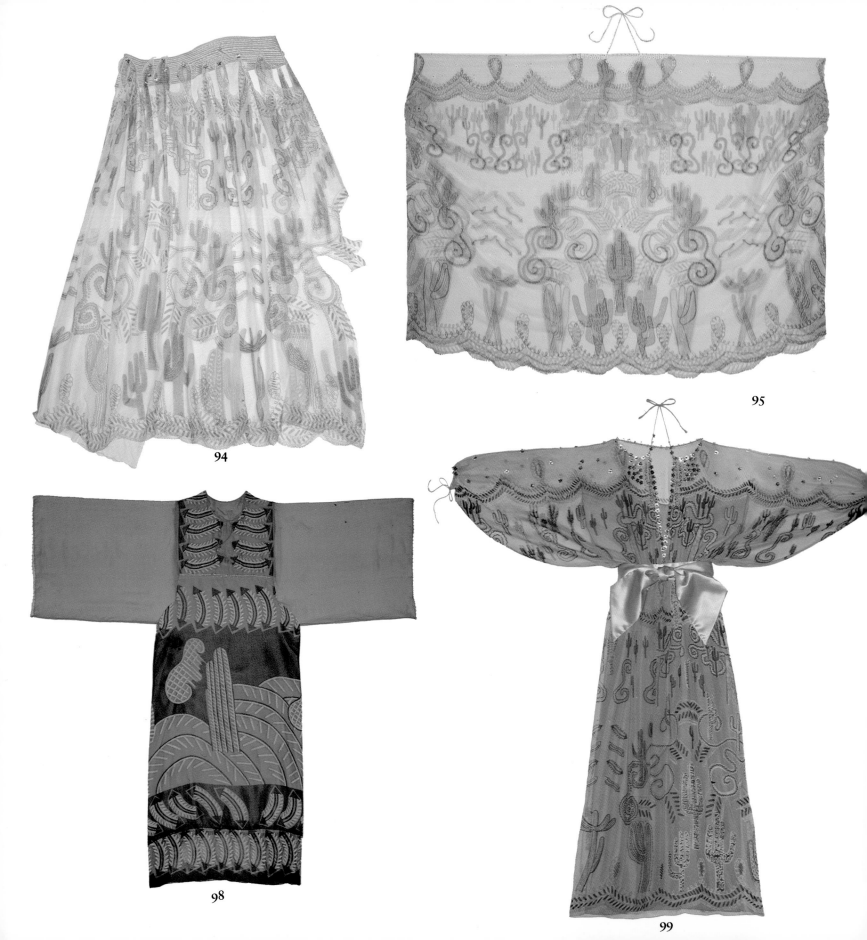

94

95

98

99

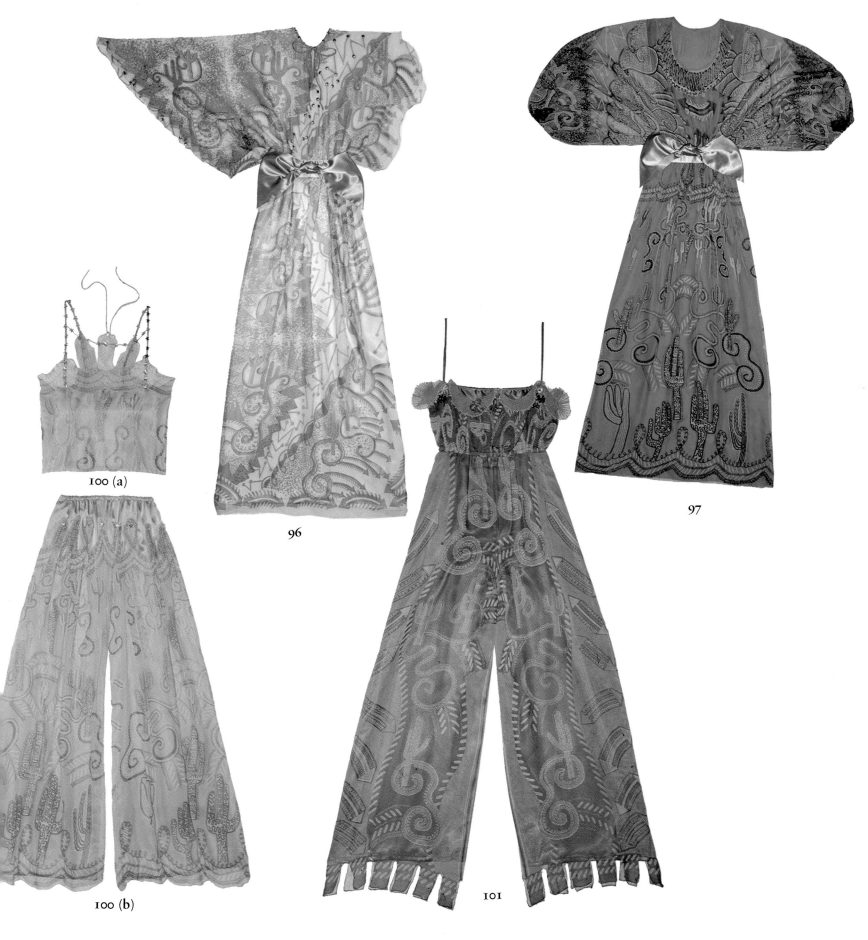

100 (a)

96

97

100 (b)

101

Bottom right, Tina Chow wearing jewelled dustkerchief with Mick Milligan arrow hairslide and cactus lariat

Below, Marie Helvin and Sandy Lieberson (Butterfly no. 96)

Bottom, Zandra at home with her cactus sculptures

The rest of the accessories were worked out in London. I made jewelled dustkerchiefs for my models to wear across the face (page 156). Mick Milligan did wonderful gold cactus and arrow brooches, pins, bracelets and, most important, cactus rings to secure the satin lariats which the girls wore. Richard Sharah and I devised 'the face', eyebrows shaved and replaced with arrows, very pale skin, altogether the very stark, hard look which I wanted (see poster, page 140).

I asked Jerry Pennick, my close friend from Texas, who had done several of my previous shows, to do the choreography. He found this show a great challenge because no American designers were as yet acknowledging their cowboy roots and no European designers had touched that theme. Jerry found it very disconcerting to be so closely involved with his roots as he had spent so long consciously rejecting them.

He set the image in music with the 'Grand Canyon Suite' and 'The Painted Desert' by Ferde Grofé (used in the Walt Disney films) and the gravelly Western singing of Jerry Jeff Walker. Visually he created corrals of cactus-printed chiffon held by black-suited cowboys. Here enters Ben Scholten as one of the cowboys (he was then a Dutch student, but has now become my design director, working closely with me on all my Collections and their conception and execution). So the scene was set to launch the Zandra Rhodes Cactus Cowboy Collection.

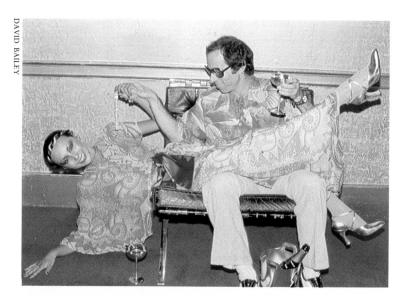

DAVID BAILEY

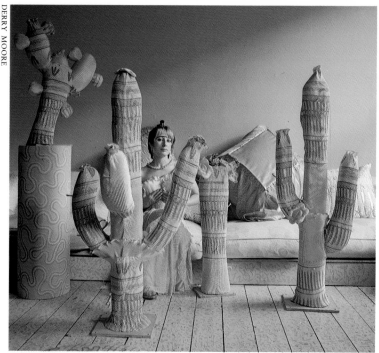

DERRY MOORE

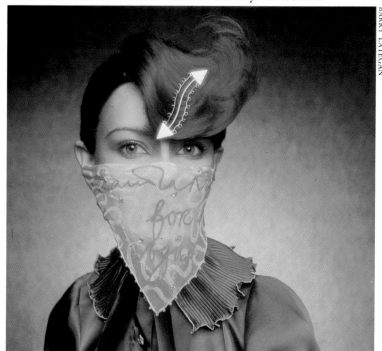

BARRY LATEGAN

ROBYN BEECHE

NORMAN PARKINSON

BARRY LATEGAN

NORMAN EALES

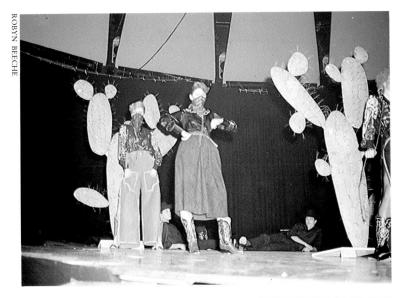

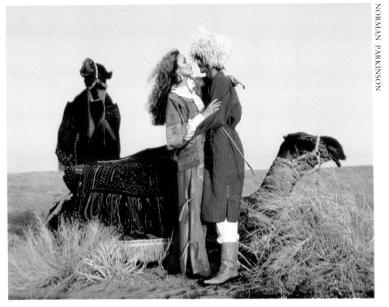

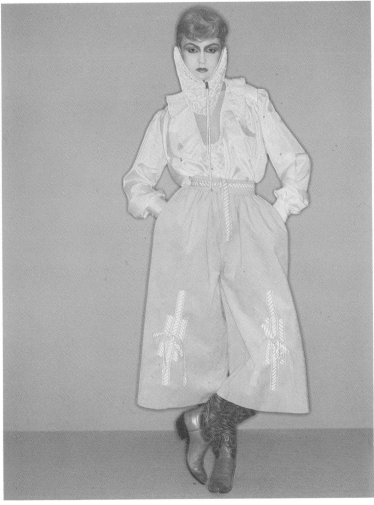

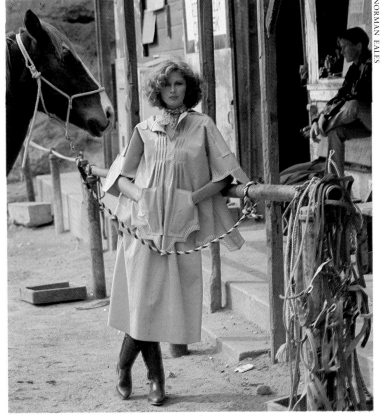

Top right, Jerry Hall in Ultrasuede split chaps
Above right, Ultrasuede jacket and skirt photographed in California (Butterfly no. 42)
Above left, the Roundhouse Show, London, 1976
Left, Ultrasuede cowboy

157

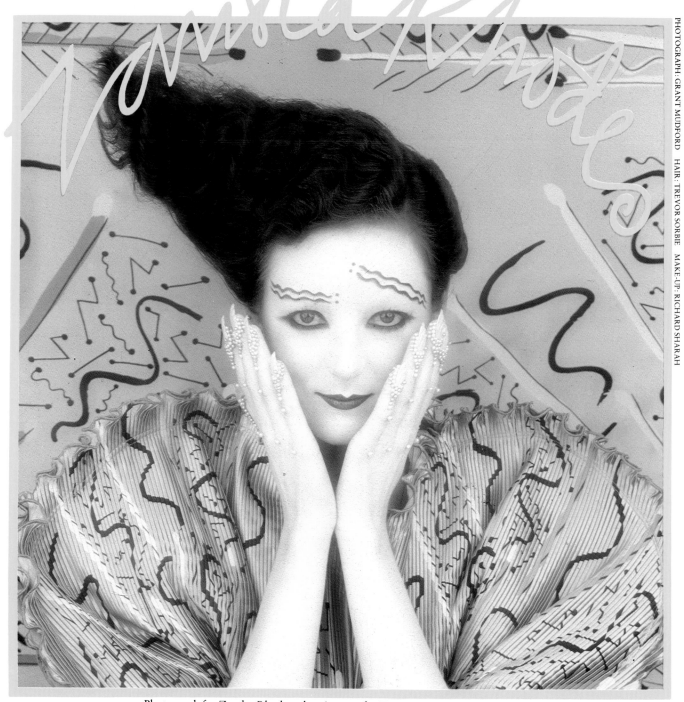

PHOTOGRAPH: GRANT MUDFORD HAIR: TREVOR SORBIE MAKE-UP: RICHARD SHARAH

Photograph for Zandra Rhodes advertisement for *Vogue*, 1978 (Butterfly no. 116)

Mexico, Sombreros and Fans

As Grant and I had developed a passion for deserts, he suggested we should go to Mexico. The idea immediately appealed to me. We were travelling in our usual Volkswagen Camper so I also bought a book on Mexican cookery and borrowed a book on the Aztecs.

We set out from Los Angeles equipped with cameras and sketchbooks, both of us mindful of the fact that every day we would feel bound to record something of what we were seeing or, in my case, ever hopeful, that I would have a blinding flash of inspiration which would be committed to paper straightaway. We travelled down through the Baha Peninsula through lonely, bandit-infested countryside. Several hundred miles of desert cactus landscape, different from that seen on the American-Mexican borders but wonderful and inspiring. Down to La Paz for a quick visit to Los Angeles artist, Billy Al Bengston, then by boat to Mexico proper.

The real, mainland Mexico was a shock. The roads were desolate and everywhere was filthy with litter. Driving like that, of course, you really see the dreadful poverty and decay of the country, which people miss when they fly into Mexico City and go straight to the glamorous resorts. On the way, we often had difficulty finding petrol and in the markets food supplies were available but I found the language barrier a problem. I was cooking on a small primus stove beside the Camper, faithfully following the Mexican cookbook recipes. I was so enthusiastic that I gave myself complete culture shock and I then started dreaming about my home-made English food; rich puddings, believe it or not, bread-and-butter puddings and custard and creamy rich trifles. Amazing, since strange and different food is usually so exciting.

We were very isolated. All the friends of friends we had been told to look up were out of the country, probably in Europe. We were there out of season. I like the stimulation of people all around me and hate being alone. I would always rather sleep on the floor of a friend's house and experience communication than be in the isolation of even the Royal suite of a hotel. We concentrated on sightseeing and historical monuments. We found marvellous Aztec walls, arenas and temples. I drew over and over again details from the wonderful stonework where pebbles and coloured stones had been pressed as decoration into the cement in between the bricks.

I really enjoyed the markets, but I was too intimidated to sketch the people around me, so I photographed them, concentrating on their costumes, their thick ink-black hair, braided with ribbons, the children carrying lizards. What attracted me most were the magnificent sombreros, giant-sized and brightly coloured with crude gold-thread embroidery. They were laid out in rows, piled one upon the other in every hue imaginable. I kept photographing them, aerial view, like looking at a bullseye, and that's how I used them in the 'Mexican Sombrero' print. Yet still I went on drawing walls, buildings, and palaces.

Stone detail from Aztec temple in Cuernavaca

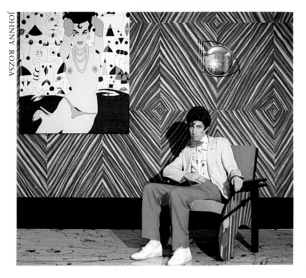

There's always a tension when I'm away, pretending it's a holiday, but agonising over the compulsion that the time must be productive, that somewhere out of it I have to find enough inspiration for the next Collection and at the same time not let the thought obsess me to the exclusion of any enjoyment. I absorb everything like blotting paper, but only one or two images actually lead me on to a firm result.

When I came back to London I started to go through my photographs and sketches to try to develop the Mexican Collection. To find the right threads, as usual I turned to my friends to show what I was doing, to talk it all out.

This time it was Duggie Fields, whose paintings illuminated the walls of my home. He and I force our ideas on art into every facet of our lives, from the flamboyant way we both dress to creating our own very personal environment, extending our work into our lifestyle so that the two are inseparable. Duggie works on his paintings as much as I work on my prints and we explore ideas, going over and around them, until the work takes on a force of its own and begins to give out its own dynamics.

After my Mexico trip, it was a particular work of Duggie's, itself inspired by Miro with the angular V's and lines with dots at the tips, which inspired me and finally led me to develop the material I had gathered, everything I had soaked up, and I added these motifs as the background. I felt they gave a dancing Mexican feel to the images I was using and that they possibly might endure to become one of those undefinable motifs that become a 'Rhodes' signature—as the Lily and the Wiggles had done.

Above and centre left, Aztec stone details

Below left, Duggie Fields at home

160

The first prints were more or less a straight interpretation of my photographs of the market sombreros. They were developed in the same way as 'Knitted Circle', the circle in this case being the outline of the sombrero, and the inside print was based on the embroidery with the dancing Miro motifs filling the spaces in between, thus 'Mexican Sombrero'.

Left, sombrero in a market

Right, pages from Zandra's sketchbook

Below, original sketch for 'Mexican Sombrero'

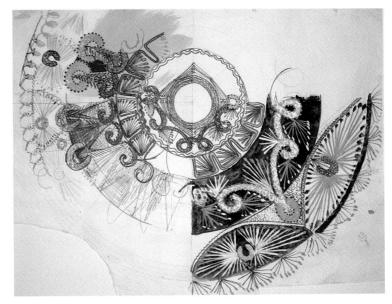

Over page, three-colour 'Mexican Sombrero' print on silk chiffon. Design repeat 47″ (119·4 cm.), width of fabric 45″ (114·3 cm.).

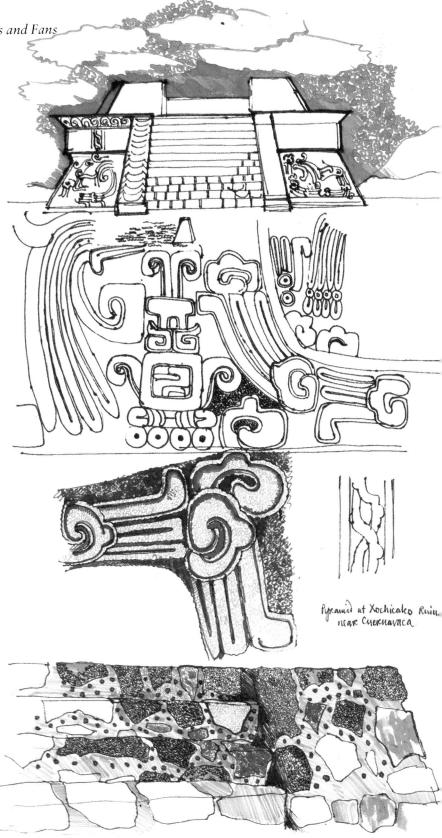

Pyramid at Xochicalco Ruin near Cuernavaca

161

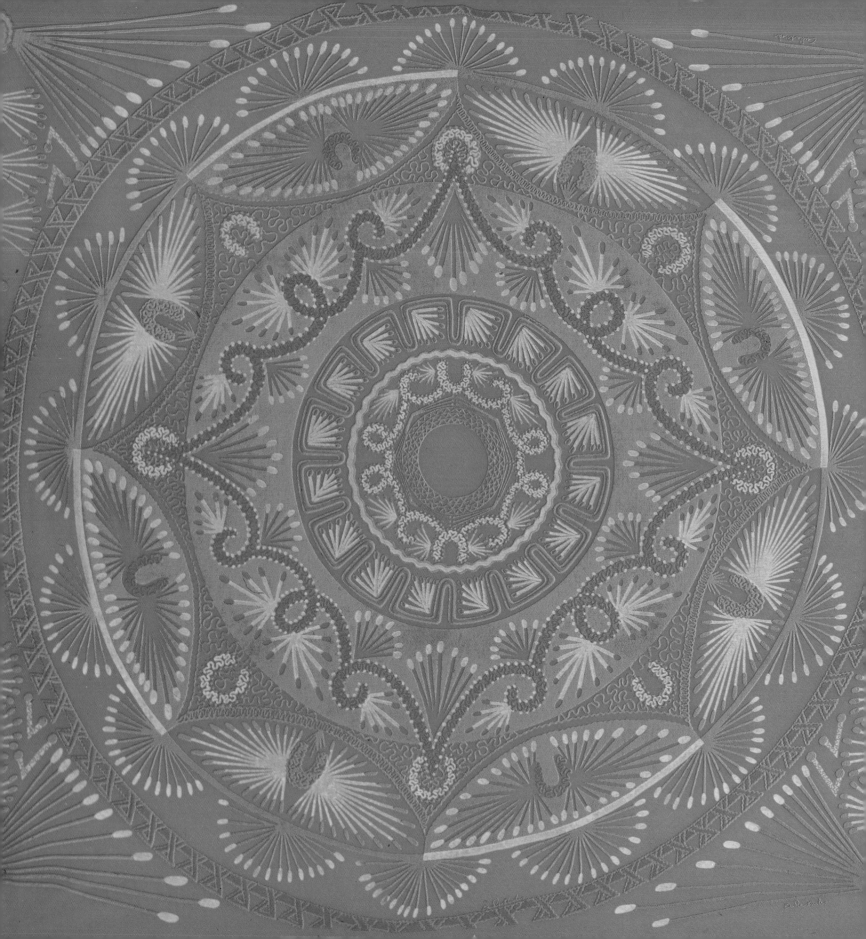

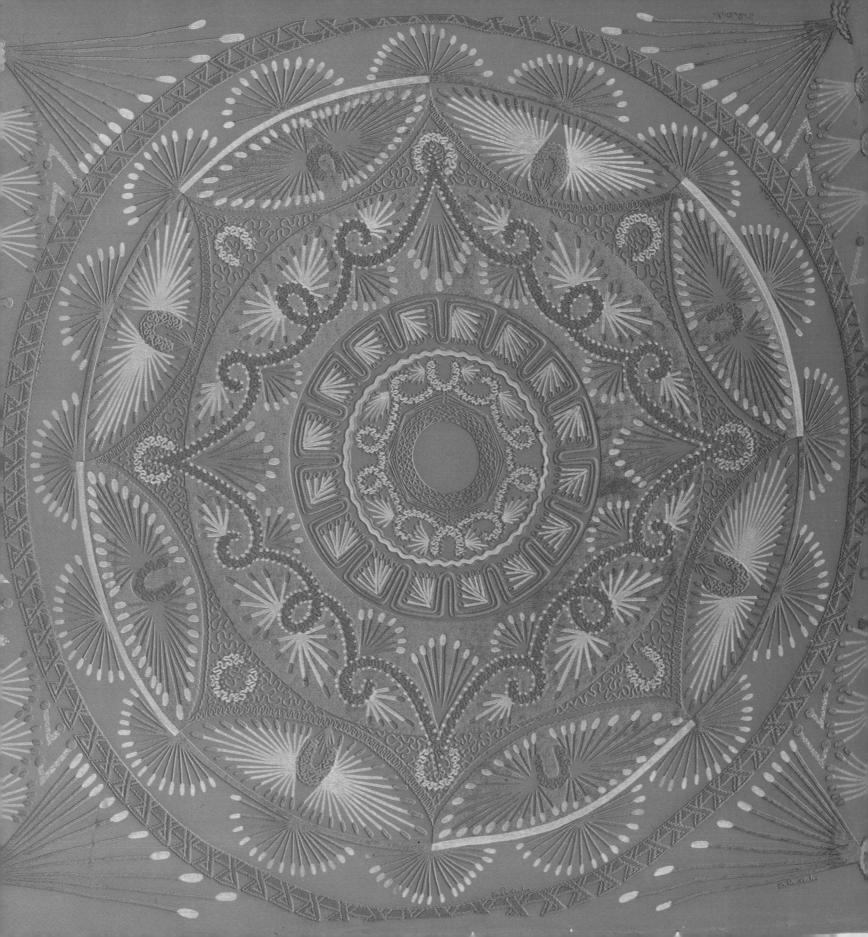

'Mexican Dinner Plate' came from the centre of the Mexican circle. I found I was cutting the centre out and wasting the rest of the 'Mexican Sombrero' print so I made this new design to be less wasteful and have plenty of small collars for the dresses (see butterfly nos 108 and 148). 'Mexican Fan' was an explosive version of the 'Mexican Sombrero' embroidery developed into two fan shapes across the width of the fabric.

Above, three-colour 'Mexican Dinner Plate' print on silk chiffon. Design repeat 35½″ (90·1 cm.), width of fabric 45″ (114·3 cm.).

Right, three-colour 'Mexican Fan' print on silk chiffon. Design repeat 36″ (91·4 cm.), width of fabric 45″ (114·3 cm.).

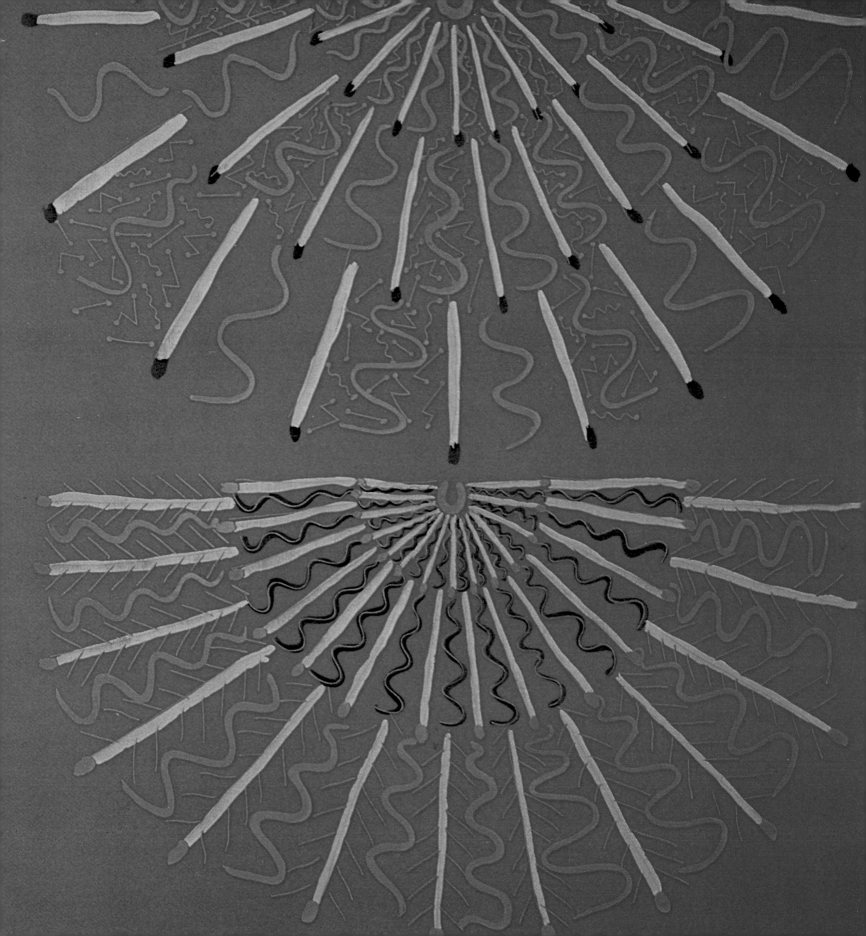

After the sombreros I started to work on drawings of the Aztec temples. My own brick motif (see Chapter 1, page 19) from my early designs began to recur, except that now the lines defining the bricks had a pattern with something definite to say because of the pressed-in Aztec pebble detailing and the dancing fields/Miro motifs being added. 'Mexican Turnaround' was the first of these. A diamond of bricks with small versions of the horseshoe-fan embroidery exploding from the corners. 'Mexican Turnaround' is printed in exactly the same manner as that for 'Reverse Lily' and 'Lace Mountain' (on pages 166 and 167) except that this design, however, had a new twist as it was really a diamond and not a bodice-shape. Because of this, it led to breakthroughs in the petal-type chiffon dresses (butterfly nos 104 and 106) and the format for this type of garment and print interpretation was used again later in the Conceptual Chic (butterfly no. 129) and even further with 'The Chinese Water Circle' (butterfly no. 151).

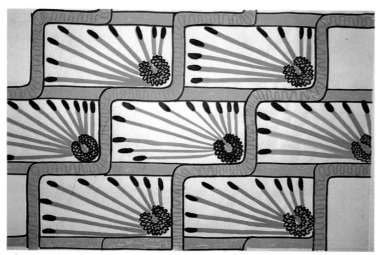

Above, preliminary brick designs

Right, three-colour 'Mexican Turnaround' print on silk chiffon. Screen repeat 26″ (66 cm.), total design repeat 52″ (132 cm.), width of fabric 45″ (114·3 cm.).

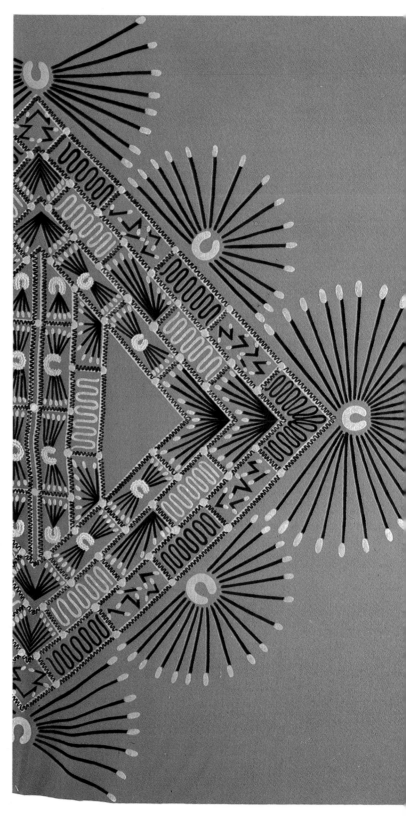

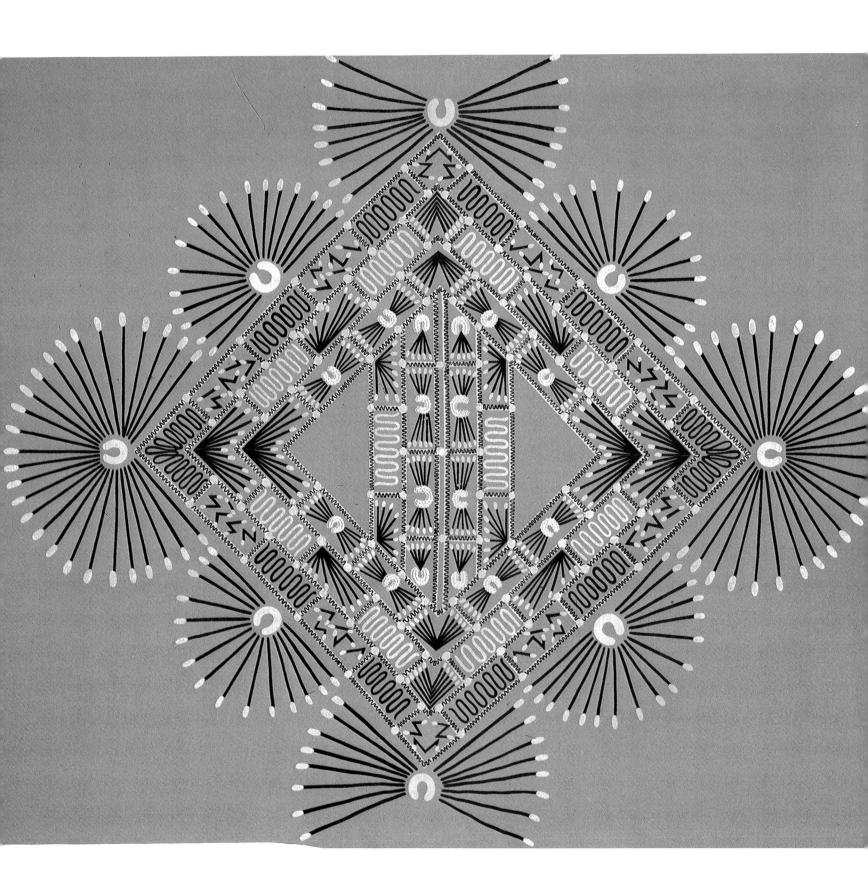

Into this chapter fits another design. This is 'Mexican Banana Leaf' It does not connect directly with the sombrero or brick motifs, but in among the bric-a-brac hotchpotch I absorbed on this trip were the banana leaves. One morning in Oxaca when I woke up very early, I saw some banana palms just by the camp site. I made sketchbook notes of how I imagined large real-sized banana leaves would look on the human body.

When I got back to London I worked on these full-scale leaves—making them 36″ long (71.5 cm) and hanging them from a trellis. I made them uneven and rippled in shape and built up their undulations by using my special wiggles. The spaces in between the leaves I filled with my new dancing Mexican motifs. That is what is so exciting in designing for dress fabrics: to try and calculate for every use a fabric might be put to. My initial idea was to revert to my old technique of cutting up in between the motifs, so that I would be making skirts and dresses with huge, full-sized fluted banana leaves hanging from them (see butterfly nos 112 and 117). I was, by filling all plain fabric space available (with the trellis and dancing motifs), leaving my options open for additional uses of the fabric when I would start to play with it on the dress stand. I topped the strapless chiffon dress with swirling shapes of pleated satin to ripple round the body as the banana leaf edges rippled.

Right, fashion sketch

Far right, preliminary 'Mexican Banana Leaf' design

Opposite page, three-colour 'Mexican Banana Leaf' print on silk chiffon. Design repeat 36″ (91·4 cm.), width of fabric 45″ (114·3 cm.).

168

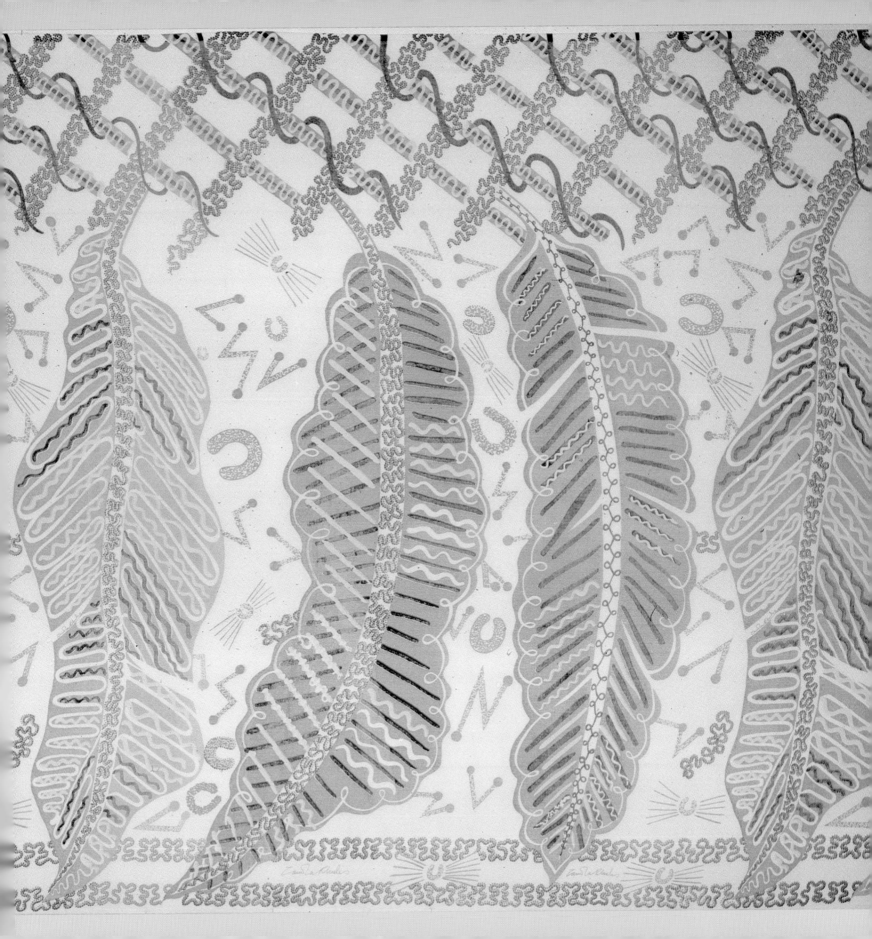

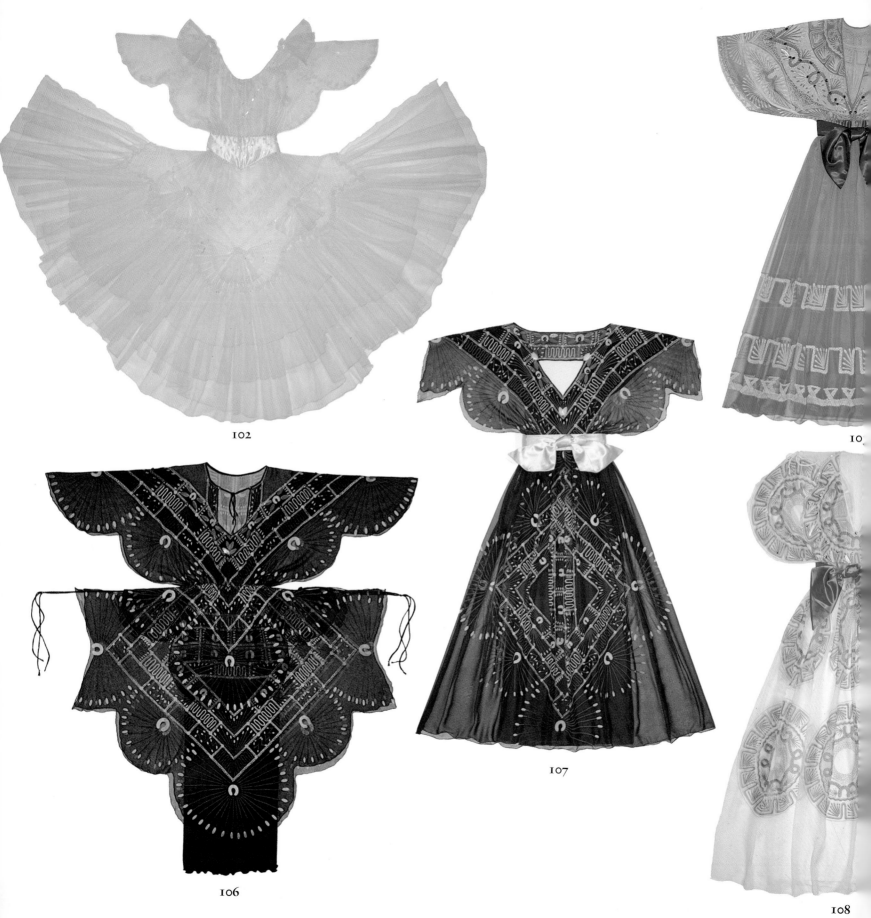

102

106

107

10

108

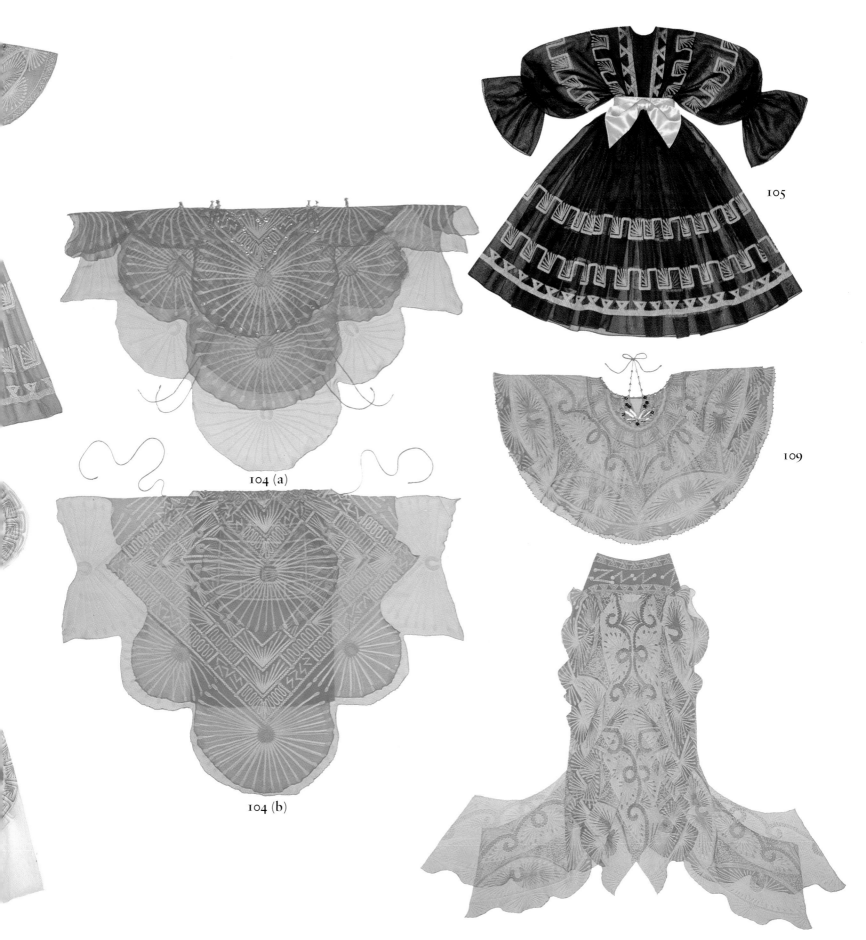

104 (a)

104 (b)

105

109

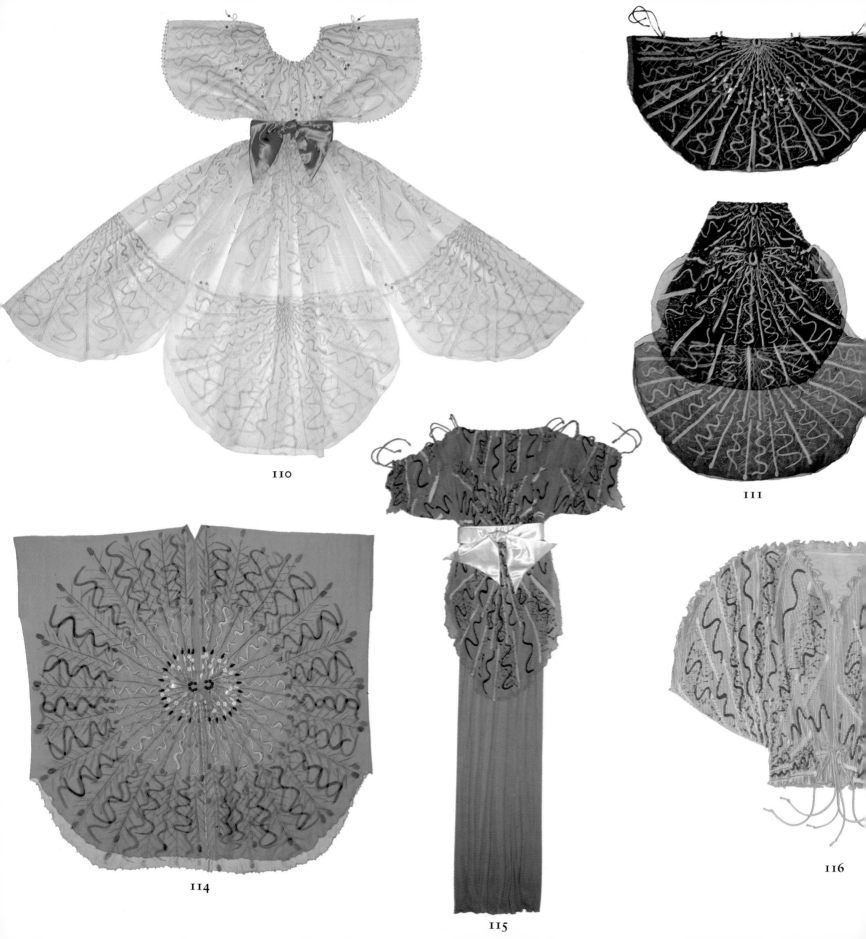

110

111

114

115

116

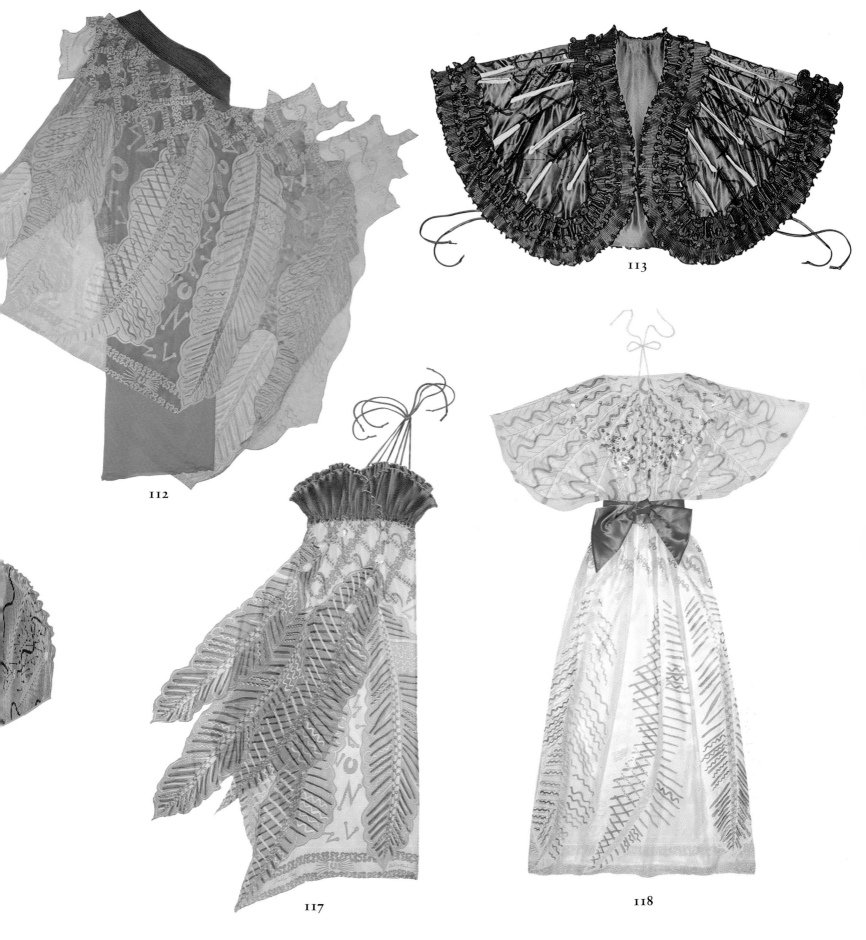

112

113

117

118

CLIVE ARROWSMITH

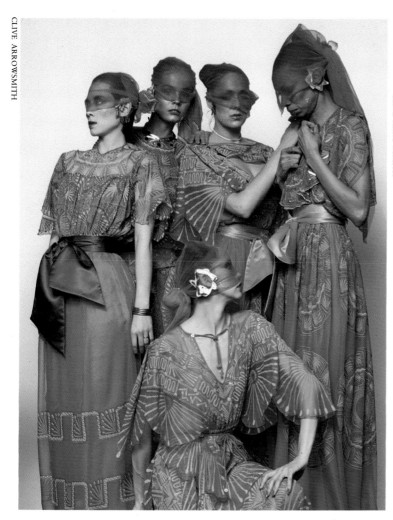

CLIVE ARROWSMITH

Below, back-stage shot from Mexican Show (Butterfly no. 118)

Left, back-stage shot from Zandra's Mexican Show (left to right, Butterfly nos 103, 109, 107, 108 and foreground 106)

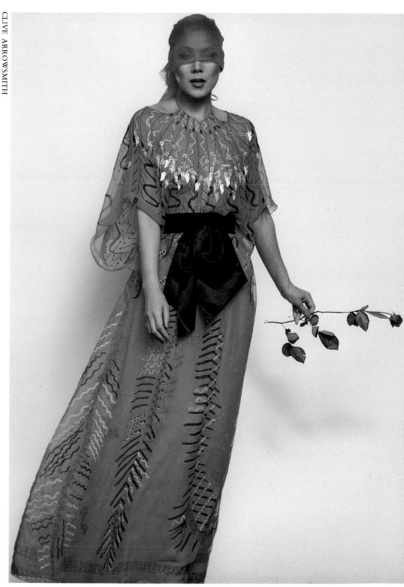

I think that it is here that I should mention that within my own London workroom I had been developing the art of dying beads to match or co-ordinate completely with print and chiffon colour statements. Ever since those early days in Paris when I had hunted out the paillette factories in order to buy paillettes by the million(!) I had been using lovely different bead shapes. These I ordered in basic white, black and iridescent. By dying them, a million more combinations were possible. With the beading beginning to have a character all of its own, it gave a further dimension to my prints. One especially good example is the chiffon jacket (butterfly no. 114). This incidentally is known as 'Sunset Boulevard'—named not by me, as I am totally non-creative in names, but by my staff, who become intensely involved with the designs until gradually special names take over from the catalogue numbers.

On reviewing this Mexican chapter, two things start to jump out at me, one, that the enjoyment of a journey does not relate to the designs that are then inspired by it, since Mexico inspired quite a bout of print designs, and, two, only the prints and their relating colours were Mexican, the dresses ended up being just Zandra Rhodes!

174

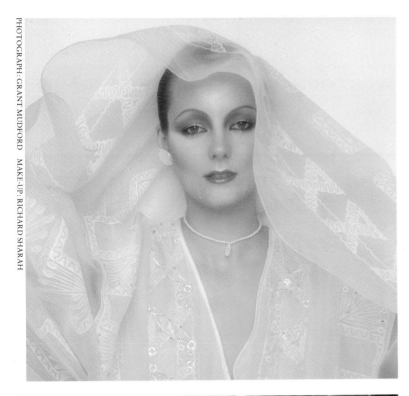

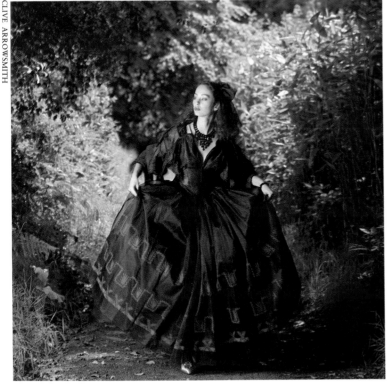

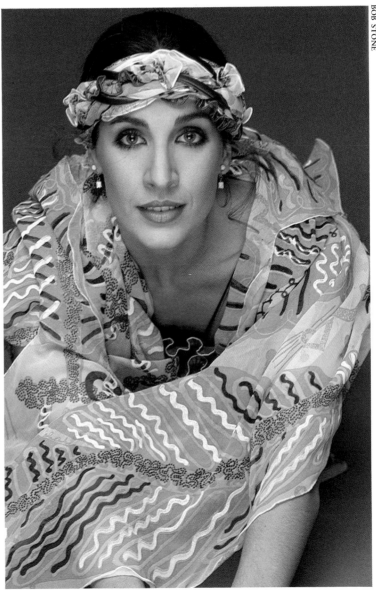

Left, above and below, Butterfly no. 105

Above, Butterfly no. 117

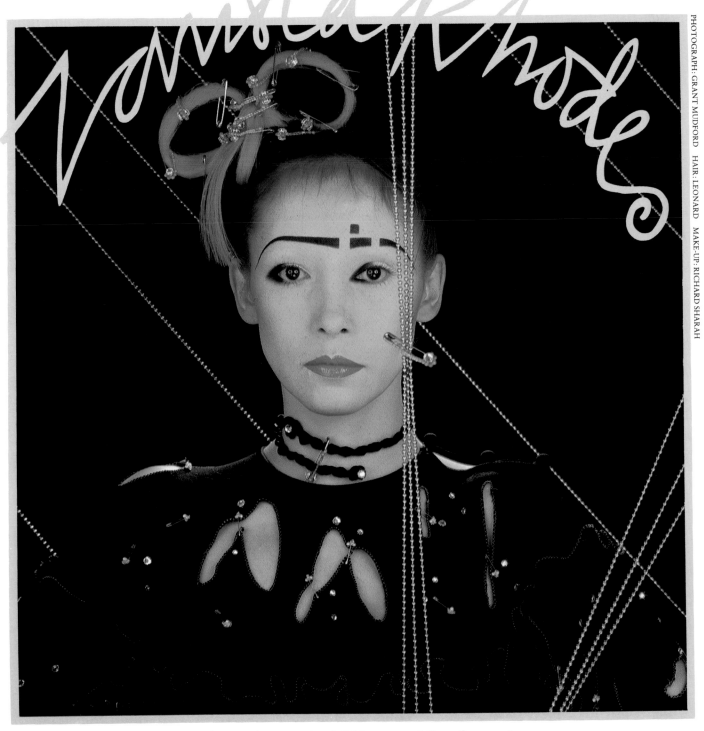

PHOTOGRAPH: GRANT MUDFORD HAIR: LEONARD MAKE-UP: RICHARD SHARAH

Photograph for 'Conceptual Chic' poster, 1978 (Butterfly no. 121)

Conceptual Chic and Punk

1977 was the year I became the infamous High Priestess of Punk—the darling and the damned of the media, but mostly the latter. In fact what I was doing wasn't Punk, but I can't say that it had nothing to do with it. I called it Conceptual Chic—but the press as a voice hailed it as Punk and that's where it stuck.

It was a journey into London street culture, that's true, but as in everything I do there were many influences at work, some lurking away in my subconscious, some staring me in the face, openly challenging me.

I remembered a stunning photograph by Norman Parkinson of Marisa Berenson wearing a Schiaparelli dress. I saw the same dress photographed by Cecil Beaton in the 1974 costume exhibition at the Victoria and Albert Museum. It was an astonishing creation, an absolutely stark tube of silk printed by Salvador Dali. This print had always haunted me, with its surrealistic shapes of jagged, torn fabric; it was almost unnerving and it became rooted in my imagination. The slashes of my Elizabethan silk collection were inside me too and I hadn't fully exploited those yet. I had tried to do a slashed print version of this Dali print but I had not been happy with the results on the drawing board.

Times were changing, there was a pulse in the air and I was starting to pick up different vibrations. I had become somewhat an acceptable establishment figure, so I had to follow my instincts and these instincts had a distinctly hard edge.

Within the English art scene of my friends I was receiving influences and vibrations which indicated the need to change. Duggie Fields was painting his figures with arms and legs missing, breasts exposed and hard 1950s-type fashion images. Allen Jones had been producing his black leather and vinyl clad waitresses and interesting 'art' furniture. Andrew Logan had become London's uncrowned party king and was hosting his

CECIL BEATON

JOHN SUTCLIFFE

Left, Schiaparelli dress with the Salvador Dali print 'Tears', 1938

Right, '"Waitress" Costume' by Allen Jones, © 1971

amazing parties and happenings where the 'underground' mixed with 'above ground' in a land filled with his individual sculptures. It was to Andrew's Gold-field exhibition at the Whitechapel Gallery that I wore a dress with one breast exposed. I felt I could now wear it even though I had shown it first in my cowboy show.

London Street-life was changing drastically. There was a new parade on the King's Road. In the clubs around there and in Soho and Oxford Street, you could feel the tension. Yesterday's youth

doré was suddenly irrelevant and in this atmosphere my floating chiffon butterflies were too delicate, too fragile, uneasy. I didn't feel right putting on any of the things I used to wear.

So I went to work without a print—I didn't even feel like doing prints—I was being challenged from within myself. I knew I wanted something totally and uncompromisingly severe. I didn't start out to shock, but I knew it had to be harsh enough to make an impact. I wanted to convey my awareness of the vibrations which I felt so strongly around me.

I did some fashion drawings on which I tore the paper by hand to make jagged holes (see page 178). Next I took pieces of silken jersey and cut tears in them. These were passed around my studio and we all worked on perfecting the tatters and stitching the edges. It proved to be quite difficult to make a 'beautiful tear' look like a tear. When the stitched edging was put on, it totally lost its shape. So many different types of holes were cut and tried. Then we started decorating and pinning them. The pins were ordinary safety pins, 10p a card, but they had to be rust-proof, and we covered them with tiny seed pearls and wonderful brilliant rhinestones so they were no longer just purely functional but glittering little jewels. Then I made the dresses, very simple unconstructed shapes, and took the scissors and cut the jagged holes—not haphazardly, but strategically placed. I wanted them to be aesthetic, but sexy and seductive as well. Finally, they were fastened with the decorated safety pins and loops of silvery chains (the same link-chains which secured the coathangers in my shop in Harrods to foil shoplifting). I used silken jersey—black, lots of it, but I clashed it against shocking pink (shades of Schiaparelli) and pillar-box red. I sharpened the intensity of the matt jersey with shiny satin sashes. The sash was my favourite of all, a jagged strip of uneven jersey fabric pinned on to the long satin band; then the band could be around the hip (see page 182); or tied around the bust as a halter it was the most glamorous thing!

I had achieved what I had set out to do. I had created fashion which tangibly demonstrated what was happening in my life. I wasn't chasing a rainbow. Parallel but totally divorced from me, was an aggressive youth movement and people were frightened by it because it was disturbing. One of the most popular clubs was the Roxy—punk in the raw—bloody and defiant. The kids were wearing black plastic garbage bags tied up with safety pins, torn rubber tee-shirts, black suspenders, laddered stockings, bondage strips of dread black vinyl. They had safety pins through their ears and noses, their hair was spiked, green or

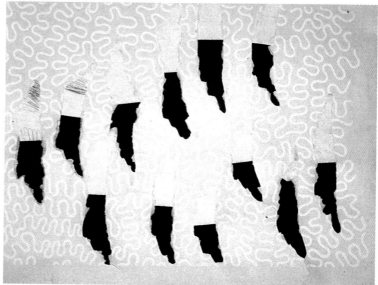

Torn paper ideas

orange, their faces bright white streaked with red. It was a revolution—it was repugnant—it was exciting, it was there, a point of no turning back in style.

While I was doing this what was so exciting about the Collection I was preparing, was the theory that developed but which was never really taken up; that in the world of today where there are fewer and fewer resources we should be able to see a movement of this kind as folk art in just the same way as we admire strength and beauty in primitive tribes. Why can't our eyes be developed to see a tear strategically placed as being just as beautiful as an embroidered flower, a safety pin just as valid as a bead? Why does a sleeve have to be sewn in—if it is pinned amazingly it can be changed.

Of course, I was treading on taboo ground, overstepping the acceptable boundaries. Safety pins and bathroom chains are not jewellery—or are they? It is my job to see things in a different light. So I set about trying at least to market myself and my extreme products correctly. I made little safety pin/brooch kits to sell in my shop, but I made them exquisitely and sold them with a beautiful label containing the following message:

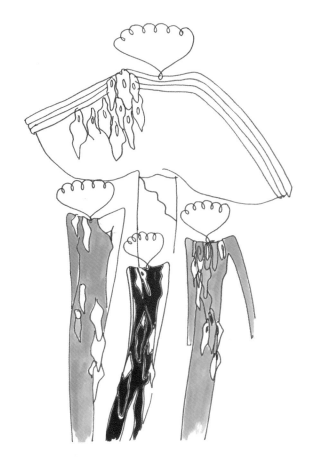

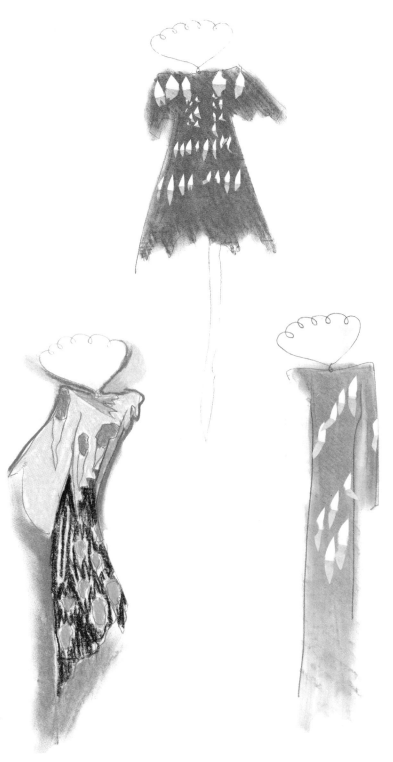

Pastel fashion sketches with real tears

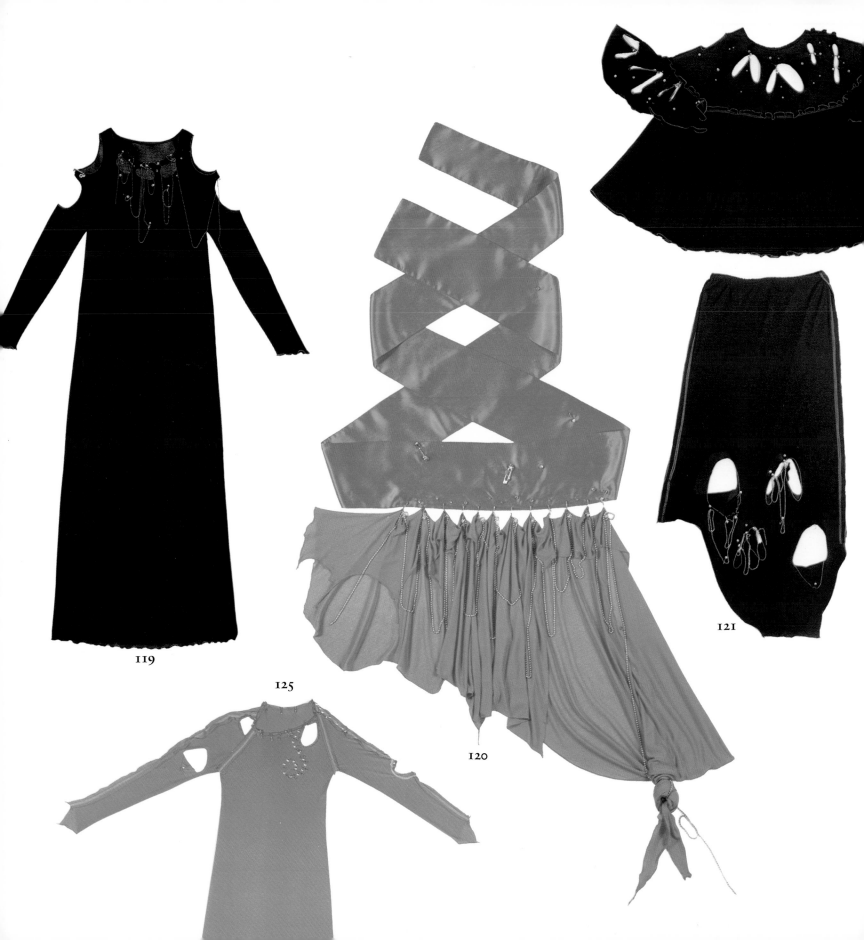

119

125

120

121

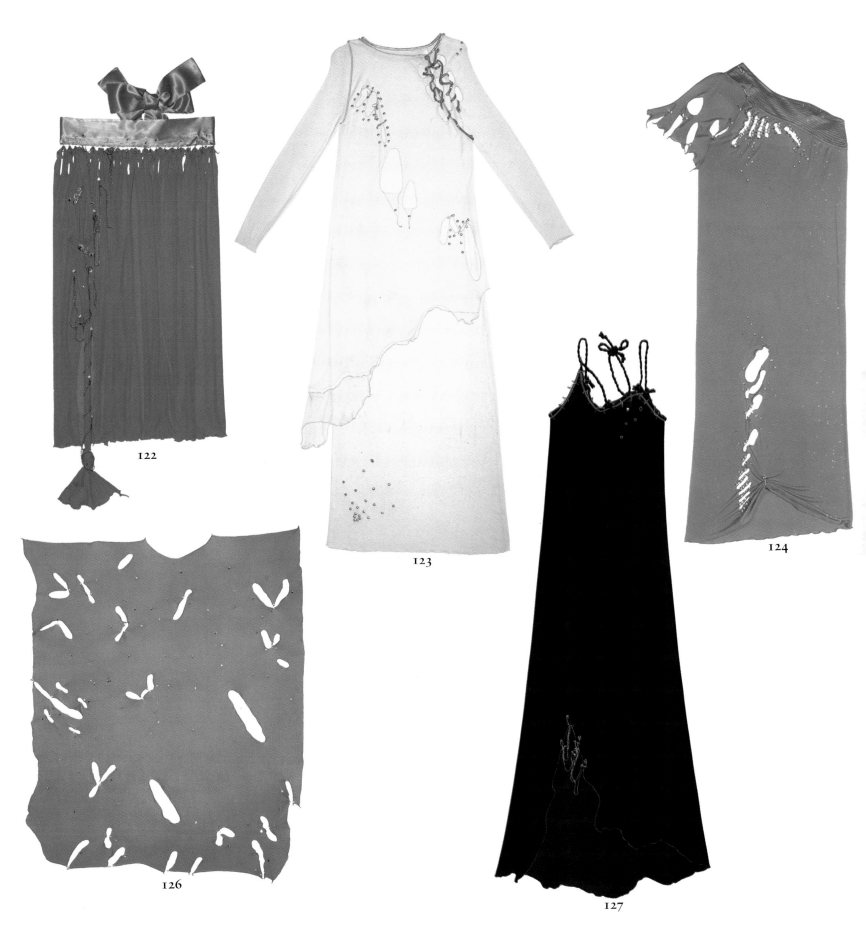

122

123

124

126

127

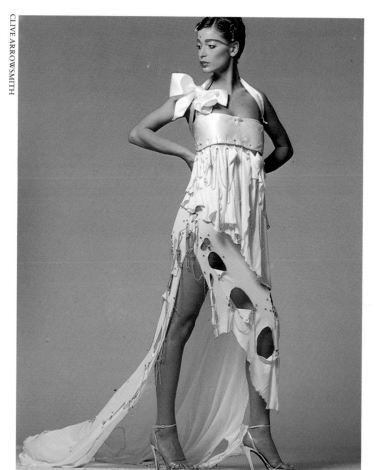

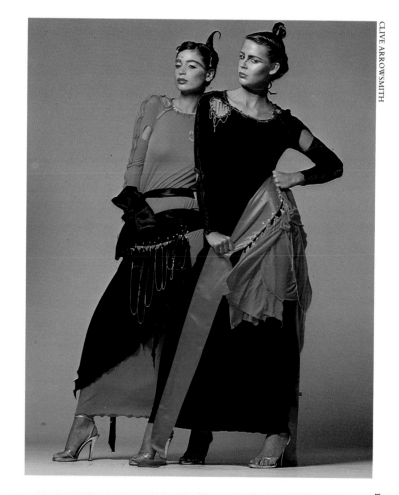

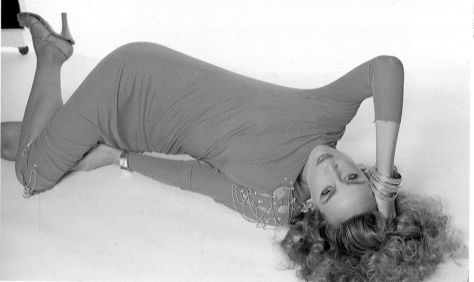

With Richard Sharah, I found 'the face'. It was an asymmetric look, eyebrows shaved and replaced by morse-code signals, punctuated with square beauty spots. Leonard twisted and tied the hair with chains and jewelled safety pins (see photograph page 182 and poster page 176).

What is shocking today becomes acceptable tomorrow. These experiments in tears led to several print designs including my 'Broderie' prints which paradoxically are the most refined and delicate I have ever done. The prints didn't come easily. I kept experimenting with the torn fabric and it didn't work. So I pinned on the wall of my studio a series of different jersey squares, each one with jagged and tattered holes fastened with jewelled safety pins and hung with the silvery chains. I drew these exactly as I saw them in front of me and then I was able to turn the drawings into a print—'Punk stole'. I used 'Punk stole' for a stole (pages 184–5). I took a piece of this printed fabric, the size of two complete repeats, and cut holes in it, embroidering all the edges with pearls. It was amazingly versatile because you could put your arms through the holes to make a loose jacket, or tie and knot the fabric through them in almost endless variations. One of the models in my show discovered seventeen different ways of wearing the stole. My customers loved it too, using it as a summer shawl to glamorise quite simple under-dresses.

'Broderie' and 'Torn Square' followed. These were originally designed for Schiffli embroidery on the lines of a torn broderie anglaise for lingerie. They were never used in this way, but the crude stitching and uneven borders were turned graphically into a two-colour print design. Eventually the 'Broderie' prints were used for the ethereal, graceful ballgowns which were worn by my most aristocratic clients. They made enchanting wedding dresses for demure young society brides, ragged hems so lyrically worked, that the possible glare and fright of their real source was softened, and the effect was so flattering that a lady might never know that all this could be linked to a night at the Roxy.

Also to launch this look, I had the whole of my shop re-done. Ben Scholten and I did a whole pink jersey torn tree with chains

Opposite page:

Top left, punk wedding dress worn with Butterfly no. 120

Below left, preliminary make-up idea using decorative mask and safety-pins

Top right, Butterfly nos 120 and 125

Below right, Jerry Hall

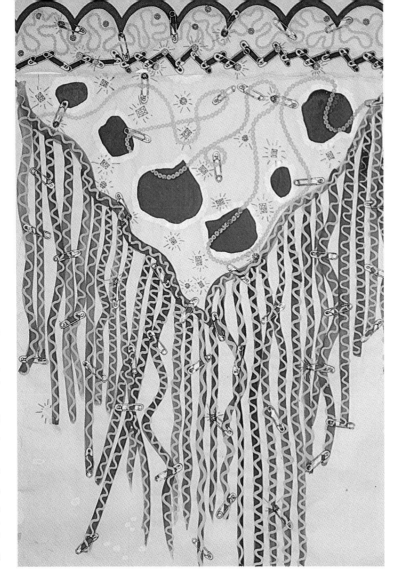

Preliminary textile idea

and safety pins and torn front curtains to match. The clothes in this window looked like the works of art I had always claimed them to be. That chic corner of Mayfair caused a minor sensation.

If you believe, as has been said, that 'clothes are a revealing reflection of the times in which we live' then I was ready to present my contribution. It caused a minor front-page scandal in *Woman's Wear Daily* and *The Chicago Tribune*, and Joan Buck, then of the *Sunday Telegraph*, was one of the few who understood what I was trying to say. For the rest it was almost a howl of derision and no one would report it. I still believe it was a major landmark in my work and now, years later, everyone agrees with me.

Above, diagram showing where holes and edges were cut on 'Punk Stole'

Right, three-colour 'Punk Stole' print on silk chiffon. Design repeat 35″ (88·9 cm.), width of fabric 45″ (114·3 cm.).

Below, 'Punk Stole' in two different colourways worn by Cathee Daymon and Tina Chow

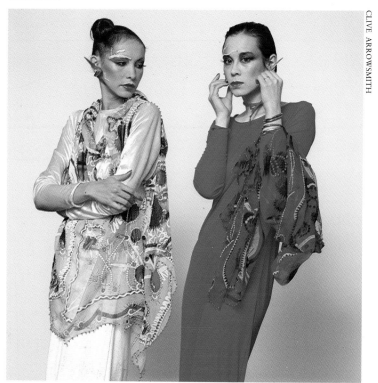

Over page, left, 'Broderie' print using two screens (one screen rainbowed to give three-colour effect) on silk chiffon. Design repeat 35″ (88·9 cm.), width of fabric 45″ (114·3 cm.).

Over page, right, three-colour 'Torn Square' print on silk chiffon. Design repeat 36″ (91·4 cm.), width of fabric 45″ (114·3 cm.).

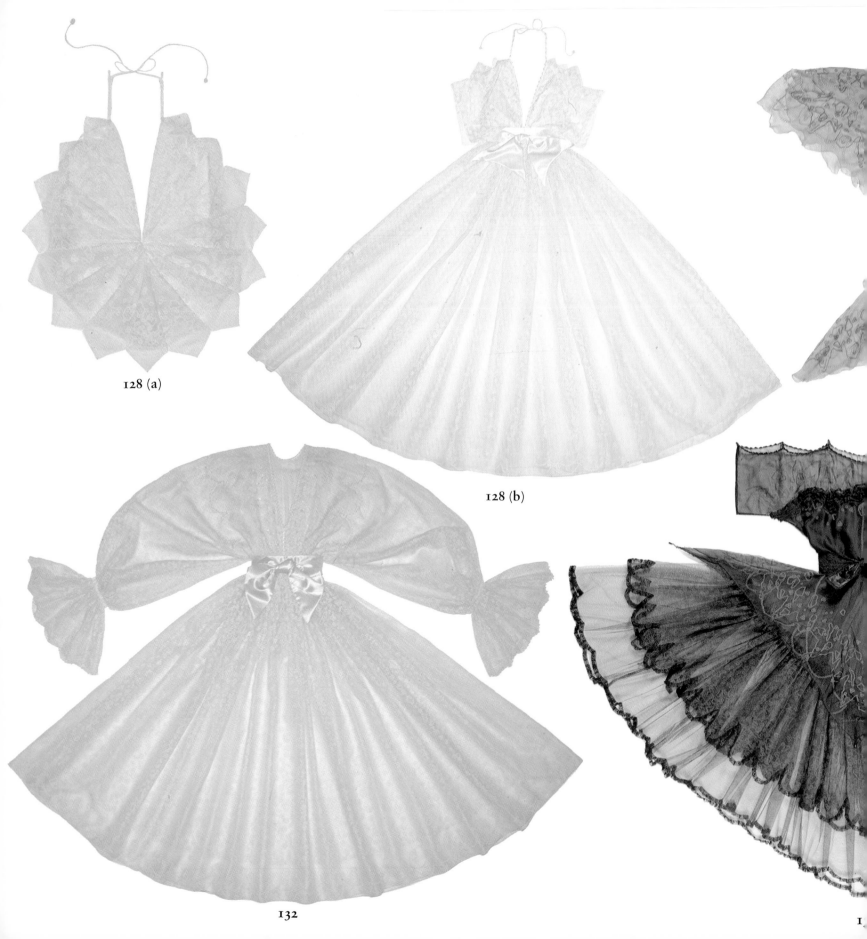

128 (a)

128 (b)

132

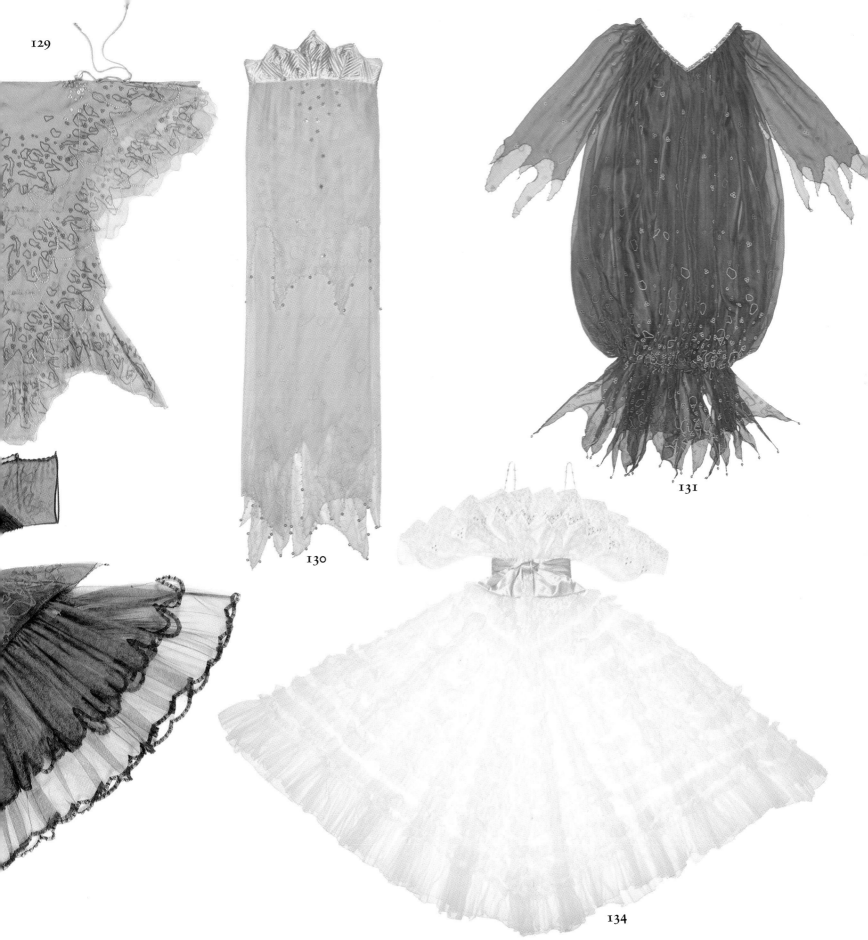

129

130

131

134

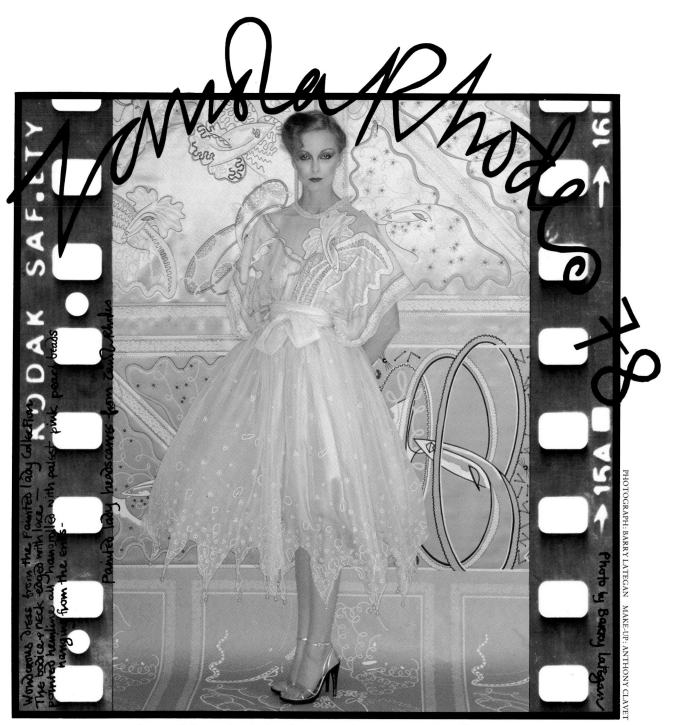

Wonderous dress from the Painted Lady Collection. The bodice + neck edges with lace — Painted hemline all hanging with palest pink pearl beads — hanging from the ends —

Painted lady headscarves from Zandra Rhodes

PHOTOGRAPH: BARRY LATEGAN MAKE-UP: ANTHONY CLAVET

Photo by Barry Lategan

Photograph for Zandra Rhodes advertisement for *Vogue*, 1978 (Butterfly no. 135)

My Head and Heads in the South of France

Christmas 1975 was not a success. Grant and I had been invited to stay with Bryant Halliday, an American horror-movie maker, who had a marvellous rustic house near Vence in the south of France. I had memories of a previous Christmas there with my Texan friends Jerry Pennick and Richard Holley, which had been terrific. We had threaded coloured popcorn garlands and oranges on to a huge festive tree and everybody exchanged lovely presents. We played charades and had a thoroughly wonderful time. I had sat until the small hours of the morning doing a huge jigsaw puzzle while Alex played on the flute and the others sang negro spirituals round the piano.

I thought this would be repeated, but more so because I would be with Grant. In fact, things started to go wrong well before we left London. Grant was never happy in England—he missed the sun and hated the damp cold. He didn't feel fulfilled working in London either. Photography as an art form wasn't greatly appreciated in England, and then he always seemed to have a lot of difficulties finding the right facilities he needed to get his work together. Anyhow, we were both trying to make the relationship work, and he'd brought with him all his cameras and photographic equipment. The day before we left for the South of France, my house was burgled; and five of his cameras were stolen. He was completely devastated by the loss and went into a terrible state of depression.

I felt guilty and responsible for what had happened in my house and was miserable about it myself. I could not get him out of his mood, nor was I capable of putting my mind to preparations for our stay with Bryant. (I always do everything very systematically at the last minute!) So that's how we started out and nothing improved. Combined with that, Jerry Pennick had decided not to come; and he had always been one of my mystic muse soul mates who had accompanied me through the adventures of the cowboy and punk. He would come to my studio at night and talk all my themes out with me. In my Conceptual Chic stage he gave me encouragement, living excitedly with me on the limits of fashion taboo and reaffirming the mystery of life; he had loved the strength and beauty found in primitive tribes that he felt I had brought back to fashion. I had looked forward to his influence this particular Christmas. So the atmosphere was not festive. I couldn't sleep—something I had never experienced before—I was up and wandering around before five in the morning so I *had* to draw.

For the first time in my life, I had absolutely top quality drawing materials which had been given to me by Barbara Nessim, a painter in New York. Barry Zaid had introduced us, and we had a tremendous mutual respect. I usually find it difficult

Left, Barbara Nessim in her studio *Right*, pastel by Barbara Nessim

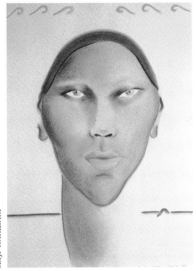

to explain my work and why I do things the way I do; but when I talked to Barbara, there were no barriers—she understood my motives, and there was a harmony between us to which I responded. She encouraged me to think about my work very much more seriously as a lasting art form—not only an expression of textile and fashion design. She felt I had more to give, that I was an artist creating three dimensional works of art. Her first lesson was on using only and always the very best artists' materials available. She said I had to stop drawing in any sketchbook that came to hand, or on odd sheets of paper from the waste paper basket.

So there I was in the South of France at five in the morning with my beautiful new watercolour pad, inevitably reminded of Barbara and of the pictures of women's heads she had been painting in New York (page 191). I started to draw heads—they were nothing like hers, but I felt her inspiration behind them—if there were another influence, it would be the refined elongated forms of Modigliani. I started with a single-line drawing, then went back to it and filled it in. Sometimes it took on life of its own, the hair flowing out from the forehead in ripples, like waves in a breeze. I would go back to these heads and wash them with watercolours. I loved my painted ladies; I felt they had taken my work to another plane, and I wanted them to stay there. They were something valuable and private that I did for my own self-expression and exploration. I gave one or two to very close friends as extra-special presents, but I had no thought to use them commercially—only as a non-commercial exercise to free my brain from fashion and 'design' and just let my hand lead me and release me from the terrible restraints of always having to do a Collection. They added a new dimension to my life.

So they remained shut away until 1978 when I was struggling with my Autumn/Winter Collection. It needed excitement and some new input. First, I put the Heads into 'art work' head scarves. Three designs, each a yard square, first one head then the square divided diagonally into two heads, and lastly into four (see opposite). After this short life as head squares, I then printed the same on felt and ultrasuede, and made big wide-boy jackets with the head cut out and placed on the back, embroidered with brilliant rhinestones; and I gave these jackets odd asymmetrical outside seams to play against the appliquéd heads. The 'Painted Lady' dresses were a different challenge—how to make a different-looking dress out of a square first designed to be a head scarf. The most interesting was the 'Painted Lady' dress used by Fabergé for their 'Touch of Class' perfume (page 200). Here, the

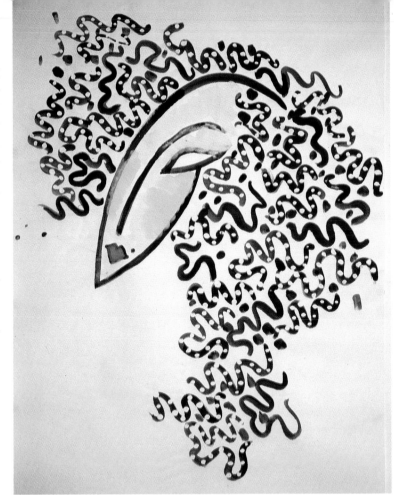

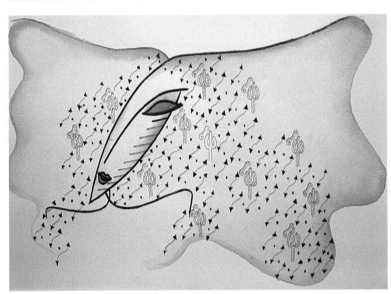

Top, 'Head' in gouache and ink
Above, 'Head' in pen and watercolour

Four-colour printed 'Painted Lady' headsquare on silk chiffon. Size 34″ (86.4 cm.) square. *Top*, style 'L'; *bottom*, style 'F'.

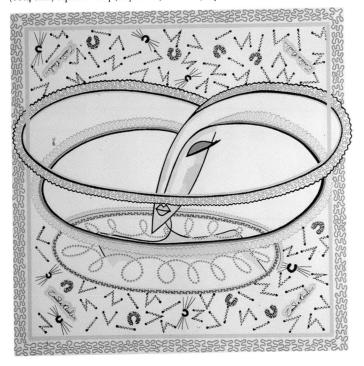

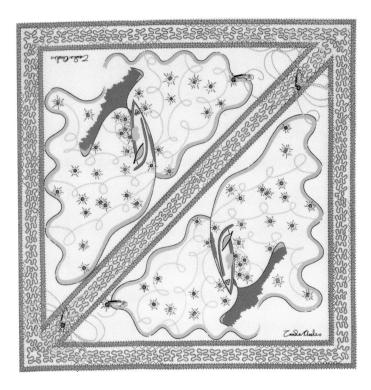

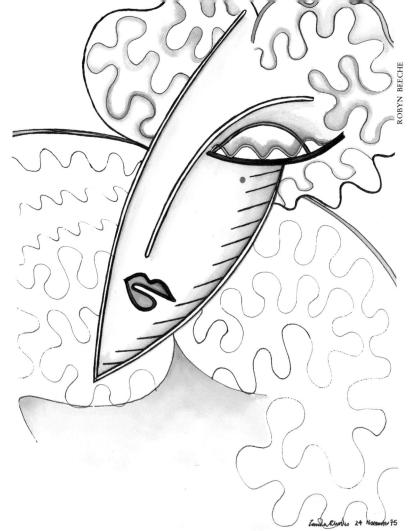

'Head' in pen and watercolour

square was made into a bodice, still keeping the heads but working out an asymmetrical appliquéd lining that would make the dress exciting. In the end the whole of the centre of the square was replaced with silken tulle with gathered lace and pearls around the neck and lace around the square's edges.

From then on the painted ladies took over. I designed the 'Painted Lady' brooches and buttons, made in resin. The inspiration here was Schiaparelli's 'Circus Collection' buttons which I had seen at Diana Vreeland's 'Extraordinary Women of Fashion' exhibition at the Metropolitan Museum in New York. Since then, I have made small 'head' squares for handkerchiefs too; and the 'Painted Lady' head is printed on to sweatshirts and tee-shirts and then embroidered with glittering stones.

The use of the head for headsquare prints was only the

beginning. The next hurdle was to work out all-over print designs that would have more use than just being reproductions of my drawings. Essential elements had to be simplified so the head became a symbol with its eyebrow, one eye and wavy lines for hair. Once it was there, what could go with it? Ben had been asking me for a long time to use a question mark as a motif, so 'Magic Heads' came into existence as a one-colour print with its strong linear symbols including the heads. Then I tried to use ideas that would replace those tiny wiggles of mine, and would also act as a nondescript filler for such things as shading or backgrounds. In the technique of pigment printing (which I use) solid blotch* grounds present a problem, because, when printing on finer fabrics and especially silk chiffon, too much dye coverage makes the fabric stiff and boardlike so other means have to be found to print a solid colour effect on fabric. So I started playing around with little scribble motives. 'Scribble Turnaround', the next design, used this scribble technique and gave me virtually total coverage of the cloth in a very Zandra manner (see pages 196 and 197). Other designs using scribble as shading or accent were 'Scribble Border' and 'Painted Lady Scribble'.

One-colour designs have always been difficult to use because accent colours have nothing to be linked with for belts, satin quilted bands or beadwork. All contrasts jump out too much. I was also wanting to create again some harder designs with a 1950s type of striped approach—so I added two more screens to the 'Magic Head' design, making it become 'Magic Head Stripe'. Here my strong stripes were formed with hard matchstick-type scribble lines as a background to the original 'Magic Head' linear motifs. Another version, 'Magic Head Wiggle' is also shown on pages 194–5 demonstrating the use of different screens around the original 'Magic Heads' to achieve another print simply.

*Blotch is a term used in textile printing to mean a printed, solid colour background.

Right, three versions of 'Magic Heads':
(left) Three-colour 'Magic Head Stripe' print on silk chiffon using two additional colours to make a stripe. Design repeat 27″ (68·5 cm.), width of fabric 45″ (114·3 cm.).
(centre) Original one-colour 'Magic Heads' print. Design repeat 27″ (68·5 cm.), width of fabric 45″ (114·3 cm.).
(right) Three-colour 'Magic Head and Wiggle' print, two new screens added to give another totally different effect. Design repeat 36″ (91·4 cm.), width of fabric 45″ (114·3 cm.).

Over page, three-colour 'Scribble Turnaround' print on silk chiffon. Screen repeat 27″ (68·5 cm.), total design repeat 54″ (137·1 cm.), width of fabric 45″ (114·3 cm.).

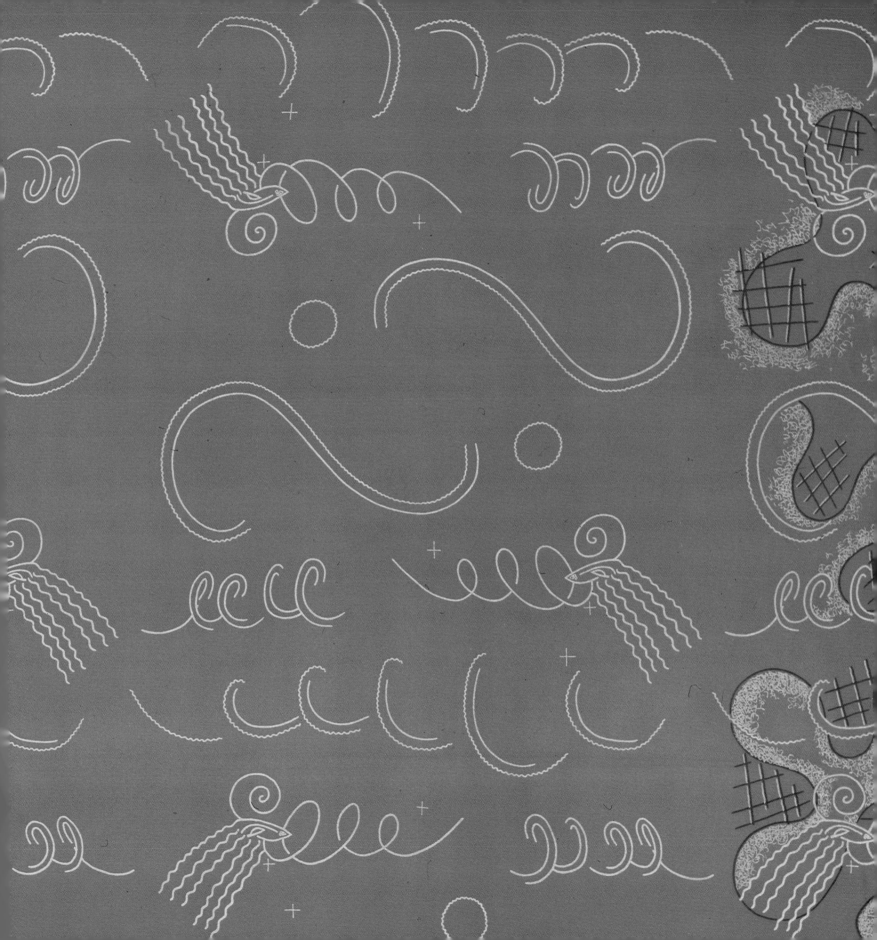

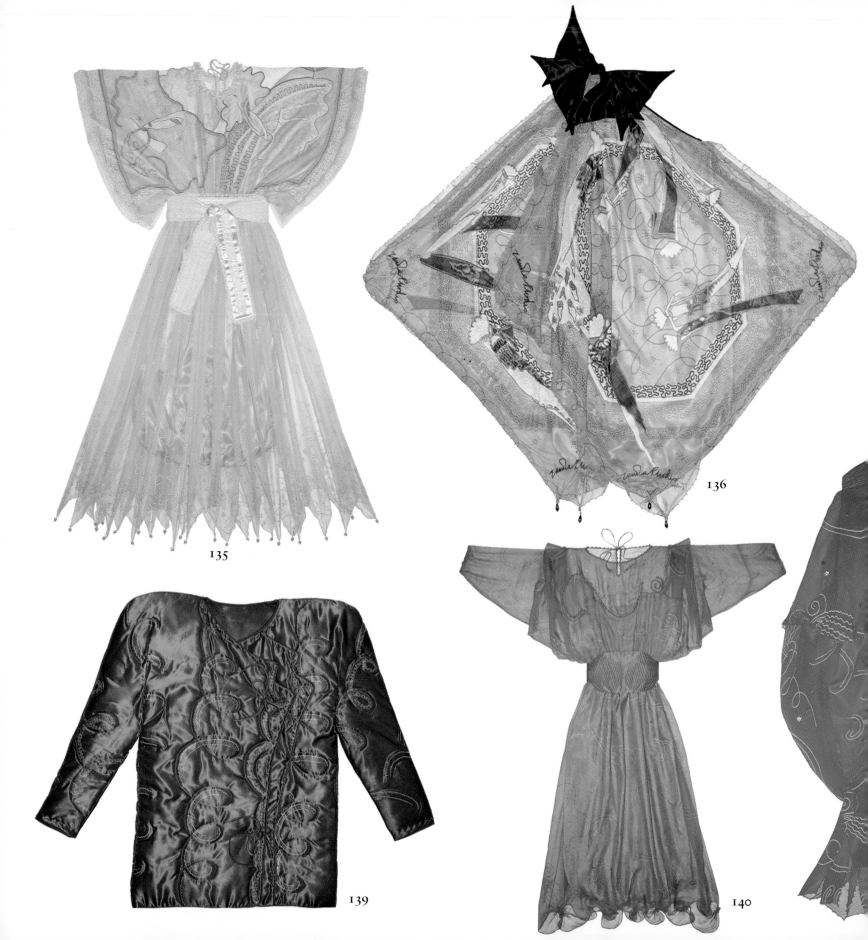

135

136

139

140

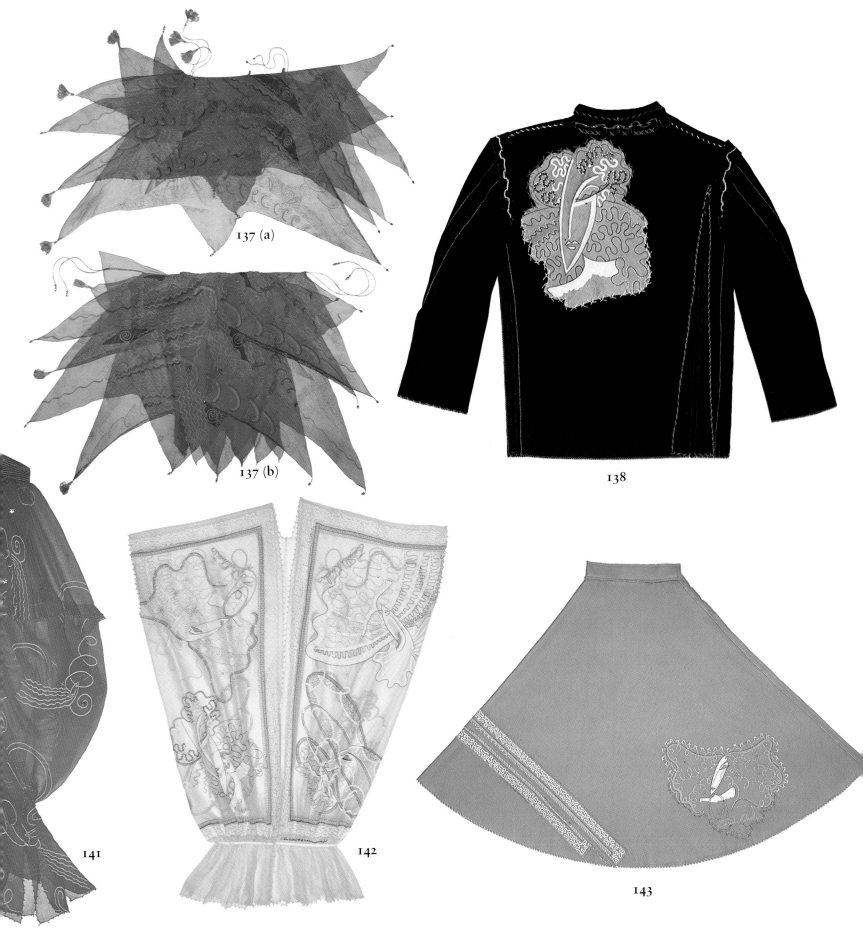

137 (a)

137 (b)

138

141

142

143

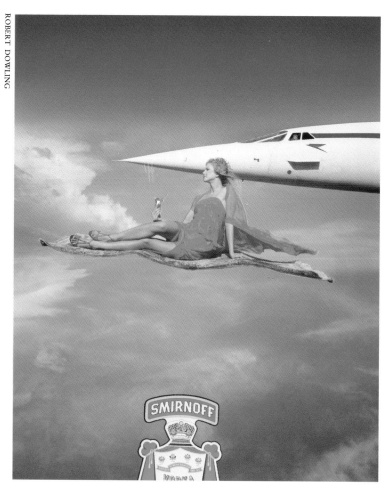

Above, a Smirnoff advertisement (Butterfly no. 141)

Above right, a Fabergé advertisement (bodice of Butterfly no. 135)

Below right, Marsha Hunt with Mick Milligan brooches

Vogue photographed the 'Painted Lady' jacket and Barry Lategan asked me to put painted ladies on the backgrounds of his photographic set. When he was hunting through all of his transparencies to help me find essential pictures for this book, he came across some quick snapshots he took of me painting the backdrop (see page 201). Anthony Clavet did the make-up for that particular session and he did meandering 'Z's for eyebrows. Put together they made ZZZZ which I think is a wonderful tongue-in-cheek comment on the fact that not only am I Zandra with a 'Z' but I'm always falling asleep ZZZZ!!

To date I have used fourteen different 'Painted Lady' textile designs. The 'Painted Lady' is now recognisably Zandra Rhodes in the same way as the 'Lovely Lily'. My new perfume bottles are a 'Painted Lady' head. She appears, very tiny, in my signature print, which has also been made into a jacquard weave. I find the head an ideal way to capture the living essence of whatever look I am putting over; drawing on to these heads the correct make-up, jewellery and hairstyles in an imaginative manner. So, when I do the drawings for my fashion collections, I do them to represent and christen all the themes; there are African, Chinese, Cowboy and Indian Heads—no doubt I will continue this pattern, and there will be other heads in my head.

I shall love them all, but I can't help feeling some pangs of remorse that my original 'Painted Lady' has now been absorbed into my repertoire—I think I would like her to have stayed in her place in 'fine art' and only for museum exhibits.

PHOTOGRAPH: RICHARD DUNKELEY HAIR: TREVOR SORBIE

Above, Butterfly no. 138

Zandra's resin brooches

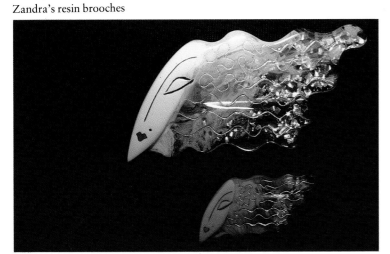

Los Angeles and Star Wars

STAR WARS—another Christmas—another year—1977.

I had been to Los Angeles many times—it's paradise—I can't get enough of it and its instant inspiration. I always stay with Joan and Jack Quinn, who are discerning collectors of modern art and the friends of all the West Coast artists. Joan is a dynamic person with amazing energy and interested in everything; and when I am there, she chauffeurs me around in her green Cadillac, anywhere I want to go and always leading me in new directions and recording everything with her Instamatic camera. (That is how we got to know each other, because, years before, when Allen Jones brought her to my London Studio, she left her camera; and all hell was let loose until it was found.) She is a very social lady too; so the social scene takes me over. It suits my

'Washington Boulevard' by David Hockney. Crayon, $13\frac{1}{2} \times 10\frac{1}{2}$ inches (34.3×26.7 cm.) © David Hockney 1964

temperament perfectly, it's go, go, go all the time—marvellous! And I dare not miss a moment—it is, all of it, breathlessly exciting. This is a page torn out of my diary and for me, typifies any day in L.A.

8.0 a.m.	Exercise class with Joan and ex-Russian ballet star, Tatiana Riabouchinska Lichine. Emmanuelle Khanh joins us. Drive back via star-studded homes route. Stop at Danny Thomas's to take snap.
9.30	Breakfast interview and photographic session with Mary Lou Luther for the *Los Angeles Times*.
10.30	Mary Lou Luther takes us to meet Edith Head, the great movie costume designer. Call in on Billy Al Bengston for Joan to select latest painting.
12.00	Fittings with Eydie Gorme, and then Mrs Charles Bronson. Wave to Diana Ross as we drive back along Beverly Hills.
1.00 p.m.	Lunch at the Bistro with Contessa Cohn, Joan Collins and Mrs Harold Robbins. Jody Jacobs chats with Joan. Nancy Reagan also lunching there with Mrs Walter Annenberg. At another table, Mrs Norman Chandler and Mrs Gregory Peck.
3.00	Present slide lecture to patrons of the Los Angeles County Museum—Larry and Mai Hagman pop in.
4.30	Tea with David Hockney at Gemini, where he is doing some prints. Ed Ruscha is next door working on his cheese-mould screen prints.
6.00	Home to catch breath and return telephone calls. Jo Goode called. Andy Warhol called to confirm Joan's visit to Houston for his book opening. Regis Philbin's office called to confirm time for my car for next day's 'Good Morning, L.A.' show. Watch Quinn twins try on my dresses, quick coffee, chat with Jack, change.

7.00 Drinks with Ann and Kirk Douglas.
8.00 Attend opening of Divine's new film 'Polyester' with John Watters and Tab Hunter.
11.00 Go back to the Chateau Marmont Hotel for drinks with Divine. Talk to Russ Meyer and Paul Morrissey while there.

Back to 1977—I had gone to L.A. to spend Christmas with Grant—it was another near-disaster. This time I was ill with labyrinthitis (an ear infection) and spent the entire holiday in bed, unable even to sit up and sketch. When I finally could stand up, I started to get around to do the things I already had in my mind and find the inspiration that would spark me off. I wanted to do a Collection influenced by Los Angeles. I didn't know what form it would take. For me, David Hockney epitomised L.A. with his paintings (see page 202), but I didn't want to echo that. I had drawn the incredible Watt's Towers—an amazing construction of arches and spires studded with broken china and glass—but nothing came of that. I drove in my white 1950s Thunderbird Convertible from 'Rent-A-Wreck' to the Griffith's Observatory (the white 1930s museum where they had filmed 'Rebel without a Cause') so I had planets and heavenly bodies spinning around my mind and in my sketchbook. With hindsight, I can see the catalyst was the film 'Star Wars', that had just opened at Grauman's Chinese Theatre and was the talk of the town. So more extra-terrestrial images started to find their way into my sketchbook.

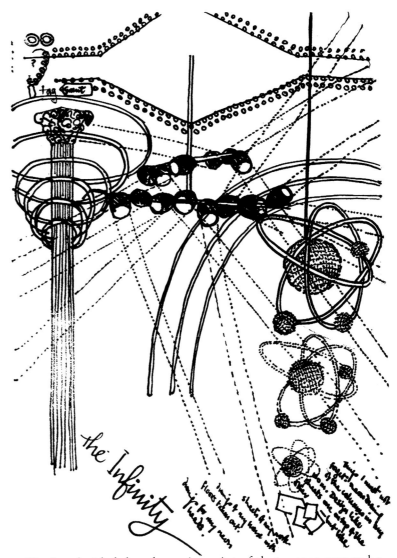

the Infinity

Left, Tesla coil
Right, 'The Space Mural—A Cosmic View' by Robert T. McCall
Above right, Sketch of lighting in a New York night club

Having decided that the major print of that season was to be influenced by space and planets, the next step was to collect all the information available. As I am an avid collector and sender of postcards I had gathered postcards & slides from both Griffiths Observatory, Los Angeles, and the Space Museum in Washington. The next step was a trip to the Victoria & Albert Museum—the answer to all questions: when lost, pick any direction as long as you pick a direction. There I looked through the postcards and it was a print of Eduardo Paolozzi, nothing to do with planets but rather, machinery, that gave me the new angle with its circles and their planet-like trails. Here was the missing link—my planets with their rings began to curve with strange mechanical bends and 'Star Wars' was born.

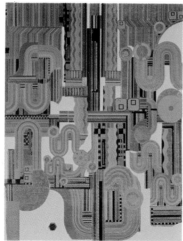

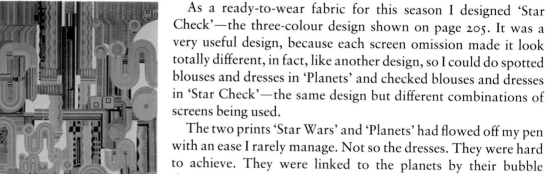

As a ready-to-wear fabric for this season I designed 'Star Check'—the three-colour design shown on page 205. It was a very useful design, because each screen omission made it look totally different, in fact, like another design, so I could do spotted blouses and dresses in 'Planets' and checked blouses and dresses in 'Star Check'—the same design but different combinations of screens being used.

The two prints 'Star Wars' and 'Planets' had flowed off my pen with an ease I rarely manage. Not so the dresses. They were hard to achieve. They were linked to the planets by their bubble shapes—a landmark never enough developed. And I would still like to do a Collection truly of Los Angeles . . .

Above left, sketch of Watts Tower, Los Angeles
Above right, 'Torstai Keskivukko' by Eduardo Paolozzi, 1975

Right, unused textile idea for 'Star Wars'
Below, preliminary design sketches

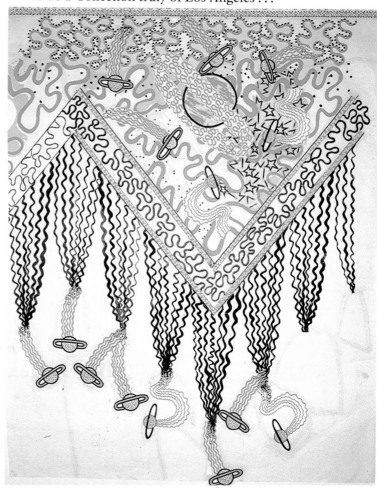

Opposite page, 'Star Check' print. *Left*, 'Star Check', renamed 'Planets' for the one-screen format of this design. Design repeat 36″ (91·4 cm.), width of fabric 45″ (114·3 cm.); *right*, three-colour original 'Star Check' print on silk chiffon. Design repeat 36″ (91·4 cm.), width of fabric 45″ (114·3 cm.).

Over page, two different colourways of 'Star Wars' print in three colours on silk chiffon. Design repeat 36″ (91·4 cm.), width of fabric 45″ (114·3 cm.).

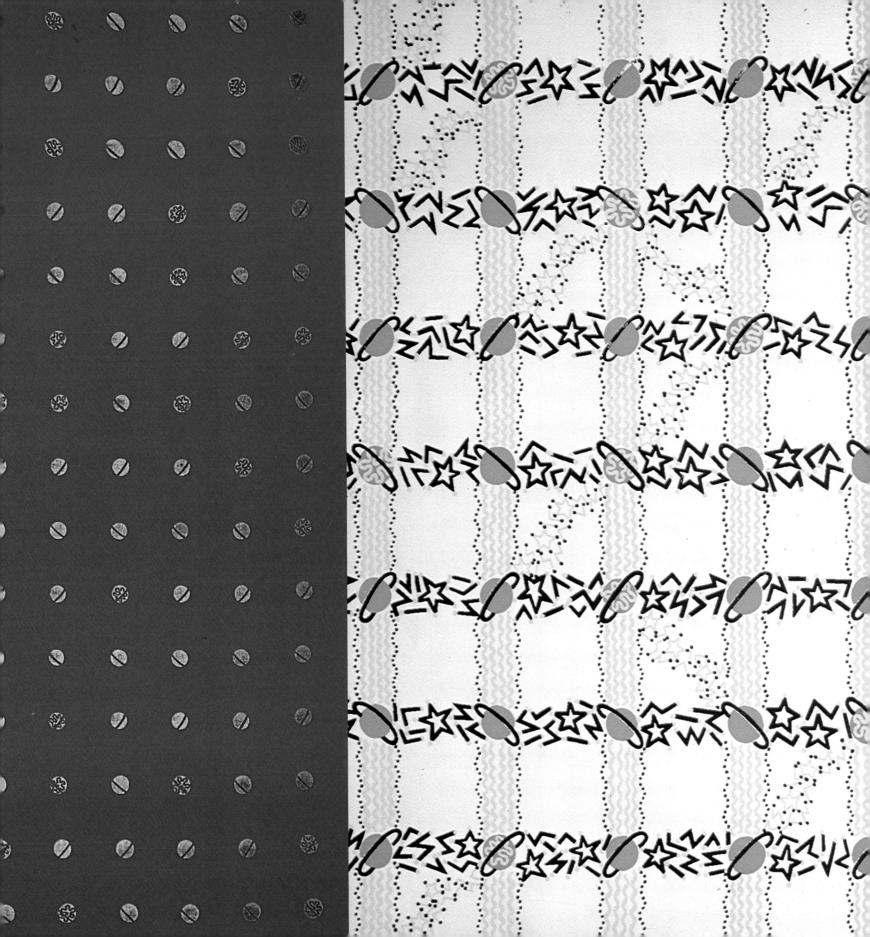

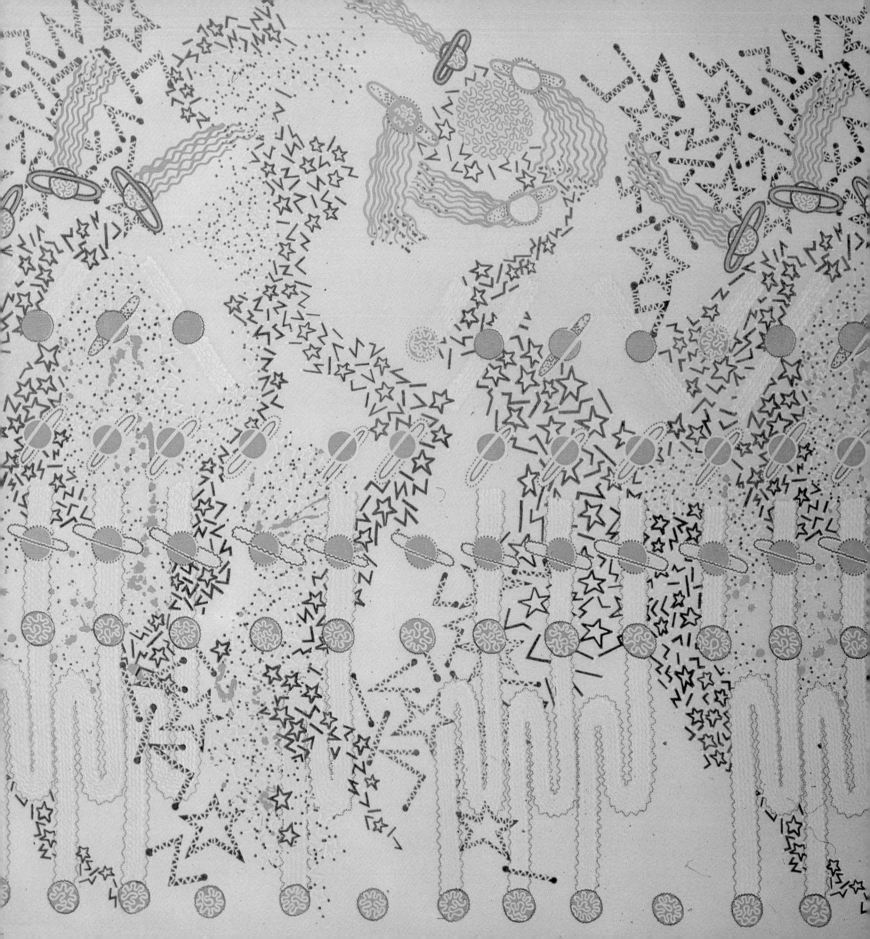

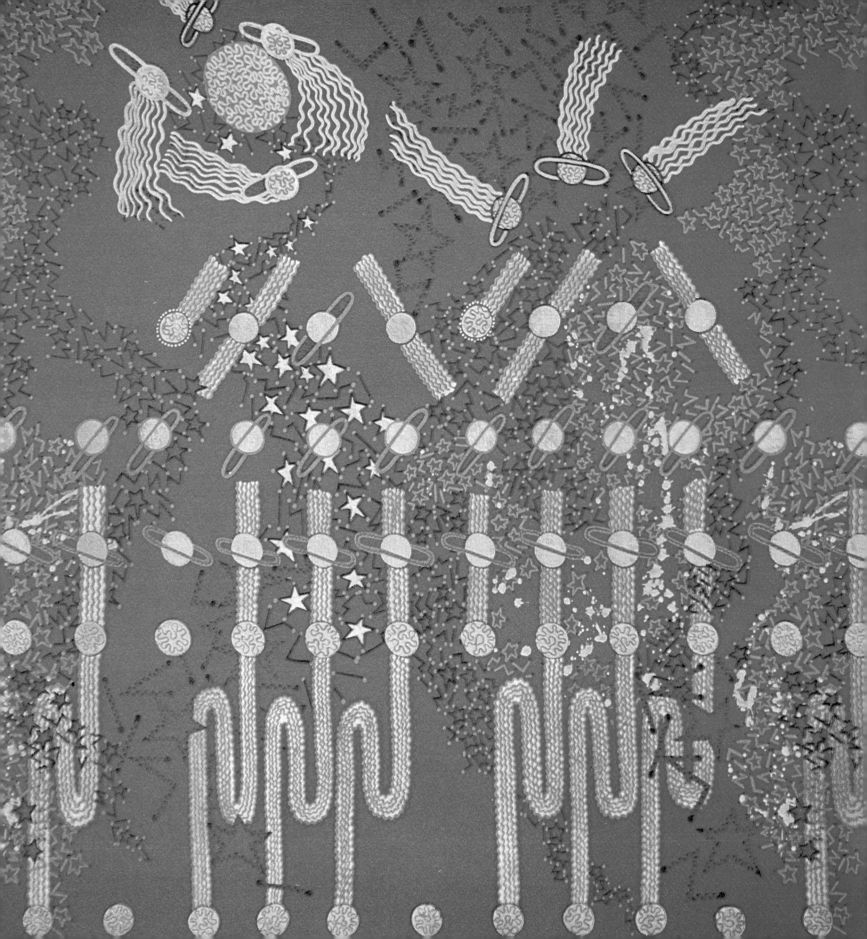

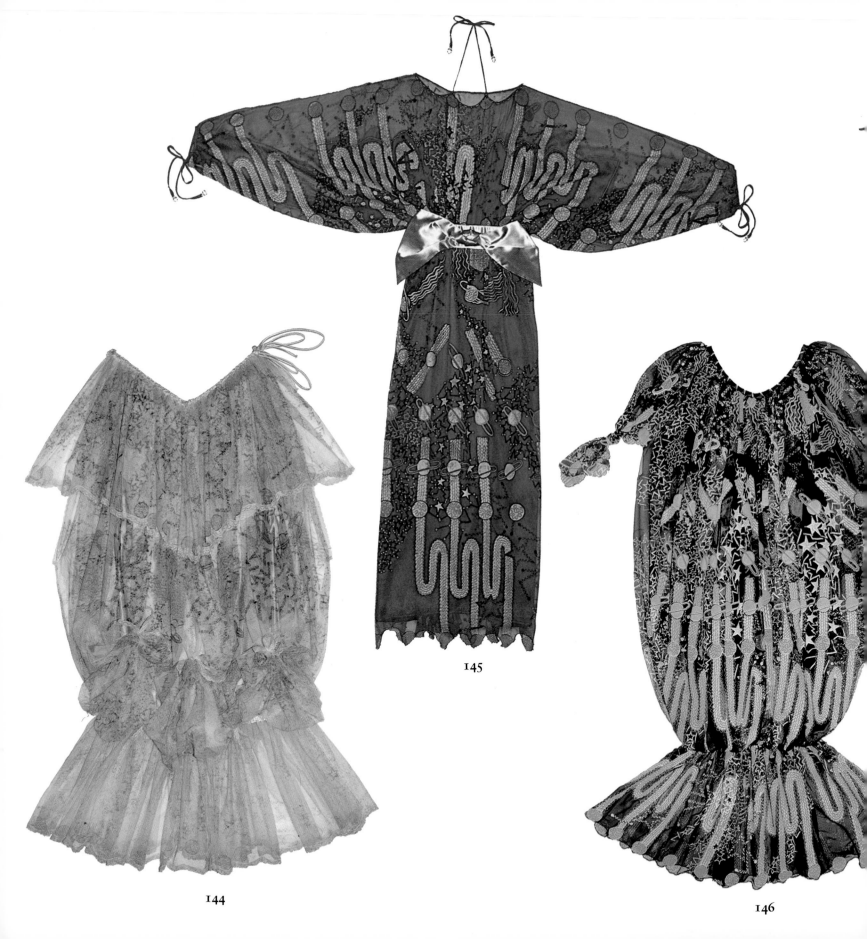

144

145

146

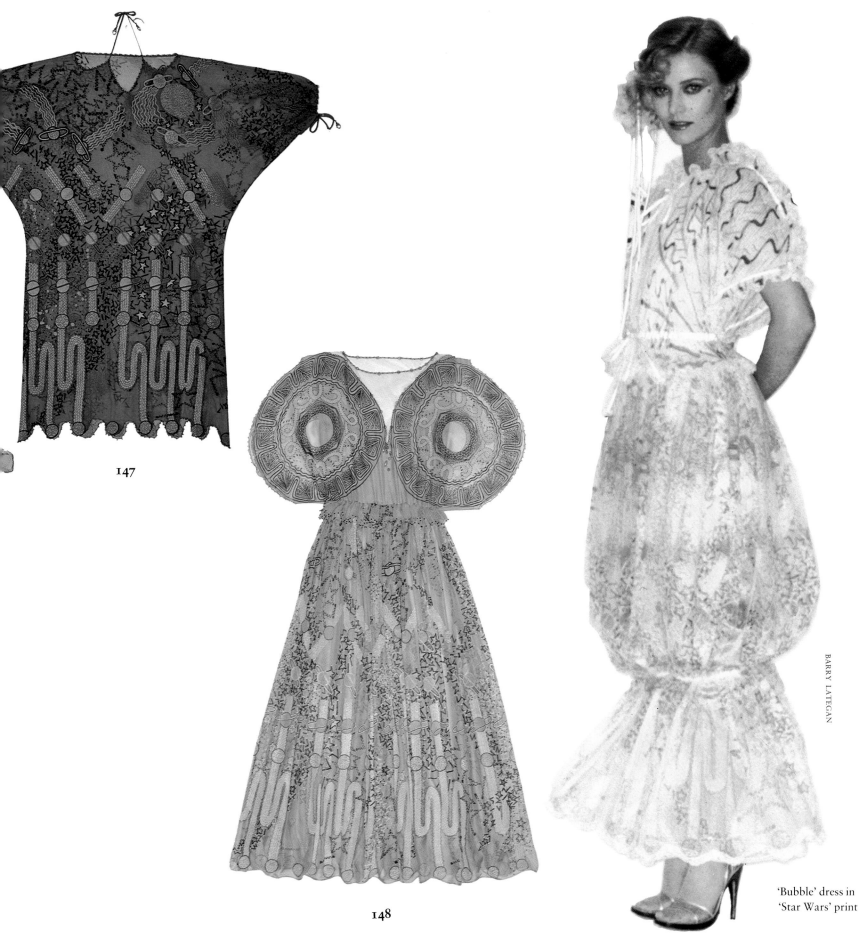

147

148

'Bubble' dress in
'Star Wars' print

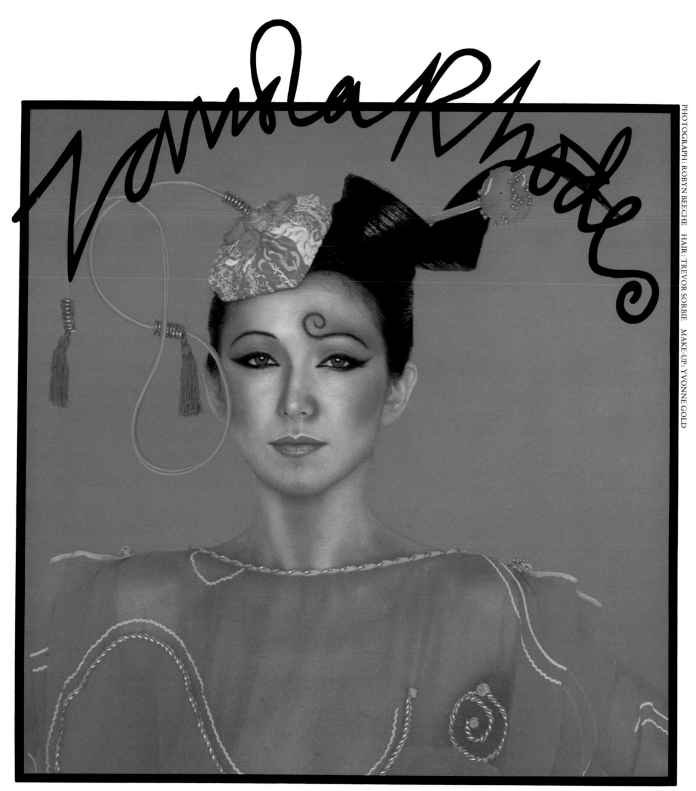

PHOTOGRAPH: ROBYN BEECHE HAIR: TREVOR SORBIE MAKE-UP: YVONNE GOLD

Photograph for 'Chinese' poster, 1979 (Butterfly no. 140)

China and Circles from Another World

Couri Hay* had suggested we join one of the first groups of Americans, patrons of the Kennedy Centre, on a cultural tour of China and nine of us set off from San Francisco in great mood of celebration, crossing into the mainland by train from Hong Kong to Canton on New Year's Day 1979. The trip was perfectly organised down to the last detail and our stay was like a university field trip, complete with guides and lectures. Couri has a fantastic talent for making new places come alive and finding out the most important things to see, and he has that terrific energy which made sure we did everything. He also had a positive effect on my work, insisting that I took out my sketchbook wherever we went, and had me drawing furiously to catch all my impressions. Since the Chinese are so inquisitive, especially the children, I often felt like the Pied Piper of Hamelin with a crowd of people around me, breathing heavily over my shoulder, but when I got home I had such a wealth of references to use I was grateful to Couri.

From Canton we flew to Shanghai. The plane was ancient by comparison with our modern jets—they all were in China—with wooden seats and overhead shelves and no air pressure, so the pain in our ears was agonising. The airport waiting rooms (like all other buildings, including the museums and palaces) had no heating whatsoever and in the Chinese winter this was a real hardship, since we were often stranded in them on account of weather delays. All our layers of wool and fur were vital, both indoors and out, and as we flew further north the weather became increasingly, brutally cold. I had to wear gloves to draw and at the Great Wall I kept my camera inside my fur muff so that the batteries wouldn't freeze. We had expected it to be very cold, but when we got to this Great Wall it seemed like 'Scott of the Antarctic'. But what a Wall, and what a wiggle that wall had! It snaked towards the skyline, no doubt it stretched into my

Zandra with Couri Hay in China

sketchbook, my bank of wiggles and walls, which ultimately meshed into my new designs.

Just before I left London I had phoned Michael Chow, who I knew had relatives in mainland China, to ask if he would like me to contact anyone for him. He showed me a film of his father, the super-star of the celebrated Peking Opera, the grand master, Chow Hsin Fang who had been cruelly persecuted and imprisoned by the Gang of Four and died soon after his release from

*R. Couri Hay became a close friend and companion from about 1978. An exciting extravert jet-set personality, he was until late 1983 special correspondent for the *National Enquirer*.

211

jail. I took a radio/cassette recorder for his brother, William, whom I met in Shanghai, and it was he who introduced me to the delights of the Peking Opera, explaining its traditions, costumes and unique make-up. The beards amazed me, they hung from the ears, covering the mouth. These operas were performed with screeches and dramatic clanging of gongs, gesticulations and terrific rolling of the eyes.

The head-dresses, and the hard, strong make-up of the Chu Opera all made an impact on me. These elements seemed more linked to ancient Crete and Egypt in my mind, nothing like I had imagined I would find in China. The colours and elements became an influence in the presentation of my Chinese Collection.

The legendary Chow Hsin-Fang (stage name Ch'I Lin-Tong) who was Michael Chow's father and a famous Peking opera star

Of my many images of China those of the people in the streets were very impressive. Their clothing was a uniform of washed out navy blues and, other than in Canton (where the weather was mild) everybody was wrapped in drab layers and layers of fabric, without jewellery or make-up. The exceptions were the children who captivated us all with their boot-button eyes, wearing vibrant colours, again in so many layers, they were like brilliant little round balls topped with colourful wool hats and ear muffs, and Mickey Mouse printed handkerchiefs pinned to their fronts. It was quite obvious the privileges in the way of food and heating in the hotels which were extended to the tourists were not enjoyed by the Chinese, but they didn't seem at all unhappy. They regarded all of us with wonder and they seemed to have an innocence which must have stemmed from a complete lack of materialism—I hoped it wouldn't be spoiled by tourism.

We wandered through temples and tombs, the magnificent relics of the Ming Dynasty, and I sketched, photographed and noted. I found myself constantly fascinated and amazed by the trellises and fretwork used by the Chinese, framing everything, making squares, bordering each simple visual plane. I loved all the carved stone, textured surfaces, dragons along the walls, carved, curly-haired dogs, pillars and columns. I was struck by the peace and surprise of the gardens, rocks displayed in pots instead of plants, an esoteric idea which seemed typically Oriental and new to me.

Peking street scene

A rock in a pot

Pages from Zandra's Chinese sketchbook

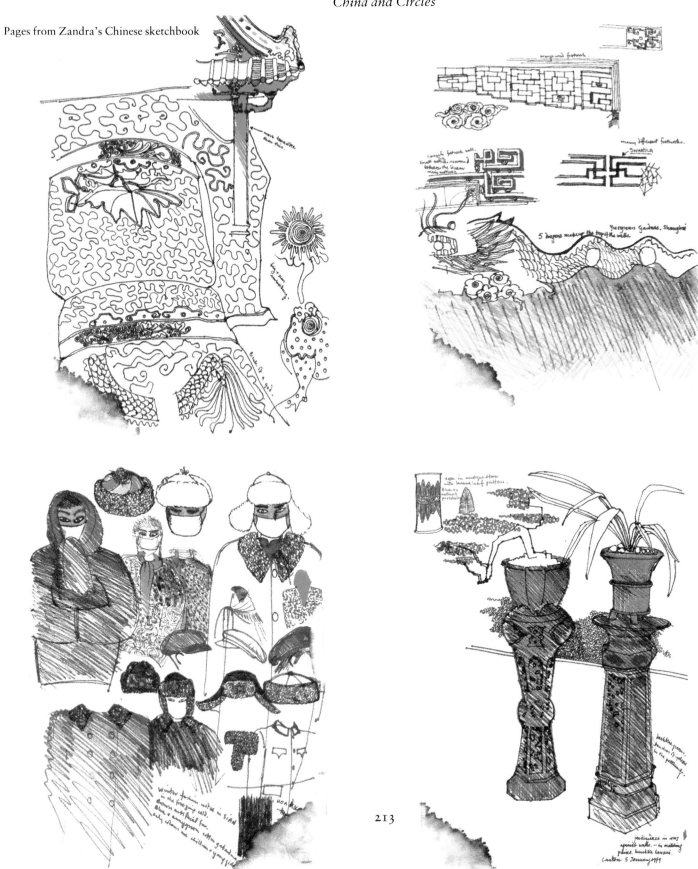

To me China had purity and strength; as ancient Greece was to Rome, so China was to Japan. I try not to go anywhere with preconceived ideas. I take reading matter about the place but never study it in advance, so that what hits me comes with total newness. The strongest influences upon my Chinese prints were first, the stone carvings of water and clouds in the palaces, from which I drew the designs 'Chinese Water Circle' and 'Chinese Balls'. Then the trellises came in to make 'Chinese Squares'. Filling those squares though, were my scribble heads. Why were they there in this Chinese chapter?

I find it very difficult to jump on to a new theme every six months for the sake of fashion. Once a particular set of images are ingrained upon me I cannot just drop them at whim—I must work them through my system until they release me—not me them. The heads were like that—such a strong image with infinite variety. They crept into the 'Star Wars' theme as 'Tiny Beaded Faces' and then into this Chinese chapter—in the 'Chinese Squares'.

It seems the right time to mention here that both the prints and garments take a long while to be born. Sometimes the prints do not get done quickly enough, which then means my design process has to work in reverse. This was especially true for the Chinese Collection, where during the space of print creation other past designs were printed up in the new Chinese colourways of jade and cinnabar so that the garments could progress simultaneously. One such print used was 'Magic Heads', and butterfly nos 139 and 140 were from the Chinese Collection, but not using Chinese print motifs.

One-colour 'Chinese Water Circles' print on silk chiffon. Design repeat 50″ (127 cm.), width of fabric 45″ (114·3 cm.).

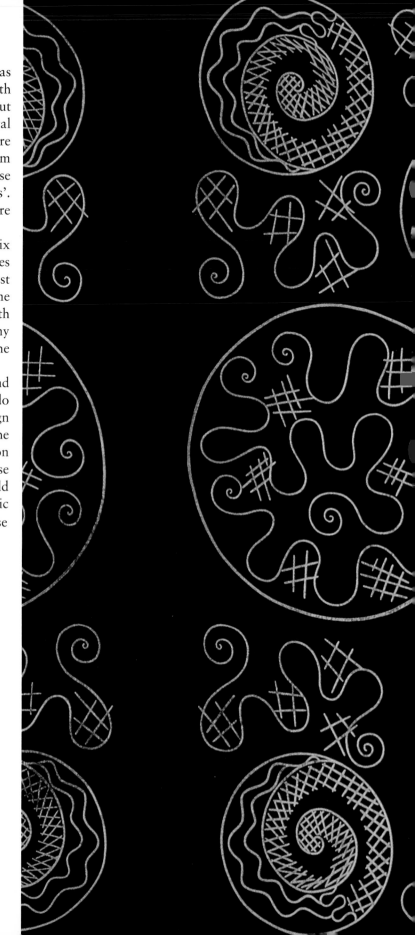

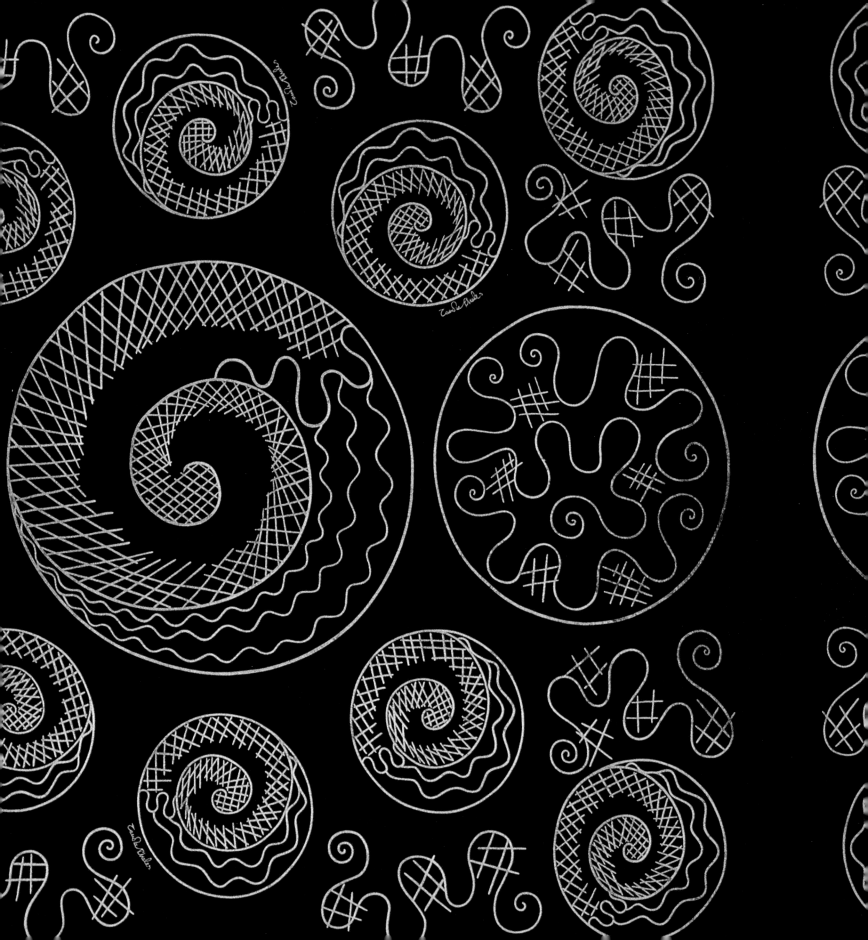

Three-colour 'Chinese Squares' print on silk crêpe de chine. Design repeat 29″ (73·6 cm.), width of fabric 45″ (114·3 cm.).

'Composition VIII' by Wassily Kandinsky, 1923, from the Solomon R. Guggenheim Museum, New York

Six months later, for my second Chinese Collection of prints, my mind had been further invaded by a constructivist exhibition of paintings in Paris. But I was still haunted by my Chinese period so the design that happened next was 'Chinese Constructivist' with Kandinsky's chopstick-like images combined with small versions of 'Chinese Water Circles'. This print had a strong graphic purity. After that, 'Chinese Constructivist and Clouds' was designed, where I superimposed another design of clouds and a Dali-like torso mesh on to the already existing chopstick layout, by the addition of two extra screens. So in this way, I produced a new screen print by taking out two screens from the design in its 'Chinese Constructivist' form and adding two new ones to make it into 'Chinese Constructivist and Clouds' (see this illustrated on pages 218 and 219).

I wanted to do some Chinese flower prints for a lingerie collection, so I drew geometric-shaped blooms and leaves which were intensely oriental in feeling. For colours, I took the wonderful cinnabar and jade shades and I also printed a delicate, clear, pale blue with yellow, which I called 'Chinese Summer Sky'.

When it came to designing the clothes I made several versions of the dramatic robes worn by the girls in the traditional Chinese ballet. They had elongated sleeves which they unfurled and

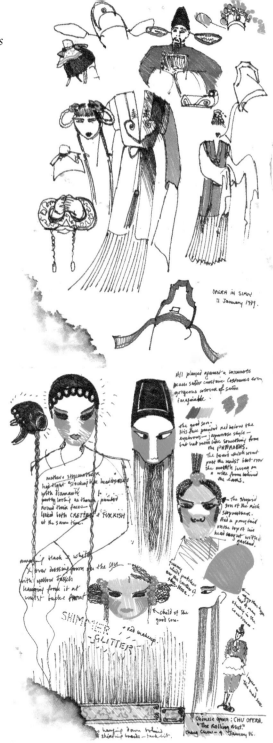

swirled in the pattern of the dance. To achieve an accordion and expanding sleeve effect I used pleating at the sleeve head so that the sleeve could be untied and concertina down in a new but linked way to the Chinese ballet sleeve movement. For one top, a pagoda sleeve (page 225) was created by joining squares of the 'Chinese Squares' print together; and when the corners were weighted down with embroidered tassels a very new, exciting sleeve came to life.

It was the hats that gave the finishing touch to the Chinese Collection. Graham Smith, the London milliner, and I had pored over my sketchbook and my swirly wiggly shapes were echoed in fabulous curlicues both on the hats for day wear with their fur pom poms (page 217) and on those for evening with their tassels. These evening hats were beautiful witty shapes, some like little rounded boxes. In my workroom we made face-masks in quilted and pleated satin to cover nose and mouth—a fashion accessory glamorising those seen on the people in the streets that cold winter in Cheng Chow.

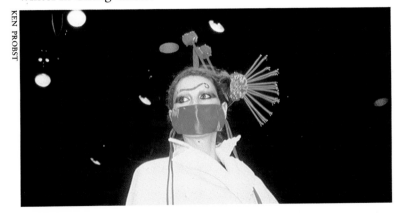

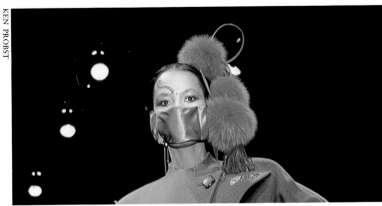

Zandra's coat show for Sabrina, New York, 1979, with Chinese inspired accessories
Right, sketches

Over page, left, three-colour 'Chinese Constructivist' print on silk chiffon. Design repeat 36″ (91·4 cm.), width of fabric 45″ (114·3 cm.); *right*, 'Chinese Constructivist and Clouds' print on silk chiffon. Original orange screen from 'Chinese Constructivist' is retained and two new screens added, still keeping to a three-colour design format. Design repeat 36″ (91·4 cm.), width of fabric 45″ (114·3 cm.).

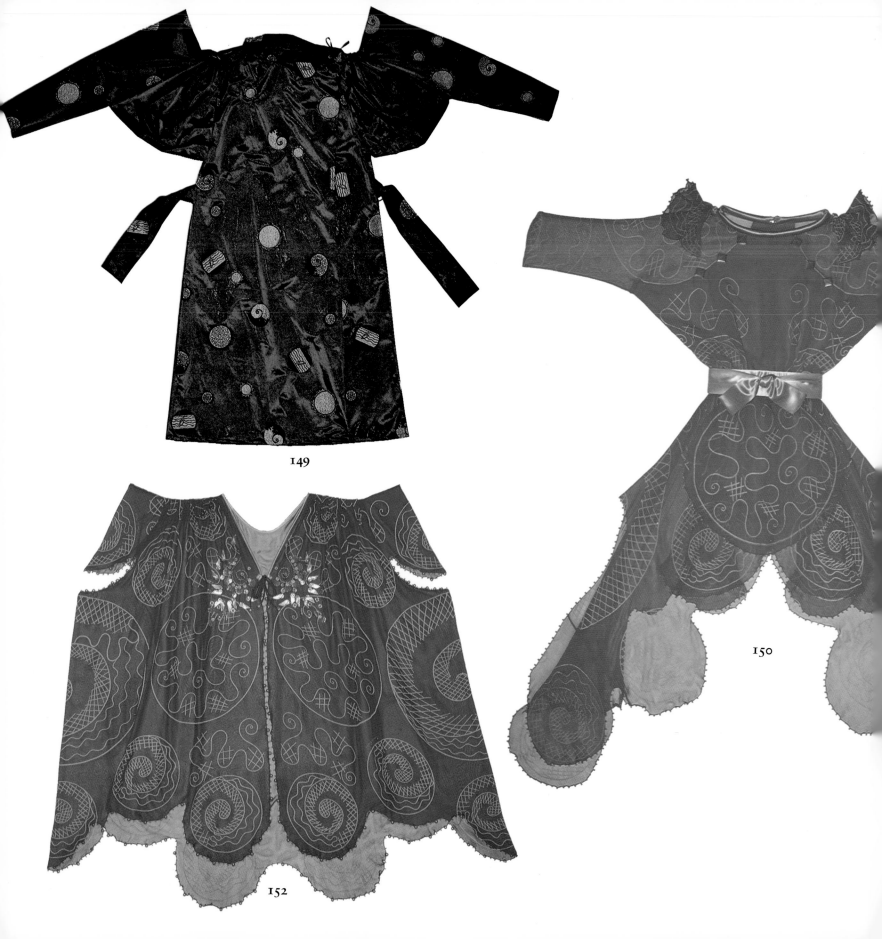

149

150

152

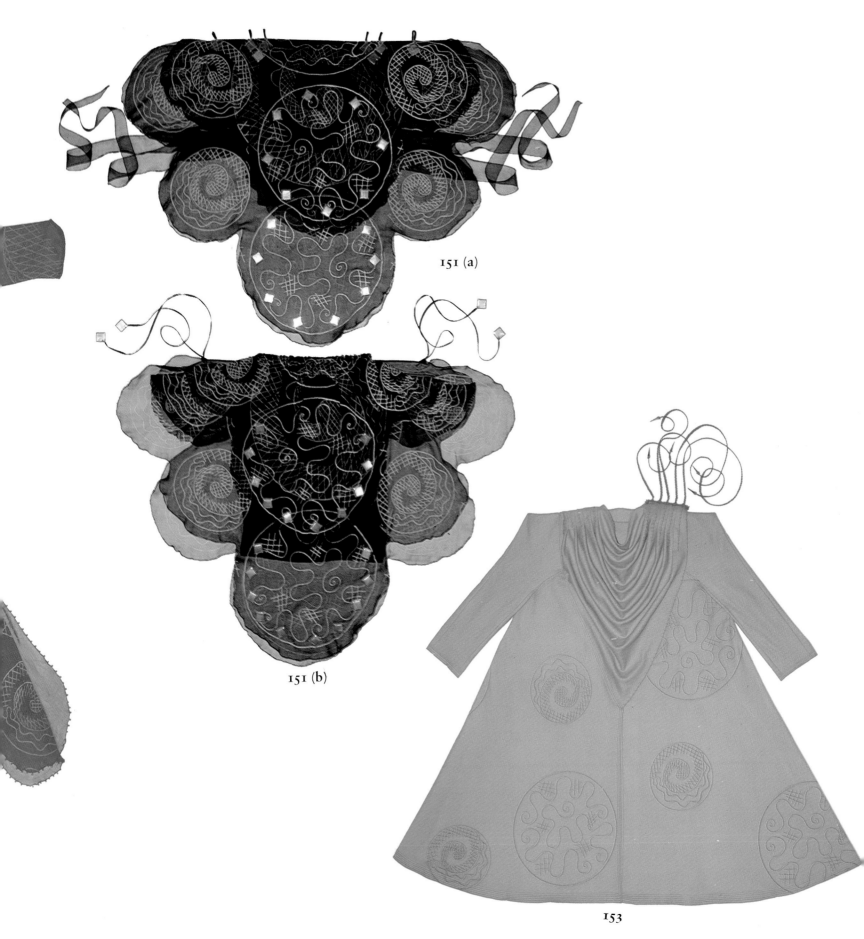

151 (a)

151 (b)

153

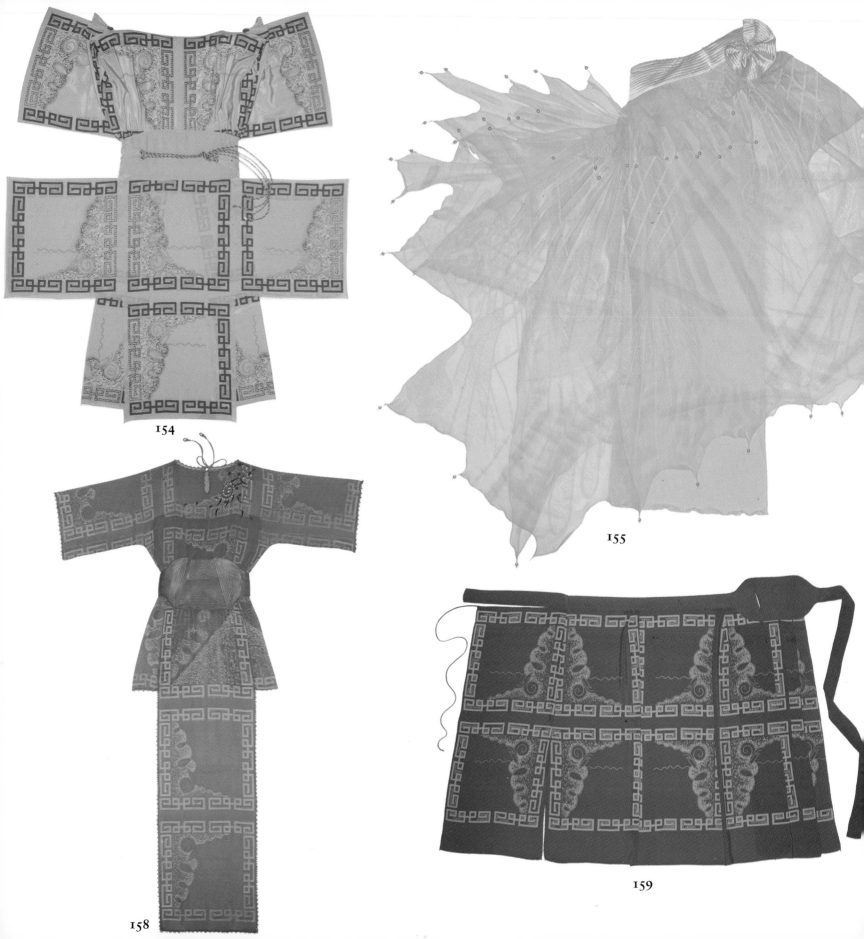

154

155

158

159

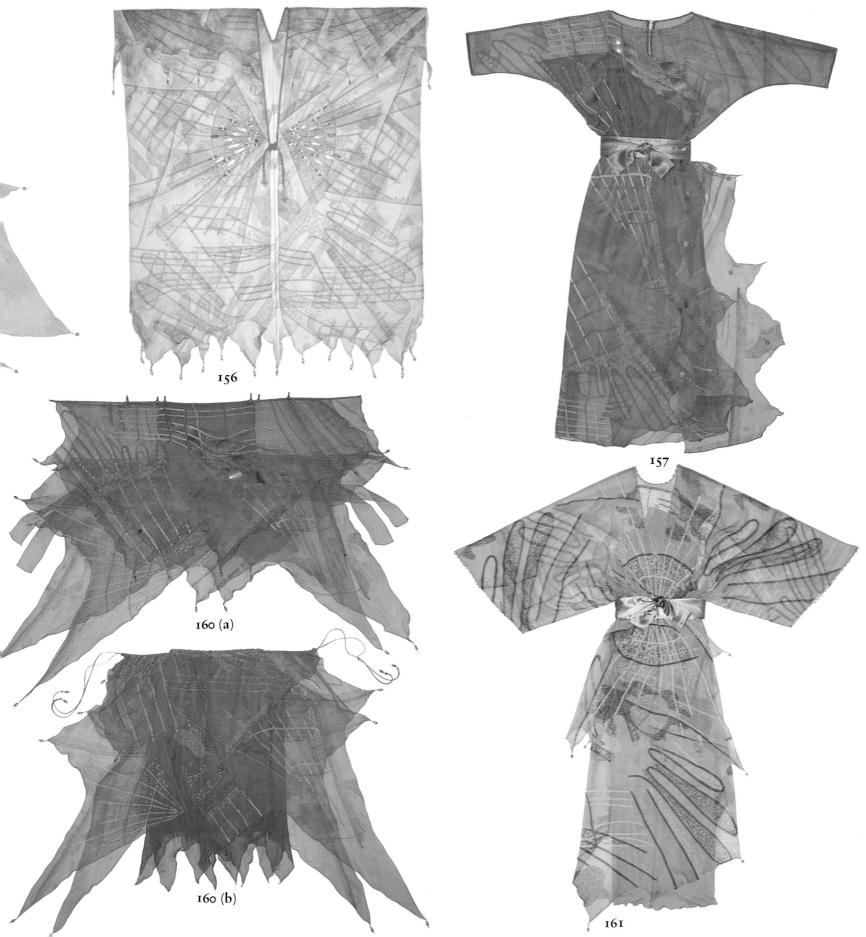

156

157

160 (a)

160 (b)

161

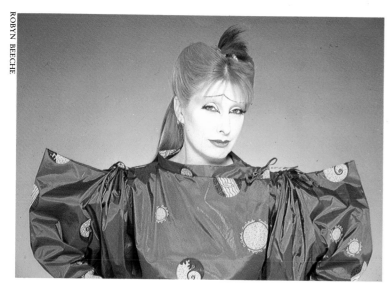

ROBYN BEECHE

Zandra in her raincoat (Butterfly no. 149). The expanding sleeves were influenced by ballet sketches. (See p. 217.)

The hats and the face masks ensured that when the Collection came out on the catwalk it looked Chinese. The same applied to the make-up, pagoda eye-brows (me on page 225) or golden-hued faces with Chinese twirls (page 225). What a pity the press ignored these as I think they were wonderful fashion statements … Also when I came to review the editorial pages on this Chinese Collection, all of the Chinese elements were left out by the press, only leaving bare bones with none of my original story line conveyed for posterity. This ephemeral quality and the fact that creating dresses is then left to the mood of the Press, or what Paris does, made me realise that all my statements were as a light under a bushel, and this is what forced me to write this book and give my own story.

On the day of the show the atmosphere in the theatre was tense. The imagery and presentation I had devised was very dramatic. The curtain rose to the slow, intense beat of Chinese gongs and fell to rapturous applause. My vision of 'Pictures from Another World' was a success.

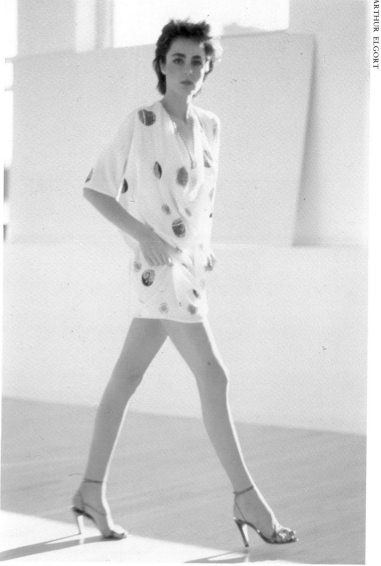

ARTHUR ELGORT

Above, silk cowl neck mini dress

Opposite page:

Above left, organza blouse with pagoda sleeves

Below left, Zandra's Chinese look

Above right, red quilted Chinese jacket (Butterfly no. 139)

Below right, photograph for second Chinese poster, 1980

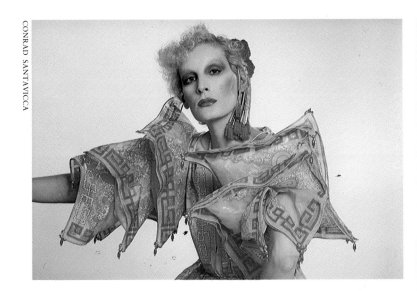

CONRAD SANTAVICCA

ROBYN BEECHE

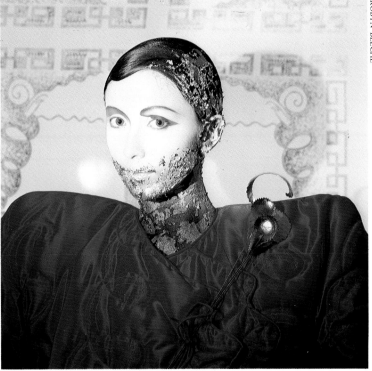

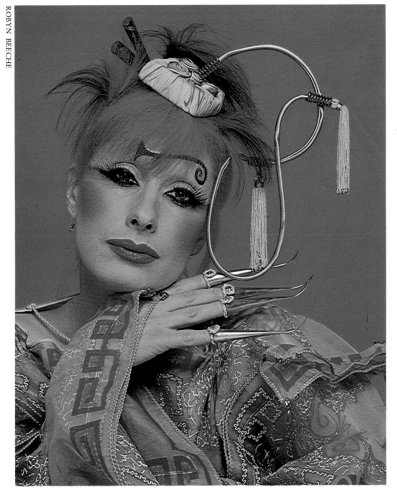

ROBYN BEECHE

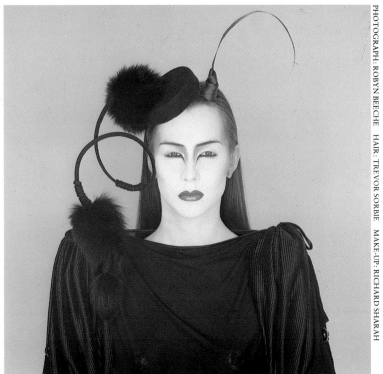

PHOTOGRAPH: ROBYN BEECHE HAIR: TREVOR SORBIE MAKE-UP: RICHARD SHARAH

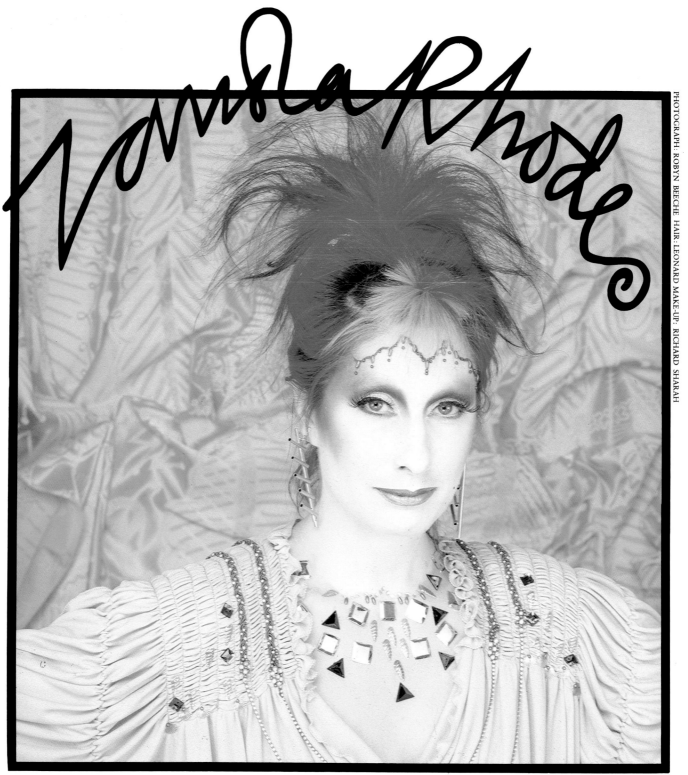

PHOTOGRAPH: ROBYN BEECHE. HAIR: LEONARD MAKE-UP: RICHARD SHARAH

Photograph of Zandra for 'African' poster, 1981

Kenya and Zebras

I left London by air for Nairobi in the summer of 1980 to join a photographic safari with Couri Hay. Being the organising genius he is, he had made the most impeccable arrangements for the trip, and contrary to any preconceived notions I may have had, Kenya was all very civilised. The hotels we stayed in, built to accommodate the safari tourists, were quite luxurious. Sometimes there were tents to sleep in but they had all the facilities of a chic hotel close by; or they looked like thatched huts, or were lodges on stilts, and one wonderful hotel looked like a Flintstone Villa. There was no hardship. We usually left at 6 a.m. or even 5 a.m. to see the animals feeding at dawn. We photographed intensively, travelling by Land Rover and being covered with dust, searching for game, finding things as they really are, with the savanna stretching away to the distance and very dusty sunsets. My sketchbook was out all the day, bouncing on my knees together with my camera, and my diary was out every night. In the middle of the day, when the animals were resting, everyone had a quiet time around the hotel pool and after resuming our activities in the afternoon we dressed for dinner in the evening, when we were served lovely English-type puddings—my favourite food.

All this tranquillity contrasted strangely with the harsh reality of the living world around us. Our first stop was at the Masai Mara Game Park. I hadn't studied Kenya before I went. As I explained earlier, I never do read about the place ahead of time, because I like to arrive with a completely free mind, without preconceptions or expected colours, a blank canvas. So my first encounter with the Masai people was a total surprise. I was not prepared for the Masai warriors and the beauty of their appearance. By their sheer physical well being, polished ebony skin, proud bearing and noble heads they emanated unique assurance. The children were acquisitive little scamps, running

Zandra with two Masai warriors

around picking things up, and I had to keep a sharp eye on my pencils and bits and pieces. The jewellery and adornments worn by the tribe were splendid and I took photographs and made sketches galore for my records. Our first stop also gave me my first view of zebras and wild beasts. As the safari continued, we saw antelopes, lions, herds of elephants, ostriches, leopards lying in the trees, so still in the branches that they looked like dappled sunlight, and suddenly I was acutely aware of the reason for camouflage.

In the muddied waters there were crocodiles gliding silently around and resting like logs at the water's edge, while the

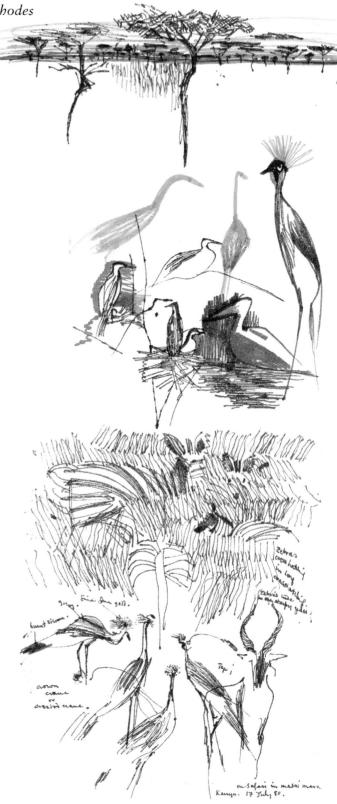

hippopotamuses, moving under water, were huge, Miss Piggy-like ballet dancers, not at all ungraceful. Throughout the trip I was moved most by seeing the animals in their wild state and realising what fantastic creations nature made. Their condition in their natural surroundings was so obviously different from the poor creatures I had seen in zoos. They had faultless coats and seemed to be in the peak of health. What came through to me most strongly here was the reality of the constant struggle of the wild, the survival of the fittest. The animals' coats were luxuriant and sleek; they were lean, savage, primed to attack or defend. I became intensely aware of the laws of nature, the pattern of survival; and watching a lion devouring a dik-dik, with the vultures standing away, waiting, was an experience which made it all totally understandable—much more than anything I had read, seen or dreamt about.

The landscape impressed itself on me. The trees were different and had new shapes; some had cruel thorns. A look-out for the vultures who were always waiting, impatiently alert. Some trees were crowned with a plateau of leaves and were hanging with strange bird-nests. They were far removed from the lush English blanket of green foliage. They were unforgettably rooted in my imagination and, although I haven't yet interpreted them, I know they will eventually take a significant place in my work.

Finally there was the gaudy life of the markets. Side by side with exotic fruits and flowers, jewellery, and beads, fertility charms and ornaments, I found a stall selling kangas (a sort of

Above, tree with bird-nests
Right, sketchbook pages

228

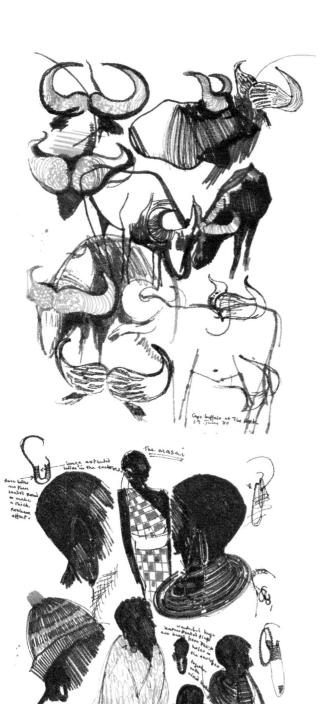

cotton sari), printed with primitive, bold, one- or two-colour prints in such colours as indigo, orange or crimson, neatly folded and displayed to show the designs to advantage. I liked the prints with their primitive and crude interpretations of fruit such as pineapples, their raw colours and borders created by hard dot and dash textures. I came back to London with hundreds of Instamatic photographs, an abundance of drawings and a well-filled diary.

Just as in 'Star Wars' I surrounded myself with whatever extra information I could glean on-hand in London—in this chapter I gathered about me additional information on the zebra. Late at night I went by a moth-eaten zebra rug in a shop window—I drew it (it stood much stiller than its original!) Then I went to the National History Museum and collected the postcard of a zebra from the Moghul period (see page 229). Then soon after my return I was invited to appear in a television documentary series, 'The Best of British', in which I had to design something in front of the camera. So I chose the 'Zebra Skin' as being an example of my work and explained how the original inspiration led me to my interpretation. I drew the outline of the zebra skin, shaded the stripes and then, as a background filler, used the crude dashes and dots from the kanga prints to give a new, dramatic and subconscious feel of Africa. I also included the Chinese trellis as part of the design, which illustrates how everything I do has a link somewhere in the past and is not easily discarded.

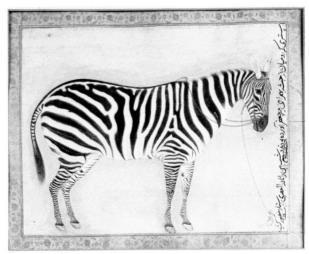

Above, zebra. Mughal miniature from the Victoria and Albert Museum. *Over page*, four-colour 'Zebra Skin' print on silk chiffon. Design repeat 38″ (96·5 cm.), total design repeat with motif reversed 76″ (193 cm.), width of fabric 45″ (114·3 cm.).

229

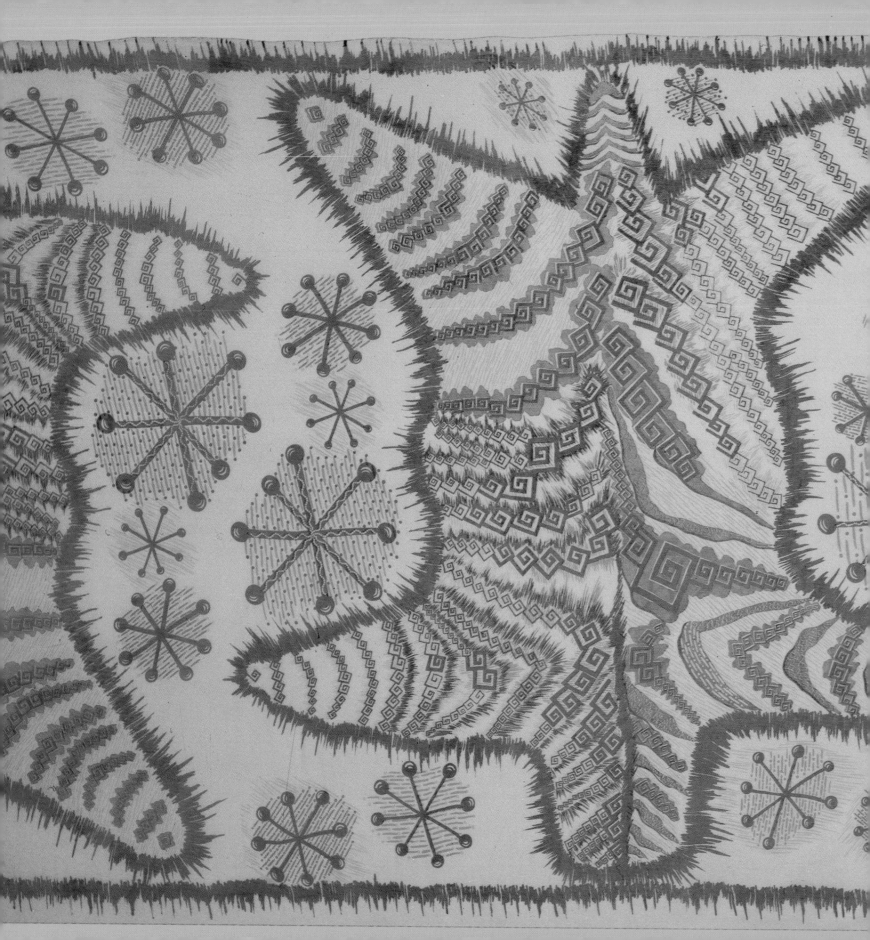

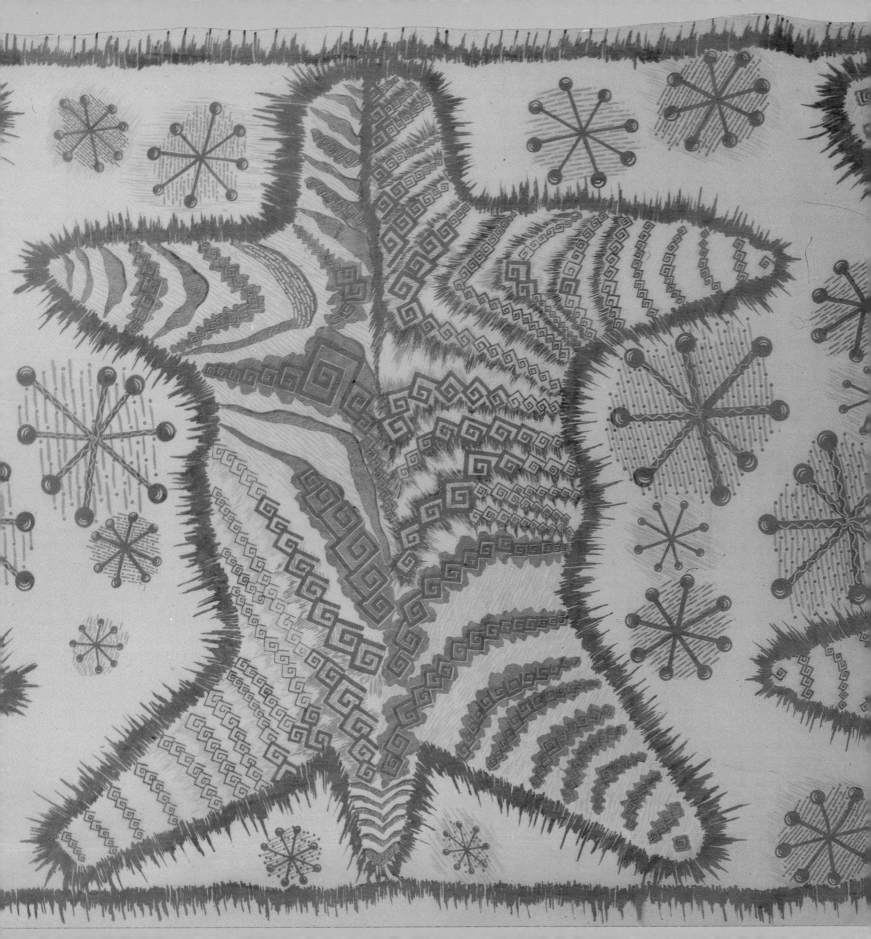

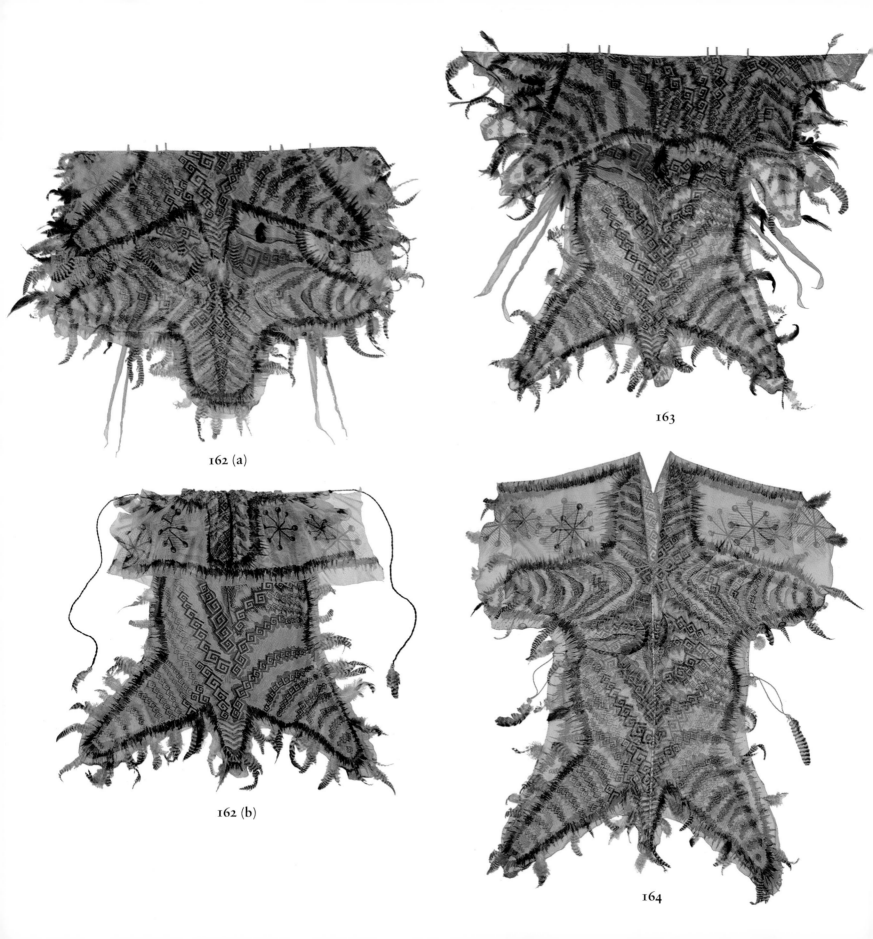

162 (a)

163

162 (b)

164

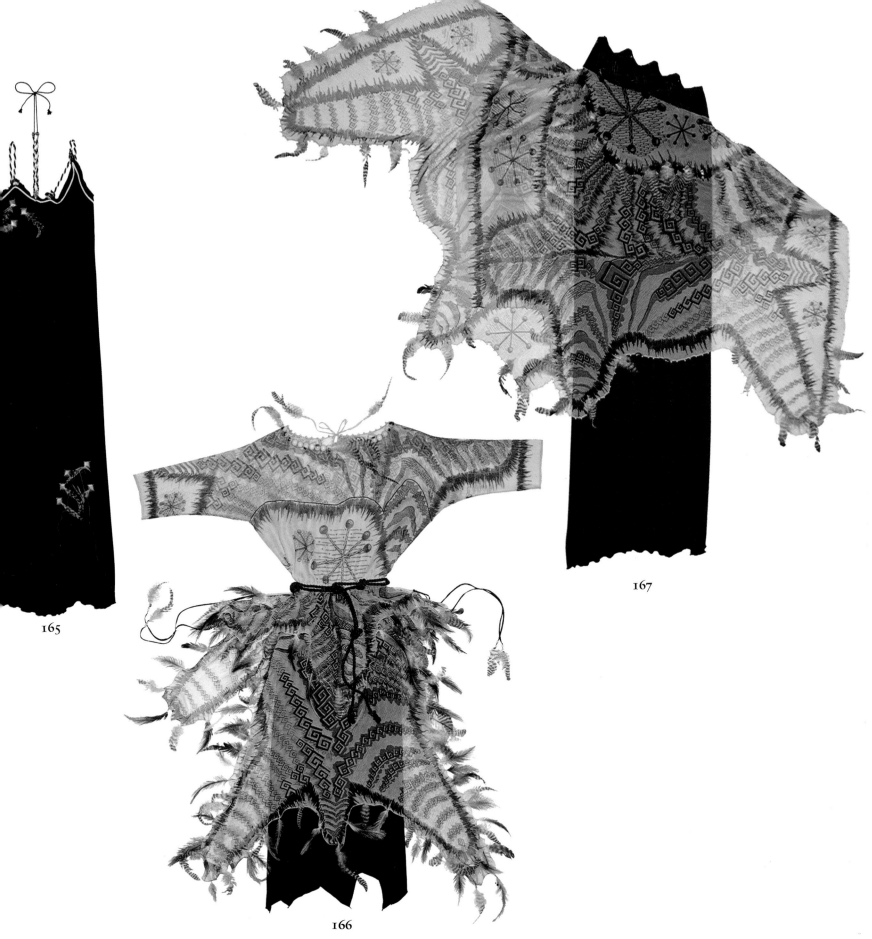

165

166

167

Top, cotton kanga from Mombasa market

Above, design sketch

Around the outside of this flat skin-like shape I added my own crude version of fringing. I used the reverse screen technique so the shapes would fit more interestingly together—a sort of uneven interlocking of arms and legs and as usual I filled the space in between with pattern. This time the patterns were of dot and dash and crude starry motifs—a sort of African night sky. In this Collection this use of space was a very important contribution to the butterfly no. 167 where the linings were attached as the skin shape dictated, and the rest of the over-all bodice was my other African sky pattern. The first print I did after visiting Kenya was 'Zebra Skin'.

Then came October, when I had to present my 1981 Spring/Summer Collection to the international buyers and press. I had been working on the designs for the African Collection and I was thrilled with the results, which were alive with primitive colour, Masai Red, African Queen (a blazing purple), Kenya Coffee and Safari. The 'Zebra' print was dazzling. I cut round its animal shape and then emphasised the skin shape with native tribal decorations of feathers and burnt wooden beads and string. I had not used feathers since the 'Chevron Shawl' but this time I used brown and beige striped turkey feathers to give a very primitive look (butterfly no. 163). The jewellery made by Mick Milligan was taken from the prints. It was an extension of the crude cross-hatching, expressed as a lattice of pearl-studded gold. Mark Kirkley, a jeweller who had just graduated from the Royal College of Art, worked with me on the interpretation of the Masai ornamentation. He produced earrings that stuck right out from the ears and cleverly-balanced necklaces that hung down the models' backs. These I showed with the low-back, draped dresses created by turning the classic front drape round and deepening it to the lower curve of the back. The dramatic 'Sparkle' print with its primitive Elizabethan and Red Indian influences was resurrected to add another sort of clash. Here it was differently used as a one-coloured black and white.

By this time I had a little empire to support and I knew that to unleash an unbridled display of primal art, while it would be fulfilling to me, would not please the majority. I talked it over with colleagues and decided to present the show at Olympia in double-face. First, I would show, in a gentle mood, my English Rose Garden Collection, floating, chiffon dresses in delicate prints, painted Tea Rose, Peace, Damask, and Mousseline, to a background of classical music. Then backstage, Leonard would feverishly manipulate the models' hair into a primaeval style. Richard Sharah would emphasise the crude make-up, decorate the girls' faces with jewels, and colour the design already devised. The gems would be already cut to shape and prepared with glue ready to apply.

Front-house the music changed and the magnificent Pillar Hall reverberated to the sound of jungle drums. In violet lights a ballet dancer took to the stage wearing a black leotard and chiffon 'Zebra Skin', beckoning the mannequins on to the catwalk in an exciting ritual. It was pure theatre—the audience was on its feet.

Kenya, the Masai, and the wild animals had served me well, and I had paid my homage to them.

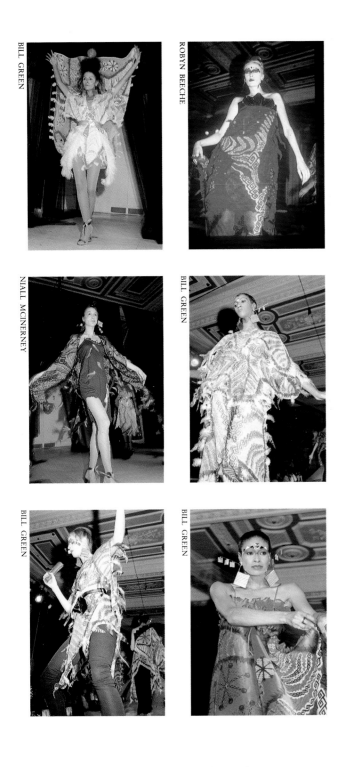

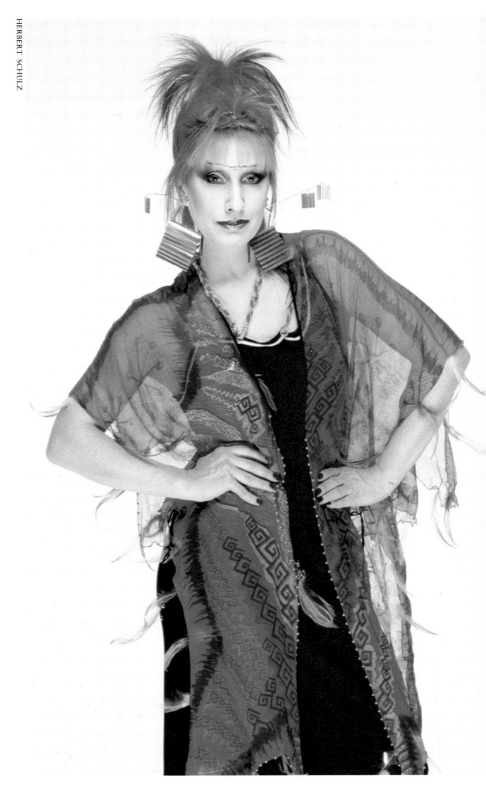

BILL GREEN

ROBYN BEECHE

NIALL McINERNEY

BILL GREEN

BILL GREEN

BILL GREEN

HERBERT SCHULZ

Above, shots from Zandra's African Show, Olympia, 1981

Right, Zandra wearing Butterfly nos 164 and 165

Index of Butterflies

The early collection of garments (butterfly pages 22 and 23) using my prints were not catalogued. The cataloguing started with my own first collection (butterfly pages 32 and 33) simply with Z1, Z2, Z3, etc., before I realised what a mammoth quantity of garments I would produce in the future. In the following collection (butterfly pages 46 and 47) the catalogue numbers become more methodical, and include the year and garment number.

1 Journey into Lights

1 Mini dress, in three-colour 'Lipstick' print on natural slub silk.

2 Mini dress, in 'Mr Man and Lightbulb' print, fluorescent pigment on paper.

3 Mini coat, in 'Mr Man and Lightbulb' print on calico, with contrast 'Mr Man' print on pockets.

4 Waistcoat, in 'Neon Flowers and Grid' print, fluorescent pigment on underfelt.

5 Evening pyjama, individually handscreened 'Lipstick Stripe' print with hand-crayoning effect, on satin.

6 Blouse with tie sash, in three-colour 'Lipstick' print on satin.

7 Mini dress, in 'All Over Neon' print on jersey (print developed from body transfer idea).

8 Mini dress, using combination of 'Mr Man', 'Superman Star' (made from cuttings of comics) and 'Lipstick Stripe' prints on crêpe.

2 Wales and Knitting

9 Quilted 'Kaftan style' dress, in 'Knitted Circle' print on three different colour satins. Circular skirt in three layers; first layer consisting of one circle, second layer of three circles and third layer of nine circles (see also butterfly no. 16). CAT. NO. Z1.

10 Kaftan, combining 'Knitted Circle' and 'Wiggle Square' prints on contrast silk chiffon. (Variation of butterfly no. 13, each sleeve using one instead of two yards). CAT. NO. Z17.

11 Dress, combining 'Knitted Circle' and 'Diamonds and Roses' prints on silk chiffon. Bodice and sleeves consist of three complete circles. CAT. NO. Z6.

12 Circular coat, combining one-colour 'Diamonds and Roses' and two-colour 'Knitted Circle' prints on felt; skirt consists of one circle; stitched collar with cords and wooden beads. CAT. NO. Z23.

13 Kaftan with hood, in 'Knitted Circle' print on silk chiffon. Kaftan made from eight circles and hood made from one circle. CAT. NO. Z7.

14 Skirt, in two colourways of 'Knitted Circle' print on silk chiffon: consists of eight 'half circle' panels and one complete circle cut into 'quarters' for hem scallops. CAT. NO. Z3.

15 Jodhpur trousers, in 'Knitted Circle' print on lurex; shape dictated by print. CAT. NO. Z11.

16 (As butterfly no. 9.) CAT. NO. Z1.

3 The Ukraine and 'Chevron Shawl'

17 (a) 'Kaftan style' jacket, in 'Chevron Shawl' print on silk chiffon; cut to shape of print, trimmed with feathers; and with hand-rolled edges. CAT. NO. 70/4. (b) Skirt to match. CAT. NO. 70/24.

18 'Kaftan style' dress, with padded silk bodice, in 'Chevron Shawl' print on silk chiffon; cut to shape of print, trimmed with cord and feathers; and with hand-rolled edges. CAT. NO. 70/5.

19 Reversible quilted coat, in 'Chevron Shawl' print on calico; cut to shape of print. CAT. NO. 70/23.

20 Quilted waistcoat, in 'Chevron Shawl' print on silk; cut to shape of print, trimmed with feathers; and with machine-rolled edges. CAT. NO. 70/9.

21 Dress, with padded satin bodice, combining 'Wiggle and Check' and 'Tasselled Circle' prints on silk chiffon. (Skirt made as butterfly no. 14.) CAT. NO. 70/28.

22 Dress, combining 'Wiggle and Check' and 'Tasselled Circle' prints on jacquard satin; consisting of separate circular pleated skirt and quilted bodice (back bodice joined on to off-centre of circle, making the back longer than the front). CAT. NOS 70/17 & 70/18.

23 Circular coat, in 'Snail Flower' print on felt; stitched yoke with cords and wooden beads. CAT. NO. 70/14.

24 Dress, in 'Snail Flower' print, made from twelve yards of silk chiffon; gathered diagonally front and back on to bodice to form sleeves, and skirt ruched to form 'swags', with yoke and ribbon edging in satin. CAT. NO. 70/11.

25 Quilted 'Chinese style' dress, in 'Snail Flower' print on natural silk; quilting following the print and satin-stitch picking out the shape of side-opening. CAT. NO. 70/29.

26 Circular cape, combining 'Wiggle and Check' (in two colourways), and 'Tasselled Circle' prints on felt; with small stitched flaps for collar and pockets, trimmed with tassels. CAT. NO. 70/22.

4 New York and 'Indian Feathers'

27 Kaftan, in 'Indian Feather Sunspray' print on silk chiffon; cut to shape of print, with hand-rolled edges. CAT. NO. 70/33.

28 Man's shirt, in 'Indian Feather Sunspray' print on satin; side-opening following the print, with satin-stitch edges. CAT. NO. 71/M/3.

29 Man's shirt, combining 'Feather and Triangle' and 'Indian Feather Sunspray' prints on silk chiffon, with 'Sunspray' flap attached to front yoke, and hand-rolled edges. (Variation of butterfly no. 20.) CAT. NO. 71/M/6.

30 Pleated jacket, in 'Indian Feather Sunspray' print (sunspray blocked off) on satin, with satin-stitch 'lettuce' edging. CAT. NO. 74/54.

31 Kaftan dress, in 'Indian Feather Sunspray' print on silk chiffon; shape dictated by print, and hand-rolled edges. CAT. NO. 70/32.

32 Kaftan, in 'Indian Feather Border' print on silk chiffon; the 'Feather' border folded back, cut between the 'Feathers' and edges hand-rolled, stitched with several contrast velvet ribbons. CAT. NO. 71/16.

33 Kaftan, in 'Indian Feather Border' print on silk chiffon; separate 'Feather Border' hanging from ruched yoke and sleeves, which concertina on to the body of the kaftan; trimmed with velvet ribbons. CAT. NO. 70/10.

34 Jacket, in 'Indian Feather Sunspray' print on silk chiffon, cut to shape of print, with hand-rolled edges. (Worn with matching shorts – not illustrated.) CAT. NO. 70/34.

5 The Victoria & Albert Museum and Elizabethan Silks

35 Silk dress, shoulders with cut edges; with smocked panel in 'Sparkle' print on natural silk, edges bound with silk rouleaux. CAT. NO. 71/4.

36 Dress, in 'Sparkle' print on natural silk, slashed cuffs and shaped hem with cut edges; velvet bodice decorated with ribbons and ostrich feathers. CAT. NO. 71/8.

37 Dress, in 'Sparkle' print on natural silk, with slashes and cut edges; bodice smocked at centre front and back. (Shape variation of butterfly nos 38 and 42.) CAT. NO. 71/3.

38 Jersey top, with contrast satin-stitch 'lettuce' edging, with all seams on the outside. Bodice, machine smocked at centre front and back. (Shape variation of butterfly nos 37 and 42.) CAT. NO. 72/31.

39 Overdress, combining 'Sparkle' and 'Indian Feather Border' prints on silk, with cut edges, and hem bound with silk rouleaux. (Worn over butterfly no. 40.) CAT. NO. 71/2.

40 Natural silk dress, in 'Indian Feather Border' print on sleeves and front panel, and 'Sparkle' print on smocked tassels. Extra-long slashed sleeves which concertina when worn. (Worn under butterfly no. 39.) CAT. NO. 71/1.

41 Knickerbockers, in 'Sparkle' print on natural silk, with cut edges and smocking at knees. (Worn with butterfly nos. 36 or 37.) CAT. NO. 71/9.

42 Ultrasuede top, with 'Hatched' panel print (rainbowed while printing, using one screen), to emphasise edges of garment shapes; smocked at centre front and back. (Shape variation of butterfly nos 37 and 38.) CAT. NO. 76/U/101.

6 Paris, Frills and Button Flowers

43 Quilted satin 'Kaftan style' circular dress, skirt and shoulder panels in two contrasting colourways of 'Frilly' print (cut in circles, although not a circular print), and 'Button Flower' print on sleeves; plain black satin bodice with appliquéd 'Button Flower' motif on front bodice. CAT. NO. 71/34.

44 (a) Jacket, in 'Frilly Flower' print on crêpe, edged in contrasting satin binding. (b) Pleated skirt to match, with 'Sunray' pleated peplum and appliquéd 'Button Flower' motif. CAT. NO. 71/24.

45 Jersey dress, with 'lettuce' edging, quilted satin collar, and appliquéd 'Button Flower' motifs. CAT. NO. 71/20.

46 'Chinese style' dress, with quilted collar, in 'Frilly' print on satin. Rouleaux ties and contrast satin edging picking out shape of opening and hem. (Variation of butterfly no. 25.) CAT. NO. 71/28.

47 Quilted 'Kaftan style' circular coat-dress, in 'Frilly Flower' print and two colourways of 'Button Flower' print on satin. Contrast satin edging picking out shape of opening and hem. (Coat-dress version of butterfly nos 9, 16, and 43.) CAT. NO. 71/27.

48 Jersey dress, with 'lettuce' edging, ruched hem and contrasting blue 'epaulettes', with appliquéd 'Button Flower' motifs. (Jersey version of butterfly no. 11.) CAT. NO. 71/26.

49 Dress, combining 'Frilly Flower' print on satin, and 'Button Flower' print on silk chiffon with 'curtained' hem; satin bands on bodice decorated with sequins. CAT. NO. 71/29.

50 Pleated skirt, in 'Button Flower' print on satin, with appliquéd 'Button Flower' motifs attached to straps. CAT. NO. 71/30.

51 Jersey top, decorated with gathered frills and flowers, contrast 'lettuce' edging, and all seams on the outside. CAT. NO. 72/47.

52 Layered jersey dress, with contrast 'lettuce' edging, and quilted satin yoke. CAT. NO. 72/7.

53 Felt 'Dinosaur' coat, showing lining in 'Button Flower' print on satin, with appliquéd 'Button Flower' motifs; with cut edges as decorative outside seams. CAT. NO. 71/19.

54 Knotted jersey tunic, with 'lettuce' edging, and contrast gathered jersey frills and ties; with all seams on the outside. CAT. NO. 72/37.

55 Jersey dress, gathered with ties, and contrast 'lettuce' edged frills and hems. CAT. NO. 72/29.

56 Felt 'Dinosaur' jacket, in 'Button Flower' print with appliquéd 'Button Flower' motifs; with cut edges as decorative outside seams. CAT. NO. 71/23.

57 Closed front view of butterfly no. 53. CAT. NO. 71/19.

7 Japan and Lovely Lilies

58 Jersey dress, with contrast 'lettuce' edging, and 'Field of Lilies' print on bodice panel in silk chiffon, lined with satin; circular skirt, and all seams on the outside. CAT. NO. 72/11.

59 Dress, in 'Field of Lilies' print on silk chiffon, with contrast satin linings under bodice, gauntlets, skirt and collar; and hand-rolled edges. CAT. NO. 72/4.

60 Dress, in 'Field of Lilies' print on silk chiffon, with contrast satin linings under bodice, gauntlets, skirt and collar, with 'Lilies' outlined in satin-stitch on front, and hand-rolled edges. CAT. NO. 72/8.

61 Variation of butterfly nos 59 and 64, with additional underskirt in silk chiffon. CAT. NO. 72/4a.

62 Jersey dress, with contrast 'lettuce' edging, and bodice in 'Field of Lilies' print on silk chiffon, with contrast satin lining held in place with satin-stitched 'Lilies'; all seams on the outside. (Only top section of dress illustrated.) CAT. NO. 72/11.

63 Kaftan, in 'Field of Lilies' print on silk chiffon; with ruched sleeves, and collar edged with stiffened 'Lily' shapes lined in black satin, and edged in matching rouleaux. (Off-shoulder version of butterfly no. 10.) CAT. NO. 73/7.

64 Dress, in 'Field of Lilies' print on silk chiffon, with frill details, and satin lining under bodice, gauntlets and skirt. (Variation of butterfly nos 59 and 61.) CAT. NO. 72/9.

65 Dress, combining 'Reverse Lily' and 'Field of Lilies' prints on silk chiffon; collar and sleeves with pearled hand-rolled edges, and satin sash. (Note print shape *clearly* shows derivation from bodice and gauntlet influence: butterfly nos 59, 60, 61 and 64.) CAT. NO. 74/15.

66 Dress, combining 'Reverse Lily' and 'Field of Lilies' prints on silk chiffon; beaded front bodice and satin sash. 'CLASSIC' CAT. NO. 73/44.

67 Dress, in 'Reverse Lily' print on silk chiffon; ruffles and frills on skirt in net; and satin sash. (Worn with frilled net crinoline petticoat – not illustrated.) CAT. NO. 74/19.

68 (a) Top, in 'Reverse Lily' print on silk chiffon, with beaded collar and hand-rolled edges. (b) Skirt to match, in 'Field of Lilies' print. CAT. NO. 74/16.

69 (a) Stole, using centre section of 'Reverse Lily' print on silk chiffon and edged with net frills. (Worn with butterfly no. 69b.) (b) Crinoline, using combination of three fabrics, 'Reverse Lily' print on silk chiffon for skirt bordered with net frills; pleated satin bodice with swirls at bust, satin-stitch 'lettuce' edging; bodice attached to skirt with quilted wrap satin sash. CAT. NO. 81/52.

70 Off-shoulder crinoline, in 'Reverse Lily' print (skirt shape dictated by print) on silk chiffon; net 'curtain' ruching and frills in skirt. CAT. NO. 73/19.

8 Woodstock and Shell Basket and Many Friends

71 (a) Quilted jacket, in 'Spiral Shell' print on satin; shape dictated by print; padded edges in contrast satin. (b) Backview of butterfly no. 71a. CAT. NO. 73/28.

72 Felt coat, machine embroidered, with contrast 'shell-shaped' boned collar, appliquéd with 'shell' motifs. CAT. NO. 73/3.

73 Kaftan, combining 'Spiral Shell' and 'Reverse Lily' prints on silk chiffon; shape dictated by print. CAT. NO. 73/7.

74 (a) Off-shoulder top, in 'Spiral Shell' print on silk chiffon, with hand-rolled edges. (b) Skirt to match in 'Zig-Zag Shell and Blotch' print; shape dictated by print. CAT. NO. 73/24.

75 (a) Tabard, in 'Zig-Zag Shell and Blotch' print on silk chiffon; cut between the chevron spaces in the print, and hand-rolled edges. (b) Skirt to match. CAT. NO. 73/25.

9 Australia and Ayers Rock

76 One-shoulder dress, in 'Ayers Rock' print on silk chiffon, over jersey tube, stitched satin band and slashed hand-rolled edges. (For further variations see butterfly nos 94, 112, 124, 155 and 165.) 'CLASSIC' CAT. NO. 74/5c.

77 Quilted jacket, in 'Ayers Rock' print on satin, with stitched contrast satin collar, rouleaux fastening side-opening, and satin bow edged with lace. CAT. NO. 74/1.

78 Quilted jacket in 'Spinifix Landscape' print on satin with contrast lining, and fold-back flaps on shoulders cut to shape of print. CAT. NO. 80/69.

79 (a) Wrap-round sarong, in 'Spinifix Landscape' print on satin; and edged with pleated frills, held in place and decorated with rouleaux. (b) Butterfly no. 79a opened out to show construction. CAT. NO. 76/11.

80 Square cloak, in 'Ayers Rock' print on felt, edges bound in satin and decorated with rouleaux clusters; centre-front 'slit' opening for right hand. CAT. NO. 74/22.

81 Quilted coat, in 'Ayers Rock' print on satin; stitched contrast satin collar and edges, with rouleaux clusters at top of side-openings and front fastening. CAT. NO. 74/2.

82 Pleated jacket, in 'Spinifix Landscape' print on satin; sleeves and hem with satin-stitch 'lettuce' edging, and contrast satin trim with 'Chinese' knots of rouleaux; shape dictated by print. CAT. NO. 76/36.

83 Off-shoulder dress, in 'Spinifix Landscape' print on silk chiffon; beaded bodice with slashed hand-rolled edges and satin sash. CAT. NO. 75/24.

84 Crinoline, in rainbowed 'Spinifix Landscape' print on silk organza, pleated bodice decorated with contrast ribbon and satin sash. CAT. NO. 76/19.

85 Back view of 'Dragon' dress, in 'Spinifix Landscape' print on silk chiffon, over jersey tube, side edges slashed to shape of print and hand-rolled. Pleated satin band at bust with contrast satin-stitch 'lettuce' edging and rouleaux shoulder ties. CAT. NO. 76/17.

86 Dress, in 'Lace Mountain' print on silk chiffon. Pleated skirt frilled at waist, with peplum caught up by beading on to bodice; hand-rolled edges and satin sash. CAT. NO. 74/50.

87 (a) Pleated tabard top, in 'Lace Mountain' print on silk chiffon (made from diamond section of print). Belt and edging in pleated satin ribbon. (b) Pleated skirt to match, in 'Indian Feather Border' print. CAT. NO. 75/1.

88 Dress, in 'Lace Mountain' print on silk chiffon, with pleated collar and, laced-up front; hand-rolled edges and satin sash. CAT. NO. 75/33.

89 Off-shoulder dress, in 'Lace Mountain' print on silk chiffon with pleated top; shoulder frills and peplum edged with pleated satin ribbon and criss-cross lacing on shoulders. CAT. NO. 75/11.

90 Dress, in 'Lace Mountain' print on silk chiffon, pleated collar (panels cut from left-over sections between diamonds of print) with pearled hand-rolled edges, and satin sash. CAT. NO. 75/57.

91 Dress, in 'Lace Mountain' print on silk chiffon, with 'V' neck, and pleated skirt, frilled at waist by edging in pleated satin ribbon and caught up with silk flowers. CAT. NO. 74/47.

92 Kaftan top, in 'Spinifix Square' print on silk chiffon, made from two squares joined together, their centre edges folded back (as butterfly no. 32), cut to shape of print; hand-rolled edges and neck decorated with linked satin rouleaux in contrast colours. CAT. NO. 76/12.

93 Dress, in 'Lace Mountain' print on silk chiffon; asymmetric top and pleated collar decorated with beads,
pleated ribbon edging and sash in satin. CAT. NO. 75/61.

94 One-shoulder dress in 'Cactus Everywhere' print on silk chiffon, over jersey tube; dress cut round scallops of

print and attached to stitched satin band with mirrored stars; hand-rolled edges. (Variation of butterfly nos 76, 112, 124, 155 and 165.) CAT. NO. 75/5c.

10 Across the U.S.A. – Cactus and Cowboys

95 Kaftan, in 'Cactus Everywhere' print on silk chiffon with beaded neckline and front; and hand-rolled edges. CAT. NO. 75/42.

96 Asymmetric dress, in 'Cactus Volcano' print on silk chiffon; hand-rolled edges and satin sash. CAT. NO. 75/61.

97 Dress, combining 'Cactus Volcano' and 'Cactus Everywhere' prints on silk chiffon; pleated collar with beading, and satin sash. CAT. NO. 75/62.

98 Kaftan, in 'Giant Cactus' print on silk chiffon with beaded bodice. (Variation of butterfly no. 13.) CAT. NO. 75/6.

99 Dress, in 'Cactus Everywhere' print on silk chiffon, with beaded neckline, rouleaux ties at cuffs and satin sash. CAT. NO. 76/1.

100 (a) Top, in 'Cactus Everywhere' print on silk chiffon, beaded with mirrored stars, and hand-rolled edges; lined in satin. (b) Evening pyjama to match. CAT. NO. 75/55.

101 Evening pyjama, in 'Cactus Highway' print on silk chiffon, with pleated frill bodice caught up with beads on to satin lining, and slashed hand-rolled edges. CAT. NO. 75/53.

11 Mexico, Sombreros and Fans

102 Crinoline, in 'Mexican Turnaround' print on silk chiffon; bodice and skirt cut to shape of print and beaded; fan details and skirt frills in silk net; and beaded satin sash. CAT. NO. 79/107.

103 Dress, combining 'Mexican Sombrero' and 'Mexican Border' prints on silk chiffon, with beaded front and contrast satin sash. CAT. NO. 76/29.

104 (a) 'Petal' top, in 'Mexican Turnaround' print on silk chiffon; shape dictated by print; beaded at front; hand-rolled edges. (b) Skirt to match.
(For further variations see butterfly nos 137, 151, 160 and 162.) CAT. NO. 77/1.

105 Crinoline, in 'Mexican Border' print on silk organza; cuffs hand-rolled with pearls and contrast satin sash. CAT. NO. 76/51.

106 'Petal' dress, in 'Mexican Turnaround' print on silk chiffon, over jersey skirt; shape dictated by print; beaded bodice and hand-rolled edges. CAT. NO. 77/11.

107 Dress, in 'Mexican Turnaround' print on silk chiffon, bodice shaped to print and beaded; with hand-rolled edges and contrast satin sash. CAT. NO. 77/10.

108 Dress, in 'Mexican Dinner Plate' print on silk chiffon, sleeves and beaded collar cut to shape of print, with hand-rolled edges and contrast satin sash. CAT. NO. 77/9.

109 (a) Circular top, in 'Mexican Sombrero' print on silk chiffon, beaded and edges hand-rolled with pearls. (b) Skirt to match, using eight 'half' circles (as in butterfly nos 14 and 21.) CAT. NO. 76/26.

110 Crinoline, in 'Mexican Fan' print on silk organza, cut to shape of print; edges hand-rolled with pearls, beaded bodice and satin sash. CAT. NO. 78/50.

111 (a) Top, in 'Mexican Fan' print on silk chiffon with beaded bodice and hand-rolled edges. (b) Skirt to match. CAT. NO. 78/1.

112 One-shoulder dress, in rainbowed 'Mexican Banana Leaf' print on silk chiffon, over jersey tube, cut to shape of print; with stitched satin band and hand-rolled edges. (Variation of butterfly nos 76, 94, 124, 155 and 165.) CAT. NO. 77/5c.

113 Quilted jacket, in 'Mexican Fan' print on satin, edged with pleated ruffles and rouleaux ties. CAT. NO. 78/53.

114 Kaftan jacket, in 'Mexican Fan' print on silk chiffon, beaded centre front fastening, and edges hand-rolled with pearls. CAT. NO. 78/7.

115 Off-shoulder pleated 'tunic dress', in 'Mexican Fan' print on silk chiffon, over jersey tube, and edges hand-rolled with pearls. CAT. NO. 78/4.

116 Pleated jacket, in 'Mexican Fan' print on satin, with satin-stitch 'lettuce' edging. CAT. NO. 78/44.

117 Dress, in 'Mexican Banana Leaf' print on silk chiffon, over jersey tube, cut to shape of print with separate hand-rolled leaves attached; pleated satin bodice with contrast satin-stitch 'lettuce' edging and rouleaux shoulder ties. CAT. NO. 76/21.

118 Dress, combining 'Mexican Fan' and 'Mexican Banana Leaf' prints on silk chiffon, beaded front bodice and satin sash. CAT. NO. 78/2.

12 Conceptual Chic and Punk

119 Jersey dress, with holes at shoulders, decorated with chains and beaded safety-pins and contrast 'lettuce' edges. CAT. NO. 78/31.

120 Long satin sash, an asymmetric jersey strip attached with beaded safety-pins, decorated with chains and rhinestones, and contrast 'lettuce' edges. CAT. NO. 77/15.

121 (a) Jersey top (made from four circles), with asymmetric holes, decorated with chains, beaded safety-pins and rhinestones, with contrast 'lettuce' edges. CAT. NO. 77/25. (b) Matching skirt. CAT. NO. 77/18.

122 Jersey skirt, attached to satin sash with beaded safety-pins, decorated with chains and 'lettuce' edges. Separate knotted and chained tassel attached to 'torn' pocket. CAT. NO. 78/38.

123 Jersey dress and tunic, with asymmetric holes, decorated with beads and beaded safety-pins, contrast 'lettuce' edging and satin binding. CAT. NO. 77/12 & 77/20.

124 One-shoulder jersey dress, with asymmetric holes, decorated with beads, rhinestones and beaded safety-pins, contrast 'lettuce' edging and stitched satin band (Variation of butterfly nos 76, 94, 112, 155 and 165.) CAT. NO. 78/5c.

125 Jersey dress, with asymmetric holes, decorated with beads and beaded safety-pins; and contrast 'lettuce' edging. (Only top section of dress illustrated.) CAT. NO. 77/3.

126 Jersey stole, with beaded asymmetric holes held together with beaded safety-pins, and contrast 'lettuce' edging. (Can be worn as jacket by putting arms through the two large diagonal holes.) CAT. NO. 78/S/61.

127 Jersey dress, decorated with beaded safety-pins, chains and diamanté; with contrast 'lettuce' edging and twisted rouleaux shoulder straps. CAT. NO. 78/64.

128 (a) Backview of top, showing 'fan-shaped' detail. (See butterfly no. 128b.) (b) Crinoline, consisting of 'fan-shaped' top and matching skirt in 'Arab Broderie' print on silk organza, with beaded neckline and satin sash. CAT. NO. 80/88.

129 Dress, made from four squares of 'Torn Square' print on silk chiffon, front decorated with beads, hand-rolled edges and rouleaux ties at shoulders. CAT. NO. 79/1c.

130 Dress, in 'Broderie' print on silk chiffon over jersey tube, edges cut like tears and hand-rolled with pearls; and stitched satin band. CAT. NO. 81/16.

131 Dress, in 'Broderie' print on silk chiffon gathered into a 'V' neck satin band, and elasticated at knees to form bubble. Edges cut like tears and hand-rolled with pearls; twisted and beaded satin rouleaux at neck. CAT. NO. 78/96.

132 Crinoline, in 'Arab Broderie' print on silk organza; beaded 'V' neckline and cuffs hand-rolled with pearls and satin sash. CAT. NO. 79/104.

133 Crinoline, combining two prints, 'Torn Square' on silk chiffon and 'Arab Broderie' on net. Top of bodice lining dictated by shape of print and accentuated with rows of black lace; lace also used to edge frills on skirt, and satin sash. CAT. NO. 79/108.

134 Crinoline, bodice in 'Arab Broderie' print on silk organza, and frilled net skirt; beaded bodice and contrast satin sash. CAT. NO. 81/65.

13 My Head and Heads in the South of France

135 Dress, combining 'Painted Lady' and 'Broderie' prints on silk chiffon, bodice with machine appliquéd net yoke; hand-rolled edges with beaded points on hem, satin 'Bubble' skirt lining and sash covered with rows of lace. CAT. NO. 78/47.

136 Dress, made from four squares of 'Painted Lady Figures' print on silk chiffon with quilted satin bodice; edges hand-rolled with pearls and satin 'Bubble' lining. CAT. NO. 79/15.

137 (a) Top, in 'Scribble Turnaround' print on silk chiffon; hand-rolled edges with beaded points, tassels and rouleaux ties. (b) Skirt to match. (Variation of butterfly nos 104, 151, 160 and 162.) CAT. NO. 79/94.

138 Backview of Ultrasuede jacket, with asymmetric embroidered seams on the outside, appliquéd 'Magic Head' motif in contrast colours; beaded with diamanté. CAT. NO. 78/65.

139 Quilted jacket, in 'Spiral Heads' print on satin, with double side-opening. CAT. NO. 79/110.

140 Dress, with 'Chinese style' bodice, in 'Magic Head' print on silk chiffon; special pleated detail to form shoulders, edges hand-rolled with pearls, and jersey underskirt. CAT. NO. 79/74.

141 'Bubble' dress, in 'Magic Head' print on silk chiffon; beaded, and edges hand-rolled with pearls; stitched band and lining in satin. CAT. NO. 79/9.

142 'Bubble' kaftan, made from two squares of 'Painted Lady' print on silk chiffon, edges hand-rolled with pearls. CAT. NO. 78/88.

143 Felt skirt, with appliquéd 'Painted Lady' and 'Wiggle Stripe' motifs, and embroidered seams on the outside. CAT. NO. 78/82.

14 Los Angeles and Star Wars

144 'Bubble' dress, in 'Star Wars' print on net, edged with lace, lined in contrast satin, and rouleaux ties at neck. CAT. NO. 78/99.

145 Dress, in 'Star Wars' print on silk chiffon, with beaded rouleaux ties at sleeves and neck, hem hand-rolled with pearls, and satin sash. CAT. NO. 79/37.

146 'Bubble' dress, in 'Star Wars' print on silk chiffon, edges hand-rolled with pearls; arm-openings under 'knotted' epaulettes. CAT. NO. 79/96.

147 Kaftan, in 'Star Wars' print on silk chiffon, hem cut to shape of print and edges hand-rolled with pearls. (Narrow variation of butterfly no. 96.) CAT. NO. 79/53.

148 Dress, combining 'Mexican Dinner Plate and Star Wars' prints on silk chiffon with beaded net inset, and edges hand-rolled with pearls. CAT. NO. 78/63.

15 China and Circles from Another World

149 Raincoat, in 'Chinese Balls' print on 'shot' taffeta, with pointed shoulder 'heads' and 'concertina' arm-hole details. CAT. NO. GM/81/3062.

150 Dress, in 'Chinese Water Circles' print on silk chiffon, bodice lining and hem cut to shape of print, edges hand-rolled with pearls, satin binding and sash. (Worn over narrow jersey evening trousers – not illustrated.) CAT. NO. 80/94.

151 (a) Top, in 'Chinese Water Circles' print on silk chiffon, beaded and cut to shape of print with hand-rolled edges. (b) Skirt to match. (Variation of butterfly nos 104, 137, 160 and 162.) CAT. NO. 80/1.

152 Kaftan jacket, in 'Chinese Water Circles' print on silk chiffon, beaded front feature, cut to shape of print and edges hand-rolled with pearls; contrast satin binding at neck. CAT. NO. 80/130.

153 Coat, in 'Chinese Balls' print on felt with dramatic cowl neckline fastened with beaded rouleaux ties. CAT. NO. 80/64.

154 Dress, in 'Chinese Squares' print on silk crêpe de chine, 'concertina' sleeves and cut to shape of print. CAT. NO. 79/129.

155 One-shoulder dress, in 'Chinese Constructivist and Clouds' print on silk chiffon, over jersey tube with stitched satin band and rosette; cut to shape of print and hand-rolled beaded edges. (Variation of butterfly nos 76, 94, 112, 124 and 165.) CAT. NO. 81/5c.

156 Kaftan jacket, in 'Chinese Constructivist and Clouds' print on silk chiffon, beaded centre front feature and pearl droplets on hand-rolled hem. CAT. NO. 81/7.

157 Dress, in 'Chinese Constructivist and Clouds' print on silk chiffon, beaded bodice and neckline, hand-rolled edges and satin sash. CAT. NO. 80/112.

158 Dress, in 'Chinese Squares' print on silk chiffon, beaded front feature, cut to shape of print and edges hand-rolled with pearls. CAT. NO. 79/89.

159 Wrap skirt, in 'Chinese Squares' print on silk crêpe de chine with stitched waistband. CAT. NO. 79/133.

160 (a) Top, in 'Chinese Constructivist and Clouds' print on silk chiffon, beaded and cut to shape of print, pearl droplets on hand-rolled edges. (b) Skirt to match. (Variation of butterfly nos 104, 137, 151 and 162.) CAT. NO. 80/119.

161 Dress, in 'Chinese Constructivist and Clouds' print on silk chiffon, beaded bodice and edges hand-rolled with pearls and droplets; jersey underskirt and satin sash. CAT. NO. 80/114.

16 Kenya and Zebras

162 (a) Top, in 'Zebra Skin' print on silk chiffon, cut to shape of print; edges hand-rolled with feathers. (b) Skirt to match. (Variation of butterfly nos 104, 137, 151 and 160.) CAT. NO. 81/85.

163 Kaftan, in 'Zebra Skin' print on silk chiffon, cut to shape of print; edges hand-rolled with feathers. CAT. NO. 81/86.

164 Kaftan jacket, in 'Zebra Skin' print on silk chiffon, cut to shape of print; edges hand-rolled with feathers. (Worn over butterfly no. 165.) CAT. NO. 81/79.

165 Jersey dress, with twisted shoulder straps, decorated with string, burnt beads and feathers, and contrast 'lettuce' edging. (Worn under jacket butterfly no. 164. Variation of butterfly no. 127.) CAT. NO. 81/87.

166 Dress, in 'Zebra Skin' print on silk chiffon, beaded neckline, edges hand-rolled with pearls and feathers; jersey underskirt and cord belt. CAT. NO. 81/77.

167 One-shoulder dress, in 'Zebra Skin' print on silk chiffon, over jersey tube, cut to shape of print, edges hand-rolled with pearls and feathers, and stitched satin band. (Variation of butterfly nos 76, 94, 112, 124 and 155.) CAT. NO. 81/84.